I CLAVDIA II

Withdrawn

I CLAVDIA II

Women in Roman Art and Society

EDITED BY *Diana E. E. Kleiner and Susan B. Matheson*
Yale University Art Gallery

UNIVERSITY OF TEXAS PRESS
Austin

To All the Claudias

The publication of this book was aided by a subsidy from the Yale University Art Gallery

Funding for the symposium at the Yale University Art Gallery was provided by a grant from the National Endowment for the Humanities, a federal agency, and the Beinecke Rare Book and Manuscript Library, Yale University

First edition, 2000

Requests for permission to reproduce material from this work should be sent to Permissions, University of Texas Press, Box 7819, Austin, TX 78713-7819.

♾ The paper used in this book meets the minimum requirements of ANSI/NISO Z39.48-1992 (R1997) (Permanence of Paper).

LIBRARY OF CONGRESS CATALOGING-IN-PUBLICATION DATA

I Claudia II : women in Roman art and society / edited by Diana E. E. Kleiner and Susan B. Matheson. — 1st ed.
 p. cm.
 Papers presented at a symposium held at the Yale University Art Gallery in November, 1996.
 Sequel to I, Claudia.
 Includes bibliographical references and index.
 ISBN 0-292-74340-8 (pbk. : alk. paper)
 1. Art, Roman Congresses. 2. Women in art Congresses. 3. Women—Rome—Social conditions Congresses. I. Kleiner, Diana E. E. II. Matheson, Susan B. III. Title: I Claudia 2. IV. Title: I Claudia Two.
N5763.I253 2000
704.9'424'0937—dc21
 99-37955

CONTENTS

ACKNOWLEDGMENTS

In 1996, we characterized the exhibition and catalogue *I, Claudia: Women in Ancient Rome* as a magical collaboration that continued to grow and expand. Nowhere is that better demonstrated than in this sequel volume: *I Claudia II: Women in Roman Art and Society.* While busily mounting the exhibition and preparing the catalogue, nothing was further from our minds than a second *Claudia.* And this book would probably have not seen the light of day had not editors of several university presses encouraged us to think in that direction. Once the scholarly symposium on *I, Claudia* was presented at the Yale University Art Gallery in November 1996, we recognized that the papers delivered there not only spoke to many of the themes of the exhibition but expanded further our knowledge and understanding of Roman women in a way that we believed merited publication. The papers by Diana Delia and Ann Ellis Hanson that were delivered at a complementary session on women in Roman Egypt, organized by Robert Babcock for the Beinecke Rare Book and Manuscript Library at Yale, are also included here. We appreciate Bob Babcock's and the authors' willingness to publish them in this volume. Since this second *Claudia* was so closely interwoven with the subject and approach of the first, many works of art discussed here were also part of the exhibition. For that reason, we have chosen to repeat here some of the illustrative material that appeared in volume I.

Our greatest debt is to Joanna Hitchcock of the University of Texas Press and Susan Chang of Oxford University Press for encouraging us to proceed with this project and to the reviewers for those presses, all of whom revealed themselves to us—Karl Galinsky, Elaine Fantham, and William Metcalf. Their comments were wide-ranging and insightful and enabled us to improve this volume. Joanna Hitchcock has been especially supportive from the days of *I, Claudia I* (the University of Texas Press distributed the catalogue), as has her colleague James Burr. Working with them both has been a consummate pleasure, and we are grateful that we have been so fortunate.

Profound thanks are also due the distinguished scholars who have contributed to this volume—Mary T. Boatwright, Eve D'Ambra, Diana Delia, Ann Ellis Hanson, Andrew Oliver, Jr., Cornelius C. Vermeule, Rolf Winkes, and Susan Wood. Their contributions not only made the Yale Symposium a great success but they also collegially and promptly readied their essays for publication and acquired the necessary illustrations.

It is a pleasure to offer special thanks to Helen Cooper, former Acting Director of the Yale University Art Gallery, for her encouragement and for lending the Gallery's support to the sequel volume. Additional research and editorial assistance were efficiently and cheerfully provided by Genevieve Gessert, whose important contribution continued to keep alive the Claudia tradition of close collaboration with Yale graduate students.

The Yale Symposium was generously supported by the National Endowment for the Humanities, and the Provost's Office and Department of Classics of Yale University.

Funding for the Beinecke Symposium was provided by the Beinecke Rare Book and Manuscript Library.

We and all of the contributors to this volume are grateful to the following museums, photographic archives, photographers, and artists for providing photographs, drawings, and permissions: Alinari/Art Resource, New York; American Numismatic Society, New York; Archivio Fotografico della Soprintendenza Archeologica di Ostia; British Academy; The Trustees of the British Museum, London; The Nuffler Foundation; Deutsches Archäologisches Institut, Zentrale, Berlin; Deutsches Archäologisches Institut, Madrid; Deutsches Archäologisches Institut, Rome; Arthur M. Sackler Museum, Harvard University Art Museums, Cambridge, Massachusetts; Indiana University Art Museum, Bloomington; Los Angeles County Museum of Art, Los Angeles; Museo Nazionale Archeologico, Naples; Museum of Fine Arts, Boston; North Carolina Museum of Art, Raleigh; Ny Carlsberg Glyptotek, Copenhagen; Franc Palaia; San Antonio Museum of Art, San Antonio; Sterling Memorial Library, Numismatic Collection, Yale University, New Haven; Toledo Museum of Art, Toledo; Virginia Museum of Fine Arts, Richmond; Walters Art Gallery, Baltimore; Mary Grosvenor Winkes; P. Witte; Yale University Art Gallery, New Haven.

We also want to thank the Yale and scholarly communities and the general public for their warm response to the *I, Claudia* exhibition. As we delivered countless gallery talks and public lectures on Claudia and other Roman women, we were continually greeted by enthusiastic audiences made up of individuals with lively, penetrating, and challenging questions. Many of their comments and queries helped us refine our own thinking on the subject and enhanced our individual contributions to this volume.

For us, the *I, Claudia* journey has been long but extraordinarily rewarding and it is gratifying to be able to celebrate this sequel by dedicating it to *All the Claudias*.

DIANA E. E. KLEINER
Dunham Professor of Classics and History of Art
Deputy Provost for the Arts
Yale University

SUSAN B. MATHESON
The Molly and Walter Bareiss Curator of Ancient Art
Yale University Art Gallery

NOTES TO THE READER

All dates are AD unless otherwise indicated or unless failure to specify might cause confusion. Latin forms of names are generally used, except where the source or context makes this inappropriate. Cross references in the text to "vol. I" are to illustrated entries in the catalogue of the exhibition *I, Claudia: Women in Ancient Rome* (Yale University Art Gallery, New Haven 1996). Illustrations are numbered to correspond to the chapter to which they belong, beginning with the *Introduction*.

ABBREVIATIONS

Abbreviations used are those listed in the *American Journal of Archaeology* 95 (1991) 4–16 and the *Oxford Classical Dictionary,* 3rd editions (1996), plus the following:

BIEBER, *Copies*
M. Bieber, *Ancient Copies* (New York 1977)

D'AMBRA, *Roman Art in Context*
E. D'Ambra ed., *Roman Art in Context: An Anthology* (Englewood Cliffs 1993)

DIXON, *Roman Family*
S. Dixon, *The Roman Family* (Baltimore 1992)

FITTSCHEN, *Faustina*
K. Fittschen, *Die Bildnistypen der Faustina Minor und die Fecunditas Augustae* (*AbhGött* 126, 1982)

FITTSCHEN–ZANKER
K. Fittschen and P. Zanker, *Katalog der römischen Porträts in den Capitolinischen Museen und der anderen kommunalen Sammlungen der Stadt Rom I* (Mainz 1985); III (Mainz 1983)

GARDNER, *Women in Roman Law*
J.F. Gardner, *Women in Roman Law and Society* (Bloomington 1986)

INAN AND ROSENBAUM
J. Inan and E. Rosenbaum, *Roman and Early Byzantine Portrait Sculpture in Asia Minor* (London 1966)

KAMPEN, *Sexuality*
N.B. Kampen ed., *Sexuality in Ancient Art* (Cambridge 1996)

KAMPEN, *Image and Status*
N.B. Kampen, *Image and Status: Roman Working Women in Ostia* (Berlin 1981)

KLEINER AND MATHESON, *I, Claudia*
D.E.E. Kleiner and S.B. Matheson, *I, Claudia: Women in Ancient Rome,* exhibition catalogue, Yale University Art Gallery (New Haven 1996)

KLEINER, *Roman Sculpture*
D.E.E. Kleiner, *Roman Sculpture* (New Haven 1992)

KLEINER, *Roman Group Portraiture*
D.E.E. Kleiner, *Roman Group Portraiture: The Funerary Reliefs of the Late Republic and Early Empire* (New York 1977)

LEFKOWITZ AND FANT
M.R. Lefkowitz and M.B. Fant, *Women's Life in Greece and Rome: A Sourcebook in Translation*[2] *(Baltimore 1992)*

POULSEN I AND II
V. Poulsen, *Les portraits romains I* (Copenhagen 1973); II (Copenhagen 1974)

RAMAGE AND RAMAGE, *Roman Art*
N.H. Ramage and A. Ramage, *Roman Art: Romulus to Constantine* (New York 1991)

RICHARDSON, *Topographical Dictionary*
L. Richardson, jr, *A New Topographical Dictionary of Ancient Rome* (Baltimore 1992)

ROSE, *Dynastic Commemoration*
C.B. Rose, *Dynastic Commemoration and Imperial Portraiture in the Julio-Claudian Period* (Cambridge 1996)

TREGGIARI, *Roman Marriage*
S. Treggiari, *Roman Marriage* (Oxford 1991)

WEGNER, *Hadrian*
M. Wegner, *Hadrian, Plotina, Marciana, Matidia, Sabina* (*Das römische Herrscherbild* 2.3, Berlin 1956)

"HER PARENTS GAVE HER THE NAME CLAVDIA"

DIANA E. E.
KLEINER AND
SUSAN B.
MATHESON

The material remains from ancient Rome have preserved valuable evidence for the appearance and accomplishments of Roman women. Nonetheless, these remains have only begun to be examined for what they tell us about Roman women of all social classes. In fact, the surviving public buildings, portrait statues, historical reliefs, wall paintings, cameos, and coins often reveal information about Roman women that is not available from any other source, and they enhance the picture provided by extant historical texts and Latin literature.

I, Claudia: Women in Ancient Rome, an exhibition organized by the Yale University Art Gallery, was the first attempt to study the lives of Roman women as revealed in Roman art. The goal of the exhibition was to explore and attempt to recreate the lives of women of all ages and social levels in the public and domestic spheres and to illuminate the ways in which they were commemorated after death. The exhibition was accompanied by a catalogue that allowed us to explore such topics as gender theory, portraits of Roman empresses and princesses, the assimilation of women to goddesses and personifications, and women's roles in society, in the home, in Latin literature, and as patrons of the arts and to document what each work of art in the exhibition reveals about Roman women.[1]

The scholarly symposium that accompanied the exhibition was designed to introduce additional topics and points of view beyond those featured in the exhibition and its catalogue, while maintaining a focus on the fundamental themes presented there. Another symposium held in connection with the exhibition, sponsored by the Beinecke Rare Book and Manuscript Library at Yale University, focused on women in Roman Egypt, with papers by Diana Delia and Ann Ellis Hanson. The papers from both symposia published here thus center on such subjects as mothers and sons, marriage and widowhood, aging, adornment, imperial portraiture, and patronage. This introduction is intended to give the reader an overview of the exhibition's themes, as a context for these papers.

The *I, Claudia* exhibition and its catalogue were about Roman women whose lives were, in a sense, encapsulated in that of Claudia's. While Claudia's name was hardly chosen haphazardly, and we were clearly borrowing from the title of Robert Graves's near mythical *I, Claudius,* we were mindful that Claudia was a name replete with historical associations.[2] The Claudians were an illustrious patrician family. Livia Drusilla, wife of Rome's first emperor Augustus, was herself a Claudian, and her son, Tiberius, became second emperor of Rome. The first Roman imperial dynasty is known as the Julio-Claudians, because its emperors, Tiberius, Caligula (Gaius), Claudius, and Nero were descended by blood from a Claudius, like Tiberius, son of Tiberius Claudius Nero, and adopted by Julius Caesar's adoptive son Augustus; descended from a marriage between the two families; or, like Nero, of Julian descent and adopted by a Claudian. While Roman men possessed tripartite Roman names, with the family name or

nomen the middle of the three, accompanied by a first name *(praenomen)* and a nickname *(cognomen),* women had legal claim to only two: the *nomen* and *cognomen*.[3] Since the *nomen* was the family name, women in the same Claudian family might be distinguished by being referred to as the older or younger Claudia.

Augustus counted a Claudia among his ancestors,[4] and there were several Claudias in the Claudian branch of the Julio-Claudian family. Antonia the Younger and Germanicus had a daughter named Claudia Livilla, who was the wife of Tiberius's son Drusus. After Drusus's death in 23, her hand was sought by Sejanus, who later conspired unsuccessfully to assassinate Tiberius. Claudia Livilla's brother, the emperor Claudius, had several daughters named Claudia. Among them, Claudia Octavia, although empress, was perhaps the least fortunate. Married to the emperor Nero, she was first divorced by her husband, then banished by him on contrived charges of adultery and treason, and finally put to death. Claudius's wife, Messalina, had Claudian connections of her own; her aunt and cousin was Claudia Pulchra, friend of Agrippina the Younger. Being a friend of Agrippina was a dangerous alliance in the late principate of Tiberius. The same Sejanus, who sought the hand of Claudia Livilla, preceded his attempt to assassinate Tiberius by consolidating his own power, largely through eliminating Agrippina's friends. Claudia Pulchra was among these unfortunate associates, and was convicted on charges of adultery and treason, brought against her by Sejanus.[5]

Since, upon manumission, freedwomen and freedmen took the *nomen* of their patron, there were also many Claudias among the non-elite who lived among the imperial family, sometimes as domestics. Claudia Parata, for example, a freedwoman, possibly of the emperor Claudius, served as a hairdresser in the imperial household. Her husband erected a funerary altar for her at her death at the age of 27.[6] In addition, many non-citizen women from the empire took the name Claudia when their father or family was given citizenship by a Julio-Claudian emperor.[7]

Outside the imperial family but still from a high social stratum, Claudia Severa was the wife of a military officer, and she accompanied him on campaign to the Roman province of Britain. A letter of hers inviting a friend to her birthday party survives from the second century. Although the letter was written for her by a scribe, she added a personal greeting at the end in her own hand.[8]

Another literate Claudia, a woman named Claudia Trophime, was a priestess of Hera at Ephesus in the first century. She also served a term as chief priestess of Hestia, and in celebration of this honor, she wrote two poems praising the goddess for tending the eternal flame of fire from heaven.[9]

Even more prestigious was the office of Vestal Virgin, held by several Claudias from various branches of the Claudian family. The most famous of these was Claudia Quinta, a respectable historical figure who was transformed in post-Augustan mythology into a Vestal Virgin whose chastity was questioned, a type of misconduct that brought the death penalty on the offender.[10] The mythical Claudia Quinta was miraculously vindicated, however, by the goddess Cybele, who gave the woman strength to haul a ship bearing the goddess's image up the Tiber to her temple on the Palatine; Claudia Quinta thus became an enduring model in antiquity for the chaste and noble woman.[11]

Equally public in her demonstration of virtue was Claudia Pulchra, daughter of Appius Claudius Pulcher (consul in 143), who rode with her father in his chariot during a military triumph that he chose to celebrate during a senatorial ban. The privilege that Claudia Pulcher enjoyed as a Vestal Virgin protected her father from persecution for going against a senatorial decree, or in the eyes of his supporters, from being destroyed by his enemies. Cicero cites both of these Claudias as examples of outstanding moral behavior.[12]

Freedwomen outside the imperial household took their *nomen* from the Claudian family as well, and they engaged in various professions. Another Claudia Trophima, probably a freedwoman, was a midwife who lived to be 75. Her funerary monument was erected by her son and grandson.[13] Other freedwomen named Claudia were the dedicants of funerary reliefs for their husbands and sons.[14]

Outside Rome, a woman named Claudia Isidora (Appia), from the nome of Oxy-rhynchus in Egypt, achieved wealth and prominence as a landowner and real estate investor. Claudia Isidora is named in fifteen surviving papyri.[15] These documents record the financial dealings of a woman who acted on her own to buy, sell, and lease her property, purchased luxury goods such as imported honey, and employed others to act as her deputies. Although her estate was ultimately confiscated and turned over to the treasury, her name was still well known after her death.

Even this brief sample of Claudias demonstrates the broad social range of the historical women who bore the name. In their diversity, these Claudias reflect the unique place Roman women held in antiquity. Within the context of the ancient world, Roman women led surprisingly varied and public lives. They enjoyed far more freedom than their counterparts in ancient Egypt or fifth-century Greece, although by contemporary western standards we would still consider their lives restricted. Roman women could attend dinner parties and public events to a degree that would have been totally unacceptable in ancient Greece, but they could not vote or be elected to office, and they were under the control of a male guardian for much of their lives.[16]

In spite of these restrictions, Roman women did have significant power in certain spheres, notably in politics, religion, and business. This power most often derived from the women's association with men. At all levels of Roman society, a woman's status was tied to that of her father and husband. The empress's authority derived from her husband and from her son, if he too succeeded to the principate.[17] Such associative power enabled her to be a force in Roman political life. Empresses such as Livia (fig. Int. 1 [vol. I, no. 1]) and Agrippina the Younger were influential enough to be able to bestow patronage, influence political decisions, arrange marriages, and set moral standards. All of these acts were recorded, sometimes openly and sometimes more subtly, in state relief sculpture, portraiture, the Roman coinage, and precious cameos. If the empress was herself wealthy (associative power derived from her father), as was Livia, that increased her authority.

Some authoritative positions in the religious sphere were held by Roman women. Most powerful and influential among these were the Vestal Virgins, who enjoyed numerous honors in return for their service to the cult of Vesta.[18] Many of these privileges, such as sacrosanctity, special seats in the theater, and the right to travel in a special cart *(carpentum),* were denied to virtually all other women. Livia and Augustus's sister Octavia were made sacrosanct by Augustus, but they were unique among secular women in this regard.[19] Other cults were served by women as priestesses. Livia was the first priestess of the Divine Augustus, a role subsequently reserved for the empress, and other empresses and members of the imperial family served as priestesses and were associated with a wide variety of cults. Non-imperial women, such as Eumachia, were also priestesses, especially of the cults of Venus, Cybele, Demeter, and Fortuna. As was noted above, Claudia Trophime was the priestess of Hera and Hestia at Ephesus. The office of priestess brought distinction both to the woman who held it and to her family, and it was generally a reflection of the prominence her family held in the community in which she served.

Outside the imperial family, women could also be commanding presences in religion and business. Eumachia achieved wealth and power as a priestess and successful businesswoman in Pompeii.[20] Her achievements were her own, but the opportunities

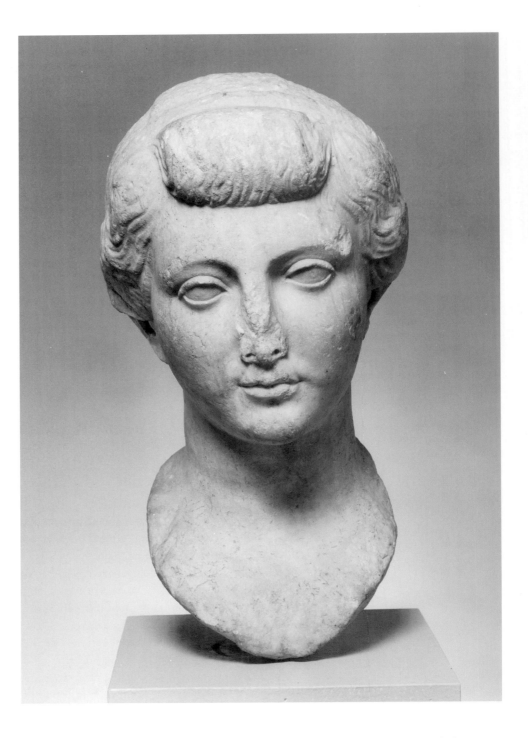

FIGURE INT. I
Portrait of Livia. Baltimore,
Walters Art Gallery,
museum purchase 23.211.
[photograph: museum]

provided her derived from association: she inherited her wine, amphora, and tile-export business from her father, and her priestly office was probably the result of either her filial ties to an old Pompeiian family or the prominence of her husband, Marcus Numistrius Fronto, an elected official.

Family businesses were also left to women by their husbands, either in their absence or after their death. Women could also inherit, buy, or sell property such as real estate and slaves. They could also work at a profession.[21] Women were midwives, actresses, writers, domestics, hairdressers, nurses, seamstresses, and vendors of a wide variety of goods.[22] These opportunities allowed such women to amass significant financial resources that they could use to advance the political and social position of their family. Some backed their sons in political careers and arranged advantageous marriages for

their daughters; others increased the family's landholdings or expanded or decorated the family residence; still others funded their manumission from slavery.[23] Wealthy women devoted some of their fortunes to obtaining fashionable jewelry or clothing for themselves or for dowries for their daughters.[24] A surprising amount went into the commissioning of works of art, ranging from portraits and buildings selected by the empress and other women in the imperial circle to funerary monuments commissioned by freedwomen.

Literary evidence for women as patrons of the arts is scarce; here the material remains serve to document the manner and purpose of female patronage. In his *Res Gestae,* Augustus does not mention the building commissions of Livia. Perhaps it was inappropriate to do so in his personal record. Yet we know from inscriptional evidence, a third-century marble plan, and surviving archaeological remains that Livia built monumental and visible public buildings and temples in Rome. These included a porticus, which served as a public museum, and a market, both of which bore the empress's name. The temples and shrines she commissioned were dedicated to virtues associated with women, such as fertility (Temple of Bona Dea Subsaxana), chastity (shrines of Pudicitia Patricia and Pudicitia Plebeia), the fortune of women (Temple of Fortuna Muliebris), and harmony (Temple of Concord).[25] Livia's beneficence inspired other women. The wealthy Eumachia commissioned a porticus, based on Livia's, that opened onto the Forum in Pompeii.[26]

Surviving Roman portrait and relief sculpture provides additional evidence for women as patrons of the arts. The empress Julia Domna appears to have commissioned her official portraits from a nameless sculptor known today only as the Caracalla Master (fig. Int. 2 [vol. I, no. 42]), reflecting that he also carved portraits of Julia's son, the notorious emperor Caracalla.[27] At the same time, the emperor Septimius Severus, Julia's husband, employed a different sculptor for his official portraits. Such works represented the image that the imperial family wanted to project for itself,[28] and it is significant that the empress had sufficient latitude in her choice of image maker that she could choose a sculptor other than the one selected by her husband.

A similar choice may be reflected in funerary portraits in relief of non-elite women who, according to accompanying inscriptions, dedicated the monuments themselves. A relief bearing the portrait of Petronia Hedone and her son in the Museum of Fine Arts, Boston, displays a portrait of a mother and her son and is inscribed with a text that tells us Petronia dedicated it herself. No man is present, suggesting that she was a widow. She may thus have been free to choose the sculptor who would commemorate her and her son and to dictate the manner in which they were represented.[29] Pliny the Younger notes that it is desirable when commissioning a portrait to select a sculptor who can best represent one's appearance and character.[30] Petronia Hedone and Julia Domna apparently had this in mind when they chose the man who would depict them in their portrait likenesses. Portraits of women like Eumachia of Pompeii[31] and others discussed by Boatwright in this volume provide further evidence of women as patrons of the arts.[32] A woman named Plancia Magna, of Perge (in modern southern Turkey), for example, commissioned an elaborate city gate and triple arch adorned with portrait statues of imperial women as a donation to her city.

The power a Roman woman had in politics, business, or state or foreign religion, enhanced by personal wealth and family lineage, was largely exercised in public. A similar authority was available at home, where financial resources and family connections were also paramount. In a domestic setting, Roman women not only were household managers but also set the standard for and guarded the moral behavior of their children and their slaves.

Whatever a Roman woman's social or economic status, home and family were the primary focus of her life. The Roman *domus* was not a retreat from professional life, as

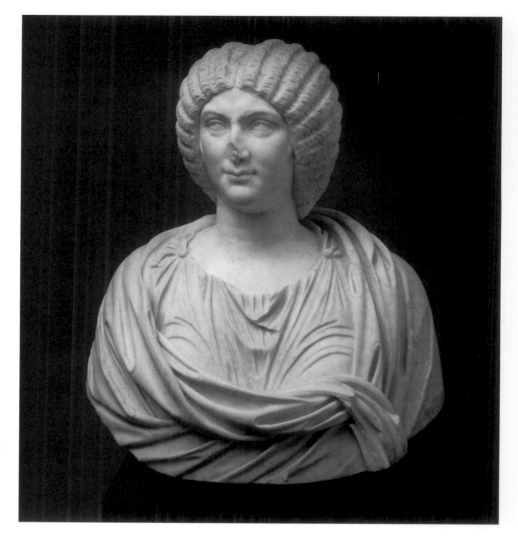

FIGURE INT. 2
Portrait of Julia Domna. Bloomington, Indiana University Art Museum, Gift of Thomas T. Solley, 75.33.2. [photograph: Michael Cavanagh and Kevin Montague]

it often is today, but a relatively open and public space where official and family business were transacted. It was in the Roman *domus* that the *paterfamilias,* or head of household, received his clients, guests, relatives outside his immediate family, and others seeking political or financial favors. The house was also often the site of the family enterprise, and some had shops *(tabernae)* opening onto the street, which could be operated by the family, or rented to another owner. The atrium of the house was its central circulation point and transversed by all visitors to the *domus.* It was filled with symbols of family life, including the ancestor shrine, which defined the genealogical identity of the family; the marriage bed, standing for the continuity of the family; the loom, making reference to the wife's virtue; and often the *lararium* or shrine to the household gods.[33] Evidence of the family's wealth might also be present, and special interests of family members might be reflected in the subjects of the paintings that decorated the walls. While painted portraits of women in domestic contexts appear to have been rare, they were not unheard of.[34]

The goal of a woman's life, whether empress or freedwoman, was a successful marriage and the raising of children.[35] Even slave women, although denied the legal right to marry, formed equivalent relationships and then worked to attain the freedom that would legalize the union and ensure the free status of their children.[36] Roman women were generally first married in their late teens, and they were expected to have children by the time they were aged 20.[37] Legislation sponsored by Augustus required remarri-

age after the death or divorce of a spouse, and women were exempt from this requirement only if they had given birth to three or more children, or if they were over 50.[38] Many women remarried in spite of these exemptions, generally for financial reasons. Some, however, such as Antonia the Younger,[39] chose to remain widows, and if they were wealthy, these widows could exercise considerable political and moral authority.

The significance of marriage to the Romans is well known and underscored by its inclusion as a theme in Roman funerary art. Sepulchral reliefs, paired funerary portraits, and stone sarcophagi depicted husbands and wives joining right hands, the gesture of *dextrarum iunctio,* which referred both to the marriage ceremony and to the marital vows that united the couple in perpetuity (fig. Int. 3).[40] Funerary reliefs and altars were often accompanied by epitaphs that celebrate the couple's marital virtues. Virtues such as fertility, beauty, and especially fidelity were associated with the woman as marital partner. The ideal of the *univira* was an old one in Rome. It signified that a woman married one man and remained a widow after her husband's death. This ideal was opposed by Augustus's marriage legislation, where remarriage among the aristocracy was favored because it allowed the increased production of children.[41] The epitaphs that may have been painted on the inscription plaques of Roman sarcophagi have long since faded. Thus we rarely know who commissioned the many surviving coffins or for whose remains they were intended. Marriage is a frequent theme. It is sometimes the focus of the narrative and sometimes subsidiary to the main subject. It sometimes appears on the main body of the coffin and sometimes on the lid or the short sides. It can be depicted in a variety of ways, among them the scene of *dextrarum iunctio,* portraits with attributes that refer to fertility, chastity, and so on, and the conflation of the married pair or one of the partners with a mythological being, such as Alcestis, in a story that refers to marriage or to marital virtues.[42] Scenes of marriage and scenes featuring the virtues of women (for example, fertility, fidelity, and beauty) are sometimes combined with those that refer to male virtues like prowess in battle or the hunt, the granting of clemency to vanquished foes, and pious offerings to a beneficent god (fig. Int. 4 [vol. I, no. 162]).[43] Thus the virtues of both husband and wife are highlighted, as is the desired continuity of the family that their marriage ensures. These dynastic ambitions of marriage were universal through all levels of Roman society, and they appear to have been held equally by men and women.

Once married, a woman was expected to bear children and to educate them by instilling Roman moral values. The relationship of a Roman mother to her children was strikingly different from ours. While contemporary society values close and affectionate ties between mother and child and expects the mother to participate in the daily physical care of young children, Roman society emphasized the role of the mother as educator and moral instructor. That is not to say that the mother had the same moral authority as the father in whose power or *potestas* the children found themselves.[44] While surviving literary sources focus on the mother's role in moral guidance, funerary epitaphs and reliefs provide evidence for the affection Roman mothers had for their children.[45] Since inculcating moral values in children began at a very young age, even the wet nurse was supposed to possess high moral character. Furthermore, she needed to be able to speak good Latin and to be abstemious when it came to drink.[46] Since many women died in childbirth, and others were not allowed to keep their children after divorce, young children were also often cared for by female relatives other than their mother. A widowed woman, for example, might return to her married son's home to care for his offspring. Older women, especially widows, were considered to embody austere moral character, an attitude that is reflected in the numerous seemingly naturalistic portraits of elderly Roman women.[47] A combination of tutors and schools completed a child's education.[48]

The Roman mother's aim was to advance her children economically, socially, and

professionally. For daughters, this meant arranging advantageous marriages. For sons, the goal was political and economic advancement, whether through marriage, a military campaign, a foreign service post, a high public office, and preferably all of these, and mothers as well as fathers devoted every possible effort to their sons' success. We see this maternal drive in imperial women such as Livia and Agrippina the Younger, but it was not entirely magnanimous. Such well-placed mothers were only too well aware that their son's advancement enhanced their own positions in Roman society and public life. These same women might use extreme means to achieve the desired results. Agrippina, for example, is rumored to have poisoned her husband Claudius in order to advance the political ambitions of her teenaged son Nero. That his youth might enable her to serve as regent in the early years of his principate was clearly another motivating factor. Surviving ancient texts, such as Suetonius's biographies of the Roman emperors through Nerva, relate lively stories that demonstrate the details of such familial relationships.[49] Material evidence elucidates these further and provides a vivid visual record of the evolution of the alliance between parent and child. Agrippina the Younger, for example, appears on coins with Nero in a succession of issues that explore the growth of his power and the corresponding diminution of hers (fig. Int. 5 [vol. I, no. 20]).[50]

FIGURE INT. 3
Funerary Relief of a Roman Couple. **Musei Vaticani.** [photograph: Alinari/Art Resource, NY]

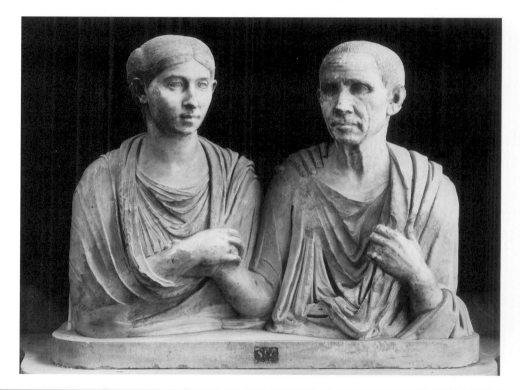

FIGURE INT. 4
Biographical Sarcophagus. **Los Angeles, Los Angeles County Museum of Art, The William Randolph Hearst Collection, 47.8.9.** [photograph: museum]

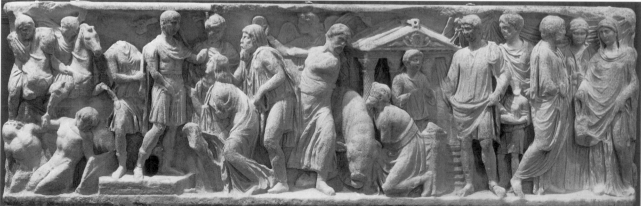

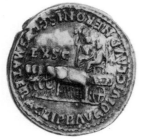

Agrippina and Nero and other imperial mothers and sons were often depicted in freestanding family portrait groups that were arranged in architectural settings around the empire. The intention was a dynastic display that featured not only the current emperor and his spouse but likely heirs and future leaders. Such family groups could be encountered just about everywhere in a typical Roman city: in the forum or marketplace, at the theater or baths. The individual statues were placed in niches and on pedestals with inscriptions that often mentioned family relationships.[51] Family unity was also the subject of the relief sculpture on such public monuments as the Ara Pacis Augustae, erected between 13 and 9 BC. While the altar reliefs were carved in commemoration of a political act of the emperor (the bringing of peace to Rome and the empire), it also celebrates the imperial family and the concept of dynastic continuity. Augustus is accompanied not only by lictors, priests, and magistrates but by his family: his wife Livia, his daughter Julia, and their children, and other imperial families. All were put on prominent view to underscore the emperor's commitment to hereditary dynasty and to the increased procreation of children among the Roman elite.[52]

Family advancement and family unity were also the goals of Roman freedwomen who commissioned sepulchral monuments that publicly expressed their pride in their children's upward climb in what was a mobile Roman society. Since the children of enfranchised slaves were themselves free, their inclusion in the reliefs and portrait sculptures of such monuments heralded their access to careers and social alliances that had eluded their parents. That the family could also afford a costly stone memorial spoke to its professional and financial success. Parents and their children were depicted together, even though they died at different times, in order to underscore the importance of familial bonds and to emphasize that those unions that were formed in life were not broken by death.

Mothers and sons of all social classes were often depicted together in art; mothers and daughters less often.[53] Freestanding portraits of girls appear, however, to have been frequently commissioned, and when they represent girls in their teens, it is likely that they were produced at the time of betrothal or marriage.[54] Such portraits of girls show them with the bearing and hairstyles of a mature woman. A girl, now in the Yale Art Gallery (fig. Int. 6 [vol. I, no. 121]), wears the *nodus* coiffure popularized by Octavia and Livia, a hairstyle she probably chose for her wedding portrait because it indicated not only that she was fashionable but that she possessed the same feminine virtues as the empress.[55] A girl still young enough to treasure her favorite rag dolls and pet dog is portrayed with an elaborate bun that covers most of the back of her head and dangling earrings as she reclines on her funerary couch in a poignant portrait, now in the J. Paul Getty Museum.[56] Such a combination of the freshness of childhood and the oncoming responsibility of womanhood emphasize the girl's unfulfilled future as a *matrona*. Accompanying epitaphs mourn the premature death that precluded marriage. A girl who died before marriage was often buried with more jewelry and fine attire than a wealthy adult woman, and it seems likely that the girl's material belongings were part of her dowry, buried with her rather than taken by her at marriage to her new household.[57]

As mentioned above, certain virtues were frequently associated with Roman men and women of all classes. While men were heralded for their manliness and loyalty, women were praised for their beauty, fertility, and fidelity. Fertility and fidelity were the cornerstones of Augustus's moral and marriage codes, and it was during his principate that Livia was invested with these virtues. Even though Augustus was not Livia's first husband, it was ideologically advantageous to the first couple to present themselves as having the kind of harmonious marriage that once achieved would last in perpetuity. If Augustus were to predecease her, Livia would surely remain a widow, the very embodiment of the ideal *univira*.[58] And yet, the marriage legislation encouraged childbirth. Here, Livia was aided by Augustus's adoption of his grandsons Gaius and Lucius

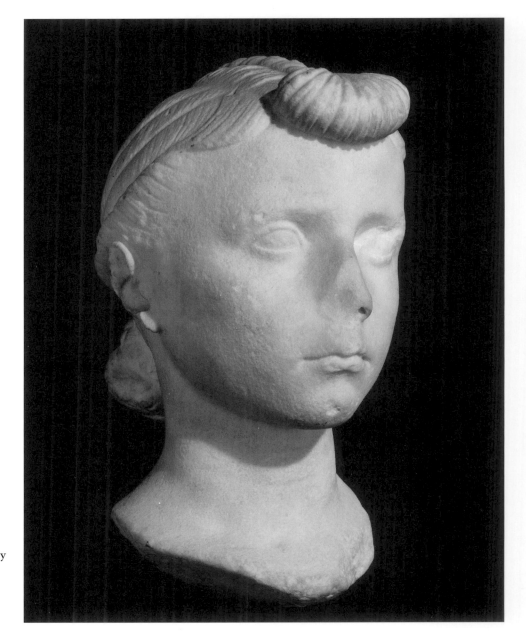

Head of an Augustan Girl.
New Haven, Yale University
Art Gallery, Maitland F.
Griggs, B.A. 1896, Fund,
1995.80.1. [photograph:
museum]

as his sons. While that adoption probably did not allow Livia to count the boys legally
as her children,[59] public perception, aided by such visual affirmation as the imperial
family groups on the Ara Pacis, might have embraced such a concept. Since Livia was
already the mother of Tiberius and Drusus by a former marriage, she was already
viewed as fertile and when Drusus died in 9, she acquired the *ius trium liberorum* (pri-
vilege of three children). On the Ara Pacis, Livia was depicted near Gaius and Lucius
and Tiberius and Drusus and also near Tellus Italiae, herself represented with two ba-
bies on her lap. The proximity of Livia and Mother Earth forcefully presented the pub-
lic with a striking image of a fertile and productive role model for all other Roman
women.[60] Goddesses like Venus, Juno, and Ceres were amply endowed with the char-
acteristics most prized in a Roman woman, and the near assimilation of Roman imperial
women to their divine alter egos was openly advertised on the official Roman coinage.
Since that coinage was used in daily commerce around the empire, such imagery was
widely dispersed and highly influential. Empresses like Livia were depicted on Roman

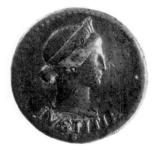

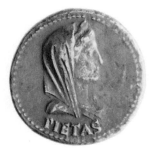

aurei with the attributes of various divinities and personifications (figs. Int. 7 and Int. 8 [vol. I, nos. 9 and 10]).[61]

The highpoints of an empress's public career were also featured on the Roman coinage. When Agrippina was regent, she appeared on a coin's obverse facing her son, the emperor Nero.[62] Faustina the Younger was heralded on a series of coins, relating the story of the single and twin births of her thirteen children.[63] Similar alliances and accomplishments were made reference to in marble portrait statues of imperial women, sometimes set up alone but more often in conjunction with those of husbands and sons.[64]

Non-elite women were proud to possess the same virtues as their imperial counterparts and were depicted as if they did in art. Whether they actually possessed such characteristics in life was never the point. Their lives were modeled after an ideal image that was widely held, and they wanted to be remembered for posterity as the very embodiment of those prized virtues. Virtues such as beauty, chastity, fertility, fidelity, and devotion were most often chosen to associate with deceased wives and mothers. This was accomplished visually by providing the woman with the characteristics or attributes of the chosen goddess or personification. A woman renowned for her beauty might be portrayed as a sensuous Venus, as is a freedwoman in a sepulchral relief now in the Virginia Museum of Art in Richmond (fig. Int. 9 [vol. I, no. 55]).[65] A woman shown in the guise of Alcestis, who offered to die for her husband, would be celebrated for her wifely devotion.[66]

In Roman antiquity, beauty was physical comeliness but, at the same time, was perceived as a feminine virtue. A woman with an exquisite hairstyle was at once attractive and also virtuous. Empresses and princesses worked with their hairstylists to create new coiffures because they wanted to be perceived as fashionable, on the cutting edge, and prosperous, but, at the same time, these hairstyles proclaimed that their wearer possessed all the traits desirable in the ideal Roman woman. In addition, these hairstyles were not chosen haphazardly. Instead, each corkscrew curl, each flowing tress, and each

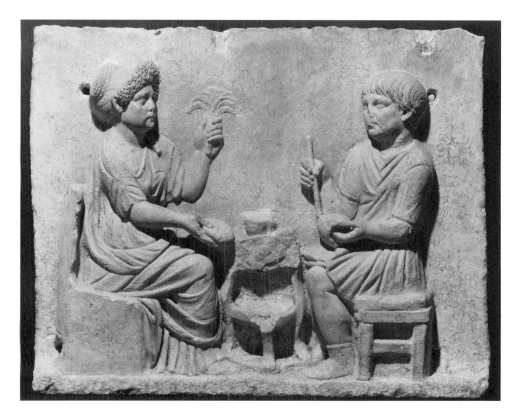

blunt cut bang was carefully arranged to make reference to the political or social agenda of the current dynast and his family. Octavia appears to have invented the new *nodus* coiffure, but it was Livia who transformed it into a *cause célèbre,* to be imitated by Roman girls and matrons throughout the empire. Livia's hairstyle was copied in large part because it was hers and she was empress of Rome. But it was also imitated because it literally had bound up with it all the desirable features of ideal Roman womanhood, enumerated in the Augustan marriage and moral legislation. By wearing the hairstyle, the woman took on, almost by magic, all of the trappings of the ideal Roman woman. An additional nuance was that this very coiffure had become associated in the minds of the Romans with the Roman state itself and with a nationalistic fervor. Livia wore the simple hairstyle as a statement that she, unlike Cleopatra, her husband's foe at Actium, was a woman of high moral character, a patrician from a noble Roman family, and not a foreign woman given to what was reported to be ostentatious excess. The simplicity of Livia's hairstyle was not only a striking contrast to the intricacy of Cleopatra's tresses but a reflection of the simple austerity of the Republican values being revived by Augustus in his program of moral reform. When aristocratic women, freedwomen, and even female slaves adopted Livia's hairstyle, they did so in imitation of the current trendsetters but also to indicate that they possessed the same virtues as their imperial counterparts and that they were Romans.

Elegant hairstyles made their wearers beautiful and virtuous Roman women, and their possession of such status is apparent even when all that is preserved of the statue or bust portrait is the head. It must be remembered, however, that most Roman portraits belonged to full-length statues that took the form of a wide variety of body types. These too were carefully chosen by their commissioners, and these too were fraught with pronouncements about current politics, religious affiliations, and personal predilections. In their portraiture, Roman women took on roles as they chose body types. Enviable was the ability of Roman women to fashion themselves as fit but amply endowed, wealthy but modest, elaborately coiffed but capable of working with wool, and sensuous but models of correct behavior. One of the ways that they took on these roles in their portraiture was to select body types, in a sense costumes, associated with specific Roman goddesses whose physical characteristics and personal qualities were well known. By donning a given goddess's body type, the new bearer also took on her attributes. The messages could, however, still be complex and polysemous. The predilection that Roman empresses and former slaves had for Venus imagery was due in part to their wish to be depicted as physically desirable but also to underscore the female fertility that provided them the capability to bear numerous healthy children.[67]

The association of mortal Roman women with goddesses was not limited to their affiliation with Venus, although these appear to have been the most common. Demeter and Persephone[68] as well as Ceres and Fortuna were assimilated to both empresses and non-elite women. The representation of Roman women in the guises of such goddesses was one of the ways in which visual language was used to convey belief in certain social values, each goddess associated with certain traits that the women who were depicted in her guise also possessed.

Chastity was highly prized by the Romans, and they equated it in art with the act of working with wool. The story of Lucretia, as told by Livy, is a case in point.[69] While on a military campaign, Lucretia's husband made a bet with one of his comrades about the relative virtues of their wives. They hastened to Rome to see what their wives were up to in their absence. All were out carousing except the chaste Lucretia, who was at home, working her wool.

Working in wool also demonstrated prudent management of the household, another wifely virtue. Funerary reliefs depicting women working in wool are meant to refer to their domestic skills. A cinerary urn in the shape of a basket in the Metropolitan

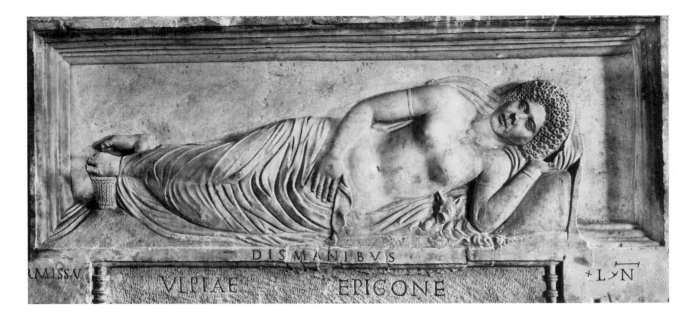

Museum of Art was used to house the remains of a woman who was prized by her
husband and children for the way she tended to the home.[70] Another sepulchral relief
portrays a reclining woman with a wool basket (fig. Int. 10). While the basket refers to
her expertise in household management, her nudity proclaims that she was also attrac-
tive and fertile enough to bear children.[71] The loom, which traditionally stood in the
house's atrium, also made reference to judicious housekeeping, and in the procession to
her new home, the bride carried the distaff and spindle.[72]

That Roman society was grounded in masculine values is apparent in the choice of
virtues esteemed in women — chastity, fertility, beauty, and so on — qualities that
defined these women's lives in a man's world. The ideal woman needed to be attractive,
able to tend the household, bear children, and set a moral example for those children
through correct behavior. Such a woman, if she lived, might enjoy a long and respect-
able marriage. The *Laudatio Turiae,* a long epitaph from the first century BC, com-
memorates a marriage of forty years.[73] In it, the husband praises the virtues of his dead
wife. While he notes that she saved his life and helped him escape his enemies, he
emphasizes the personal qualities that she brought to their marriage, namely, her loy-
alty, obedience, affability, reasonableness, sobriety of nature, modesty of appearance,
and industry in working wool. A much earlier funerary inscription of the second cen-
tury BC, written for a woman by a man, also evokes these values, indicating that they
were well established during the Republic:

Friend, I have not much to say, stop and read it.
This tomb, which is not fair, is for a fair woman.
Her parents gave her the name Claudia.
She loved her husband in her heart.
She bore two sons, one of whom she left on earth, the other beneath it.
She was pleasant to talk with. She walked with grace.
She kept the house. She worked in wool.
That is all. You may go.[74]

These epitaphs make it apparent that the virtues men praised in women were closely
associated with home and the family. Nonetheless, historical sources, Latin literature,
inscriptions, and especially works of Roman art provide sound evidence that the lives of

Roman women were multifaceted and often had a public face. Independence and action in the service of moral causes were respected. Women in particular were expected to maintain a high moral character and to serve as examples of correct behavior for Roman society. It is too limiting to see Roman women only as wives and mothers, although that was their primary role in the view of Roman society. That some of these women were also writers, doctors, entrepreneurs, students of philosophy, world travelers, and patrons of the arts, sometimes on a very grand scale, among other professions and avocations, irrefutably contradicts the image of the purely domestic Roman woman. It was not only Livia and the empresses who followed her who made significant contributions to their society. Women at all levels of the Roman social pyramid did as well, and they left the material evidence of that contribution in the form of museums, markets, temples, shrines, houses, villas, arches, tombs, altars, relief sculpture, portraits, metalwork, coins, epitaphs, and so on. Each one of these works of art or architecture narrates part of the story left by an ambitious empress, an innocent princess, an aristocrat with a patrician pedigree, a well-placed priestess, a gifted poetess, a solid middle-class tavern owner, a popular midwife, and a fetching concubine. Bringing this material evidence together and evaluating what it tells us about the lives and accomplishments of Roman women is what the *I, Claudia* exhibition and catalogue were all about. This second volume is a continuation of that effort.

NOTES

1. Kleiner and Matheson, *I, Claudia.* The exhibition was shown at the Yale University Art Gallery, New Haven, Connecticut (6 September–1 December 1996), the San Antonio Museum of Art, San Antonio, Texas (3 January–9 March 1997), and the North Carolina Museum of Art, Raleigh, North Carolina (6 April–15 June 1997).

2. R. Graves, *I, Claudius: From the Autobiography of Tiberius Claudius, Born BC 10, Murdered and Deified AD 54* (New York 1965).

3. For Roman nomenclature, see I. Kajanto, "Women's *Praenomina* Reconsidered," *Arctos* 7 (1972) 13–30; I. Kajanto, "On the First Appearance of Women's *Cognomina*," in *Akten des VI. Internationalen Kongresses für Griechische und Lateinische Epigraphik, München 1972* (Munich 1973) 402–404.

4. Macrobius *Saturnalia* 2.5.1–10, trans. Lefkowitz and Fant 195–96 no. 266.

5. A. Barrett, *Agrippina: Sex, Power, and Politics in the Early Empire* (New Haven 1996) 34–35.

6. *CIL* VI, 8957, trans. Lefkowitz and Fant 422 no. 334.

7. We would like to thank Elaine Fantham for bringing these Claudias to our attention.

8. From Vindolanda, England, second century (Tabula Vindolandensis inv. no. 85/87), trans. Lefkowitz and Fant 205 no. 272.

9. Inscr. Eph. 1062 G, trans. Lefkowitz and Fant 9 no. 24.

10. On the evolution of the myth, see T.P. Wiseman, *Clio's Cosmetics* (Leicester 1979) 94–99; we are grateful to Elaine Fantham for this reference.

11. J. Scheid, "Claudia, la vestale," in A. Fraschetti ed., *Roma al femminile* (Rome 1994) 3–19.

12. Cic. *Pro Caelio* 14; trans. Lefkowitz and Fant 36 no. 71.

13. *CIL* VI, 9720, trans. Lefkowitz and Fant 267 no. 377.

14. See, for example, *CIL* VI, 37769 and 38354 (Baltimore, Johns Hopkins University Archaeological Museum); R. Huitt, in Kleiner and Matheson, *I, Claudia* cat. nos. 169–70.

15. For one of these, and a discussion of the group, see J. Allen, in Kleiner and Matheson, *I, Claudia* cat. no. 62.

16. Gardner, *Women in Roman Law;* J. Thebert, "Private and Public Spaces: The Components of the Domus," in D'Ambra, *Roman Art in Context* 213–37.

17. For the associative power empresses gained from their sons, see D.E.E. Kleiner, "Family Ties," this volume.

18. M. Beard, "The Sexual Status of Vestal Virgins," *JRS* 70 (1980) 149–65.

19. For the granting of *sacrosanctitas* to Livia and Octavia, see most recently D.E.E. Kleiner, "Imperial Women as Patrons of the Arts in the Early Empire," in Kleiner and Matheson, *I, Claudia* 28 and n. 5; also B. Scardigli, "La *sacrosanctitas tribunicia* di Ottavia e Livia," *AFLS* 3

(1982) 61–64; N. Purcell, "Livia and the Womanhood of Rome," *PCPS* 212 (1986) 85–88.

20. For Eumachia, her family associations and architectural commissions, see most recently Kleiner (supra n. 19) 33–34.

21. Gardner, *Women in Roman Law;* Lefkowitz and Fant 94–127; J. Allen, in Kleiner and Matheson, *I, Claudia* cat. nos. 62–63.

22. For the professions of Roman women, see Kampen, *Image and Status;* S. Treggiari, "Jobs in the Household of Livia," *BSR* 43 (1975) 48–77; S. Treggiari, "Jobs for Women," *AJAH* 1 (1976) 76–104; Lefkowitz and Fant 208–24.

23. R. van Bremen, "Women and Wealth," in A. Cameron and A. Kuhrt eds., *Images of Women in Antiquity* (London 1993) 223–42.

24. See further A. Oliver, "Jewelry for the Unmarried," in this volume.

25. For Livia's building program, see Kleiner (supra n. 19). On the Temple of Concord, see M. Flory, "*Sic Exempla Parantur:* Livia's Shrine to Concordia and the Porticus Liviae," *Historia* 33 (1984) 309–30, with earlier bibliography.

26. For Eumachia's porticus, see most recently Kleiner (supra n. 19) with earlier bibliography.

27. The sculptor in question was first called the Caracalla Master by S. Nodelman, *Severan Imperial Portraiture, 193–217 AD* (Diss. Yale Univ. 1965) 392–418. See also S. Wood, *Roman Portrait Sculpture 217–260 AD* (Leiden 1986) and Kleiner, *Roman Sculpture* 326–29.

28. For a similar approach, see R. Winkes, "Livia," in this volume.

29. For this point of view, see Kleiner, "Family Ties," in this volume. See also S.H. Cormack, in Kleiner and Matheson, *I, Claudia* cat. no. 151.

30. Pliny the Younger *Letters* 3.10.6.

31. Kleiner (supra n. 19).

32. See further M.T. Boatwright, "Just Window Dressing?," in this volume.

33. For the Roman house and its panoply of symbols, see A. Wallace-Hadrill, "Engendering the Roman House," in Kleiner and Matheson, *I Claudia,* and *Houses and Society in Pompeii and Herculaneum* (Princeton 1994); J.R. Clarke, *The Houses of Roman Italy, 100 BC–AD 250* (Los Angeles 1991).

34. Some mythological pairs from Pompeii may represent women and their spouses, real or imaginary. See D.L. Thompson, "Painted Portraiture at Pompeii," in *Pompeii and the Vesuvian Landscape* (Washington, D.C. 1979) 78–92. Pliny the Elder (*HN* 35.147–48) records the name of one woman painter, Iaia, who specialized in portraits of women; perhaps these hung in domestic

settings. Fayum portraits may originally have been displayed on the walls of houses and may provide evidence for others elsewhere in the Roman empire, no longer preserved. On Fayum portraits, see K. Parlasca, *Mumienporträts und verwandte Denkmäler* (Wiesbaden 1966); A.F. Shore, *Portrait Painting from Roman Egypt,* rev. ed. (London 1972); D.L. Thompson, *The Artists of the Mummy Portraits* (Malibu 1976); L. Corcoran, *Portrait Mummies from Roman Egypt* (Chicago 1995). Some paintings with female protagonists in mythological or divine settings may have included portraits of Roman mythological women. The likenesses of Livia and Julia, for example, may have been in the roundels in the Black Room of the Villa of Agrippa Postumus at Boscotrecase. See M. Anderson, "The Portrait Medallions of the Imperial Villa at Boscotrecase," *AJA* 91 (1987) 127–35.

35. For Roman marriage, see Treggiari, *Roman Marriage.*

36. For slave marriage or *contubernia* not recognized by Roman law, see S. Treggiari, "*Contubernales* in *CIL* 6," *Phoenix* 35 (1981) 42–69; Treggiari, *Roman Marriage;* Kleiner, *Roman Group Portraiture.*

37. K. Hopkins, "Age of Roman Girls at Marriage," *Population Studies* 18 (1965) 309–27; B.D. Shaw, "The Age of Roman Girls at Marriage: Some Reconsiderations," *JRS* 77 (1987) 30–46.

38. For Augustus's marriage legislation, see D.E.E. Kleiner, "The Great Friezes of the Ara Pacis Augustae: Greek Sources, Roman Derivatives, and Augustan Social Policy," *MEFRA* 90 (1978) 753–83; R.I. Frank, "Augustus' Legislation on Marriage and Children," *CSCA* 8 (1975) 41–52; P. Csillag, *The Augustan Laws on Family Relations* (Budapest 1976); K. Galinsky, "Augustus' Legislation on Morals and Marriage," *Philologus* 125 (1981) 126–44; Treggiari, *Roman Marriage* 277–98.

39. N. Kokkinos, *Antonia Augusta: Portrait of a Great Roman Lady* (London 1992).

40. For the *dextrarum iunctio* as a sign of marriage and as a theme in Roman funerary art, see Kleiner (supra n. 38); G. Davies, "The Significance of the Handshake Motif in Classical Funerary Art," *AJA* 89 (1985) 627–53; D.E.E. Kleiner, "The Funerary Relief of Apuleius Carpus and Apuleia Rufina," *ArchClass* 30 (1978) 246–51; D.E.E. Kleiner, "Social Status, Marriage, and Male Heirs in the Age of Augustus: A Roman Funerary Relief," *North Carolina Museum of Art Bulletin* 14 (1990) 20–28.

41. Gardner, *Women in Roman Law;* G. Wil-

liams, "Some Aspects of Roman Marriage Ceremonies and Ideals," *JRS* 48 (1958) 16–29; M. Lightman and W. Feisel, "*Univira:* An Example of Continuity and Change in Roman Society," *Church History* 46 (1977) 19–32.

42. E.g., Los Angeles County Museum of Art 47.8.9, P.J.E. Davies, in Kleiner and Matheson, *I, Claudia* cat. no. 162; Musei Vaticani, Museo Chiaramonti 1195; see also N.B. Kampen, "Biographical Narration and Roman Funerary Art," *AJA* 85 (1981) 47–58; G. Koch, *Sarkophagen der Römische Kaiserzeit* (Darmstadt 1993) 68–69 and n. 302; G. Koch and H. Sichtermann, *Römische Sarkophage* (Munich 1982) 99–100, 107–108, 260. On Alcestis sarcophagi, see S. Wood, "Alcestis on Roman Sarcophagi," *AJA* 82 (1978) 499–510.

43. E.g., the biographical sarcophagus in the Los Angeles County Museum of Art, The William Randolph Hearst Collection, 47.8.9 (vol. I, no. 162), Davies (supra n. 42).

44. Gardner, *Women in Roman Law* 137–42; but cf. S. Dixon, *The Roman Mother* (Norman 1988), who argues that the Roman mother had moral authority in the family equal in many ways to that of the father.

45. Literary sources, e.g., Cicero *Brutus* 210–11; Quint. *Inst.* 1.1.5; see also J.F. Gardner and T. Wiedemann eds., *The Roman Household: A Sourcebook* (New York 1991) 98–109. Epitaphs, e.g., Ann Arbor, Kelsey Museum of Archaeology KM 1581 and 1446, R.W. Huitt, in Kleiner and Matheson, *I, Claudia* cat. nos. 159 and 160. See also Dixon (supra n. 44) 104–14.

46. K.R. Bradley, "Wet-Nursing at Rome: A Study in Social Relations," in B. Rawson ed., *The Family in Ancient Rome* (Ithaca 1986) 201–29.

47. See S.B. Matheson, "The Elder Claudia," in this volume.

48. For the education of Roman children, see Gardner and Weidemann (supra n. 45) 102–108; S.F. Bonner, *Education in Ancient Rome: From the Elder Cato to the Younger Pliny* (London 1977).

49. Suet. *Claud.* 44 and *Nero* 34 for elements of the Nero and Agrippina story.

50. On the relationship of Roman mothers to their sons, see Kleiner, "Family Ties," in this volume; cf. vol. I, nos. 19–20.

51. Rose, *Dynastic Commemoration*.

52. For the Ara Pacis and its reference to Augustus's political and social goals, see Kleiner (supra n. 38) 753–83; Kleiner, *Roman Sculpture* 90–99.

53. Kleiner, "Family Ties," in this volume.

54. Roman girls married as early as age 10 and usually by 14. See Hopkins (supra n. 37).

55. Yale University Art Gallery, Maitland F. Griggs, B.A. 1896, Fund, 1995.80.1; M.J. Behen, in Kleiner and Matheson, *I, Claudia* cat. no. 121.

56. The J. Paul Getty Museum 73.AA.11; S.H. Cormack, in Kleiner and Matheson, *I, Claudia* cat. no. 142.

57. See A. Oliver, "Jewelry for the Unmarried," in this volume.

58. That Livia became Rome's principal *univira* is disputed by G. Herbert Brown, *Ovid and the Fasti* (Oxford 1994) 147. We would like to thank Elaine Fantham for this reference.

59. Brown (supra n. 58) 63.

60. See Kleiner, *Roman Sculpture* 96–98.

61. F.S. Kleiner, in Kleiner and Matheson, *I, Claudia* cat. nos. 8–10.

62. Aureus of Agrippina the Younger with portraits of Nero and Agrippina, New York, American Numismatic Society 1905.57.29, F.S. Kleiner, in Kleiner and Matheson, *I, Claudia* cat. no. 19.

63. For these, see F.S. Kleiner, in Kleiner and Matheson, *I, Claudia* cat. nos. 37–39, and Fittschen, *Faustina*.

64. See Kleiner, "Family Ties," in this volume, and Rose, *Dynastic Commemoration*.

65. Richmond, Virginia Museum of Art 60-2, J.M. Barringer, in Kleiner and Matheson, *I, Claudia* cat. no. 55.

66. Wood (supra n. 42).

67. See E. D'Ambra, "Nudity and Adornment," in this volume.

68. See S. Wood, "Mortals, Empresses, and Earth Goddesses," in this volume.

69. Livy *Ab Urbe Condita* 1.57.6–58, trans. Lefkowitz and Fant 132–33 no. 166.

70. New York, Metropolitan Museum of Art 37.129a–b, S.H. Cormack, in Kleiner and Matheson, *I, Claudia* cat. no. 153.

71. E. D'Ambra, "The Cult of Virtues and the Funerary Relief of Ulpia Epigone," *Latomus* 48 (1989) 392–400.

72. Wallace-Hadrill, in Kleiner and Matheson, *I, Claudia* 109.

73. *ILS* 8393, trans. Lefkowitz and Fant 135–39 no. 168.

74. *CIL* VI, 15346, trans. R. Lattimore, in Lefkowitz and Fant 16 no. 39.

LIVIA TO HELENA
Women in Power, Women in the Provinces

CORNELIUS C.
VERMEULE III

CORNELIA

When a person named Cornelius is asked to keynote a symposium on gender from the Thames to the Tiber to the Tigris, his thoughts naturally turn to the Cornelias, not those in his own family in the past but those of ancient Rome. The star in the ancient Roman firmament is Cornelia, daughter of Scipio Africanus and mother of the Gracchi, who regarded her two sons as her jewels. She wrote famous letters, admired by Cicero, and she continued to hold salons after her sons were killed. And another Republican Cornelia, the "cultured daughter" of Metellus Scipio, married P. Crassus in 55 BC and Pompey in 52. After the battle of Pharsalus she accompanied Pompey to Egypt and saw him murdered. She then returned to Italy.

It was all downhill thereafter. Few remember Cornelia Supera, wife of Aemilianus in 253, and immediately thereafter came Cornelia Salonina, wife of Gallienus. In his reign, jointly with his father Valerian (253–260) and then with innumerable rivals for the next eight years, the Roman empire almost self-destructed. The so-called Valerian Wall in Athens is an index of what transpired when the Herulians wasted the cradles of Greek civilization. Better to turn from the Cornelias to the Claudias.[1]

THE MOST CELEBRATED CLAUDIA

To borrow from Robert Graves's semihistorical autobiography of the Emperor Nero Claudius Drusus (41–54) and to genderize the title to "I, Claudia" is most appropriate, since the most famous person at Sardis after King Croesus is surely the Antonine lady Claudia Antonia Sabina. Her sarcophagus is a glory of the Istanbul Museum, and her three names are celebrated too, the first because of this exhibition and the second and third because they were strong and influential ladies of the Julio-Claudian and the Hadrianic ages.

Antonia (Minor) (36 BC–AD 37), daughter of Octavia and Mark Antony, beloved widow of the popular general Nero Claudius Drusus, and mother of Germanicus and the future emperor (I) Claudius, died of grief, self-starvation, and old age at the end of the reign of her suspicious, reclusive brother-in-law, Tiberius, or in the rule of her mad grandson Gaius Caesar "Caligula."[2] She is called "Minor" because her older sister (born 39 BC) bore the same name. Antonia Major married Lucius Domitius Ahenobarbus, and their grandson was the last Julio-Claudian, the Emperor Nero, also a mite mad. To complicate matters, Tacitus called Antonia Major "Minor" because Mark Antony's daughters had a much older half-sister also named Antonia, after her mother, yet another Antonia. (Clearly, imagination in choice of names was not Mark Antony's strong suit.) In 34 BC the eldest daughter Antonia disappeared into Asia Minor as the bride of

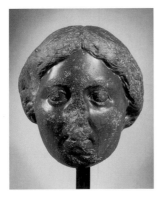

a Greek millionaire, Pythodorus of Tralles. Their daughter started a Romano-Pontic dynasty by marrying Polemo I, king of Pontus.

To my knowledge, portraits in the round, in relief (possibly in the reliefs of the Ara Pacis), and on coins have been identified only for Antonia, the Julian who married into the Claudian family. Antonia's long life meant that her portraits progressed from a round-faced youthfulness to one with sharp, pointed edges, an idealization of seeming emaciation.[3] Rarest of all her likenesses is a youthful head in Egyptian basalt from the Fayum area (fig. I.I).[4] It has been demonstrated that such portraits were not indicators of a person's color but denoted their status as rulers of Pharaonic Egypt. Antonia was given the posthumous, courtesy title *Augusta* by her son, the emperor Claudius. Her connections with Egypt were solid from birth, her father Mark Antony and her mother Octavia appearing in Egyptian basalt, as did her uncle Octavian-Augustus as ruler of Egypt, his personal province, for forty-five years.

Sabina, daughter of Matidia the Elder and granddaughter of Trajan's elder sister Marciana, endured her marriage to Hadrian with dignity and restraint. An arch across the Via Flaminia (Corso) in Rome portrayed her apotheosis as a monumental panel.[5] Why a local Roman Sabina at Sardis? A visit by the empress Sabina around 125 may have triggered the naming of noble babies Sabina. After all, Claudia Antonia Sabina was no hag when she died, as her portrait on her big sarcophagus bears witness. It was here at Sardis, on this memorable imperial visit, that Hadrian toured the brothels, and Antinous had a history-making tantrum.

And we should remember that there was an imperial Claudia Antonia, the daughter of the emperor Claudius and Plautia Urgulanilla. This Claudia was the recipient of an honorary statue at Ilium (Troy). She married her distant cousin Faustus Sulla. Since they had children, perhaps some of the later Claudias in Italy or Asia Minor were descendents of this Claudia and this Cornelius!

GREAT LADIES IN ASIA MINOR

Claudia Antonia Sabina was not the only great lady Claudia in metropolitan Asia Minor. The mausoleum or heroön of Claudia Antonia Tatiane (or Tatiana) at Ephesus belongs to the year 204. Fragments of three high-quality marble sarcophagi of diverse origins were discovered. In an inscribed letter, Claudia Antonia Tatiane granted permission for her brother Aemilius Aristeides and his wife to be buried in her heroön. An inscription on one of the sarcophagi tells us that Quintus Aemilius Aristeides was an imperial procurator for Septimius Severus and Caracalla.[6]

Also at Ephesus and sometime in the years around 220 to 230, Claudia Crateia Veviane was a *prytanis* and an *archiereia*. Her lineage was awesome. Her mother Ulpia Demokratia held high office at Mylasa and, after remarriage, seemingly at Samos. Her grandmother, Flavia Polla, was prominent at Hypaipa and, after marriage, at Mylasa. Claudia Crateia could trace her roots back through her great-grandmother, Julia Polla, to the late Flavian and early Trajanic Gaius Antius Aulos Julius Quadratus, who had ties to or was honored by five cities from Pergamum to Laodicea in Syria.

Around 250, one Claudia (Pythia?) was honored by her husband with statues at Teos and at Ephesus. She hailed from Rhodes and Sardis and was a sister of Claudia Sosipatra; further inscriptions tell us she was descended from Caninia Gargonilla, a forbidding name.

There were other Claudias at Ephesus and the cities just mentioned. Thus, the power of women from the great cities of Asia Minor and beyond was amazing, extending from public offices to architectural benefactions to the construction of mausolea and, of course, to self-serving genealogical inscriptions.[7]

Five years ago, a Claudia was discovered with marbles from Smyrna and Nysa on the Maeander in the wreck of the Royal Netherlands Steamship Company (KNSM) steamship *The Castor,* ten miles southwest of Dover, in the English Channel. She proved to be Claudia Tyrannio, who shared a tombstone with her husband, Lucius Julius Maximus, which was shipped to the Leiden Museum by the Netherlands' Consul in Smyrna, Alfred van Lennep, in July 1894. This Claudia died in Smyrna about the year 180. Like the legions of Claudius the emperor, the memorial to Claudia Tyrannio has made it to Britannia and may stay there, or go on to Batavia, or return to Ionia in Asia Minor.[8]

In the north necropolis at Termessus in Pisidia, a prostyle-tetrastyle temple tomb formed the heroön of Tiberia Claudia Perikleia. Once two sarcophagi faced each other in the two arched niches in the side walls. Claudia Perikleia also set up (bronze) statues in the niches of the peribolos wall. In addition to the architecture and the sculptured sarcophagi, these statues would have been further confirmation of her family's affluence.[9]

In short, from the banks of the Pactolus to the slopes of Mount Solymus, above the Pamphylian Gulf, Claudia was a name with connotations of power and achievement in the arts, sculpture, and architecture. The Sardian Claudia bore three imperial names, the greatest Ephesian Claudia the first two. The Lycian-Pisidian Claudia had a *praenomen* recalling the second emperor and sundry other imperial Claudians. Her *cognomen* was that of a dynast of Lycia in the fourth century, before the advent of Alexander the Great and before the Persians lost their grip on Anatolia.

THE IMPERIAL WOMEN

Since the focus of this "keynoter" is perforce numismatic, I must turn to the women close to power, the imperial "I, Claudias." The imperial women are the ones who appear on Roman imperial coins and their provincial counterparts, mainly in the East, the so-called Greek imperial series. However wealthy and influential were women like Plancia Magna at Perge in Hadrian's time, they never made it onto their copious city coinages. They could be honored with gorgeous statues, hold priestly offices, dedicate statues of the imperial women and men, and finally come to rest in elaborate tombs with sumptuous sarcophagi just outside the city gates. But statues and reliefs belonged to Greeks and Romans in all walks of life. We know the face and physiognomy of the baker's wife at their oven-shaped tomb up against the Porta Maggiore in Rome.

The Julio-Claudians

Women in power do not appear on Roman coins until the time of Augustus, and then Livia is represented under the guise of the female virtues *Pietas* and *Concordia.* The one woman to make it onto the Roman Republican coins was a lady of infamy, the traitor Tarpea, who was crushed by the Sabine shields and gave her name ever after to one of legendary Rome's group of sacred rocks, a cliff-face of the Capitoline Hill. The women of imperial Rome generally did not fare well. If spice and gossip ring true, Livia was consumed by hatred of Augustus's blood descendents (the Julians) while zealous in the promotion of the Claudians. Augustus, strongly influenced by Livia, banished his own daughter Julia the Elder to Pandateria in 2 BC, and a decade later, motivated in the same fashion, he shipped his granddaughter (Julia the Younger) off to Trimerus in the Adriatic.

Agrippina Major, sister to Julia the Younger, wife of Germanicus, and mother of Caligula, was also banished to Pandateria by her uncle-in-law Tiberius, where she staged the ultimate protest, starving herself to death in 33. The great painting at Yale by

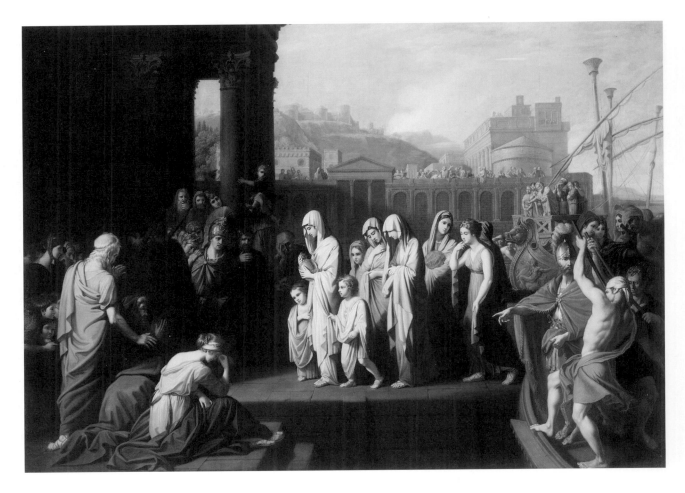

Benjamin West, *Agrippina Landing at Brindisium with the Ashes of Germanicus* (fig. 1.2) almost tells us why. She blamed Tiberius for the poisoning of her popular husband at Antioch in 19. The long voyage home from Syria and the procession across Italy and up the peninsula to the Porta Appia must have been very rough on the two doomed older boys, baby Caligula, and his three sisters. We see them as West portrayed them, like the processions on the Ara Pacis, marching along behind their mother, clinging, turning, and gesticulating. She must have had her hands full, with more than just the ashes. (There was no corps of baby-sitters then extant who could keep the little tribe from fighting, hair-pulling, howling, throwing food, running off, and all the puppy spirits which the later natures of those three girls and their little brother would suggest.) There are those who say that Agrippina the Elder became unhinged, indiscreet in her efforts to organize a dissident party, and brought ruin on herself and her two older sons, Nero and Drusus.

West's Agrippina, carrying her husband's ashes, left a mark on one of the first American neoclassical tomb monuments, the creation of Thomas Crawford in Rome, 1847 (fig. 1.3). Mary Ann Binney carries the ashes of her husband, Amos Binney M.D., in reversed direction, as if from Rome back to Brindisium, or at least to a port of embarcation for Boston.[10]

Agrippina the Elder's eldest daughter, Agrippina the Younger, poisoned her uncle-husband Claudius, feeding him a doctored bowl of his favorite mushroom soup. She was in turn murdered by her own son, the most infamous Nero, at Baiae in 59. Agrippina Minor's sister Julia Drusilla is rumored to have had an incestuous relationship with their brother Caligula and to have died in some strange way in 38. The Masterpiece Theatre "I, Claudius" stimulates our imagination, Caligula as "Zeusy," pig-gutting his

FIGURE 1.3
Thomas Crawford (1811? to
1857), *Monument to Amos
Binney, M.D.,* 1847. Mary
Ann Binney with Her Hus-
band's Ashes. Cambridge
and Watertown, Massachu-
setts, Mount Auburn Ceme-
tery, Binney Family Plot.
[photograph: author]

trussed-up sister. The family's baby-sister, Livilla, also seems to have been involved in this odd family tangle. Livilla was named after her aunt, who was executed in 31 because she helped murder her husband, Drusus the son of Tiberius.

In short, the most prominent imperial "I, Claudias" clearly did not fare any better than their male relatives.

Nero Terminates the True "I, Claudias"

The end of the true "I, Claudias" was far from peaceful and happy. Octavia, daughter of Claudius and sister of ill-starred Britannicus, was divorced, banished, and murdered by Nero in 62. Poppaea Sabina, Nero's mistress from 58 on, was made official consort in 62. Her statue, *inter alia,* stood at Amisus (modern Samsun) on the Asia Minor coast of the Black Sea. She is rumored to have died because Nero, in a tantrum, kicked her in the stomach and down a flight of steps in 65, when she was pregnant.

Nero and Poppaea did have a daughter named Claudia and also named or titled *Augusta.* Claudia Augusta was born in 63 at Antium (Anzio). She appears to have survived for only four months and was commemorated in the Roman East as a Diva. She is shown thus standing in a hexastyle temple, on the reverse of a bronze coin with Diva Poppaea seated in a distyle temple on the obverse. Claudia Augusta disappeared from history, seemingly as the result of her early death.[11]

Ironically, Poppaea's previous husband, Marcus Salvius Otho, whom Nero shipped off to outer Spain, returned to be an incapable and profligate emperor for a few brief months in 69, the year of the four emperors. We know little or nothing about the wives of Galba, Vitellius, and even the good soldier and father, Vespasian.

Vespasian to Hadrian

The Flavian and Trajanic women of power were a much finer lot, partly because they kept extremely low profiles, save when Trajan's Augusta, Plotina, arranged the succession of Hadrian, who had married Trajan's grand-niece Sabina. Titus's daughter Julia is remembered only on the coins and because uncle Domitian, her lover, was shaken by her untimely death. Family concerns including divorce from Julia's mother, however, did not prevent Titus, sacker of Jerusalem and terminator of the zealots at Masada, from having a flaming love affair with the Herodian princess Berenike. A further Flavian family note: Domitian's noble wife, Domitia, daughter of the great Neronian general Domitius Corbulo, survived the death of her infant son and then her husband's assassination in 96 and lived on in great honor and esteem until 150.

When Plotina's ally and Trajan's niece Matidia the Elder died in 119, the new emperor Hadrian, her son-in-law, spoke her funeral oration, raised her to the ranks of the gods as a *diva,* and built a huge Corinthian temple in the Campus Martius of Rome to her and her deified mother, Marciana (died 112 and already respected as Trajan's older sister). Trajan's widow Plotina lived to 122 or 123, the first Roman empress since Livia to play a constructive role in her husband's administration and termed a model of virtue.[12]

In 136/137 Sabina died (having patiently outlived Hadrian's lover Antinous by half a decade), and Hadrian accorded Sabina a big cremation in the Campus Martius, with a relief showing Sabina on the back of a torch-bearing female Aion-Aeternitas, soaring over reclining Campus Martius, a local obelisk, and himself seated with his finger pointed upwards as imperial witness to her deification.[13] Hadrian also had a little-known sister, Domitia Paulina, who was honored with a statue at Attaleia (modern Antalya), at the top of the Gulf of Pamphylia.

The last of these Trajanic and Hadrianic good women was Sabina's sister, Vibia

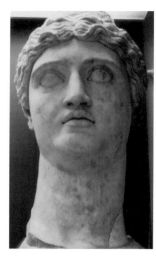

FIGURE I.4
Colossal Portrait of Faustina I. **From the Antonine Temple of Artemis and Zeus at Sardis. London, British Museum.** [photograph: author]

Matidia the Younger, who lived on into the 160s. Her portrait has not been identified among the likenesses surviving from antiquity, doubtless because she never appeared on Roman imperial coins or in the Greek imperial series, where the obscurest members of the imperial families were very apt to be portrayed.

The Family of Antoninus Pius

The Faustinas of the Antonine age were dull and virtuous. Faustina the Elder, wife of the emperor Antoninus Pius and aunt of his successor Marcus Aurelius, died and became a *diva* in 140 to 141 (fig. 1.4). The huge head and neck from the redesigned Antonine Temple of Artemis and Zeus at Sardis is a particularly splendid specimen of Antonine imperial womanhood, in this case large and lifeless, vapid and doughty.[14] Faustina the Elder rides the winged youth Aeternitas heavenwards at her husband's side on the base of the Column of Antoninus Pius, put up after his death in 161.[15] Her daughter Faustina the Younger married Marcus Aurelius and produced many babies. She is said to have had a "lively temperament" and joined the goddesses of the Roman pantheon on her death in 175. Her deified face looks down at us from the architecture of the Agora at Smyrna.[16] This vast urban complex was rebuilt by her husband after a bad earthquake and ensuing fire.

Annia Lucilla, daughter of Faustina the Younger and Marcus Aurelius, was married about the age of 16 to emperor Lucius Verus (161–169). Her decisive moment came about 182, when she conspired without success against her brother Commodus (180–192), was exiled to Capreae, and was eventually put to death. Another daughter of Marcus Aurelius was named Fadilla, was married to Cnaeus Claudius Severus, and was honored with statues at Pompeiopolis in Paphlagonia near the Black Sea and at Ephesus. There was a third daughter, another Faustina.

Commodus had a meek wife, named Bruttia Crispina, who made little impact on the doings of his bizarre reign, but a majority of the time in his last mad years was spent with his concubine, Marcia, who ran around as Omphale while Commodus played at being Hercules.[17] The most unfortunate imperial women of the last decade of the second century were Manlia Scantilla and Didia Clara, wife and daughter of Didius Julianus, who "bought" the empire for a few troubled months until Septimius Severus (193–211) marched on Rome, and his followers ended the folly, murdering Julianus in his deserted palace. Roman imperial coins show that mother Manlia was a pert-nosed matron, and daughter Didia was a willowy beauty seemingly in her 20s.

The Severan Women from Syria

The saga of the Severan age is tied to the power of women from Emesa (Homs) in Syria.[18] These Julias were the noblest of the noble in Hellenistic terms, since they were descended ultimately from the Seleucid successors of Alexander the Great. But nobility and power were no guarantee of happiness. Septimius Severus's *Augusta,* Julia Domna, saw her son Geta murdered in her arms by his older brother Caracalla in 212. She died of grief and exhaustion in 215 or 217, possibly a suicide after Macrinus caused her monster son to be murdered while Caracalla was urinating by the roadside near Carrhae in Syria. Since she was a woman of exceptional intellect and strong ambition, propelled by a will of steel, the Syrian-born Julia Domna surrounded herself with philosophers and other persons of learning, in the traditions of her Macedonian ancestors and great rulers like Augustus, Hadrian, and Marcus Aurelius. She was famous for her circle of learned friends, from historians to jurists. At the same time, she could successfully compete with courtiers and more serious administrators to direct imperial policy, in the traditions of Livia and the Agrippinas.[19] Her willingness to follow the armed forces

FIGURE I.5
*Septimius Severus and Julia
Domna, with Geta Erased.*
Rome, Forum Boarium,
Arch of the Argentarii, 204.
[photograph: courtesy of the
late D.E.L. Haynes]

won her the title *Mater Castrorum,* but she could not work much goodness into her
older son.

If Julia Domna ever walked along the Via Sacra to the Capitoline Hill, she must have
been traumatized to see Geta's name erased from her husband's Parthian arch. If she
moved on to the Forum Boarium, she must have choked on seeing Geta's whole figure
gouged from her side in their family panel, where her attribute of a large caduceus
speaks of dedication to Felicitas. The recarving of Julia Domna's left arm and drapery
below necessitated by Geta's removal leaves her looking manually challenged, with an
arm which defies reality (fig. 1.5).[20] Finally, if she ever went home to her native Syria in
her last years, she would have seen the relief of herself as Victoria crowning cuirassed
Caracalla, something that might have given her fits.[21]

Plautilla Augusta, wife of Caracalla from 202 to 205, was the tragic tool of her ambi-
tious father, the praetorian prefect Gaius Fulvius Plautianus. Julia Domna resented
Plautianus's influence over Septimius Severus, and she probably let some of these feel-
ings rub off on her daughter-in-law. The downfall of father and daughter came in 205,
when Caracalla, having no taste for this form of matrimony, persuaded Septimius Seve-
rus that Plautianus was plotting to have the senior emperor murdered. Some say that
Plautilla as Felicitas was rubbed out of the best panel of the Arch of the Argentarii
(fig. 1.5). This could have brought some small pleasure to Julia Domna, but Plautilla
was surely rubbed out of the panel that featured her husband Caracalla. Geta was the
favorite son of Julia Domna, mother's boy standing close to her.

Julia Domna's sister, Julia Maesa, came forward in 218 to rescue the dynasty from the
usurper Macrinus. Her choice, her grandson most bizarre, Elagabalus, was murdered
together with her daughter Julia Soaemias, a woman of low tastes who spread the
rumor that Elagabalus was her son by Caracalla. Elagabalus, a vicious wimp, would have
quickly passed Henry VIII in the Wife Derby had he survived longer than 222. Sweet
young Julia Paula was quickly replaced by the Vestal Virgin Aquilia Severa, a tough
character. Scandal was averted when the Vestal was supplanted by Annia Faustina, of
the family of Marcus Aurelius. Near the end, Elagabalus brought back the Vestal, her
powers over him nothing short of a miracle.

The old imperial grandmother Julia Maesa lived just long enough to see her virtuous
daughter Julia Mamaea shepherd grandson Severus Alexander into the purple. But mother
Julia Mamaea was a clinger, like Sarah Delano and Franklin Delano Roosevelt. She chose
Sallustia Barbia Orbiana as wife for her imperial son, but maternal jealously led to the
young bride's exile. In 235 the army murdered both Julia Mamaea and Severus Alexander,
feeling that mother and son were too weak to cope with the winds of barbarian war.

WOMEN AND THE MILITARY DEBACLE: HARSH TIMES FOR ALL

The military emperors who ruled from 235 to the Tetrarchy under Diocletian (emperor
in 284, tetrarch in 292) allowed women in their official lives, on their coins, but some-
times they were already dead, like Paulina wife of Maximinus the Thracian (235–238)
or Mariniana wife of Valerian (253–260). Philip the Arab put Otacilia Severa on his coins
and medallions (244–249), but we know little about her. The same may be said of Etrus-
cilla, wife of Traianus Decius (249–251). Decius continued Philip's celebrations of the
millennium of Rome but fell fighting the Goths in the badlands of Moesia. One of their
sons, Herennius, fell with Decius, and the other, Hostilianus, died of the plague in 252.
So much for Etruscilla, with her name suggesting the older Italic civilization.

Likewise, little beyond coinage is known about Severina, the wife of the stern savior
of the empire, Lucius Domitius Aurelianus (270–275). The foremost woman of the
early 270s, if not all the decades from Julia Mamaea to Helena, was Zenobia, aggressive

ruler of Palmyra. Queen Zenobia both saved and defied the Roman empire on its eastern frontier until Aurelian defeated her, forced her to march in his triumph through the streets of Rome, and then pensioned her off in a luxurious villa in the countryside.

If the empresses of the military era were as tough as their consorts, they must have relished their visits to the gladiatorial shows of the empire. If they were truly forceful women sponsors of the gladiatorial contests, they cheered on the female gladiators such as "Amazon" versus "Axilia" (fig. 1.6). These ladies are shown in combat with daggers or sticks and shields on a rectangular, inscribed relief from the Halicarnassus area and now in the British Museum. The head of the fighter on the right is broken away, but that of the lady on the left indicates she spent time at the hairdresser's before entering the arena. Their helmets lie with the open parts facing inwards, on either side of the platform on which their names appear and on which they fight. Louis Robert pointed out that they are helmetless and have chests uncovered or unarmored (even though the armor is heavy), not to create a bloodier contest but to allow spectators to admire their gender.[22] Such was the nature of female solidarity in the Colosseum as well as on the Palatine and in the provinces.

Going back thirty years, the gentle young emperor Gordianus III (238–244) had a charming wife, Furia Sabina Tranquillina, daughter of the powerful praetorian prefect, Timesitheus, who virtually ruled the empire. When Timesitheus died of an illness, the young couple's days were numbered. The wily Arab, Philip from Bostra, wanted it all for himself.

In 253 the army of Moesia created yet another emperor, named Aemilianus, who defeated and slew Trebonianus Gallus and his son Volusianus, successors of Traianus Decius. Aemilianus struck portrait coins in the name of his wife Cornelia Supera, but he lasted only three months. Cornelia Supera was slightly plump, with a very unmemorable face, like so many women on the *clipeus* sarcophagi and the funerary tondi of the decades after 250 (fig. 1.7).[23]

An exception might be a funerary tondo of about 270 or later, on which a doughty but not-overly-plump woman is focused on a stern man in a heavy toga of Late Antique type. He clutches a scroll, which could suggest either high office or great intel-

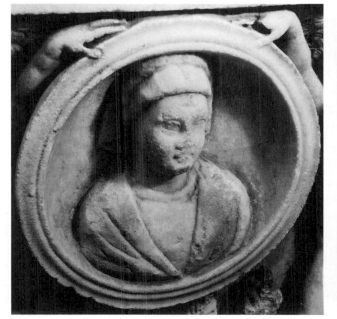

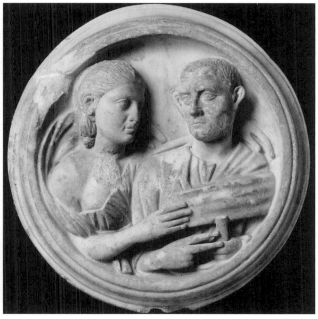

lect. Despite her adoring, hands-on pose, she shares with him the sense that they lived in an era of military crises, barbarian invasions, and political upheaval (fig. 1.8).[24] How much intellect did she muster with her tilted head, windblown and revealing costume, and long, pawing fingers is hard to say. Where such women appear alone, as on the sarcophagus discussed previously (fig. 1.7), they stare out solidly, leaving us no room for speculations about academic aptitude.

The armies on the Germanic frontier brought Valerianus (253–260) into power, something the old widower shared with his son Gallienus (253–268). Valerian was tricked into captivity by the Sassanian Persians and was forever immortalized in submissive posture on one of their rock-cut reliefs, in the Persian Valley of the Kings. Gallienus gave considerable room on the coinage to his wife Salonina, as well as to their sons Valerianus II and Saloninus. Times were very tough, but Salonina appears to have survived the murders of her husband and her younger son and the death (from plague?) of her elder Caesar.

THE TETRARCHS AND THE CONSTANTINIANS

The interaction of women and power returned with the Augustae of the Tetrarchs and the house of Constantine the Great. Constantine's wife Fausta was the daughter of the old senior tetrarch Maximianus. By false accusations of sexual misconduct with her, she caused the death of Constantine's eldest son, her stepson Crispus, but death came to the powerful princess when the depth of her guilt was ascertained. Constantine's half-sister Constantia was hardly more fortunate. She was married to Licinius after Constantine's victory over Maxentius, Fausta's brother, but Licinius was defeated by Constantine at Adrianople and Chrysopolis in 324, losing both throne and life. If the charming woman in Chicago, from Athens, is this Constantia, then she had a face blessed with elegance and grace, overlaid with a slightly haughty appearance.[25]

Constantine's mother, Helena, wife or companion of the tetrarch Constantius Chlorus (292–306), had a far finer fate, becoming well known for her Christian foundations and benefactions. Her statue in the Museo Capitolino in Rome is based on a fifth-century BC seated goddess (Aphrodite in the Gardens) copied for statues of impe-

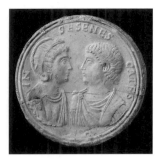

FIGURE 1.9
Roundel with Busts of a Married Couple, ca. 330–360.
Terracotta. Boston, Museum of Fine Arts, Benjamin and Lucy Rowland Fund, 1994.1.
[photograph: museum]

rial women from Agrippina the Elder onwards. She had another statue (or was it an altar?) at Side in Pamphylia, as the Roman world turned from the Sybilline Books to the Judeo-Christian Testaments.[26]

Helena is the last imperial woman to appear on a Roman medallion. It is a fitting conclusion to these thoughts on woman-power (*gynekokratia*) in ancient Roman times to remember that Helena, the sainted rediscoverer of the True Cross, also bore the name of the daughter of Zeus and Leda whose face launched a thousand ships. Romantic literature suggests Helen of Troy had a horror of growing old with Paris in Priam's castle, with Menelaos back in Sparta, or off in a Bronze Age outpost such as Gaza or Eastern Egypt. Had Helena and Constantius Chlorus lived on together, they would have come to look like the married couple in a Late Antique terracotta roundel (fig. 1.9), where the words IN SE SENES CATES can be rendered as "Growing old with you."[27]

NOTES

1. Diana E.E. Kleiner, Susan B. Matheson, John Pollini, Brian T. Aitken, and Jerome M. Eisenberg have helped me with this paper, which was circulated in preliminary form at the symposium in New Haven on Friday, 1 November and Saturday, 2 November 1996.

2. N. Kokkinos, *Antonia Augusta: Portrait of a Great Lady* (London 1992).

3. K. Polaschek, *Studien zur Ikonographie der Antonia Minor* (*Studia Archaeologica* 15, Rome 1979).

4. 11 in. (80 cm) H. Published in R. Ashton, R. Bland, S. Hurter, and G. Le Rider eds., *Studies in Greek Numismatics in Memory of Martin Jessop Price* (London 1997). Antonia the Younger appears to have been part of a shrine to the early Julio-Claudians in Egypt. With her battered portrait came a damaged head of Julius Caesar, now in a private collection in the United States. The young and trusting daughter of Mark Antony forms a contrast with her tough old great-great uncle. But Julius Caesar was required as "godfather" in any of the many exedras to the early Julio-Claudians in Egypt. There ought to be more portraits from this temple or shrine, damaged by the iconoclasts(?).

5. S.B. Matheson, in Kleiner and Matheson, *I, Claudia* 186, fig. 6.

6. *JOAI* 25 (1929) 48–50, fig. 27; C.H. Hallett, *Anatolian Studies* 43 (1993) 57, ns. 60, 61; C.P. Jones and R.R.R. Smith, *AA* (1994), 468, 472 (connections with Aphrodisias).

7. References to all the above can be found under the cities in the writer's *Asia Minor: Sites and Sculpture, an Encyclopedia* (Boston 1996).

8. D. Keys, "Lost Leiden Treasure Found in the English Channel," *Minerva* 6, no. 4 (July/August 1995) 2.

9. Hallett (supra n. 6) 57, ns. 57, 62.

10. Agrippina's survival in the Mount Auburn Cemetery: C. Vermeule, "Greek Sculpture, Roman Sculpture and American Taste: The Mirror of Mount Auburn," *Sweet Auburn: Newsletter of the Friends of Mount Auburn* (Watertown, Mass., Fall 1990) 1, fig. 1. Agrippina the Elder's great-granddaughter Claudia: D.R. Sear, *Roman Coins and Their Values*[3] (London 1983) 168 no. 614.

11. Poppaea Sabina appears as *Augusta* on a unique(?) imperial dupondius. Her elegant head faces to the left. See K.K. Wetterstrom, *Classical Numismatic Group, Auction 40,* New York, 4 December 1996, p. 169 no. 1401.

12. The Flavian and Trajanic women of power are chronicled, and illustrated, by the writer in "Matidia the Elder: A Pivotal Woman of the Height of Roman Imperial Power: An Imperial Portrait in the Style of Asia Minor from the Area around Rome," in N. Basgelen and M. Lugal eds., *Festschrift für Jale İnan, Armağani* (Istanbul 1989) 71–76.

13. The obelisk is very hard to see, much easier in the Apotheosis of Antoninus Pius and Faustina the Elder. Compare S.B. Matheson, in Kleiner and Matheson, *I, Claudia* 186–87, figs. 6–7; C.C. Vermeule, *Roman Art: Early Republic to Late Empire* (*Art of Antiquity* 3, Boston and Cambridge 1978) 114, figs. 118, 119. Campus Martius gives Sabina a farewell salute but hands the task of greeting or recognition off to Roma on the base of the Column of Antoninus Pius. See also Ramage and Ramage, *Roman Art* 183, 185, fig. 7.29.

14. 57 in. (145 cm.) H. (max.) Ramage and Ramage, *Roman Art* 196–97, fig. 8.2. Inan and Rosenbaum I, 75–76 no. 41, pl. 26, figs. 3–4.

15. S.B. Matheson, in Kleiner and Matheson, *I, Claudia* 186–87, fig. 7. Ramage and Ramage, *Roman Art* 205–206, figs. 8.17, 8.19.

16. E. Akurgal, *Griechische und römische Kunst in der Turkei* (Munich 1987) 146, pls. 53.a, 236–37 (the Triad reliefs and the setting). Faustina the Younger: Inan and Rosenbaum I, 78–79, no. 48, pl. 3c, figs. 3–4.

17. The famous bust of Commodus as Hercules Amazonius, wearing the skin of the Nemean Lion and supported by Amazons, from the Horti Lamiani and in the Palazzo dei Conservatori, Rome; Ramage and Ramage, *Roman Art* 216–17, fig. 8.36.

18. M.J. Price and B.L. Trell, *Coins and Their Cities* (London and Detroit 1977) 167–70, figs. 296–301. J.-P. Rey-Coquais, "Emesa (Homs)," in *The Princeton Encyclopedia of Classical Sites* (Princeton 1976) 302.

19. Julia Domna's iconography is chronicled most recently in K.K. Wetterstrom, *Triton II* (New York 1998) 164; Sear (supra n. 10) 218–31. Sear states she took her own life at Antioch, following Caracalla's murder.

20. D. Strong, *Roman Art,* prepared by J.M.C. Toynbee, revised by R. Ling (Harmondsworth 1988) 221–22, fig. 155. E. Strong, *Art in Ancient Rome* II (New York 1928) 143–44, fig. 474.

21. The date is from the spring of 215 to early 216, when the imperial court was installed at Antioch, although there is no evidence Julia Domna was there. The relief is in Warsaw, National Museum. See C.C. Vermeule, *Hellenistic and Roman Cuirassed Statues* (*Art of Antiquity* 4, part 3, Boston and Cambridge, Mass. 1980) 25 no. F5A, plate.

22. 2 ft., 1 ½ in. (64.8 cm) H. (max.); 2 ft., 7 in. (78.7 cm.) W. (max.). J. Pearson, *Arena, The Story of the Colosseum* (London and New York 1973) 111; L. Robert, *Les Gladiateurs dans l'Orient Grec* (Amsterdam 1971 [reprint of 1940 edition]) 188 no. 184, pl. XII. *CIG* 6855–G856 (provenance not known). A.H. Smith, *Catalogue of Sculpture in the British Museum* II (London 1900) 143 no. 1117, fig. 6. (The "helmets" are termed heads of spectators, other gladiators[?]. They seem to have faces, or face masks, and to be beside the platform on which the women fight. The inscription above seems to say that they were "released from service," meaning that the two women survived.)

23. 15 in. (38 cm.) Diam. (of shield, max.).

Compare the more delicate, more frightened (by the vision of Rome's fall?) female on the sarcophagus of 280 or later, in the M. H. de Young Memorial Museum, San Francisco, California, from the Giardino Torregiani in Florence. See C.C. Vermeule, "Sarcophagi in America," in *Festschrift für Friedrich Matz* (Mainz 1961) 106 no. 1, pl. 301.

24. 18 ¼ in. (46.4 cm.) Diam. C.C. Vermeule, in *The Museum Year: 1989–90, The One Hundred Fourteenth Annual Report of the Museum of Fine Arts, Boston* (Boston 1990) 25 (dated about 270, perhaps too early because of her hair over the back and top of the head, which is like the hairstyles of the empresses of the Tetrarchy and the young Helena or even the ill-starred Fausta); C.C. Vermeule, "Greek and Roman Portraits and Near-Portraits," *Minerva* 6, no. 2 (March/April 1995) 20–21, fig. 8.

25. *Ancient Art at the Art Institute of Chicago* (*The Art Institute of Chicago Museum Studies* 20, no. 1, Chicago 1994) 73 no. 51 and lengthy bibliography; P.J.E. Davies, in Kleiner and Matheson, *I, Claudia* 173 no. 128 (with all the pros and cons of date, [late] Hadrianic or 313 to 314). Having discovered the jewel of a head, encouraged Chicago's late Director John Maxon to acquire it for the Art Institute, and having undertaken the initial publication, with the date as 313 to 314, I then momentarily swung back to 130 to 135, but as of this writing, I am firmly committed to a date in the time of Constantine the Great's sister Constantia. Contemplation in the *I, Claudia* exhibition made this all a final reality.

26. C.C. Vermeule, *Roman Imperial Art in Greece and Asia Minor* (Cambridge, Mass. 1968), 490.

27. 6 ⅜ in. (16.2 cm.) Diam. C.C. Vermeule, in *The Museum Year: 1993–94 Museum of Fine Arts, Boston* (Boston 1994), 22; *Minerva* 6, no. 2 (March/April 1995) 21, fig. 10. The Late Antique linear qualities of this composition, more important the proud and/or loving couples, and the self-serving inscriptions find obvious parallels in the gold-glass medallions of the 300s to 400s. Compare E. Strong (supra n. 20) 204–205, fig. 579 (this is the famous painted gilded glass medallion in the British Museum, a couple with Hercules, of all unlikely heroes, between them).

LIVIA
Portrait and Propaganda

ROLF WINKES

A very significant piece of evidence in an old scholarly debate is a beautiful marble portrait from the Walters Art Gallery.[1] It is the first entry in the catalogue of the exhibition "*I, Claudia*." The debate concerns the naming of a particular portrait type as either Livia or Octavia, her sister-in-law.[2]

The Walters head (figs. 2.1–2.4)[3] is larger than life and sits on a long neck.[4] The carving at the lower part of the neck indicates that it was made for insertion into a statue. The serene features are smoothly rendered. The upper lip of the closed mouth is slightly curved. The nose, mostly broken off, is relatively large, and the eyes are almond shaped. A complete reconstruction of the original appearance must envision the use of color. One should imagine some rouge for the lips and perhaps for the cheeks as well. The iris would have been painted and was most likely brown, like the color of the eyebrows or the hair. The coiffure is fully sculptured only in front. The sides are summarily carved but sufficiently articulated for a view of the portrait standing within a niche. In addition, the coloring of the hair would have largely covered those areas that were not fully carved. The length of the neck as well as the folds that indicate a slight inclination of the head are reminiscent of images of Venus, and we may recall in this connection Ovid's flattering words about Livia, comparing her looks with Venus and her character with Juno: *quae Veneris formam, moris Iunonis habendo.*[5]

In general, ancient sources say nothing about Livia's physical appearance beyond that she was very beautiful.[6] Even if they did, we could not necessarily trust them any more than we can trust those about the emperors, whose biographies often just paraphrase descriptions from physiognomic handbooks. All portraits of the imperial family were officially approved, and the degree to which these portraits reflected the actual appearance of their subjects cannot be determined. We really do not know what the emperors and empresses actually looked like. All we know is what they wanted to look like. We cannot hope to reconstruct much more than the image making and its processes.

For members of the imperial family, we almost never have the original image preserved. We are used to looking only at reflections of it, mostly in the form of copies. When more than one portrait was created during or after the lifetime of a person, we refer to "types" that are based on these particular creations and copied in various media. During this process of copying, alterations may occur. If these are quite substantial, we call it a variation. The head in the Walters Art Gallery is not a clear-cut type but rather such a variation.

In the Walters portrait we can see the characteristic features best in the profile and in the rendition of the coiffure. Distinctive is the arrangement of the hair in the shape of a double wave, as we know it from Livia's portraits of the type called Marbury Hall.[7] A long band appears behind the roll above the forehead and behind the lateral waves. The band extends to the bun. This band is not fully carved. One could reconstruct it as a diadem, but it also could be a braid. It easily evokes comparison with another type of Livia portrait, the so-called Zopftyp, a reference to the braid.[8]

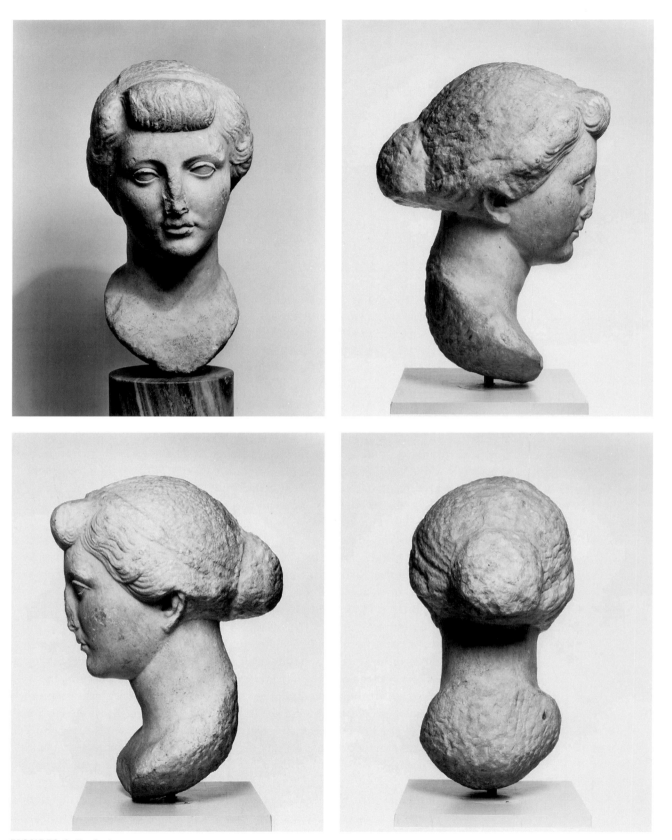

FIGURES 2.1–2.4
Portrait of Livia. First century.
Baltimore, Walters Art
Gallery, museum purchase,
23.211. [photographs:
museum]

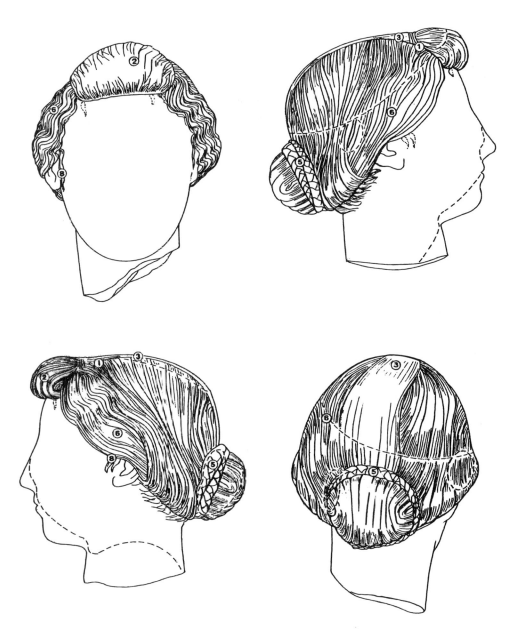

FIGURE 2.5A–D
*Portrait of Livia, Albani-Bonn
Type.* Drawings by Mary
Grosvenor Winkes.

It is, however, the Albani-Bonn type (fig. 2.5) that appears to have influenced the sculptor of the Baltimore portrait more than any other.[9] The shape of the roll on the forehead and the simple bun in the back are copied from this type. In addition, there are three small curls that fall from the corners of the roll into the forehead. Seen from the front and at a distance, the Baltimore head is most similar to the Albani-Bonn type, and it should be considered a variation of it. The Baltimore head thus combines traits taken from a type whose attribution to Livia is disputed, the Albani-Bonn type, with traits from types of Livia portraits whose attribution to the empress is not questioned. But since, in my view, it is Livia who is represented in the Albani-Bonn portrait type, the balance for the Baltimore portrait must now clearly swing in favor of Livia.[10]

In the case of Livia's portraiture, establishing the sequence of the types and their dates is one of the more difficult tasks that have faced scholars.[11] This is due to a lack of the numismatic evidence we are accustomed to having for male or later female members of the imperial family.

We know that portraits of Livia were made by the year 35 BC.[12] She was born 30 January 58 BC, and by the year 35 she would thus have been 23 years old.[13] She married her

much older cousin Claudius Nero in 43 BC, and on 16 November 42 BC she gave birth to Tiberius, the future emperor. She tried to escape the persecution of Octavian, who was her father's and husband's enemy, but she ended up marrying him on 17 January 38 BC. Shortly after the marriage she gave birth to her second son Drusus, which was the cause for considerable rumor in Rome.[14] In the year 35 BC she was declared sacrosanct, together with the sister of Augustus, Octavia.[15] This was a very unusual honor for women but very understandable in this case, if viewed in the context of an attempt to establish a dynasty.[16] Vestal Virgins were also sacrosanct, but Octavian did not seem to make that association at that point.[17] One can, of course, question whether one should interpret such honors and the dedication of such statuary as signs of special affection. I doubt that this would be the major reason. We know from the sources that Octavian and Livia were supposed to have fallen head over heels in love, but politically speaking it was one of the smartest decisions he could have made. He married into one of the oldest families in Rome, and he married a woman of considerable financial means, over which she had control from the year 35 BC on. One wonders whether Octavian may have voluntarily agreed to this control.[18] Aristocratic women during the Julio-Claudian period possessed considerable power, and it constituted great problems at times for Augustus and his successors, as demonstrated in the excellent treatise on the subject by Meise.[19] For the years following 35 BC and following the battle of Actium we do not have literary sources that would inform us about images made for Livia. For the decade following 20 BC this changes. Quite a number of honors are mentioned from then on. One can safely assume that portraits may have been commissioned in the context of such commissions as the Porticus Liviae of 15 BC.[20]

What did the first portraits of 35 BC look like? Short of a miracle that would produce a new discovery in an excavated context, it remains doubtful that one will ever know for certain. The Marbury Hall type (fig. 2.6) could be a candidate for the earliest type, based on the coiffure: the hairdo is quite elaborate. It consists of a roll above the head (a *nodus*) and a braid along the top of the head that incorporates hair from two parts. These parts run from the *nodus* to an elaborate, split bun in the back. Typical of the Marbury Hall type is also the double wave on the sides.[21] The details can be studied best on a cameo in Leiden, formerly in The Hague.[22] The *nodus* hairdo becomes fashionable during the 30s. The first public figure to wear it was, as Diana Kleiner has pointed out, Octavia.[23] For this coiffure, a woman needed to wear very long hair. One wonders whether at times this coiffure may have been worn as a wig. It is the kind of hairdo that leaves the features free and open and was supposed to stress the female beauty, characterized by roundness of the face as described by Ovid:[24] *exigum summa nodum sibe fronte reliqui, ut pateant aures, ora rotuna volunt.* During the Augustan period, this hairdo was rather quickly replaced by simpler arrangements. For the Late Republic, it is the hairdo *par excellence* for a *matrona*. The cameo in Leiden is to be dated to the late Augustan or early Tiberian period.[25] Does Livia want to be seen here as old fashioned? It is doubtful that Livia would have chosen a style that could be read as merely unfashionable. The reason for the choice is political, like a statement: "I, Claudia [as she would have been calling herself if not adopted] am the perfect *matrona,* I myself sew the toga for my husband Augustus."

Based on the hairstyle, the Albani-Bonn type (fig. 2.5) is another candidate for an early creation. It shares with Marbury Hall the roll above the forehead, the braid, and a bun, even though the last is rendered in much simpler form. Also simpler is the arrangement of the hair that is brushed in a single wave backwards along the sides of the head. A clear-cut decision about the chronology of these two types is not possible at this point. The evidence suggests that the complicated Republican hairdo may have come before the simpler version, which may have been a choice made after Actium.

For later portraits of Roman empresses and commonly for portraits of Roman rulers

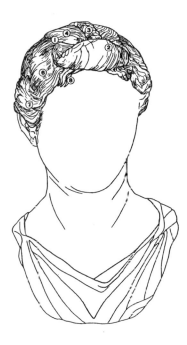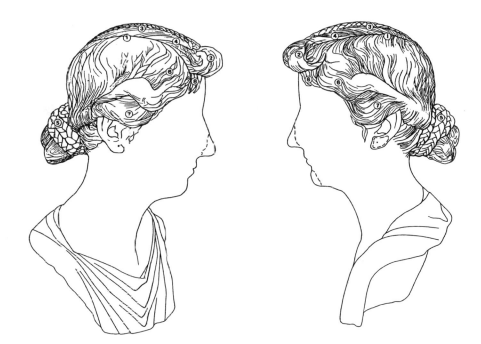

FIGURE 2.6A–C

Portrait of Livia, Marbury Hall Type. Drawings by Mary Grosvenor Winkes.

we normally date the portrait types by comparing them to numismatic types. At times inscriptions help as well. We have hundreds of inscriptions for Augustus dated during his principate but barely a dozen for Livia.[26] To expect help from numismatic evidence is even less hopeful. It is not until about 16 BC that her image is first represented on provincial coins.[27] Most of them are not well preserved, and they are thus difficult to study in detail. We find the first appearance of the Marbury Hall and Albani-Bonn types on coins from Alexandria.[28] These coins date from 10/9 BC, and the representations can still be found on the same coin types in the principate of Tiberius. They seem to use both portrait types almost interchangeably.

Considerable further confusion is created because one of Octavia's portrait types looks very similar to the Albani-Bonn type. The similarity is most apparent on the Aureus von Quelen, but it can be found on other coins as well.[29] One difference is that the bun in the back is a little longer than we see it in Livia's portraiture of the Albani-Bonn type. In addition, the braid that runs along the top of the head is articulated in a slightly different manner. Fred Kleiner has pointed out that Octavia was the only woman in Rome who was represented on coins in her own right.[30] On the reverse of the Aureus von Quelen she is represented by herself, on others facing her spouse, and she can also be seen in profile behind her husband. In such a case one profile overlaps the other, and her identity is visually lost in the interest of a message in which his image overpowers the rest. She becomes a truly supportive figure.

Other portraits that can be compared with coins representing Octavia show a different and quite elaborate coiffure. Even though there are not a large number of replicas extant in sculpture, the comparison with the numismatic images adds two more types: von Bergen[31] and Velletri.[32] Octavia died in 11 BC. One can expect her to be represented within a family group during the lifetime of Augustus, but after his death her inclusion in groups of family portraits can no longer be expected regularly or frequently.

Most of the replicas of the women of the Augustan House were made after the death of Augustus, and most belonged to family group portraits. Statistically speaking, it is no surprise that Octavia portraits are rarely found.[33] The situation is even worse for the portraits of Julia, the daughter of Augustus, who had given birth to his designated heirs.[34]

Julia and Livia are both represented on Pergamene coins in the guise of Aphrodite

and Hera respectively.[35] It is this representation that helped to identify another type of Livia's portrait, the Zopftyp.[36] The earliest date possible for the creation (fig. 2.7) appears to be 16 BC. It is a creation that did not have a large geographical distribution. All but one[37] of the sculptured portraits of this type point toward Turkey and the Balkans as their place of origin. These are indications that the original creation was commissioned in the East. It may later not have been considered politically useful for a more universal distribution.

It was during the year 4 that Tiberius, the son of Livia, was adopted by Augustus and finally became the designated heir. This new role of Livia as mother of the successor led to the creation of a new portrait type. The "Fayum" type (fig. 2.8) has rightly been associated with this event. Here her features are fuller and appear to fit well with a motherly image. This trait is represented even more strongly in her later portraiture. The hairdo of the Fayum type is still quite elaborate, but it is brushed in waves that appear more relaxed and arranged in a looser fashion. There is also a tendency to create more decorative effects by using a greater number of little curls that fall on the forehead and the cheeks. The Marbury Hall type shows a split bun in the back,[38] and it is followed in this trait by the Fayum type.[39]

Livia's Fayum portrait was, like most of her portraits, part of a group. While the provenience for the majority of the copies is no longer known, it is obvious that there was very little incentive to set up Livia's portrait by itself. The imperial propaganda avoided such options. We can see that she occupies her particular place within the Fayum group just as Tiberius assumes his. Their respective role is expressed through a simple visual means such as a difference in size[40] or, on cameos, through the traditional supportive role by letting her profile recede into the background behind the image of her husband. Early during the principate of Augustus, Livia had already received in the provinces the high honors customarily awarded to Hellenistic queens.[41] A reflection of this tradition is evident in the so-called Gonzaga Cameo[42] in which Augustus and Livia are represented in the guise of Alexander and Roxane.[43] Since these large cameos did not employ the kind of imagery that was circulated among the general populace, their intent and their message differed considerably from the images that could be seen on coins or in public spaces.

The next step in image making of Livia took place just after the death of Augustus. In his will Augustus adopted Livia, and she was now called Julia. He also bestowed on her his name. This was no longer just the name Augustus, however; in AD 14 it was more like a title.[44] Henceforth Livia was officially called *Julia Augusta*. The senate followed suit in an attempt to bestow as many honors on her as possible, but it could do so only to a limited degree because of opposition from the new emperor. For example, Tiberius vetoed the award of the title *mater patriae* and a proposal for an arch honoring Livia in Rome. One should interpret his actions and the extant visual representations not from the viewpoint of an animosity between mother and son but as part of the imperial policy. If viewed in this way, a different picture emerges. Livia's son appears to promote her image as much as possible and to avoid only those honors that could allude to a female ruler. Tiberius clearly tried to prevent anything that could be interpreted as a co-regency.

Imperial propaganda tied any eminent role for a woman to the status of her late husband, the emperor or to her role as mother of the ruling emperor. The office of priestess of the Divine Augustus, first held by Livia, became very significant, and it is well represented on the beautiful turquoise cameo in the Museum of Fine Arts in Boston.[45] This role may have lead to the promotion of a new portrait type for Livia, with a new hairstyle. The hairstyle seen in this new type was one Livia had worn once before, on the Ara Pacis, where it was also worn by other women, but it does not seem to become part of a Livia portrait type until later in the principate of Augustus or after his death.

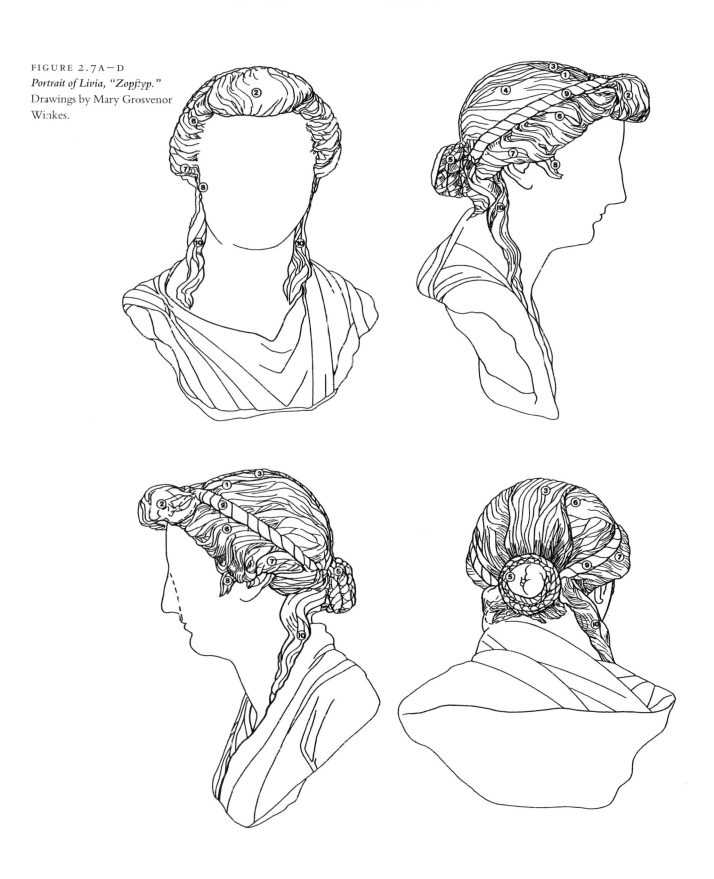

FIGURE 2.7A–D
Portrait of Livia, "Zopftyp."
Drawings by Mary Grosvenor
Winkes.

FIGURE 2.8A–D
Portrait of Livia, Fayum Type.
Drawings by Mary Grosvenor
Winkes.

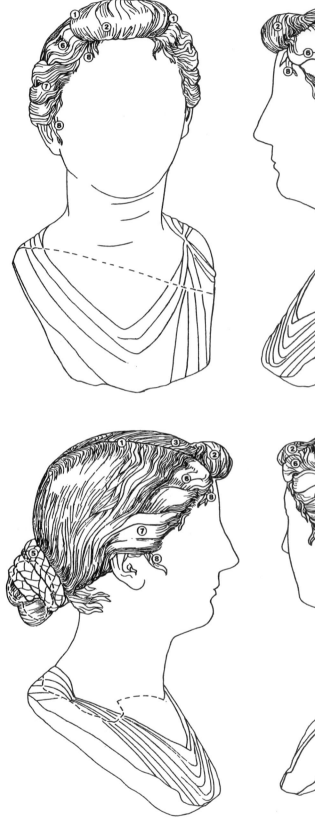
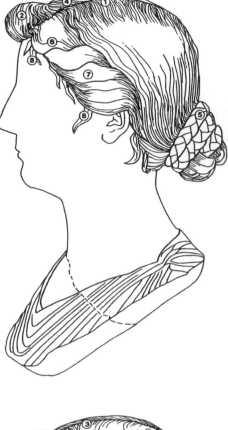
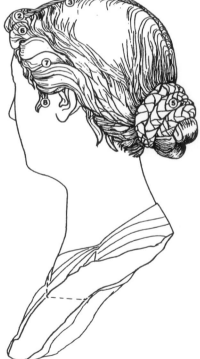

FIGURE 2.9A–D
Portrait of Livia. Bochum,
University Museum, Die-
richs Collection, 1069.
Drawings by Mary Grosvenor
Winkes.

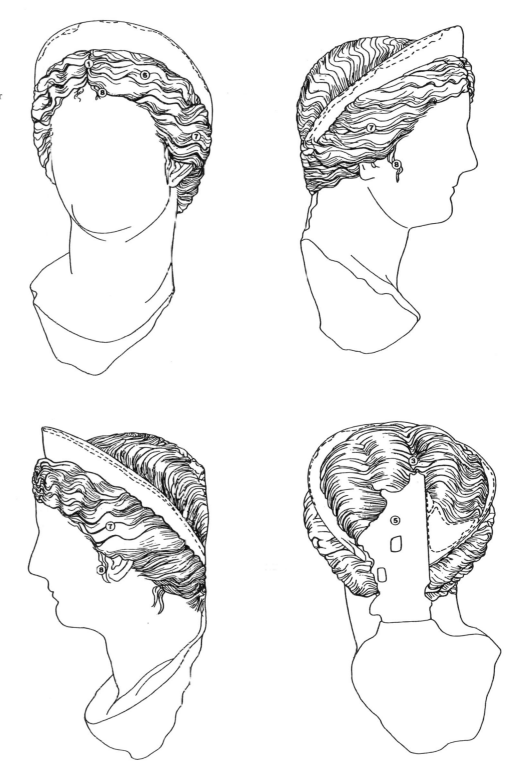

The style is characterized by a simple part along the top of the head, with the hair
combed in waves to the side, a clear evocation of the images of Greek goddesses.[46] One
of the best representatives is a head in Bochum (fig. 2.9). Following the death of Au-
gustus, Livia's new role as priestess of Augustus was combined more than ever before
with that of the goddess Ceres, and this link is expressed in a number of portraits of the
new type. It was an appropriate means through which to remind the populace of the
fecundity of the Augustan Age.

The parting of the hair in the middle appears to be the main characteristic of the new type.[47] The particular shape of the waves of hair can differ among copies, even though one can group replicas and see a certain general development.[48] This difference is clearly visible in the year 22, when Livia's image appears on the reverse of three coin types.[49] In one, the *Salus* issue,[50] her facial features appear to our modern eye more individualized than in others,[51] but it is doubtful whether this would have given the image a different value as a portrait from the viewpoint of the Roman beholder, for whom Livia as *Pietas* and *Iustitia* or *Iustitia* and *Pietas* as Livia most likely carried the same meaning. While the *Salus* coins appear to bear more individualized features, they also have a legend that reads *Augusta* in contrast to the other two coin types. This was cited as an argument to exclude the *Pietas* and *Iustitia* types as representations of Livia.[52] However, a look at images and legends on provincial coinage shows that this should not be done.[53]

Naturally, association with religious matters was one of the best means not only to increase Livia's standing in a society where she held no constitutional office but also to promote dynastic continuity. For example, Livia's association with the goddess of the hearth had already taken place in the provinces. In Athens Livia was worshiped on the Acropolis as Hestia.[54] In her old age and during the principate of her son, she was given the honor of sitting with the Vestal Virgins in the theater.[55] We assume that the depiction of the *carpentum,* the travel chariot of the Vestal Virgins, on the obverse of a sestertius is in reference to this particular honor. In AD 5 or 9 an Ara Numinis Augusti was inaugurated on the occasion of the Wedding Anniversary of Augustus and Livia.[56] There are also numerous references to association with various goddesses.[57] In this context one should remember that not only Ovid[58] but also a discovery at Ephesus have provided us with examples of Livia's image installed in Lararia. In the case of the house in Ephesus, her image was displayed together with that of Tiberius.[59]

Julia, the daughter of Augustus, would have taken the place next to Tiberius had she not been exiled and died. Therefore, the role of a first lady needed to be filled, and the natural choice was Livia. A cameo from the Medici collection attests this new role.[60] It is an image that differs, however, from comparable representations in the time of Augustus, in that she has visually gained profile. This is almost symbolic of the increase in political importance that had taken place. Naturally, the relationship between mother and son was the ultimate legitimization for Tiberius, while Augustus did not owe Livia his standing to that degree. One could, of course, declare her appearance merely a compositional device used by this particular gem cutter and attach little meaning to it. Yet, the attention to and meaning of such details on other imperial cameos makes a political interpretation of this detail here more likely.

After Tiberius, it is not until the principate of Claudius that the next significant step in image making is taken and Livia is declared a *diva.* Her image is paraded around the circus in an elephant quadriga.[61] Her statue is placed next to that of the Divine Augustus in their temple on the Palatine hill.[62] It is in the spirit of such an honor that her representation on the Grand Camée should be interpreted.[63] Livia now occupies a rather eminent place, no less a place than Tiberius. Is it the remoteness in time that makes the Augustan couple look like figures of mythology? They have become demigods who founded the dynasty and renewed the Republic. From that point of view, the political implications of granting a woman such an eminent place were perhaps also seen as remote and belonging to a mythological realm. Hence her place was not considered to have a potentially dangerous impact on the contemporary situation. Also to the Claudian period belongs the famous and colossal image of the Juno Ludovisi.[64] Andreas Rumpf identified the colossal head wrongly as Antonia,[65] but at the time of his publication, the study of portraiture was not yet as advanced. It is now clear that Antonia does not have the long curls falling on the shoulders characteristic of the Juno Ludovisi.

The latest type of Livia's portraiture, however, has them at times. We do not know where this colossal image stood. Even though there is no proof, one is tempted to associate this image with the one that was dedicated on the occasion of Livia's divination and placed next to that of her husband in their temple on the Palatine hill.

When, then, was the head in the Walters Art Gallery made? It could hardly have been done before the beginning of the first century BC. The date for the Zopftyp or the use of a diadem would speak against this. Nor does the portrait have the full and fleshy features that we find later in the principate of Tiberius and even more during the Claudian period. It fits best in the beginning of the principate of Tiberius.

Augustan sculptural copies of Livia are not frequent. The Walters portrait is also a large head, probably too large for a family group as they are known to us. It would fit better, however, in a group of two, as an image that would have stood together with that of Augustus in a temple, as we see elsewhere. The image of Livia had a profound impact on image making for later empresses. Yet, her portrait types appear not to have been copied in equal numbers. Statistics show that the type most favored was the latest one, the type that evoked more than others the association with goddesses.[66] Within that type, it was also most likely the versions of the Claudian period, when she was made a *diva,* that influenced later images most. It is that kind of image that later generations associated with the first empress. One of the most beautiful representatives of this type is the portrait in Bochum (fig. 2.9).[67] The dedication of such statues was cause for a community celebration. They are an allusion to the notion that citizens and rulers not only belong to the same Republic but are also part of the same large *familias:* in the context of imperial propaganda, this must have been an ultimate emotional goal.[68]

NOTES

1. Museum Purchase 23.211; Auction catalogue J. Brummer Galleries 9 June 1949, Part 3, 100 no. 472; *Bulletin of the Walters Art Gallery* 2.1 (October 1949); *JWalt* 12 (1949) 66; M. Milkovich, *Roman Portraits,* exhibition catalogue, Worcester Art Museum, 6 April–15 May 1961 (Worcester 1961) no. 6; D.K. Hill, "Three Portraits of the First Century BC," *AJA* 54 (1950) 264; K. Fittschen, in Fittschen-Zanker III no. 1, n. 3; D.E.E. Kleiner, in Kleiner and Matheson, *I, Claudia* no. 1 with bibliography on Livia portraiture.

2. On Livia's and Octavia's portraiture, see the author's recent book: *Livia, Octavia, Iulia* (*Archaeologica Transatlantica,* Louvain 1995) with bibliographies for particular portraits. Henceforth: "Winkes, *Livia.*"

The head was bought in 1949 at the auction of the Brummer collection. We find the name Brummer in many a North American museum file. He was active as a collector from 1906 on and amassed 30,000 objects from prehistoric European cultures to Mesoamerican civilizations. We do not know where Brummer bought this head or at what point. When it was acquired, it was published as Octavia. This was a justifiable

choice for the time, especially in view of the fact that specialized scholarship on Livia's portraiture was not available. The most recent study, by an Italian scholar written during World War II (H.L. Marella, "Di un ritratto di Ottavia," *Atti della R. Accademia d'italia, memorie della classe die scienze morali e storiche,* serie VII, vol. III [1942] 31–81), had probably just arrived on North American shores. In this study Marella attempted to identify heads of a particular type as Octavia.

3. All drawings are by Mary Grosvenor Winkes.

4. Total height with the neck 49 cm., 30 from the top of the head to the chin; the patina is brown with some red stains on the left side.

5. *Pont.* 3.1.17.

6. Vell. Pat. 2.75: *genere, probitate, forma Romanarum eminentissima.* Ancient sources were already collected by L. Ollendort, *RE* XIII, 1, 900–27. Outdated are the old contributions that trust unduly the accuracy of ancient sources. They are sometimes more a documentation of contemporary attitudes toward gender roles: J. Aschbach, *Livia, Gemahlin des Kaisers Augustus, Denkschrift der Wiener Akademie der Wissenschaft* 13 (1863, Vienna 1864); A. Stahr, *Römische Kaiserfrauen* (Berlin 1865); J.R. Serviez, *The Roman Empresses* (New York 1894); H. Willrich, *Livia*

(Berlin 1911); F. Sandels, *Die Stellung der kaiser-lichen Frauen aus dem julisch-claudischen Hause* (Darmstadt 1912); G. Ferrero, *The Women of the Caesars* (New York 1925); more detailed is R.B. Hoffsten, *Roman Women of Rank of the Early Empire in Public Life as Portrayed by Dio, Paterculus, Suetonius and Tacitus* (Philadelphia 1939); more general is E. Kornemann, *Grosse Frauen des Altertums* (Wiesbaden 1947). Recent scholarship is more critical and different in approach: N. Purcell, "Livia and the Womanhood of Rome," *PCPS* 212 (1986) 78–88; N.B. Kampen, "Gender Theory in Roman Art," in Kleiner and Matheson, *I, Claudia* 14–25 is a superb analysis of the status of research. On Livia, see also the references in Winkes, *Livia,* chap. IV 55–57: "Erscheinungsbild und Bedeutungselemente."

7. Poulsen, *EA* 3109–3111. It is named after its former owner. I owe to C.C. Vermeule the confirmation that it was acquired not so long ago by the Merseyside County Museum in Liverpool. My attempts to obtain new photos have been unsuccessful.

8. Copenhagen, Ny Carlsberg Glyptotek 616, Inv. 748. This head was acquired in 1890 by the Danish Consul Loyted in Istanbul. J. Inan and E. Rosenbaum, *Römische und frühbyzantinische Porträtplastik aus der Türkei, Neue Funde* (Mainz 1979) 62 no. 7. Winkes, *Livia* no. 40.

9. H. Jucker, "Marmorporträts aus dem römischen Ägypten," in *Das Römisch-Byzantinische Ägypten, Akten des Internationalen Symposiums, Trier, 26–30 September 1978 (Aegyptiaca Treverensia,* Mainz 1983) 139–49.

10. Winkes, *Livia* 35, with arguments for the identification.

11. D. Boschung, "Die Bildnistypen der iulisch-claudischen Kaiserfamilie: ein kritischer Forschungsberichte," *JRA* 6 (1993) 39–79, follows Zanker to some degree and creates a very minimal list of types for Livia: Ca (Marbury Hall), Cb (Copenhagen 615 = Fayum), and Cc (Cerestyp). This author prefers as much as possible to maintain names that have become customary among scholars, unless they give a distorted impression. As for giving the name "Cerestyp" to the type that is distinguished by a hairstyle reminiscent of Classical Greek goddesses, I find no evidence to link the hairstyle only to this particular goddess or to prove that it was originally created for an image associated with Ceres. Only the latter would warrant such a name, in the opinion of this author.

12. Dio Cass. 49.39.

13. Regarding her life, see R. Winkes, *Leben*

und *Ehrungen der Livia* (*Archeologia* 36, 1985) 55–68.

14. One could speculate whether the popularity of Drusus may have come about because the people in Rome did not believe that he was the son of Tiberius as Augustus declared but because they thought he was the son of Augustus. There is, of course, no evidence for this assumption.

15. Dio Cass. 49.38.

16. Only the previous year Octavian had received the *tribunitia potestas,* which carried the *sacrosanctitas.*

17. According to Tacitus *Ann.* 1.4, she did not sit in public places with the Vestal Virgins until late in her life.

18. Sandels (supra n. 6) 12 considers this to be an allusion to the status of the Vestal Virgins, since they held the same privilege.

19. E. Meise, *Untersuchungen zur Geschichte der julisch-claudischen Dynastie* (Munich 1969). He also investigates the charges of sexually unacceptable behavior under these circumstances.

20. Begun in 15 BC and inaugurated in 7 BC; see D.E.E. Kleiner, in Kleiner and Matheson, *I, Claudia* 32.

21. This detail was observed by P. Zanker in Fittschen–Zanker III 3 no. 1, n. 8.

22. A.N. Zadoks-Josephus Jitta, "Portrait of a Great Lady," *BABesch* 33 (1958) 33–38; W.-R. Megow, *Kameen von Augustus bis Alexander Severus. Antike Münzen und Geschnittene Steine* (Berlin 1987) 251 no. B9, pl. 2.7.

23. D.E.E. Kleiner, "'Democracy' for Women in the Age of Augustus," *AJA* 98 (1994) 303.

24. *Ars Am.* 3.139–40.

25. Megow (supra n. 21) 251 no. B9, pl. 2.7.

26. T. Pekáry, *Das römische Kaiserbildnis in Staat, Kult und Gesellschaft dargestellt anhand der Schriftquellen* (Berlin 1985) 104 mentions these statistics based on the lists in H. Dessau, *Inscriptiones latinae selectae* (Berlin 1892–1916).

27. W. H. Gross, *Iulia Augusta* (*AbhGött* 52, 1962) 30–31.

28. Gross (supra n. 27) 22–66.

29. C.H.V. Sutherland, *Münzen der Römer* (Munich 1974) 115, color pl. 169/70; *Corpus Nummorum Romanorum* II 93–94; Winkes, *Livia* chap. VIII: "Die Bildnisse der Octavia."

30. F.S. Kleiner, in Kleiner and Matheson, *I, Claudia* cat. no. 5.

31. S. Fuchs, "Neue Frauenbildnisse der frühen Kaiserzeit," *Die Antike* 14 (1938) 255–80; Gross (supra n. 27) 98–100; D. Boschung (supra

n. 10) 44 is hesitant to include the van Bergen head among Octavia's portraits.

32. Marella (supra n. 2) 31–81.

33. There are only seven portrait heads that one could declare with almost certainty to be Octavia, while seven are quite uncertain, and twenty-eight are clearly wrongly identified.

34. Several attempts have been made to identify her on a bone tessera or in a fresco. All these identifications are based on shaky circumstantial evidence or imprecise detailed comparisons of iconographic traits. The best candidate in sculpture is a head from Corinth identified as Iulia by Catherine deGrazia Vanderpool. This was presented in a paper: "Fathers and Daughters: Julia f. Augusti," Abstracts of the 95th General Meeting of the Archaeological Institute of America 17 (1993) 6. The only artifact with her name attached is a bronze tessera in the Terme Museum, but one can hardly recognize her portrait on it, due to its condition. There is also the reverse of coins which show her between her two sons in a miniature representation. On Iulia, see Winkes, *Livia* nos. 264–65.

35. Gross (supra n. 27) 29–30.

36. Gross (supra n. 27) 30.

37. K de Kersauson, *Musée du Louvre, Catalogue des portraits romains, I, I, Portraits de la République et de l'époque Julio-claudienne* (Paris 1986) 94–95 no. 41; Winkes, *Livia* no. 73; G. Borromeo, *Roman Small-Scale Portrait Busts* (Diss. Brown Univ. 1993) 92–93, 245 no. 9.

38. Winkes, *Livia* 25–33: "Der Typ Marbury Hall."

39. Kleiner, *Roman Sculpture,* fig. 54; D.E.E. Kleiner, in Kleiner and Matheson, *I, Claudia* 37.

40. This is well illustrated by E. Simon, *Augustus* (Munich 1986) 81, fig. 103.

41. Typically, the *princeps* and his wife are in the East addressed as ΣΕΒΑΣΤΟΙ.

42. Regarding the name, see N. de Grummond, "The Real Gonzaga Cameo," *AJA* 78 (1974) 427–29.

43. H. Kyrieleis, "Der Kameo Gonzaga," *BJb* 171 (1971) 162–93; A. Megow "Zu einigen Kameen späthellenistischer und frühaugusteischer Zeit," *JdI* 100 (1985) 445–96.

44. On the subject, see I.F. Taeger, *Charisma* (Stuttgart 1960).

45. Accession no. 99.109. Kleiner, *Roman Sculpture* 78, fig. 56; Megow (supra n. 22) 256–57, no. B19, pl. 10.5. Kleiner has pointed out that the cameo may have been much larger and that in this case the figure next to Livia could have been a small standing figure. I agree that the

cameo could have been larger. However, the curls above the forehead of the male figure are typical for Augustus and not Tiberius.

46. Accession no. 1069; N. Kunisch, *Plastik, Antike und moderne Kunst der Sammlung Dierichs* (Kassel 1979) 54–65; Winkes, *Livia* no. 16. In the back, the bun can either be short or elongated, and this seems to be both interchangeable and without a particular meaning.

47. This is the type called Cerestyp by Boschung. See supra n. 11.

48. Winkes, *Livia* chap. II.5, 44–50, "Typ der Mittelscheitelfrisur."

49. This subject has been debated extensively by scholars, most recently by F.S. Kleiner, in Kleiner and Matheson, *I, Claudia* cat. nos. 8–10.

50. F.S. Kleiner (supra n. 49) cat. no. 8.

51. F.S. Kleiner (supra n. 49) cat. nos. 9–10.

52. Gross (supra n. 27) 18.

53. Winkes, *Livia* chap. I 19–24: "Liviabildnisse auf Münzen."

54. *IG* III 316; Winkes (supra n. 13) 60.

55. Tac. *Ann.* 4.16.

56. L.R. Taylor, "Tiberius' *ovatio* and the Ara Numinis Augusti," *AJP* 58 (1937) 185–93.

57. I.C. Colombo, "Funzioni politiche ed implicazioni culturali nell'ideologia religiosa di Ceres nell'impero romano," *ANRW* II, 17.1 (1986) 427. Winkes (supra n. 13) 64.

58. *Pont.* 2.8.1–8.

59. M. Aurenhammer, "Römische Porträts aus Ephesos: Neue Funde aus dem Hanghaus 2," *ÖJh* 54 (1983) 106–12; Winkes, *Livia* no. 98.

60. Megow (supra n. 22) 179–80 no. A49, pl. 10.10; Winkes, *Livia* no. 28.

61. Suet. *Claud.* 11.2.

62. Dio Cass. 65.5; Winkes (supra n. 13) 68. The Arval brothers sacrifice here on the day of her consecration, her priestesses are called *flaminica* or *sacerdos*. Inscriptions with these titles go back to AD 42.

63. H. Jucker, "Der große Pariser Kameo," *JdI* 91 (1976) 211–50; Kleiner, *Roman Sculpture* 150, fig. 126, with bibliography; Winkes, *Livia* no. 71, with bibliography; Megow (supra n. 22) 252 no. B11, pl. 2.6; Kleiner and Matheson, *I, Claudia* 20, fig. 7.

64. Winkes, *Livia* no. 86; R. Winkes, "Luna Augusta," *Dédalo* 27 (1989) 161–71; A.M. Small, "A New Head of Antonia Minor and Its Significance," *RM* 27 (1990) 226–27.

65. "Antonia Augusta," *Abhandlungen Preussischer Akademie der Wissenschaften, Philosophisch-historisch Klasse* 5 (Berlin 1941) 3–36.

66. The author collected 128 portraits that he

believes can be called Livia with certainty, of which 28 belong to the Marbury Hall type, 6 to the Albani-Bonn type, 11 to the Zopf type, and 31 to the Fayum type. The rest belong to the latest type.

67. Kunisch (supra n. 46) 54–65; Winkes, *Livia* no. 16.

68. Winkes, *Livia* chap. III: "Literarische und epigraphische Quellen." In AD 18 celebrations for the erection of statues in the Forum Clodii are recorded (*CIL* XL, 3303). Livia is called *Bona Dea*. Well documented are the celebrations at Gytheion (G. Grether, "Livia and the Roman Imperial Cult," *AJP* 67 [1946] 227–52). Cookies were distributed to the *decuriones* on such occasions (*CIL* XI, 3303; Pekáry [supra n. 26] 11).

FAMILY TIES

Mothers and Sons in Elite and Non-Elite Roman Art

DIANA E. E. KLEINER

In my essay on Roman imperial women as patrons of the arts in *I, Claudia: Women in Ancient Rome,* I explored the associative power elite Roman women gained through their husbands and how they wielded it in the age of Augustus. The sacrosanctity bestowed on Livia by Augustus, for example, freed her from guardianship and enabled her to use her substantial resources to become, like her husband but unlike any Roman woman before her, a patron of public and domestic architecture.[1] What I explore here is the associative power these same elite women claimed through their sons, an associative power that was taken rather than given and is thus more intriguing and informative.

Roman law did not much concern itself with Roman mothers and their sons. By Roman law, the son was in the *potestas* (control) of the father and through the father a part of the *familia.*[2] It was the father who determined his son's education. When it came to marriage, the *pater* also had final say.[3] So it was with Roman law. In practice there was certainly more flexibility, and the part Roman women played in such matters must have varied significantly from one family to another.[4] Roman women in the imperial circle appear to have been actively involved in training their sons for public life and in arranging marriages that formalized political alliances. Historical and literary sources suggest that some of these women were deeply involved in the kind of court intrigue that undermined the current dynast, usually the woman's husband, and cleared the way for her ambitious son. The matriarchal link made her the queen mother and, if the boy was still very young, the regent who might rule for her son until he was old enough to take over. The sources make it apparent that in circumstances like these, the resulting relationship between mother and son was often tempestuous.

A few examples from the early empire are instructive. At Augustus's death, one-third of his estate was left to Livia and two-thirds to Tiberius, his adoptive son and Livia's biological son by a former marriage. Livia's share of the estate was a substantive addition to her own formidable resources and allowed her to maintain considerable power in public life, bolstered further by the new title *Augusta* and by the court protocol she observed in her house on the Palatine hill.[5] While Augustus was still alive, Tiberius expected his mother to intercede with the emperor on his behalf. The sources make it clear that Augustus hoped to be succeeded by a gifted young man and, to Tiberius's disappointment, Augustus's hopes fell in turn on Marcellus, Julia's first husband, and Gaius and Lucius Caesar, Julia's sons by Marcus Agrippa. This state of affairs caused Tiberius to retreat to the island of Rhodes. Nonetheless, he continued to expect Livia to urge Augustus to grant him honors and titles and to recall him from his self-imposed exile.[6] Suetonius tells us that Augustus eventually gave in to Livia's entreaties and summoned Tiberius to Rome.[7] Livia's successful lobbying, however, was apparently motivated not only by maternal devotion but also by personal ambition as she began to envision herself as co-emperor of Rome.

Once Tiberius secured the principate, however, he had diminished need for his mother's intervention. Suetonius reports that Tiberius, hearing that a fire at the Temple

of Vesta had caused Livia to supervise its dousing personally, warned his mother that, as a woman, she should not interfere in matters of state. He began to avoid lengthy and frequent meetings with her so as not to have to hear or consider her opinions. Tiberius was so offended by the senate's bestowal on him of two new titles, *Liviae filius* ("Son of Livia") and *Augusti filius* ("Son of Augustus"), that he vetoed providing Livia with the title *parens patriae* ("Parent of the Country").[8] The situation continued to degenerate and, in part because of the feuding, Tiberius retired to the island of Capri. Suetonius remarks that Tiberius only visited his mother once in the last three years of her life and that the visit was noticeably brief. Tiberius did not attend Livia's funeral, refused to have her deified, and annulled her will.[9] The vilification of Livia continued after her death. Caligula called his great-grandmother Livia a *Ulixes stolatus* ("Ulysses in petti-coats"), suggesting that her meddling at court was the result only of her feminine wiles, and he sent a letter to the senate in which he described her as of low birth. He showed no less disdain for his grandmother Antonia, whom he reputedly had poisoned.[10]

Mothers were also not always openly supportive of their sons and grandsons. While Livia may have championed Tiberius's career, she heaped scorn on her grandson Clau-dius, whom she never addressed directly but instead in letters or messages. Even Clau-dius's mother, Antonia, referred to him as a monster.[11] Perhaps Livia's and Antonia's disdain for Claudius encouraged the emperor's wives and freedmen to take advantage of him and to govern in his stead.[12] Messalina, Claudius's third wife, plotted to replace him as emperor with her lover Silius; Claudius was reportedly so cowed by this action that he fled to the camp of the praetorian guards, muttering over and over "Am I still emperor?"[13] While Messalina plotted for her lover, Claudius's next wife Agrippina had ambitions for her son Nero, convincing Claudius to adopt him as a son, even though he already had a grown son Britannicus who could succeed him. At Claudius's death, there was widespread speculation that the emperor's demise was due to his having con-sumed a bowl of his favorite mushrooms, poisoned by Agrippina at a family banquet.[14] If Agrippina did poison Claudius, her motive was clear.

After becoming emperor, the 17-year-old Nero allowed his mother to manage all his public and private affairs. *"Optima Mater"* ("The Best of Mothers") was the official watchword given the praetorian guard on his day of accession.[15] The relationship of mother to son was so close that there was speculation that they committed incest to-gether while riding around in her litter.[16] Nonetheless, whatever associative power women like Agrippina were able to secure, final control lay in the hands of the male dynast. Nero eventually tired of Agrippina's domineering ways. He acted swiftly to strip her of her honors and her bodyguard and expelled her from his palace. Convinced that she must die, he made three attempts to poison her. She was already wary of him and swallowed antidotes in advance. More daring measures were needed. He unsuc-cessfully plotted with accomplices to dislodge panels from her bedroom ceiling so that they would fall on her when she slept, and he commissioned a collapsible boat that would sink under her weight or bury her under the roof of the boat's cabin. He was eventually successful but later felt remorse and was haunted by what he had done.[17]

Even empresses who had no biological sons were not immune from favoring prom-ising young men who might in turn enhance their power and influence. Pompeia Plo-tina, not Trajan, was the matchmaker for the marriage of Hadrian and Sabina.[18] Plotina favored Hadrian and championed him for a governorship at the time of the Parthian Wars.[19] It was Plotina's intervention that ensured Hadrian's adoption by Trajan. It is unclear where Trajan himself stood on this. Trajan was already dead when the adoption took place, Plotina supposedly arranging for an impersonator to mimic his voice.[20]

While the ancient historical and literary sources are informative, there is some ques-tion as to how much is fact and how much is rumor. The male authors of such texts may have wished to portray imperial women in a more negative light than their actions

actually warranted. For this reason, it is instructive to let the works of art narrate for themselves the story of the political relationship of women in the imperial circle to their sons. Also telling is when and how such works were emulated by those in the lower social strata of Roman society. What, if any, impact did the sex of the patron have on the way in which those relationships were viewed and represented?

The highly visible public monuments that imperial women put up in honor of their sons' accomplishments are important to look at first. Some of these appear to have been erected by the women alone and others by mother and son together. My intention here is not to present a comprehensive list of such commissions but to provide an example or two of a phenomenon that needs further study. The Porticus Octaviae, for example, was either built by Octavia in honor of her son Marcellus or begun by Marcellus and completed by Octavia as a memorial to him after his death.[21] The Porticus incorporated a library, also dedicated to Marcellus. The Porticus Liviae was jointly dedicated in 7 BC by Livia and her son Tiberius, possibly in connection with the culmination of Tiberius's military campaigns in Germany.[22] Nicholas Purcell points out that the structure's commemoration of Tiberius's triumph allowed the empress to come close to envisioning herself *triumphator* by proxy in the putting up of *monumenta*.[23] By joining with her son to erect a monument to one of his military accomplishments, she could see herself as having participated in that very accomplishment. If Purcell is right, this is a clear case of an elite Roman woman capitalizing on what I am calling associative power.

What gave Livia stature during Augustus's principate was his bestowal on her of *sacrosanctitas*, a tribunician sacrosanctity that provided her with a public role. What gave her authority in the time of Tiberius was her adoption into the Julian family in Augustus's will, receiving the title *Augusta*, and as such being an integral part of the *domus Augusta*, an appellation for the imperial family that appears to have been coined in the last years of Augustus's life and made reference to the family unit and its future role.[24] The title *Augusta* was awarded Livia in her position as mother of the *princeps*, and until the Neronian period, no imperial woman was awarded this title who was not either the mother or surrogate mother of the emperor or intended successor.[25] The mother of the emperor thus held an honorific position in public life recognized by the senate in Rome, a body that had recently debated whether to award Livia the title *mater patriae* or *parens patriae*.[26] Livia was granted many other honors after Augustus's death, among them the right to a lictor, to sit in the theater with the Vestal Virgins, freedom from the provisions of the *lex Voconia,* and so on.[27] But what is especially significant in this context is that her position as mother of the emperor merited recognition by the state. With Livia's adoption and Tiberius's assumption of the principate, the Julian and Claudian families were united. In fact, when Livia became a Julian, Tiberius was provided with two Julian parents, increasing still further his legitimacy as heir to Augustus.[28]

Even though the sources tell us that Livia and Tiberius had a falling out, and we know that he refused to deify her at her death, the bond between mother and son was strong enough to cause him to strike coins from the mint of Rome with Livia's portrait during her lifetime and to vow to build a major monument in her name, both after her recovery from serious illness in AD 22.[29] That he struck coins with her portrait is especially noteworthy, because this was an honor she had been denied in Rome by her husband. These Tiberian coins include the inscription *Salus Augusta,* the health of the empress, and the monument, the Ara Pietatis Augustae, was a tribute to the kind of respect a dutiful Roman son owed the mother who conceived him and who did so much to make possible his rise to the principate. On the south frieze of the earlier Ara Pacis Augustae, Tiberius follows in the procession right behind Livia and, although they do not face one another, their arms and hands are arranged by the artist in an x-shaped pattern that binds them together (fig. 3.1).[30] In fact, Tiberius's bond with his mother is presented on the Ara Pacis as his most significant relationship. He is depicted

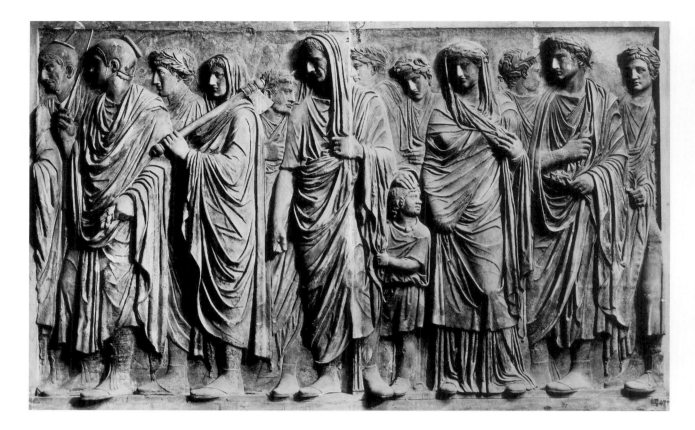

FIGURE 3.1
Ara Pacis Augustae, south
frieze. Rome. [photograph:
Alinari/Art Resource, NY]

with her and not with his wife, Vipsania Agrippina. Livia's other son, Drusus, is also
depicted nearby, as are Augustus's adoptive sons, Gaius and Lucius Caesar.

The Ara Pacis makes apparent that Livia was doubly abundant, producing two sons
by an earlier marriage and two new "sons," a message underscored by the panel relief
on the southeast side of the altar representing Italiae Tellus, assimilated to Livia, with
two babies on her lap.[31] The Ara Pacis was dedicated on Livia's birthday, the 30th of
January, and is as much a monument to Livia as it is to Augustus. Ostensibly put up to
commemorate Augustus's return to Rome from Spain and Gaul and the pacification of
the Roman world, it also celebrates Livia as Augustus's counterpart *(princeps femina)* and
as the foundation of the imperial family.

That the Ara Pacis and the Ara Pietatis, two of the most significant monuments in
Augustan and Julio-Claudian Rome, commemorated the same woman, is noteworthy.
The Ara Pacis honored Livia and the power she had gained through her association
with her husband; he was *princeps,* and she *princeps femina.* That the other was vowed
by her son indicates that he had received some benefit from his association with her.
Nonetheless, he was still in charge, and when they had a falling out, it was in his power
to decide not to build the monument after all. By the time Claudius decided to make
good on Tiberius's vow and build the Ara Pietatis (dedicated AD 43), he had already
consecrated Livia as a *diva.* In fact, some scholars believe that a series of reliefs usually
associated with the Ara Pietatis belonged instead to the Ara Gentis Iuliae on the Capi-
toline hill in Rome, a monument that celebrated Claudius's respect for the Julian family
and the new *diva* Livia. A scene of her consecration may have occupied pride of place
on the altar.[32] It was, at this time, advantageous for Claudius as another "son" of Livia,
that is, a member of her Claudian as well as Augustus's Julian family, to associate himself
with her. The consecration of Livia as *diva* may have been a key scene on the Ara Gen-
tis Iuliae, but there is, at present, no way of knowing for certain whether it was actually
carved and even if it was, what it looked like.

On the Ara Pacis, however, the depiction of mother and son offers insight into their relationship. Tiberius and Livia participate in the procession that took place in honor of the laying of the foundation stone of the altar on 4 July 13 BC. At that time, Gaius and Lucius were Augustus's heirs apparent. They were adopted as the emperor's sons in 17 BC, and Livia may have been perceived as their adoptive mother by association, although certainly not by law. It is therefore not surprising to see the boys presented in the procession closer to Augustus than either Livia or Tiberius.[33] What was Tiberius's status in 13 BC? As son of Livia and Tiberius Claudius Nero, he had lived with his younger brother Drusus in the household of Augustus since he was 4 years old. He had a distinguished military career, and in the year 20 BC, at the age of 22, he accompanied Augustus on an important journey to the East.

After Augustus negotiated a settlement with the Parthians, it was Tiberius who received the Roman standards that had been lost to the Parthians in 53 BC by the Roman general Crassus. This pivotal event is depicted in the center of the decorated breastplate of the marble statue of Augustus from Livia's Villa at Primaporta and now in the Vatican Museums.[34] That it was Tiberius who was the recipient of these highly charged symbols of Augustus's foreign policy demonstrates the confidence the emperor had in him at the time, entrusting him with further military campaigns in Germany, Illyricum, and Pannonia.[35]

Tiberius's marital status at the time of the altar's construction is also relevant, although the positioning of figures on the south and north friezes makes it apparent that the relationship between mother and son was paramount. In 13 BC, at the time the altar was begun, Tiberius was still married to Vipsania Agrippina, who had borne him a son, Drusus the Younger. It was Vipsania and Drusus who would have been with Tiberius in the procession of 13 that accompanied the laying of the foundation stone. Marcus Agrippa, however, died in 12 BC, and Tiberius was coerced into divorcing Vipsania and marrying Agrippa's wife and Augustus's daughter, Julia. He was married to Julia at the time the altar was actually being carved. Since the historical accuracy of the scene was clearly altered to include protagonists who were not present at the actual event and to underscore dynastic, social, and religious principles important to Augustus, it is unclear whether it would have been Vipsania or Julia with whom he would have been paired. There is a woman on the north frieze, seemingly dressed in a widow's fringed mantle, roughly in the same part of the procession as Tiberius is on the south side. If she is Julia, as I believe she is, she is at once Agrippa's mourning widow and Tiberius's new wife. Nonetheless, Tiberius's primary bond is with his mother, with whom he is depicted on the south side in a complex pairing of posture and gesture. Gaius Caesar is ahead of him in line and in the succession, although he looks back both towards his new mother Livia and his new brother Tiberius. I dwell on these actual and imaged relationships in order to underscore the bonds between mother and son in Roman life and art.

Once Tiberius became emperor, the imagery continued. An example is a striking turquoise cameo in Boston depicting Tiberius with his mother (fig. 3.2). The empress's hairstyle suggests a date of around 14–19, that is, when Tiberius was in his late 50s.[36] Close examination of the cameo not only reveals Livia assimilated to a seductive Venus with her drapery slipping off her shoulder but Tiberius as a child, with the two gazing intently at one another. Such a precious cameo had a limited audience and served usually as a private presentation piece from one member of the imperial family to another or as a gift to a foreign dignitary. That the person in the imperial family who commissioned this piece chose to depict an infantalized Tiberius with a sensual and elaborately coiffed Livia, not only older but much larger in scale than her son, is both fascinating and instructive. There are many ways to interpret this image, and since we do not know the identification of the commissioner, it is impossible to ascertain whether any of these hypotheses is correct: Livia was the more powerful of the two at least at the beginning

of Tiberius's principate; the mother and child imagery was advantageous to Tiberius, because it connected him not only to his biological mother but, by association, to his adoptive father Augustus, now a god; Livia or Tiberius had sentimental feeling about their bond; and so on. In truth, the accurate interpretation of the iconography of this cameo may be dependent on knowing whether a woman or a man, perhaps even Livia or Tiberius, were the commissioners of the cameo. What the cameo does underscore is that the relationship between mother and son was a frequent choice for depiction in elite Roman art and thus a reflection of the importance of this same bond in Roman life.

We have thus seen that the familial ties between the elite Roman mother and her son were visually expressed for the first time in the age of Augustus in large-scale public monuments that presented to the Roman citizenry complex notions of privilege, entitlement, responsibility, and other principles. Both sons and their mothers benefited from accentuating their biological relationship in works of art. Tiberius, for example, succeeded Augustus and continued many of his political and social policies. But what he could not alter was that he was not Augustus's son, nor even his grandson. Nonetheless, he could give himself legitimacy through the matrilineal line. Livia was a genuine Claudian, a family with the aristocratic pedigree that the Julians lacked. In any case, during Augustus's principate, Livia was a power in her own right. Works of art that associated the two were to his advantage in claiming his birthright and maintaining its legitimacy. Livia could also benefit from the arrangement. Given the title *Augusta* by Tiberius, the queen mother continued to greet clients and petitioners in her home on the Palatine hill. Since Tiberius was himself middle-aged when he became emperor, she could not attempt to rule in his stead, but she could remind the people of Rome that she was the mother of the *princeps* and thus still a force to be reckoned with. It is critical to remember that when Livia and Tiberius commissioned monuments that underscored their familial bond, they had no precedents to follow. Nonetheless, they set the Roman world on a course that established them as the models to emulate by later emperors and empresses.

Large-scale monuments were not the only ones that showcased the relationships of mothers and sons. Dynastic group portraits designed to be displayed in the niches of fora, basilicas, theaters, baths, and other public structures consisted of one or more generations of the imperial family, including women in their roles as mothers, wives, and daughters. These began to be commissioned in the age of Augustus and were especially popular in Italy and around the empire under Tiberius and Claudius. Some groups were commissioned all at once, while others were added to over time, sometimes by succeeding patrons. The patrons were the city itself, professional guilds, or well-to-do individuals of substantial means. The Augustan and Julio-Claudian dynastic groups have been carefully documented by Brian Rose.[37] His comprehensive study provides evidence that the groups commissioned in Italy under Augustus did not include, with a single exception, portraits of imperial women.[38] The majority depicted Augustus with his adoptive sons and heirs Gaius and Lucius Caesar or the two boys alone or with Agrippa Postumus.[39] Augustus was also paired with Marcus Agrippa and Tiberius[40] or with Drusus the Younger and/or Germanicus.[41] This was not the case for the empire as a whole, where both women and children were included in dynastic groups, modeled on those of the Hellenistic period.

The exception in Italy is the nucleus of what was to become a large group found in the Cryptoporticus in a large insula in Velia put up by an association of doctors who may have used the structure as a medical *collegio* with ties to the imperial cult.[42] Portraits were added in four phases corresponding to the Augustan, Tiberian, Caligulan, and Claudian periods. The Augustan phase includes Gaius and Lucius, Livia and Octavia

the Younger, although Rose is uncertain about the dates of the women's portraits, situating the portrait of Livia sometime before AD 14.[43]

It was, therefore, Tiberius who began to add women to these groups; Claudius followed suit and even augmented the practice. While Augustus had provided Livia and Octavia with special status, Tiberius owed his position to the political and personal maneuvering of his mother. That Livia was wife of Rome's first *princeps,* an official member of the Julio-Claudian family, and herself now Rome's *Augusta* bolstered Tiberius's legitimacy. For her part, Livia certainly had no reason to resist inclusion in such public displays, because they kept her where she wanted to be: in the public eye.

The Tiberian groups follow the pattern of the Augustan dynastic assemblages in that they often include Tiberius amidst an array of family members, including Divus Augustus, his brother Drusus the Elder, his son Drusus the Younger, and his nephew Germanicus. These groups differ from their Augustan prototypes in their inclusion of Livia as *Augusta,* usually in a threesome with her son, now emperor, and her divine husband. Such an arrangement was appealing to Tiberius, because it allowed him to underscore that he was the biological child of the mortal Livia and the adoptive heir of the new god Augustus, both members of the Julian family.

In one group in Rusellae, Tiberius honored his first wife, Vipsania Agrippina, possibly on the occasion of the awarding in AD 23 of posthumous honors to their son, Drusus the Younger,[44] and in an unusual group, he honors Livia's mother and father as well as his own biological father.[45]

We know the dates of these groups and have some knowledge of how they were arranged, but what do all the surviving portrait statues, busts, and heads, the last severed forever from their accompanying bodies, tell us about the relationship of Roman mothers and their sons? Once again, it is the works of art themselves that tell the story of these elite women and their sons, as numerous pieces in the *I, Claudia* exhibition attest.

Thus Livia wielded power in the age of Augustus through her sacrosanctity, her commissioning of public buildings and temples, her position as the embodiment of feminine virtue and, at the same time, the source of fecundity and the model *univira* in Augustus's new social order.[46] In a portrait of Livia from the Walters Art Gallery, the empress was portrayed as the ideal Roman woman, wearing an innovative *nodus* hairstyle that encapsulated Augustus's military opposition to Mark Antony and her own war of appearances with the ostentatious coiffure and clothing of Antony's Egyptian consort Cleopatra.[47] More important in this context, however, is how Livia was portrayed in art when she became First Mother. Her elevated status as mother of the *princeps* Tiberius is signaled by the open depiction of her on the official coinage of Rome. Three Tiberian dupondii, struck right after her recovery from a serious illness in 22,[48] are thought to depict Livia in the guise of *Salus Augusta, Iustitia,* and *Pietas.* While Livia's facial features are possible to discern in these bronze coins, the likenesses are not accompanied by her name, blurring the boundaries between empress and personified virtue. While the *Salus Augusta* legend refers to Livia's regained health, the other legends make reference to her possession of virtues admired in a Roman woman.

The mother-son relationship of Agrippina the Younger and Nero is even more fruitful to explore. Agrippina was the last of Claudius's four wives and, given her ambition and talent, was fortunate to have been empress to a *princeps* who valued the political participation of his wives and freedmen. Among the latter were his secretary Narcissus and his treasurer Pallas. It was in fact Narcissus who engineered the death of Claudius's third wife, Valeria Messalina. Before Messalina's death, their union had, however, produced an heir apparent in Britannicus. Marrying Agrippina, Claudius's niece, was risky for the emperor. She had already been implicated in a conspiratorial plot and banished from Rome. Moreover, she had her own son, Nero, from a former marriage. Agrip-

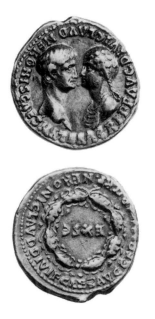

FIGURE 3.3
*Aureus of Agrippina the
Younger with Portraits of Nero
and Agrippina.* **New York,
American Numismatic Soci-
ety, ex D. Parish Jr. Collec-
tion, 1905.57.29.** [photo-
graph: museum]

pina's ruthlessness and her blatant ambition for her young son appear to have manifested themselves first in her single-minded effort to get Claudius to adopt Nero as Britannicus's legal guardian, even though Britannicus was only four years Nero's junior. She went even further in her plot to have her elderly husband murdered. Her position was clear. Her own political ambitions would be more readily achieved if her teenaged son were emperor of Rome. Their plotting against each another complicates our understanding of the dynamic between them and how we interpret the historical and literary sources on this aspect of their relationship. Contemporary writers were hostile to aggressive women and to Nero's tyrannical ways; their writings surely reflect their bias. It may be that Agrippina's decision to write an autobiography was the result of her desire to set the record straight. Unfortunately, that autobiography is not preserved, but the surviving material evidence is valuable in providing an enhanced picture of the associative power she seized in return for the imperial power she gave her son.

Although Agrippina immediately set out to make a public statement about her devotion to her deceased husband by commissioning a monumental temple in his honor, known as the Claudianum, its platform done in the rusticated architectural style the emperor himself had favored,[49] the extent of her enhanced power is more readily perceived on the dual sides of a gold coin (fig. 3.3 [vol. I, no. 19]). Agrippina's corkscrew-curled likeness was the first in the history of the Roman official coinage to be paired with the current emperor. What a major statement that must have been in the year 54. Even more astonishing are the portrait's accompanying legends. It is Agrippina's name that is inscribed on the obverse, while Nero's is relegated to the reverse where he is referred to as the son of Claudius. It is difficult to imagine a stronger and more open admission of Agrippina's position as unofficial head of state. Moreover, the sources confirm her activity on behalf of Rome, including ongoing negotiations with foreign kings and ambassadors.[50] In this aureus of 54, Agrippina is literally in Nero's face, confronting him in a facing-profile portrait. That she is in charge is immediately manifest. Subtle alterations in what must have been the *mano a mano* political maneuvering between mother and son is apparent in the subtle but significant change that is already signaled in coins of the next year. In an aureus of 55, Nero is forcefully in the foreground, with his mother silhouetted behind him.[51] Even the legends reveal the shift. Now Nero's name is on the obverse and Agrippina's relegated to the reverse. After the issue of 55, Agrippina vanished from the Roman coinage, victim of her own success; her banishment from the imagery of Nero's empire was made final by her murder in 59 at Nero's behest. Is there any better illustration of the way in which visual imagery or the lack thereof dramatizes the dynamic relationship between the elite Roman mother and her son?

Likenesses on coins could be struck and temples and statuary commissioned even for empresses who had no biological children but mentored talented young men with imperial ambitions who might reward these women with profound devotion and public recognition. Pompeia Plotina is a case in point. She married Trajan before his accession but bore him no children and must have yearned for a male protégé who could achieve what she herself could not within the confines of Roman law. Plotina appears to have been a dignified woman of simple tastes and quiet virtue who even refused the title *Augusta* when it was first proffered. She later demurred and accepted her due. At the same time, she was persistent in her support of Hadrian, interceding on his behalf whenever she could. Even with her urging, Hadrian seems not to have been officially adopted by Trajan at Trajan's death in 117. Plotina had to make sure that the death was not announced publicly until she was able to arrange for the adoption. Her devotion was rewarded not only by a series of coins but also by at least two temples, consecration at her death, and numerous honorific statues, one of which surmounted the Arch of Trajan at Benevento, the attic of which was completed by Hadrian.[52]

While Plotina was able to fulfill her destiny as empress by finding and supporting a young male surrogate as a replacement for a biological son, most empresses and princesses went to great lengths to produce sons. There is no better example than Faustina the Younger who carried to term eleven pregnancies, resulting in thirteen births. Twin boys died along the way, and it was not until the ninth birth that she provided her husband Marcus Aurelius with a son. Her persistence and eventual success led to such honorific titles as *Augusta* and consecration at her death. At each birth, Faustina was also allowed a new official portrait type, establishing a striking link between her fertility and her public persona.[53] The Roman coinage was used to get across the message. In a dupondius from the mint of Rome, now in the Numismatic Collection at Yale University, Faustina is heralded on the coin's reverse as the new mother of twin boys (fig. 3.4 [vol. I, no. 38]). She cradles the pair in her arms (one was the future emperor Commodus), and four daughters cluster around her skirts below. They look up and gesture in acknowledgment of their new brothers. The happy family group is accompanied by the legend *Temporum Felicitas,* referring to the happy times for Rome that have been ushered in by the birth of a male successor for Marcus Aurelius.[54] Even more striking is the imagery of a sestertius, also from the mint of Rome and now in the American Numismatic Society in New York.[55] While Faustina's portrait is still on the obverse, she and her daughters are no longer on the reverse. Mother and daughters have been replaced by a potent image of the twin boys seated alone on an elaborate throne. The legend proclaims that happy times have expanded to a farther reaching happy era *(Saeculi Felicitas),* extending prospectively into a splendid future. The stars above the boy's heads allude to their alliance with Castor and Pollux, the twin sons of Jupiter, the Olympian equivalent of the boy's father, Marcus Aurelius.

An issue that has intrigued me for some time is the Roman emphasis on physical resemblance in the portraiture of the biologically linked elite. Depicting a son in the image of his father was one of the ways a society that valued position and possession could make concrete the transferal of both to the next generation; such a depiction stressed the inevitability of that transferal. There is nothing astonishing nor unique about this. Biological resemblance is emphasized in the portraiture of numerous civilizations. What sets ancient Rome apart is the Roman penchant for establishing dynastic inevitability through resemblance even when there was no biological link. When a given emperor had no son, the chosen heir was provided with a fictionalized resemblance. While Gaius and Lucius Caesar resembled Augustus in their portraiture because they were his grandsons, Tiberius, Livia's son by a former husband, is unlikely to have resembled Augustus, and yet he is depicted as if he did in his portraiture because he was Augustus's adoptive son and heir to the principate. This phenomenon has been explored for the portraiture of imperial men,[56] but it has yet to be studied in depth for imperial women.

Exploration of such physical linkage among the elite is complicated in the Roman context for many reasons, among them that we have few names of Roman artists and only a rudimentary understanding of an individual artist's oeuvre. Consequently, we cannot readily group the portraits of mother and son carved by a single artist. In addition, most of the marble portraits that survive are replicas of lost bronze originals. Nonetheless, I believe we could make strides here. In the portraits, for example, in the *I, Claudia* exhibition, there are some striking physical resemblances among family members whose marble portraits were carved by different artists at different times. A portrait representing one of Caligula's three sisters, perhaps Agrippina, now in the Rhode Island School of Design,[57] depicts the imperial princess with the straight brow and distinctive slightly protruding upper lip of Caligula, apparent in a portrait from Rome, now in the Yale University Art Gallery.[58] The type that this portrait belongs to has been associated by scholars with all three of the sisters. That in itself is of consider-

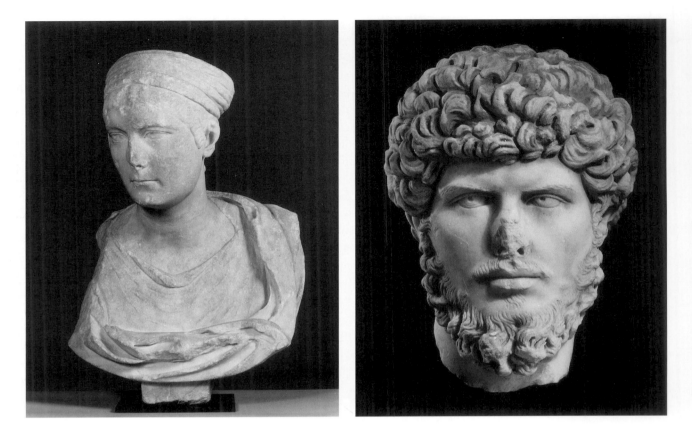

FIGURE 3.5
Portrait of Avidia Plautia.
New Haven, Yale University
Art Gallery, The Leonard D.
Hanna, Jr., B.A. 1913, Fund
and the Stephen Carlton
Clark, B.A. 1903, Fund,
1992.2.1. [photograph:
museum]

FIGURE 3.6
Portrait of Lucius Verus.
Toledo, Toledo Museum of
Art, Purchased with Funds
from the Libbey Endow-
ment, Gift of Edward Drum-
mond Libbey, 76.20. [photo-
graph: museum]

able interest. What was important to Caligula was that his sisters be depicted as an indis-
tinguishable imperial unit, a unit of which each member resembled the emperor. The
hope was that at least one of the four could produce a male heir for Caligula. If the boy
resembled his father Caligula, or his mother, a sibling of Caligula, he would then bear
a striking and desirable resemblance to the emperor.[59]

That physical resemblance was accentuated in Roman portraiture cannot only help
us understand Roman public policy but can sometimes help us identify imperial moth-
ers and sons, when all other evidence is lacking. Sons resembled their mothers as well as
their fathers. This resemblance was sometimes deemed a political asset, as in the case
of Tiberius and Livia, and thus important to accentuate in public portraiture. Until
recently, there were no identified portraits of Avidia Plautia, the mother of Lucius
Verus. Yale's acquisition in 1992 of the portrait of a Hadrianic woman triggered the
realization that another portrait, the present whereabouts of which are unknown, rep-
resented the same woman (fig. 3.5 [vol. I, no. 30]).[60] That there are two replicas of the
same prototype suggests that she must have been an imperial personage, and her obvi-
ous resemblance to Lucius Verus (fig. 3.6 [vol. I, no. 29]) suggests that she can be iden-
tified as his mother. Both have the same high cheekbones and the same distinctive,
narrow, almond-shaped eyes.

There was perhaps no Roman empress who became as intertwined with the lives and
art of her sons as Julia Domna. Julia Domna's colorful past and impressive abilities are
well known. Born in Syria to a priest of the cult of Elahbel, she was predicted to marry
a king one day. Word of this encouraged the North African Septimius Severus to be a
persistent suitor. Once married, she followed Faustina's lead and set out to produce
male heirs, only she did so much more rapidly. Caracalla and Geta were born in quick
succession, and she was duly honored with the title *Mater Augusti et Caesaris.* The boys
had a volatile rivalry, and Julia Domna fretted that if tension between them was not
kept under control, the empire would be torn asunder. Her extreme concern was

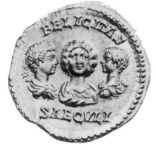

FIGURE 3.7
Aureus of Septimius Severus with Portraits of Septimius Severus, Julia Domna, Caracalla, and Geta. New York, American Numismatic Society, 1959.228.33. [photograph: museum]

warranted, as she was forced to accept the murder of Geta at the hands of Caracalla's henchmen. An intelligent woman, not only especially astute to political nuance but also gifted with an eye and ear for the best art and literature of her day, she gathered around her a salon of artists and intellectuals. When they were young, the boys were depicted as if they were twins, in an openly retrospective Antonine style, as in a triple group portrait with their mother on a coin of the year 201 from the mint of Rome, now in the American Numismatic Society (fig. 3.7 [vol. I, no. 47]).[61] Julia Domna is situated in a frontal position, a rarity in numismatic portraits but chosen here to signal her importance as generator of the same *Felicitas Saeculi* or happy era ushered in earlier by Faustina's production of male twins. Caracalla, slightly older, is depicted as a bit larger at left, with Geta on the right. The boys are similarly depicted in paired portraits in the round, and it is in the Severan period that a single artist, known today as the Caracalla Master, can be associated with portraits of Julia Domna and her sons. The Caracalla Master may have been a member of the empress's artistic and intellectual circle, because she commissioned him to create likenesses not only of herself but of Caracalla and Geta from infancy on. Among these was a striking portrait in the Museo Capitolino in Rome of Caracalla as the newborn Hercules strangling serpents. Other portraits of both Caracalla and Geta, such as the head found near Rome and now in the Phoebe Hearst Museum of Anthropology at the University of California at Berkeley, were crafted by other artists of the day.[62] Nonetheless, it was the Caracalla Master who was responsible for creating a truly distinctive and innovative portrait style, inspired not just by his patroness, the empress of Rome, but by the sheer force of the personality of the mature Caracalla. The master artist impressively confronted the ruthless brute that the once innocent boy Caracalla had become and turned his subject's visage and temperament into art in such portraits as that in the Metropolitan Museum of Art of Caracalla as an adult.[63] In this *magnum opus,* the sculptor effortlessly interweaves the strict geometry of the emperor's face with his upright military mien and his cruel disposition, fashioning an image that unites physiognomic description with a profound characterization of the subject's complex psyche.[64]

I have thus far concentrated on the special circumstances within the rarefied circle of the imperial family, where the relationship of elite women to their sons is explicitly presented in highly visible public monuments, in the official Roman coinage, and in multifigured dynastic groups, all of which eloquently presented the public policy of the emperor, empress, and imperial family. Our understanding of this relationship is enhanced by historical and literary sources. These written sources are missing for nonelite female slaves and freedwomen and their sons, and we must therefore rely on material evidence alone. Most, if not all, of this material evidence comes from funerary inscriptions and sepulchral sculpture, because, by Roman law, slaves and freedmen were denied the right of self-imaging while they were alive.[65]

Nonetheless, funerary imagery, like political and domestic imagery, was very public in its orientation. Roman cemeteries were not hidden away in isolated locations but were lined up along all the major thoroughfares leading in and out of cities and towns. Large-scale tombs with prominent facades, often enhanced with sculpture, were visible to all who entered or exited those urban environments.[66] Portraits and figural scenes confronted the passerby in a very direct way, with many tombs beckoning with an inviting message. The bench tomb of the public priestess and business woman Eumachia of Pompeii and its epitaph encourage the passerby to sit and contemplate the professional accomplishments and family ties of the woman who was buried there.[67] Women who were devoted wives and mothers, bakers and nurses, good housekeepers, builders or commissioners of mausolea or portrait sculptures are memorialized in tombs or in sepulchral sculpture, all placed in prominent places and meant not only to be accessible immediately to Roman contemporaries but to preserve their family saga and

professional contributions for posterity. It was, therefore, possible for freedwomen who themselves commissioned such funerary monuments to feature business enterprises they shared with their sons, family unity, and the hopes and dreams they had for their son's future. In fact, the act of simply bringing a son into the world and of thus establishing a family that would perpetuate itself was fraught with meaning for slaves who had been wrenched from distant lands and forcibly transported to Rome.

Women brought to Rome as slaves or born into slavery in Italy were routinely divested of their own mothers and fathers, becoming the possessions of their patron or patroness. While slaves, they were not permitted to contract legal marriages, and they therefore entered into *contubernia* or quasi-marriages.[68] The easy upward mobility of Roman society, however, allowed them to earn or purchase their freedom, and, once freed, their marriages were recognized by Roman law. That recognition was very important to them, and it is, therefore, not surprising that they memorialized this legal bond by depicting the most important moment of the marriage ceremony on their tombstones.[69]

An example is a funerary relief from the North Carolina Museum of Art in which a freedwoman, Vesinia Iucunda, is majestically situated in the center of a rectangular windowlike frame, flanked by her husband, Sextus Maelius Stabilio and son, Sextus Maelius Faustus (fig. 3.8 [vol. I, no. 150]).[70] That husband and son share the same *praenomen* and *nomen* indicates that they belonged to and were freed by the same male patron: Sextus Maelius. Vesinia Iucunda, on the other hand, was owned and freed by a woman, owner of slaves whose identity is signaled by the retrograde C following Vesinia's name. That Vesinia's marriage to Stabilio was now a legal Roman marriage is underscored by Vesinia's wedding veil. Furthermore, her *pudicitia* pose, with left cheek resting on left hand, signals her chastity and modesty at the time of her marriage. Not only the veil but also the *dextrarum iunctio* allude to the actual marriage ceremony as Vesinia and Sextus Maelius Stabilio join right hands. It is unlikely that all three family members died in a tragic catastrophe; the relief was instead probably commissioned at the death of the first of the three. The family ties of non-elite husband and wife and non-elite mother and son were so strong that they wished to be depicted as a family unit in perpetuity. The composition of that family unit was inviolate. Only very rarely were such family-group reliefs altered later. This is in contrast to elite dynastic groups that were frequently edited by adding or subtracting individuals who were in or out of favor at a given time.

The sepulchral relief of Petronia Hedone depicts her alone with her son, Lucius Petronius Philemon (fig. 3.9 [vol. I, no. 151]).[71] Such a mother and son group is relatively rare among such funerary reliefs; its exceptional status is therefore worth speculation.[72] Why was a portrait of Philemon's father not included? The epitaph tells us that in this instance we are dealing with a freeborn woman who has erected *(fecit)* the stone to her freeborn son, who apparently predeceased her. If he was her only son, she must have been desolate. She was wealthy enough to be able to afford slaves, because the epitaph goes on to say that the stone is also dedicated to their freedmen and freedwomen and all their descendants. These individuals were clearly also allowed burial within the family tomb. One can only speculate that the omission of the father's portrait and name signifies that the couple was divorced or that she was widowed. And yet, I have some uneasiness about such an interpretation. After divorce, the father would have retained *potestas*. Even widowed mothers did not have *potestas* over their sons.[73] In addition, family members who predeceased one another were frequently depicted together as if united in perpetuity, which is the case with the North Carolina relief. The omission of her husband from the relief she commissioned probably signals a willful quest for freedom on Petronia Hedone's part.

Funerary Relief of Sextus Mae-
lius Stabilio, Vesinia Iucunda,
and Sextus Maelius Faustus.
Raleigh, North Carolina
Museum of Art, Purchased
with Funds from the State of
North Carolina, 79.1.2.
[photograph: museum]

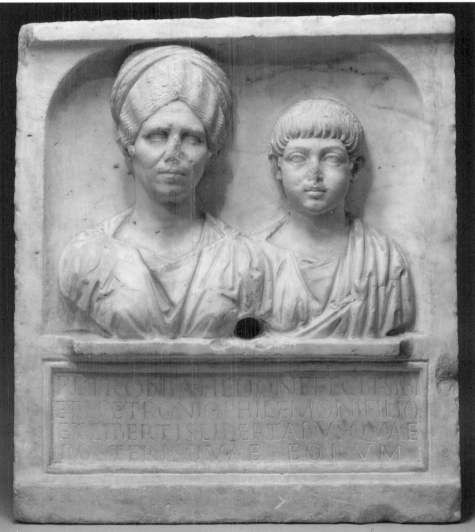

Funerary Relief of Petronia
Hedone and Her Son, Lucius
Petronius Philemon. Boston,
Museum of Fine Arts, H.L.
Pierce Fund, 1899.348. [pho-
tograph: museum]

The lives and deeds of the emperors were frequently recounted in large and impressive public monuments, like columns and arches. Some of these sagas were depicted in detailed documentary fashion, such as those in the reliefs that circle the Column of Trajan,[74] and others were excerpted, such as those from an Arch or Arches of Marcus Aurelius,[75] both to be more economical and to emphasize an important event. This biographical mode is also used in sepulchral sculpture. Urns, altars, and even sarcophagi are decorated with such stories, but they are not large enough to allow extended narratives. Instead the life story must be encapsulated in a few carefully chosen scenes. A biographical sarcophagus, once in Old St. Peters and now in the Los Angeles County Museum of Art, is a case in point.[76] The scenes on the sarcophagus appear to recount from left to right the life and accomplishments of a Roman general, that is, an elite patron. He is depicted putting on his armor, participating in battle, granting clemency to his barbarian foes, and sacrificing in front of a temple. At the far right of the front of the coffin, almost as an afterthought, he marries. The scene on the right short side is of special interest and allows a multivalent reading of family dynamics. The scene depicts the birth and bath of a child (fig. 3.10 [vol. I, no. 162, ill. on p. 206, below]). A woman, presumably the wife, is seated in a chair. Her head is veiled, she leans over, and her legs are slightly parted. Even though she is fully dressed, the parted legs suggest that she has just given birth. Her veiled and inclined head give her a somber and resigned air, suggesting that she may have died in childbirth. The lively naked child, presumably a boy, is squirming in the hands of the *nutrix* or nurse who kneels down to bathe him. At the right, a woman with a towel or blanket waits to wrap him, while another woman writes with a metal *stylus* or graver on a shield (or globe?). The likely interpretation of the threesome is that they are the three Fates, inscribing the prospective events of the boy's life on a shield. This is a child who is already destined to duplicate the illustrious deeds of his father. While the scenes narrate a biography, they are carefully chosen, and each one corresponds to one of the major virtues of the ideal Roman man: *virtus* (manly excellence in battle), *clementia* (the bestowing of mercy on the barbarians who kneel before him), *pietas* (the loyal sacrifice), and *concordia* (the harmonious marriage scene). The way the birth scene is presented represents a Roman general's view of the mother and son relationship. Other sacrcophagi with birth and bath scenes combine these with education scenes or other vignettes from childhood.[77] Here the mother is a wraithlike vessel. Once she has produced the child, she reticently fades away, leaving the lively child to be cared for by a surrogate and to follow in the illustrious footsteps of his illustrious father. It is a stunning contrast to the Petronia Hedone relief, where the mother and son bond takes front stage. That Petronia Hedone *fecit* clearly makes all the difference in the world.

Our understanding of the important and complex bond between a Roman woman and her son can be enhanced by examining works of Roman art. A careful study of that art underscores the elite woman's quest for associative power that was sometimes given and sometimes seized. In addition, while the mother and son dynamic among the elite set a standard that was emulated by the non-elite, this does not mean that the non-elite were slavish copyists. The life circumstances and values of the non-elite were different, and that distinctiveness manifests itself in their art. Third, the sex of the Roman patron is as important a determinant of the subject matter, style, and point of view of the work of art as social status and ethnic background.

While the impact of the social status and ethnicity of a Roman patron on Roman art has been of interest to scholars for some time, that of the sexual identity of the patron has not. The explanation for this omission is obvious. Until recently, Roman women were rarely recognized as the patrons of works of Roman art. If Roman women did not commission art, they could not use art to express a particular point of view. Now that Romanists are beginning to compile a list of the major works of architecture, sculpture,

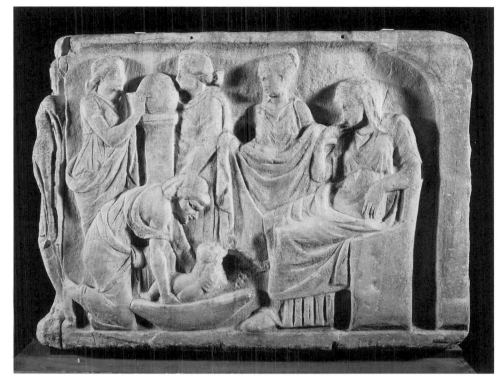

painting, and those in other media commissioned by women, we will finally be able to engage ourselves in determining whether there was something that we could identify and define as a Roman woman's point of view. Was it Livia who realized that she could manipulate her hair and dress to dramatically set herself up as a foil to a world-famous Egyptian queen? And was her agenda the same as her husband's? Was Agrippina's jockeying for power just that: a blatant grab for political potency? When she insinuated herself on to the Roman coinage, just what did she hope to accomplish? Why was it Julia Domna and not Septimius Severus who discovered and patronized the best sculptor of the day, and why did she have him create portraits of her and her sons and not of her husband? Was this a power play or does it simply indicate that she had a sensitive eye for quality and that her husband did not? Since this same Severan sculptor revolutionized Roman portraiture, does the empress not deserve to share the credit? Why did the anonymous Roman general who commissioned the sarcophagus in the Los Angeles County Museum of Art see his wife's role in the birth and education of their son as less important than his own? What caused Petronia Hedone to defy tradition and commission a marble relief that depicted her with her son and not with her husband? I believe we are on the cusp of discovering the Roman woman's point of view, and I am convinced that it will be the careful study of material remains that will make that discovery possible. It is my fervent hope that *I, Claudia* has contributed to that quest.

NOTES

1. D.E.E. Kleiner, "Imperial Women as Patrons of the Arts in the Early Empire," in Kleiner and Matheson, *I, Claudia* 28–41.

2. Gardner, *Women in Roman Law* 137–42.

3. Gardner, *Women in Roman Law* 146–54.

4. Dixon, *Roman Family* 36.

5. Suet. *Aug.* 100. For the extensive slave retinue needed for this protocol, see S. Treggiari, "Jobs in the Household of Livia," *BSR* 43 (1975) 48–77.

6. Suet. *Tib.* 12–13.

7. Suet. *Tib.* 13.

8. Suet. *Tib.* 50.

9. Suet. *Tib.* 51.

10. Suet. *Calig.* 23.

11. Suet. *Claud.* 3.

12. Suet. *Claud.* 29.

13. Suet. *Claud.* 36.

14. Suet. *Claud.* 44.

15. Suet. *Ner.* 9.

16. Suet. *Ner.* 28.

17. Suet. *Ner.* 34.

18. Scriptores Historia Augustae (S.H.A.) *Traj.* 3.5.

19. S.H.A., *Traj.* 3.5.

20. S.H.A., *Traj.* 4.10.

21. Prop. 3.18.11–20; Ov. *Ars Am.* 1.69–70; M.J. Boyd, "The Porticoes of Metellus and Octavia," *PBSR* 21 (1953) 152–59; B. Olinder, *Porticus Octavia in circo Flaminio* (Stockholm 1974), esp. 88–124; P. Fidenzoni, *Il teatro di Marcello* (Rome 1970) 145–58; L. Richardson, jr, "The Evolution of the Porticus Octaviae," *AJA* 80 (1976) 57–64; Richardson, *Topographical Dictionary* 318–20; Kleiner (supra n. 1) 32.

22. Dio Cass. 55.8.1–2; M. Flory, "*Sic Exemplar Parantur:* Livia's Shrine to Concordia and the Porticus Liviae," *Historia* 33 (1984) 309–30, with earlier bibliography; Richardson, *Topographical Dictionary* 314; Kleiner (supra n. 1) 32.

23. N. Purcell, "Livia and the Womanhood of Rome," *PCPS* 212 (1986) 89.

24. M. Flory, "Dynastic Ideology. The *Domus Augusta* and Imperial Women: A Lost Statuary Group in the Circus Flaminius," *TAPA* 126 (1996) 292–93. The term *domus Augusta* appears first in the poetry of Ovid *Fast., Trist.,* and *Epist. ex Ponto.*

25. Flory (supra n. 24) 298. Tac. *Ann.* 15.23; Suet. *Ner.* 35.3.

26. Flory (supra n. 24) 299. Tac. *Ann* 1.14.1; Dio Cass. 57.12.4; Suet. *Tib.* 50.3.

27. Flory (supra n. 24) 299–300.

28. Flory (supra n. 24) 297.

29. It is worth noting that coins with the portrait of Livia were never struck in the Rome mint while Augustus was emperor. Kleiner, *Roman Sculpture* 77, fig. 55 (*Salus Augusta* coin); 141–45, figs. 118–20 (Ara Pietatis Augustae), with earlier bibliography.

30. Kleiner, *Roman Sculpture* 90–99, fig. 75, with earlier bibliography.

31. Kleiner, *Roman Sculpture* 98–99, figs. 75, 77, 80.

32. Kleiner, *Roman Sculpture* 142–44, with earlier bibliography.

33. Gaius and Lucius Caesar are closer to Augustus if one accepts two controversial arguments. First, that the scenes of procession on the north and south sides of the monument are two parts of the same procession and second, that the two boys in Trojan costume with torques around their necks are Gaius and Lucius in the Trojan costume of the equestrian games popular among aristocratic youths in the age of Augustus. See Kleiner, *Roman Sculpture* 92–93. For the identification of these boys as princely oriental hostages rather than Gaius and Lucius, see C.B. Rose, "Princes and Barbarians on the Ara Pacis," *AJA* 94 (1990) 453–67, reprinted in D'Ambra, *Roman Art in Context* 53–74.

34. Kleiner, *Roman Sculpture* 63–67, with earlier bibliography.

35. Kleiner, *Roman Sculpture* 123.

36. Kleiner, *Roman Sculpture* 77, fig. 56.

37. Rose, *Dynastic Commemoration.*

38. Rose, *Dynastic Commemoration* cat. no. 49.

39. Rose, *Dynastic Commemoration* cat. nos. 2, 6, 10, 27, 34.

40. Rose, *Dynastic Commemoration* cat. nos. 18, 31, 47.

41. Rose, *Dynastic Commemoration* cat. nos. 7, 19, 24.

42. Rose, *Dynastic Commemoration* 120–21 cat. no. 49.

43. Rose, *Dynastic Commemoration* 120.

44. Rose, *Dynastic Commemoration* 116 cat. no. 44.

45. Rose, *Dynastic Commemoration* 95–96 cat. no. 23.

46. For a discussion of the *univira* in the age of Augustus, see above, Introduction, p. 7 and n. 41.

47. D.E.E. Kleiner, in Kleiner and Matheson, *I, Claudia* cat. no. 1.

48. F.S. Kleiner, in Kleiner and Matheson, *I, Claudia* cat. nos. 8–10.

49. J.B. Ward-Perkins, *Roman Imperial Architecture* (Harmondsworth 1981) 56, 63–66, figs. 28–29.

50. F.S. Kleiner, in Kleiner and Matheson, *I, Claudia* cat. no. 19.

51. *Aureus of Nero with Portraits of Nero and Agrippina the Younger and Elephant Chariot of Divus Augustus and Divus Claudius,* New York, American Numismatic Society, ex. E.T. Newell Collection, 1967.153.219; F.S. Kleiner, in Kleiner and Matheson, *I, Claudia* cat. no. 20.

52. Kleiner, *Roman Sculpture* 224–29.

53. Fittschen, *Faustina.*

54. F.S. Kleiner, in Kleiner and Matheson, *I, Claudia* cat. no. 38, fig. 38.

55. *Sestertius of Faustina the Younger with Two Baby Boys on Throne,* New York, American

Numismatic Society, ex E.T. Newell Collection, 1944.100.49528; F.S. Kleiner, in Kleiner and Matheson, *I, Claudia* cat. no. 39.

56. See, for example, Kleiner, *Roman Sculpture*.

57. Providence, Rhode Island School of Design Museum, 56.097; M.J. Behen, in Kleiner and Matheson, *I, Claudia* cat. no 13.

58. New Haven, Yale University Art Gallery, 1987.70.1; E.R. Varner, in Kleiner and Matheson, *I, Claudia* cat. no. 12.

59. For the portraiture of Caligula's three sisters and especially the Rhode Island head, see A.M. Clark, "An Agrippina," *Bulletin of Rhode Island School of Design, Museum Notes* 44.4 (May 1958) 3–5, figs. 2–3 on p. 10; B.S. Ridgway, *Museum of Art, Rhode Island School of Design, Classical Sculpture* (Providence 1972) 86–87, 201–204; S. Wood, "Diva Drusilla Panthea and the Sisters of Caligula," *AJA* 99 (1995) 457–82.

60. For the Yale head, see S.B. Matheson, "A Woman of Consequence," *YaleBull* (1992) 87–93; P.B.F.J. Broucke, in Kleiner and Matheson, *I, Claudia* cat. no. 30. For the other head, see G. Lippold, *EA* 17 (Munich 1947) 43 no. 5077; K. Fittschen, "Courtly Portraits of Women in the Era of the Adoptive Emperors (98–180) and Their Reception in Roman Society," in Kleiner and Matheson, *I, Claudia* 48. Fittschen thinks that the mouth of this portrait resembles that of Lucius Verus's father Aelius Verus rather than that of Avidia Plautia. For Aelius's portraits, see N. Hannestad, "The Portraits of Aelius Verus," *AnalRom* 7 (1974) 67–100, pls. 3–4, 8. In any case, close physical correspondences like these underscore the Roman interest in portraying family resemblance. M. Koortbojian, "*In commemorationem mortuorum:* Text and Image along the 'Street of Tombs'," in J. Elsner ed., *Art and Text in Roman Culture* (Cambridge 1996) 210–33.

61. *Aureus of Septimius Severus with portraits of Septimius Severus, Julia Domna, Caracalla, and Geta,* New York, American Numismatic Society 1959.228.33. F.S. Kleiner, in Kleiner and Matheson, *I, Claudia* cat. no. 47.

62. For the Capitoline statue, see most recently Kleiner, *Roman Sculpture* 322, with earlier bibliography. For the Berkeley head, see Joseph Brummer, New York, sale catalogue 1, 20–23 April 1949, lot 171; M. Del Chiaro, *Roman Art in West Coast Collections* (Santa Barbara 1973) 24 no. 10 (identified as Geta); S. Nodelman and J. Frel eds., *Roman Portraits: Aspects of Self and Society* (Malibu 1980) 104 no. D (not the same head); C.C. Vermeule, *Greek and Roman Sculpture*

in America (Berkeley 1981) 353 no. 304 (Geta); Fittschen-Zanker I 99 no. 1; E.R. Varner, in Kleiner and Matheson, *I, Claudia* cat. no. 44. For portraits of the princes in an unabashed Antonine style, see L. Budde, *Jugendbildnisse des Caracalla und Geta* (Münster 1951). See also S. Nodelman, *Severan Imperial Portraiture AD 193–217* (Diss. Yale Univ. 1965); M. Wegner, *Caracalla, Geta, Plautilla, Macrinus bis Balbinus* (Berlin 1971); Kleiner, *Roman Sculpture* 321–25.

63. G.M.A. Richter, *Roman Portraits.: The Metropolitan Museum of Art* (New York 1948) no. 107; Nodelman (supra n. 62); Wegner (supra n. 62); Kleiner, *Roman Sculpture* 322–25.

64. Nodelman (supra n. 62); Kleiner, *Roman Sculpture* 324, 326–29.

65. See esp. A.N. Zadoks-Josephus Jitta, *Ancestral Portraiture in Rome* (Amsterdam 1932) 32–46; O. Vessberg, *Studien zur Kunstgeschichte der römischen Republik* (Lund and Leipzig 1941) 41, 107–108; R. Bianchi Bandinelli, "Ritratto," *EAA* 6 (1965) 721–23; R. Bianchi Bandinelli, "Sulla formazione del ritratto romano" (1957), reprinted in *Archeologia e Cultura* (Milan 1961) 172–88, esp. 180–83; Kleiner, *Roman Group Portraiture* 17–19.

66. J.M.C. Toynbee, *Death and Burial in the Roman World* (London 1971); M. Eisner, *Zur Typologie der Grabbauten im Suburbium Roms* (Mainz 1986).

67. L. Richardson, jr, *Pompeii: An Architectural History* (Baltimore and London 1988) 256–57.

68. Kleiner, *Roman Group Portraiture* 18, 26–27; Treggiari, *Roman Marriage* 52–54, 123–24, 375–76, 482.

69. Kleiner, *Roman Group Portraiture* 22–25; D.E.E. Kleiner, "Social Status, Marriage, and Male Heirs in the Age of Augustus: A Roman Funerary Relief," *North Carolina Museum of Art Bulletin* 14 (1990) 23–26.

70. Kleiner (supra n. 69, 1990) 19–28; S.H. Cormack, in Kleiner and Matheson, *I, Claudia* cat. no. 150.

71. L.D. Caskey, *Greek and Roman Sculpture in the Museum of Fine Arts Boston* (Cambridge, Mass. 1925) 213–15 no. 126; M.B. Comstock and C.C. Vermeule, *Sculpture in Stone: The Greek, Roman and Etruscan Collections of the Museum of Fine Arts* (Boston 1977) 223 no. 354; S.H. Cormack. in Kleiner and Matheson, *I, Claudia* cat. no. 151.

72. There are no two-figure groups of mother and son among Republican and Augustan funerary reliefs of freedmen. See Kleiner, *Roman Group Portraiture.* Among Roman funerary altars

with portraits that range from the Julio-Claudian period to the fourth century, there are four known examples of dedications of a mother to her son. Three of the boys are depicted alone on their monuments. See D.E.E. Kleiner, *Roman Imperial Funerary Altars with Portraits* (Rome 1987) 48–49 cat. nos. 40, 99, 127. One altar from Rome, now in Naples, depicts a group portrait of mother and son (Kleiner, 49, 166–67, cat. no. 46). Made between 90 and 110, it was dedicated by Flavia Haline to her son Hermes, an imperial slave. The young man died just before his 22nd birthday and was memorialized by his mother, who had him depicted assimilated to his namesake, the god Hermes. A caduceus is depicted behind the young man's shoulder. The altar was also dedicated to Haline herself *(et sibi),* the reason she too appears in the paired portrait.

73. Gardner, *Women in Roman Law* 146–47.

74. Kleiner, *Roman Sculpture* 212–20.

75. Kleiner, *Roman Sculpture* 288–95.

76. P. Barrera, "Sarcofagi romani con scene della vita privata e militare," *Studi Romani* 2 (1914) 103–105; O. Brendel, "Immolatio Boum," *RM* 45 (1930) 206 no. 11; G. Roden-waldt, "Über den Stilwandel in der antonin-ischen Kunst," *PreussAbh* (1935) 4, n. 1; E. Feinblatt, "Un sarcofago romano inedito nel Museo di Los Angeles," *BdA,* ser. 4, 37 (1952) 193–203; E. Feinblatt, "A Roman Biographical Sarcophagus," *Bulletin of the Art Division, Los Angeles County Museum* 4 (1952) 22–26; I.S. Ryberg, *Rites of the State Religion in Roman Art (MAAR* 22, Rome 1955) 163, n. 2, and 165; E. Loeffler, "A Famous Antique," *ArtB* 39 (1957) 1–17; Kampen, *Image and Status* 40–41, 147–48 no. 25. figs. 11–12; G. Reinsberg, "Die Repräsentation der Grabherrin auf den Vita Romana-Sarkophagen," in G. Koch ed., *Grabeskunst der römischen Kaiserzeit* (Mainz 1993) 141–42; P.J.E. Davies, in Kleiner and Matheson, *I, Claudia* 206–208 cat. no. 162.

77. Kampen, *Image and Status* 33–44, discusses other examples and provides a useful chart of birth and bath scenes on Roman biographical sarcophagi (fig. 1). She also compares these to depictions of mythological births and baths, such as those on sarcophagi depicting the childhood of the infant Dionysus.

JUST WINDOW DRESSING?
Imperial Women as Architectural Sculpture

MARY T.
BOATWRIGHT

One of the many fascinating aspects of *I, Claudia* is its aim to understand the contexts of images of Roman women. There is no one context, of course. Each Roman image insists that we consider for it at least a physical context (its formal display); a sociohistorical context (the material and ideological conditions determining its production and selected representation); and even, if we dare venture so far, a receptive context (how the image may have been viewed and with what effects).[1] Starting with archaeological data, I seek to sketch out such contexts for statues from a particular group: the imperial women of the early second century AD. The attempt should expand our comprehension of Roman women and their sculptural representations.

The title of my essay needs some definition. Although "architectural sculpture" traditionally designates relief sculpture, I use the term slightly differently, to mean sculpture within its architectural setting. This viewpoint is directed by the primary significance of architectural location to Roman sculpture.[2] Different architectural contexts lent Roman sculptured portraits distinctive meanings that are almost indistinguishable now, when divorced of their contexts.

The corpus of sculptures I draw from is that of Plotina, Marciana, Matidia the Elder, and Sabina.[3] These four women, who were associated by blood or marriage with the emperors Trajan (ruled 98–117) and his adopted son and successor Hadrian (117–138), were famous as paragons of deferential womanhood. In the *Panegyricus,* for example, Pliny extolls Trajan's wife, Plotina, and his sister, Marciana, as paradigms of ancient virtue, devoted to their male relatives, unassuming, and reticent (Pliny *Pan.* 83–84).[4] Busts and statues of these circumspect yet exemplary women have been found throughout the Roman empire, a few even with fairly specific findspots. The wide diversity of original settings corresponds to that known for public statues of other Roman women during this era and is echoed by the findspots for images of other imperial women. Yet the very ubiquity and frequency of imperial women's representations beg the question of whether individual images conveyed special meanings or were simply "window dressing" of their various architectural settings, embellishment generically expressing homage to the state. Contending that setting did sharply distinguish sculpture, I turn to portraits of Trajanic-Hadrianic imperial women found in four locales: first, a political and administrative center, the Forum of Trajan in Rome; second, the elaborate city gate of Perge in Pamphylia, a province of Rome's Greek East (on the southern coast of Turkey); third, the theater of Vasio, a small city in Narbonese Gaul on the other side of the Mediterranean (now Vaison-la-Romaine in southern France); and fourth, two bath buildings in Rome's port city, Ostia.

Rome, the center of power and the source of iconography and imagery,[5] furnishes examples from the very heart of the imperial city, the splendid Forum of Trajan that was dedicated in 112.[5] In now overlooked work of the 1970s, Carlo Gasparri and others asserted that the Forum of Trajan included statues of imperial women and idealized women as well as the better-known sculptures of Trajan, prominent Roman men, and

Dacians.[7] Six extant female statues, the basis of the convincing argument, are now displayed in the Loggia dei Lanzi near the Uffizi in Florence.[8] The statues, about 2.5 m. H., are larger than life size, and all the bodies are of Greek marble (probably Pentelic). The women are depicted in long chitons with loose himations over them; some statues originally had their himations pulled over their hair, others not. Despite reworking since their discovery in the sixteenth century, upon analysis the statues can be classified into two groups. One group comprises idealized women, draped in a style reminiscent of the Small Herculaneum Woman (fig. 4.1).[9] The other, with four statues extant, represents women wearing their chitons and heavy himations in an unusual fashion (fig. 4.2), which is found elsewhere almost exclusively on statues of Hygeia and the Vestal Virgins.[10] Although one of the second Trajanic group now carries a head not originally belonging to it or to another statue of this group, the three other examples are portraits.[11]

Gasparri has identified the three portraits as Marciana (fig. 4.3), Matidia the Elder (fig. 4.2), and Agrippina the Younger (fig. 4.4).[12] The portrait of Marciana corresponds to a type appearing on coins in 112,[13] and the more generic portrait of Agrippina suggests that it is posthumous.[14] The dates suggested for Marciana's portrait, and the obvious similarity of the six extant standing pieces, indicate that the six female portrait and idealized statues were part of the original layout of the Forum of Trajan. It has long been known that much of the statuary from the Forum displayed Trajan, his commanders, and other eminent Roman men, together with the Dacians, whose conquest and pillaging in 101–102 and 105 provided both occasion and financing for the grandiose structures. The male images, espousing Rome's military and political traditions, have been interpreted within a schema that is considered quintessentially "Roman." But if the Forum of Trajan additionally featured statues of identifiable imperial women as well as ones of idealized Roman women, its putative program should be reevaluated.[15]

Women's public portraiture in the city of Rome was not uncommon in the second century AD, although it was a relatively recent phenomenon.[16] In the republican city, public display of male portrait statues had been severely controlled, and public display of female portrait sculpture almost non-existent,[17] much in contrast to portrayals of Roman women and men in the Greek East, as we see below. Before Augustus's rise to power, the number of females portrayed publicly in Rome can be counted on one hand.[18] Only one woman distinguished with a statue before the empire, Cornelia, the mother of the Gracchi, is a historical personage. A bronze seated statue in the Porticus of Metellus publicly honored this woman whom, Plutarch tells us, the people of Rome revered "no less because of her sons than because of her father [Scipio Africanus]" (Plut. *CG* 4.3).[19] The dynastic significance of Cornelia's statue is clear both in literature and on its extant base, on which Cornelia is identified first as the daughter of Scipio and then as the mother of the Gracchi (*CIL* VI, 10043; cf. Pliny *HN* 34.31).[20] To my knowledge, after Cornelia, no woman was publicly portrayed in Rome until Augustus's principate, when female statues began to be raised publicly. Members of Augustus's family were occasionally thus honored, providing impetus for other female portrait statues.[21] The incidence of such statues increased dramatically with later imperial women.[22]

As with Cornelia's statue, the female statues are often explained as serving dynastic purposes. Emperors and would-be emperors employed statuary of their family, representing females as well as males, to "legitimize" themselves. Gasparri employs this interpretation for the portrait statues from the Forum of Trajan, additionally suggesting that the imperial women's garments, which associated them with the Vestal Virgins and with Hygeia, connoted their roles both as servants of the original cults from Troy and as guardians of the victorious flame upon which depended the prosperity and might of Rome. Thus Trajan, the first "provincial" to make it to the throne, would have linked himself with Rome's past and future.[23] But I think there is a less generic explanation,[24] for which I turn to two statue groups no longer extant.

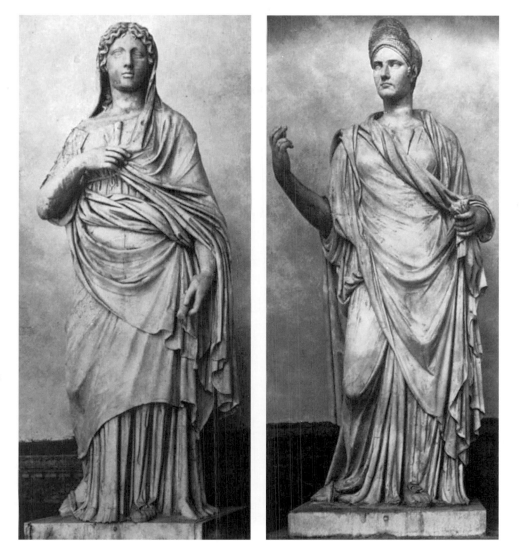

According to our most explicit record of an imperial statuary group publicly de-
creed, the Tabula Siarensis of AD 19, an arch in Rome honoring Germanicus at his
death that year displayed gilded reliefs of the nations Germanicus conquered, together
with his own portrayal and depictions of his family. The inscription names Livia, Ger-
manicus's mother Antonia, his wife Agrippina, and his sister Livia (= Livilla); also
specified, but only collectively and not by individual name, are Germanicus's daughters
and sons.[25] Similarly, a later arch, which spanned the Via Lata in Rome and celebrated
Claudius's conquest of Britain in 51–52, portrayed Antonia and Agrippina, Claudius's
mother and wife, as well as Claudius himself, his brother Germanicus, and his adoptive
and natural children, Nero, Britannicus, and Octavia. The main dedicatory inscription
of the Claudian arch, referring to the submission of the eleven kings of Britain, sets this
extended imperial family, women as well as men, in a decidedly martial context.[26]

These two examples suggest another interpretation for the representations of Marci-
ana and her "sisters" alongside statues of Trajan, other eminent Roman males, and con-
quered Dacians. The female statues underline a fundamental distinction of the Roman
empire from barbarian nations: the Roman family. Here the paradigm is elevated both
generally, by the idealized Roman women, and more specifically, by depiction of the
domus Augusta, the imperial family.[27] Since the imperial house transcended individual
dynasties, it included Agrippina the Younger.[28] The juxtaposition of statues of Roman
women with ones of Trajan and his generals and eminent counselors, as well as with

FIGURE 4.3
Head of Marciana. On a statue once in the Forum of Trajan and now in the Loggia dei Lanzi. The head is not original to the statue, although it was once on a statue of this type. For the type, see figs. 4.2 and 4.4. [photograph: after C. Gasparri, "Die Gruppe der 'Sabinerinnen' in der Loggia dei Lanzi, Florenz," *AA* (1979) 532, ill. 10; courtesy of the Deutsches Archäologisches Institut, Berlin.]

FIGURE 4.4
Statue of Agrippina the Younger. From the Forum of Trajan. Florence, Loggia dei Lanzi. This is the only one of the surviving portrait statues whose head and body are original to each other. [photograph: after C. Gasparri, "Die Gruppe der 'Sabinerinnen' in der Loggia dei Lanzi, Florenz," *AA* (1979) 534, ill. 16; courtesy of the Deutsches Archäologisches Institut, Berlin.]

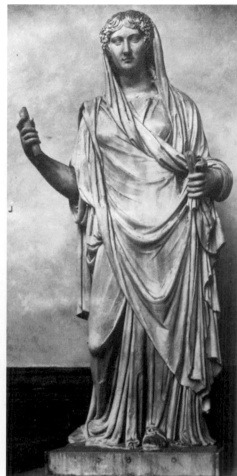

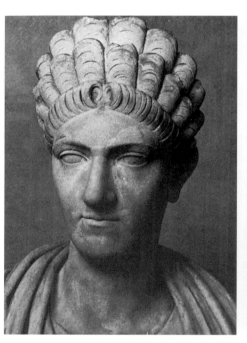

statues of the barbarians the Romans had vanquished under the emperor's command, reveals a key element of the Romans' self-image and justification for conquest: the belief in Roman order. Although here the specific contrast is to alien lawlessness,[29] Roman order was pervasive, at least ideally. It extended from the Roman army's domination of the known world, through Roman fathers' configuration and control of their families, to a Roman individual's suppression of unruly passions.[30] This wider interpretation makes sense of the series of idealized women also displayed in the Forum of Trajan, images Gasparri neglects.

My second case study comes from a very different context, provincial rather than from the capital and funded privately rather than publicly.[31] Multiple statues once graced an ornate city gate and honorific arch Perge's Plancia Magna donated as a ceremonial entrance to her native city on the coast of Roman Pamphylia.[32] In Plancia Magna's installation, an extensive remodeling of Perge's southern gate in the early Hadrianic period, statues of imperial women were placed near ones of emperors. More importantly for my purposes, such statues were outnumbered by ones of local deities, heroes, and prominent individuals, including members of Plancia Magna's own family.[33] The fourteen niches of the courtyard's lower walls displayed "Olympian" gods with cults in Perge, and the fourteen niches above them featured mythical founders of Perge as well as Plancia Magna's father and brother, likewise entitled "city founder."[34] The two-storied, triple arch facing the courtyard exhibited statues of Diana Pergensis (the city's tutelary deity) and of the personified guardian spirit of the city. Also on the arch were statues of Divus Nerva, Divus Traianus, Hadrian, perhaps Divus Augustus, and Plotina Augusta, Diva Marciana, Diva Matidia, and Sabina Augusta.[35] From the por-

trait statues of imperial women, only one seems to have survived. A statue of Sabina (fig. 4.5), found in the gate's environs, apparently belongs to the inscribed pedestal from the arch. Life-sized and of marble, Sabina's statue is of the Large Herculaneum Woman type.[36] Hadrian's statue base is dated to 121, and the nomenclature of Plotina and Matidia indicates a date from 119 to 122. Plancia Magna's renovation of Perge's city gate is thus plausibly dated to AD 121.[37]

Although Plancia Magna's installation is uncommonly elaborate, we should not be surprised by some of its aspects. Statues of Roman women had a relatively long tradition in provincial cities in Rome's Greek East, in comparison to their appearance in Rome itself. Our earliest reference to such provincial displays is in a speech Cato the Censor reportedly made in 184 BC, and Mika Kajava cites less anecdotal evidence for statues of Roman women raised in Greece and Asia Minor in the first quarter of the first century BC and afterwards.[38] Such statues honored the wives, daughters, and (more rarely) mothers of Roman officials and powerful businessmen and were located in cities' agoras or sanctuaries alongside statues of the more obviously influential males.[39] The statuary groups had been anticipated in the Hellenistic period, when freestanding monuments that communities raised to kings and generals sometimes depicted female relatives as well.[40] Public statuary groups honoring Hellenistic dynasts and their Roman successors, particularly the Julio-Claudian family, are usually said to have been made in the hopeful expectation of patronage from the powerful individuals thus celebrated.[41] Plancia Magna's statues of imperial women have a long tradition and many comparanda in Asia and elsewhere.[42]

But we should not be misled into dismissing Plancia Magna's display as ordinary. For one thing, the arch and gateway do not well suit the standard interpretation of such honorific monuments as installed *quid pro quo*. Plancia Magna dedicated the arch to her city, not to the reigning emperor or to the imperial house.[43] Moreover, we cannot equate Plancia Magna's lavish gesture with the hope for a brilliant political career for her husband and/or her son, since so far the evidence from the gate attests neither male relative. Other data document the eminence of these men in Roman politics.[44] We should look to the women involved rather than the men, taking our cue from the extant statue of Sabina and from the city gate's patron, Plancia Magna herself.

Although Plancia Magna evidently did not depict herself at the city gate, her presence there is pervasive, loudly proclaimed on the inscriptions.[45] She was also portrayed just south of the gate, albeit in an installation for which she bore no direct responsibility. Outside the city gate, two niches of a display wall featured statues of Plancia Magna larger than life size. One statue was dedicated by Marcus Plancius Pius "to his patroness," and the other by his fellow freedman, Marcus Plancius Alexander. Both inscription bases hail Plancia Magna as a priestess of the imperial cult as well as a holder of other civic positions.[46] Plancia Magna's statue from the more southern niche is well preserved (fig. 4.6), and with its garments in the Large Herculaneum Woman style it strongly resembles the statue of Sabina from the gate (fig. 4.5).[47]

Plancia Magna's gate at Perge eloquently reminds us of one means by which the iconography of imperial women was disseminated in the Roman world.[48] Visitors approaching Perge from the sea or from Pamphylia's coastal road would have seen the statues of Plancia Magna just before entering the city and then, after passing through the narrow opening of the city gate, they would have found the imperial house, women as well as men, displayed on the facing triple arch. The proximity of Perge's city founders and gods emphasized the close ties of the imperial family with the city, ties that Plancia Magna mediated and reinforced as one of the municipal elite. At least one statue of Plancia Magna visually echoed the portrayed empress Sabina. Ironically, the assimilation is more apparent than real. Sabina, as the other women of the Trajanic-Hadrianic court discussed in this essay, has very few attested benefactions, much in contrast to what we

know for Plancia Magna.[49] But citizens and visitors in Perge would probably not have known the details of Sabina's benefactions. Instead, the similarities of Plancia's statue to that of Sabina would have implied that their own patroness and "city daughter" represented this empress in Perge.

The third ensemble I address, that featuring Sabina and Hadrian in the theater at Vasio (in Gallia Narbonensis; now Vaison-la-Romaine), is less ornate, though remarkable for its very routineness. Though still in a provincial setting, the statuary comes from the Latin West, with its relatively unsophisticated traditions. The imperial statues from Vasio's theater may have been publicly sponsored by the city, although the unscientific manner of the theater's excavation confounds the evidence.[50] In the first half of the second century a local grandee paid for marble work on the *proscenium* (stage) of Vasio's theater (*CIL* XII, 1375), a middling-sized structure that probably dates to the first century AD.[51] Vast quantities of fragmentary sculpture indicate that the Vasio theater was richly decorated over the years, like many others in the Roman world. In it were found caryatids; mask appliqués and oscilla; friezes with maenads, Sileni, and other Dionysiac figures; freestanding statues of Dionysus, Venus, and Apollo; and representations of private individuals.[52] With these, and probably also displayed originally on the *scaenae frons* (stage facade), were a head of the young Tiberius, a statue of Claudius, and ones of Domitian, Hadrian, and Sabina (fig. 4.7).[53] Made of local white marble and larger than life size, the standing statue of Sabina, and its companion statue of Hadrian, are idealized portraits stylistically dated to the early 120s.[54] Sabina's gesture and clothing evoke the *pudicitia* statue type, but the Vasio sculpture of the empress has no close parallels. It and Hadrian's statue are associated with Hadrian's known trip to Gaul in this period.[55]

Without being able to identify the patron(s) or exact location of Sabina's statue, we can speak only generally about its context. Yet the generalities are worth stating, since they are so often overlooked. Statues of emperors, even ones of imperial women, are fairly well attested for theaters. Hans Georg Niemeyer, for example, lists theaters third in his catalogue of known findspots for imperial statues, the first being temples, and the second being the political centers of the forum, basilica, and curia. In a more recent investigation of theatrical decoration in Italy and the Latin West, Michaela Fuchs identifies some thirty theaters with such displays.[56] The imperial statues and busts usually graced the huge *scaenae frons*,[57] a "receptive context" for us to consider.

Although it has been argued that such statues had cultic functions, they were not icons per se.[58] Nevertheless, the statues must have had symbolic worth. Theaters were an important part of Roman life. Often much larger than seems warranted by a particular city's urban fabric, Roman theaters brought city dwellers, the rural population, and visitors together for festivals and holidays. The audience included women, men, slaves, elite, freed, and freeborn. How many such days involved provincial theaters is not exactly known—two or three per month?—but during them the imperial statues and other theatrical sculptures on the *scaenae frons* faced an audience often seated for hours on end. Religious processions involved with the imperial cult, in the Greek East and Latin West, seem to have stopped at theaters, and all scenic spectacles involved religious rites.[59] At Vasio the statues of Sabina and Hadrian reminded theatrical spectators that their *otium* (their leisure) was dependent on the imperial house and its harmony.

More, perhaps, can be concluded from the unique nature of Sabina's image. The heavy garments that envelop her completely, save for her sturdy left forearm, markedly contrast the heroic nudity of Hadrian's statue. Moreover, although Sabina's portrait type is attested in other replicas, the appearance of the whole statue is unique. In contrast, Hadrian's heroic presentation is attested also at Pergamum and perhaps at Argos.[60] These differences may be due simply to better organization for official portraiture of the emperors themselves than of the women of the emperors or possibly to Hadrian's

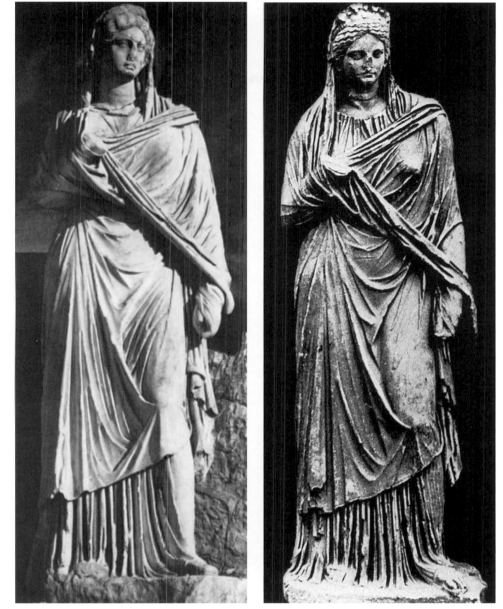

personal appearance in the region. Yet I also think that the representation of Sabina in unpretentious attire must have made her seem more accessible to Vasio's audience. In Perge, comparable representations of Plancia Magna and Sabina visibly bridged the distance between imperial woman and local patroness. In Vasio, the depiction of Sabina in chaste, possibly local garb proclaimed that the imperial house was approachable, even as Hadrian's heroic nudity underlined his majestic power.

My fourth case study of imperial women as architectural sculpture raises more forcefully the topic of gender.[61] Representations of Plotina, Marciana, and Sabina were found in the Baths of Neptune and the Baths of Marciana, two thermal amenities at Ostia. The Baths of Neptune are a well-planned structure adjacent to the Barracks of the Firefighters, near Ostia's eastern entrance. They seem to be the baths documented by an inscription that commemorates an unidentified bath structure that Hadrian began but Antoninus Pius finished.[62] The presumable imperial funding may account for the unusually high quality of the sculpture found here, including a lovely, life-sized statue of Sabina of costly Parian marble. The empress is portrayed as Ceres, with veiled head

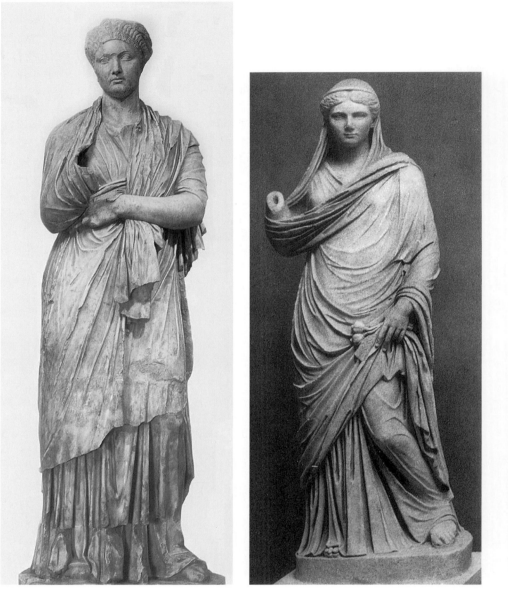

FIGURE 4.7
Statue of Sabina. **From the
theater of Vasio. Sabina's
stance and idiosyncratic gar-
ment suggest that the statue
was made locally by a pro-
vincial workshop.** [photo-
graph: after C. Goudineau and
Y. de Kisch, *Vaison-la-Romaine*
(Paris 1991) 136; courtesy
Editions Errance]

FIGURE 4.8
Statue of Sabina as Ceres.
**From the Baths of Neptune
in Ostia. The statue was
found in a central niche of
the western side of the
Baths' palestra.** [photograph:
after Wegner, *Hadrian,* pl.
41.a; courtesy of the
Deutsches Archäologisches
Institut, Berlin]

and poppies and ears of grain in her lowered left hand (fig. 4.8).[63] The portrait has been
dated to the end of Sabina's life (AD 137), the date generally assigned the baths' incep-
tion,[64] and it is so idealized that Raissa Calza suggests it was made posthumously to
depict the divinized Sabina.[65] More recent discussion of its findspot, a central niche in
the palestra that Fikret Yegül likens to imperial cult shrines in Asian baths, would also
speak in favor of a cultic interpretation for the statue.[66] But it is dubious that Sabina's
statue ever had such a function: there is no arrangement for an altar in front of it, and
icons used for imperial cult were usually portable and of precious metal.[67] Moreover,
the other female imperial portrait found at the Baths of Neptune, a head of Plotina that
was once inserted in a statue (fig. 4.9), comes from the frigidarium, a room attested in
other bath buildings as packed with statuary of all kinds.[68] The portrait of Plotina,
slightly smaller than life size and of Greek marble, is an early type. Plotina wears a sweet
and slightly suffering expression.[69]

No precise findspots were recorded for the two female marble portraits from the
Baths of Marciana at the Porta Marina, baths dated to the Hadrianic period but of
unknown funding.[70] A head of an imperial woman of the period, larger than life size

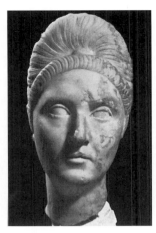

and now in the Ny Carlsberg Glyptotek in Copenhagen, came from here in the 1830s. The characteristics are so indistinct that the head was first identified as that of Plotina and then of Marciana and is now held to be that of Sabina.[71] Better known and more telling is the colossal head of Marciana (fig. 4.10), the discovery of which gave the baths their modern name. Marciana's head was originally fitted into a statue.[72] The portrait has an excellent parallel in the Marciana statue from the Forum of Trajan, which now stands in the Loggia dei Lanzi (fig. 4.3).[73]

Besides their obvious physical resemblances, these two images of Marciana have other comparanda. If the Baths of Marciana were imperially sponsored, their patronage would duplicate that of Trajan's Forum and of the Baths of Neptune. Although at first sight the apparent concentration of female statues in the Baths of Marciana (as well as its misleading modern name) suggests that this bath complex was primarily or exclusively for women, the inference is rebutted by the lack of any other evidence for female clientele, the baths' marginalized and less safe location outside Ostia's gate towards the sea, and portrait heads of Hadrian and Trajan found here.[74] The Baths of Marciana were most likely used principally by men.[75] The other Ostian baths with imperial statuary, the Baths of Neptune, were ideally located for a male clientele composed of firefighters from the neighboring barracks, workers from surrounding granaries, and sailors and others attracted to this sector of Ostia by the nearby theater. Likewise, the Forum of Trajan must have served men, first and foremost, with its governmental and banking functions.

Yet outward similarities of financing and clientele should not obscure the very different purposes of the Ostian baths and the Forum of Trajan, purposes that radically distinguish the contexts of these two images of Marciana. Trajan's Forum was for politics, weighty matters, affairs of state; in contrast, baths were for leisure, frivolity, perhaps even private affairs. Although imperial statues are not unknown in baths, they do not seem to have been common in this setting. In his investigation of the sculptural decoration of imperial baths, Hubertus Manderscheid counts only 34 imperial portrait statues from baths in the Roman world.[76] Statues of the Trajanic-Hadrianic women outnumber ones of other imperial women in his catalogue—surprisingly, in light of the sharp contrast between baths' racy reputation and these women's retiring personas.

Luciana Jacobelli's monograph illuminating the erotic paintings of Pompeii's Suburban Baths illustrates how baths' risqué reputation was enhanced by their decoration, at least at this choice Pompeian site of the first century.[77] Admittedly, the erotica at Pompeii were carefully covered over a few years before Vesuvius erupted, suppressed, according to their investigator, in the more sober and moralistic climate of the Flavian period.[78] Overall during their long history, however, Roman baths were enticing, sensuous locales in which one could let oneself go. Their popularity is demonstrated by their ubiquity in Roman cities and by a celebrated epitaph from imperial Rome: "Baths, wine, and lovemaking destroy our bodies, but these are the stuff of life" (*CIL* VI, 15258).[79] Baths usually featured statues of Aphrodite, Dionysus, and other symbols of self-indulgence and sensuality, alongside images of healing and water deities.[80] One could claim that provocative statues and erotic frescoes had no real significance: Livia, for example, dismissed glimpsing inadvertently a group of naked men by saying, "To chaste women such men are no different from statues" (Dio Cass. 58.2.4).[81] Yet in Domitian's principate a woman was accused and executed for undressing before a statue of an emperor (Dio Cass. 67.12.2). Baths had to be problematic sites for statues of emperors and their female kin.[82]

The undertone of baths' impropriety runs counter to the retiring and chaste characters of Plotina, Marciana, and Sabina. (No wonder the Plotina from the Baths of Neptune looks distressed!) In historical hindsight, these august women seem completely out of place in such surroundings. Why their statues and busts would be put in baths at all is

a good question, and I have considered various responses: as perfunctory gestures of homage to the imperial house; due to a *horror vacui;* perhaps even to elicit a *frisson* of naughtiness from the bathers. Whatever the motivations may have been, I feel sure that the images of Marciana, Plotina, and Sabina located in the Ostian baths provoked responses unlike those elicited by the ostensibly similar images of Marciana and Matidia the Elder in the Forum of Trajan.

Now, of course, we cannot discern the intellectual or emotional reaction of any individual man or woman to a particular Roman portrait. We cannot know what Perge's visitors or inhabitants thought or felt when faced by Plancia Magna's formidable array of imperial women and men, or what an ancient traveler experienced at seeing Marciana's statue in Rome's Forum of Trajan after bathing earlier in Ostia's Baths of Marciana. Nevertheless, our own appreciation and understanding of Roman portrait sculpture is infinitely enriched when, wherever possible, we consider their original setting, the conditions determining their production and style, and the *mentalité* of their audiences. If we accept that images are powerful—as ancient and modern evidence overwhelmingly demonstrates, despite Livia's disclaimer—we must also recognize the significance of their contexts.

NOTES

1. See E.K. Gazda and A.E. Haeckl, "Roman Portraiture: Reflections on the Question of Context," *JRA* 6 (1993) 289–302. For the last set of questions, cf. C. Mango, "Antique Statuary and the Byzantine Beholder," *DOP* 17 (1963) 55–75, and A.P. Gregory, " 'Powerful Images': Responses to Portraits and the Political Uses of Images in Rome," *JRA* 7 (1994) 80–99.

2. E.g., C.C. Vermeule, "Graeco-Roman Statues: Purpose and Setting," *Burlington Magazine* 110 (1968) 551, 613.

3. The standard corpus, Wegner, *Hadrian,* is still useful but should be updated. See also A. Carandini, *Vibia Sabina. Funzione politica, iconografica e il problema del classicismo adrianeo* (Florence 1969); M. Bonanno Aravantinos, "Un ritratto femminile inedito già nell' *Antiquarium* di S. Maria Capua Vetere. I ritratti di Marciana: una revisione," *RendPontAcc* 61 (1988/89) 261–308; M. Wegner, "Verzeichnis der Bildnisse von Hadrian und Sabina," *Boreas* 7 (1984) 146–56; K. Fittschen, "Courtly Portraits of Women in the Era of the Adoptive Emperors (98–180) and Their Reception in Roman Society," in Kleiner and Matheson, *I, Claudia* 42–52; and Fittschen-Zanker III 7–13 nos. 6–12, pls. 7–15.

4. Marciana's daughter, Matidia the Elder, had two daughters, Sabina and Matidia the Younger, and Sabina married Hadrian. These "Trajanic-Hadrianic" women contrast greatly with earlier and later Roman empresses like Livia and Julia Domna: see M.T. Boatwright, "Impe-

rial Women of the Early Second Century A.C.," *AJP* 112 (1991) 513–40.

5. P. Zanker, *Provinzielle Kaiserporträts. Zur Rezeption der Selbstdarstellung des Princeps* (Bayerische Akademie der Wissenschaften Abhandlungen N.F. 90, Munich 1983); R.R.R. Smith, "Roman Portraits: Honours, Empresses, and Late Emperors," *JRS* 75 (1985) 212–15.

6. See P. Zanker, "Das Trajansforum in Rom," *AA* 85.4 (1970) 499–544, and J.E. Packer, *The Forum of Trajan in Rome: A Study of the Monuments* (Berkeley 1997). Although building plans for the area were initiated during Domitian's principate (J.C. Anderson, *The Historical Topography of the Roman Imperial Fora* [Brussels 1984] 148–51), final composition was due to Trajan and his architects.

7. C. Gasparri, "Die Gruppe der 'Sabinerinnen' in der Loggia dei Lanzi in Florenz," *AA* (1979), 524–43; H. J. Kruse, *Römische weibliche Gewandstatuen des 2. Jhs. n. Chr.* (Diss. Göttingen 1968; Göttingen 1975) 330–32 nos. D12–17. These findings are alluded to briefly or not at all in most discussions of the Forum of Trajan: e.g., Packer (supra n. 6) 382 cat. no. 191, n. 2; Richardson, *Topographical Dictionary* 175–78, s.v. Forum Traiani; G. Lahusen, *Untersuchungen zur Ehrenstatue in Rom: Literarische und epigraphische Zeugnisse* (*Archaeologica* 35, Rome 1983) 27–31, and idem, "Offizielle und private Bildnisgalerien in Rom," in N. Bonacasa and G. Rizza eds., *Ritratto ufficiale e ritratto privato* (Rome 1988) 362–63.

8. They were moved there in the late eighteenth century from Rome, where they had been

shown after their discovery in the first half of the sixteenth century: cf. Gasparri (supra n. 7) 525–28, and G. Capecchi, *BdA* 60 (1975) 169–75. The portraits of Marciana and Matidia the Elder are discussed by Wegner, *Hadrian* 77 no. 121, and 81 no. 123.

9. For the type and that of the Large Herculaneum Woman, see M. Bieber, "The Copies of the Herculaneum Women," *ProcPhilSoc* 106 (1962) 111–34; and now H. Wrede, (*Consecratio in Formam Deorum: Vergöttlichte Privatpersonen in der römischen Kaiserzeit* [Mainz 1981] 213–14, n. 4), who argues that in Roman times the two types were used for elite women rather than for Demeter and Kore.

10. Gasparri (supra n. 7) 528–29. Bieber (*Copies* 167–68, pl. 126) classifies these statues as the type of "Diva Augusta" ("DA"). These four examples seem to be among the earliest.

11. The heads of Marciana and of Matidia were reinserted in ancient statues of the appropriate type, although the statue reused for Matidia's head was originally veiled. The statue of Agrippina the Younger is the only one of the four in the portrait series that still carries its original head.

12. Gasparri (supra n. 7) 529–30. Bieber (*Copies* 167–68) assumes that the "Diva Augusta" statue now without original head was a portrait of Plotina and identifies Agrippina the Younger as a retrospective portrait of Livia.

13. Gasparri (supra n. 7) 529.

14. A monumental head, of slightly larger proportions and once part of an *imago clipeata* (portrait shield), was discovered during excavations in the Forum of Trajan in the 1930s: S. Fuchs, *Die Antike* 14 (1938) 276–77, pl. 33; C. Pietrangeli, "Agrippina Minore," *EAA* 1 (1958) 160–61. Gasparri ([supra n. 7] 535–37) ventures that it represents Agrippina the Elder, so that both mother and daughter would be portrayed in the Forum of Trajan (cf. Marciana and Matidia). Others hold the monumental head depicts Agrippina the Younger (Fittschen-Zanker III 6–7, pl. 6; S. Wood, "Memoriae Agrippinae: Agrippina the Elder in Julio-Claudian Art and Propaganda," *AJA* 92 [1988] 424–25; Zanker [supra n. 6] 518–20); Packer (supra n. 6) 381 cat. no. 191.

15. Cf. Gasparri (supra n. 7) 540–42.

16. By "public" here I exclude the question of funerary portraits, which were exhibited on privately owned land: J.P. Rollin, *Untersuchungen zu Rechtsfragen römischer Bildnisse* (Bonn 1979) 90–91.

17. Lahusen (supra n. 7, 1983, 1988); J.C. Balty, "Groupes statuaires impériaux et privés de l'époque julio-claudienne," in N. Bonacasa and G. Rizza eds., *Ritratto ufficiale e ritratto privato* (Rome 1988) 37–38; M.B. Flory, "Livia and the History of Public Honorific Statues for Women in Rome," *TAPA* 123 (1993) 287–92.

18. Taracia Gaia, a mythic Vestal Virgin who gave the Roman people the Campus Martius (she is also known as Fufetia and is associated with Accia Larentia), had a statue in an unknown spot: Pliny *HN* 34.25. In front of the Temple of Jupiter Stator were statues to Cloelia and to Valeria, daughter of Poplicola, who both had roles in the legendary fall of the monarchy: Pliny *HN* 34.28–29; Lahusen (supra n. 7, 1983) 34, 56–57, 77, 109, 123, n. 53; G. Lahusen, *Schriftquellen zum römischen Bildnis* I (Bremen 1984) 17–19 nos. 86–93. In the vestibule of the Temple of the Magna Mater was a statue of Claudia Quinta, the savior of Rome in 204 BC: Lahusen (supra n. 7, 1983) 34; Val. Max. 1.8.11; Tac. *Ann.* 4.64. I do not treat statues of the non-Roman Cleopatra here, although one is known to have been in Rome's Temple of Venus Genetrix (App. *BCiv.* 2.102; Dio Cass. 51.22.3).

19. Another distinction of Cornelia's statue is that its location, the Porticus of Metellus (reworked later as the Porticus Octaviae), had many overtly non-religious functions, in contrast to the primarily religious settings of the statues listed in n. 18 above: cf. Lahusen (supra n. 7, 1983) 108, 123, n. 53.

20. *CIL* VI, 10043: Cornelia Africani f. Gracchorum. F. Coarelli ("La statue de Cornélie, mère des Gracques, et la crise politique à Rome au temps de Saturninus," in *Le dernier siècle de la république romaine et l'époque augustéenne* [Strasbourg 1978] 13–28) suggests that the inscription was recut in the Augustan period; Flory ([supra n. 17] 292) emphasizes Cornelia's suitability for Augustan pro-family propaganda.

21. Balty ([supra n. 17] 38–45) stresses the monopolization of public space by the imperial family; Flory ([supra n. 17] 287–308) argues for the relative infrequency of female public statues in the early part of Augustus's principate. See also the statues dedicated to Divine Augustus and members of the Augustan house by Norbanus Flaccus in the Circus Flaminius, referred to by the Tabula Siarensis (infra n. 25): cf. Rose, *Dynastic Commemoration* 107 cat. no. 35.

22. Dio Cassius reports that at Livia's death in AD 29, the senate decreed her an arch, "something never done for a woman alone," but that it

was never built due to Tiberius's reluctance: 58.2.3, 6. See S. de Maria, *Gli archi onorari di Roma e dell'Italia romana* (Rome 1988) 338; and F.S. Kleiner, "An Extraordinary Posthumous Honor for Livia," *Athenaeum* 78 (1990) 508–14.

23. Gasparri (supra n. 7) 540–43.

24. One can also note that since Trajan and Plotina had no children and Hadrian was adopted only on Trajan's deathbed in 117, the Forum of Trajan does not allude to the future of the dynasty, an important element for such displays. Balty ([supra n. 17] 32) distinguishes two types of dynastic displays: synchronic, showing the different members of a family at a given moment, and diachronic, depicting the individuals in a sort of genealogical line, within a long chronological perspective.

25. W. Trillmich, "Der Germanicus-Bogen in Rom und das Monument für Germanicus und Drusus in Leptis Magna," in J. González and J. Arce eds., *Estudios sobre la Tabula Siarensis* (Madrid 1988) 51–60. Also named are Germanicus's father Drusus Germanicus, and brother Tiberius Germanicus (Claudius). F.S. Kleiner ("The Study of Roman Triumphal and Honorary Arches 50 Years after Kähler," *JRA* 2 [1989] 200–201) doubts that twelve or more statues could all be located on the arch; *contra,* Rose, *Dynastic Commemoration* 108–10 cat. no. 37. Also for the Tabula Siarensis, J. González, "Tabula Siarensis, Fortunales Siarensis et Municipia Ciuium Romanorum," *ZPE* 55 (1984) 55–100; cf. *AE* 1984, 137–45; *AE* 1991, 20; *AE* 1992, 176; and R.K. Sherk, *The Roman Empire: Augustus to Hadrian* (Cambridge 1988) no. 36 (English translation, integrated with the Tabula Hebana). I omit discussion of the supposed Augustan arch at Pavia with its statue of Livia, since the inscriptions held to attest this are probably not original to a single monument but rather are a late collection of individual and joint dedications to the imperial family: C.B. Rose, "The Supposed Augustan Arch at Pavia and the Einsiedeln 326 Manuscript," *JRA* 3 (1990) 163–68.

26. *CIL* VI, 920–923; F. Castagnoli, "Due archi trionfali della Via Flaminia presso Piazza Sciarra," *BullComm* 70 (1942) [1943] 58–73.

27. See R.P. Saller, "*Familia, Domus* and the Roman Conception of the Family," *Phoenix* 38 (1984) 336–55. Admittedly, the idealized Roman women do not wear the *stola,* the signifier of the status of a Roman: cf. J.L Sebasta, "Symbolism in the Costume of the Roman Woman," in J.L. Sebasta and L. Bonfante eds., *The World of Roman Costume* (Madison 1994) 48–49; and B. Holtheide, "Matrona stolata," *ZPE* 38 (1980) 127–34.

28. Discussing the head of Agrippina the Younger (see Fittschen-Zanker III 6), Fittschen and Zanker remark that the inclusion of a gallery of earlier emperors and empresses, perhaps in the great exedra of the Forum of Trajan, illuminates the piety of Trajan and his era towards the history of the principate.

29. Tac. *Germ.* 18–19, though extolling the German marriage tie and German women, immediately marks both as barbaric and lawless: cf. R. Martin, *Tacitus* (Berkeley 1981) 49–52. See also N.B. Kampen, "Looking at Gender: The Column of Trajan and Roman Historical Relief," in D. Stanton and A. Stewart eds., *Feminisms in the Academy: Thinking through the Disciplines* (Ann Arbor 1995) 46–73.

30. See C. Nicolet, *Space, Geography and Politics in the Early Roman Empire* (Ann Arbor 1991); M. Foucault, *The Care of the Self,* R. Hurley trans. (New York 1986).

31. On the administrative process involved in the production of the imperial image in Greece and Asia Minor, see C.B. Rose, "The Imperial Image in the Eastern Mediterranean," in S.E. Alcock ed., *The Early Roman Empire in the East* (Oxford 1998) 108–11.

32. I have discussed this ensemble from various viewpoints in "Plancia Magna of Perge, and the Roles and Status of Women in Roman Asia Minor," in S.B. Pomeroy ed., *Women's History and Ancient History* (Chapel Hill 1991) 249–72, and in "The City Gate of Plancia Magna in Perge," in D'Ambra, *Roman Art in Context* 189–207. The present, much abbreviated, treatment differs in emphasis.

33. The architectural sculpture is known from numerous statue bases and extant statues found at the gate and arch, which indicate that statues were once in the twenty-eight niches in the gate's internal walls, articulated by a marble two-storied Corinthian facade, as well as on top of the massive, two-storied, triple arch built just north of the courtyard, and in the aediculae and semicircular and rectangular niches of the arch's primary and lateral faces.

34. See Boatwright (supra n. 32, 1993) 192–97.

35. R. Merkelbach and S. Sahin, "Die publizierten Inschriften von Perge," *Epigraphica Anatolica* 11 (1988) 120–22 nos. 29–34; Boatwright (supra n. 32, 1993) 196.

36. Kruse ([supra n. 7] 281–83) argues against matching the bases of the imperial statues with fragmentary cuirassed and draped statues also found in the general proximity, but see Inan and Rosenbaum 72–73 no. 36, pls. 19.3 and 22;

and Carandini (supra n. 3) 167–68. Sabina's statue (182 cm. H., head 26.5 cm. H.), of fine-grained white marble, was probably made in Perge.

37. Boatwright (supra n. 32, 1993) 196 and n. 26. Carandini ([supra n. 3] 168) argues unconvincingly for a date after 128 on the basis of the hairstyle, single diadem, and neoclassical style of Sabina's portrait, choosing 129 to coincide with Sabina's visit to the East in that year.

38. Cato's speech: Pliny *HN* 34.31 = Lahusen (supra n. 18, 1984) no. 2; see also M. Kajava, "Roman Senatorial Women and the Greek East: Epigraphic Evidence from the Republican and Augustan Periods," in H. Solin and M. Kajava eds., *Roman Eastern Policy and Other Studies in Roman History* (Helsinki 1990) 63–64. The difference between East and West is also demonstrated by the late date of women's public honors in Italy: E.P. Forbis ("Women's Public Image in Italian Honorary Inscriptions," *AJP* 111 [1990] 498, n. 14) notes her earliest datable inscription for a private woman is from AD 79.

39. Kajava (supra n. 38) 62–64; in general, see K. Tuchelt, *Frühe Denkmäler Roms in Kleinasien. Beiträge zur archäologischen Uverlieferung aus der Zeit der Republik und des Augustus* I (Tübingen 1979). Most statues, male and female alike, were honorific, but a few were cultic: S.R.F. Price, *Rituals and Power: The Roman Imperial Cult in Asia Minor* (Cambridge 1984) 42–47.

40. Kajava (supra n. 38) 62.

41. Rose, *Dynastic Commemoration* 3–10; also A. Wallace-Hadrill, "Roman Arches and Greek Honours: The Language of Power at Rome," *PCPS,* n.s. 36 (1990) 151–56, although without mention of women. Wallace-Hadrill cites as the first known honorific (rather than triumphal) arch the one raised to Verres in Syracuse in 70 BC (Cic. *Verr.* 2.2.154).

42. I do not know of any other examples on arches in the Greek East before this period, but in the Latin West imperial women had been depicted on arches for a century.

43. A.M. Mansel, "Bericht über Ausgrabungen und Untersuchungen in Pamphylien in den Jahren 1946–1955," *AA* 71 (1956) 117–18, n. 83, and Boatwright (supra n. 32, 1991) 251.

44. Her husband, Gaius Iulius Cornutus Tertullus, was probably born in AD 43 or 44 and may have married Plancia ca. 100–110; if so, their son, Gaius Iulius Plancius Varus Cornutus, would have been beginning his political career at the time of Plancia's gateway: see Boatwright (supra n. 32, 1991) 252–56.

45. Twin inscriptions proclaimed that she dedicated the arch to her city; on bases of the various statues installed there, her patronage is again announced; and her father and brother, identified solely by their relation to her and as "city founders," are the only non-legendary city founders distinguished on the entry wall. See supra ns. 43 and 44.

46. A.M. Mansel, "Bericht über Ausgrabungen und Untersuchungen in Pamphylien in den Jahren 1957–1972," *AA* 90 (1975) 75 (inscriptions not in Merkelbach and Sahin [supra n. 35]).

47. For Plancia Magna's statue, 203 cm. H., see Mansel (supra n. 46) 74–75; J. Inan, "Neue Porträtstatuen aus Perge," in *Mélanges Mansel* II (Ankara 1974) 648–49, and pls. 195–97; for Sabina's, see supra n. 36. Plancia Magna's surviving portrait statue is larger than that of Sabina. The statue above the other base to Plancia Magna, now without a head, is attired differently, but we cannot know if its garments resembled those worn by one of the other imperial women on the arch.

48. Smith (supra n. 5) 214. Fittschen ([supra n. 3] 42) and Rose (*Dynastic Commemorations* 113) hold that modern scholarship tends to exaggerate the similarities of imperial and private portraiture.

49. Boatwright (supra n. 4) 524; M.T. Boatwright, "Matidia the Younger," *EMC/Classical Views* 26, n.s. 11 (1992) 19–32. This also contrasts the women associated with Augustus, especially Livia and Octavia: see D.E.E. Kleiner, "Imperial Women as Patrons of the Arts in the Early Empire," in Kleiner and Matheson, *I, Claudia* 28–41.

50. C. Goudineau and Y. de Kisch, *Vaison-la-Romaine* (Association de Soutien à la Promotion du Tourisme de la Culture, Vaison-la-Romaine; Paris 1991) 106–107.

51. Goudineau and de Kisch ([supra n. 50] 107–11) opt for an original date slightly after AD 50. The theater's orchestra has a diameter of 30 m.; its outside diameter was 95 m.; and the *scaenae frons* probably rose 29 m. The theater was thus above the mean size of the ninety-some Roman theaters in France.

52. M. Fuchs, *Untersuchungen zur Ausstattung römischer Theater in Italien und den Westprovinzen des Imperium Romanum* (Mainz am Rhein 1987) 129 (caryatids resemble the Erechtheion kore type); 148, 131; 133, 135; 186, 191, 181–82.

53. Goudineau and de Kisch (supra n. 50) 111.

54. Wegner, *Hadrian* 115–16, 130–31, pls. 12.b, 14.a, 41.b, 42; see also F. Salviat, "Hadrien

et Sabine," *Archeologia* 164 (1982) 9–14; Carandini (supra n. 3) 137. The white marble statue of Sabina is 206 cm. H. (cf. that of Hadrian, 216 cm. H.).

55. Sabina's head, attested in six replicas, is one of the four portrait types known for her: Fittschen-Zanker III 12, n. 5; Fittschen (supra n. 3) 50, n. 14 and fig. 5; Wegner, *Hadrian* 115–16, 131; Goudineau and de Kisch (supra n. 50) 111; Carandini (supra n. 3) 136–37. The last scholar notes that we cannot be certain of Sabina's presence in Gaul.

56. H.G. Niemeyer, *Studien zur statuarischen Darstellung der römischen Kaiser* (*Monumenta Artis Romanae* 7, Berlin 1968) 28–37; Fuchs (supra n. 52) 166–80. For comparative numbers: Fuchs lists fifty-three theaters in Italy alone; Goudineau and de Kisch (supra n. 50) some ninety in France.

57. Fuchs (supra n. 52) 166–79; cf. T. Pekáry, *Das römische Kaiserbildnis in Staat, Kult und Gesellschaft* (*Das römische Herrscherbildnis* III.5, Berlin 1985) 42–65, esp. 47–48.

58. With references including H. Blanck, *GGA* 223 (1971) 90–93, Fuchs ([supra n. 52] 180) holds firmly against interpreting all such statues as cultic. For similar arguments, see infra on Sabina's statue from Ostia's Baths of Neptune.

59. D. Fishwick, *The Roman Imperial Cult in the Latin West* I (Leiden 1987) 522–23, argues for the symbolic power of the statues at theaters; cf. M. Clavel-Lévêque, "L'espace des jeux dans le monde romain: Hégémonie, symbolique et pratique sociale," *ANRW* II.16.3 (1986) 2405–2563.

60. Wegner (*Hadrian* 39) compares the Vasio and Pergamum sculptures, pointing out, however, that the heads are not of the same type. For the Pergamum Hadrian, see also Inan and Rosenbaum 70 no. 31, pls. 18.1–2, and 19.1; for the headless statue at Argos: W. Vollgraff, "Fouilles et sondages sur le flanc oriental de la Larissa à Argos," *BCH* 82 (1958) 550–55; Wegner (supra n. 3, 1984) 109.

61. See N.B. Kampen, "Gender Theory in Roman Art," in Kleiner and Matheson, *I, Claudia* 14–25.

62. *CIL* XIV, 98 = *ILS* 334; date corroborated by brick stamps. For a description of these Baths (in Ostia's regionary system, at II, 4, 2), see R. Meiggs, *Roman Ostia*² (Cambridge 1973) 409–11.

63. 186 cm. H. R. Calza, *I ritratti I: Ritratti Greci e Romani fino al 160 circa d.C.* (*Scavi di Ostia* 5, Rome 1964) 79–80 no. 127; Wegner, *Hadrian* 86, 127–28; H. Manderscheid, *Die Skulpturenausstattung der kaiserzeitlichen Thermenanlagen* (*Monumenta Artis Romanae* 15, Berlin 1981) 78 no. 90.

Calza notes this as one of the earliest of the more than thirty examples of the Ceres type known from Roman times (of which five were from near Ostia's theater).

64. See Carandini (supra n. 3) 195–96; H. von Heintz (in Helbig⁴ IV 71–72 no. 3080) would date it to AD 125–130.

65. Calza (supra n. 63) 79 no. 127. See also S.B. Matheson, "The Divine Claudia," in Kleiner and Matheson, *I, Claudia* 182–93, esp. 185.

66. F. Yegül, *Baths and Bathing in Classical Antiquity* (New York, Cambridge, Mass., and London 1992) 68. The statue is small enough that another statue, probably of Hadrian, could have stood next to it on the base: Manderscheid (supra n. 63) 37, 63, n. 429.

67. Blanck (supra n. 58) 90–93; Manderscheid (supra n. 63) 36–37.

68. M. Marvin, "Freestanding Sculptures from the Baths of Caracalla," *AJA* 87 (1983) 351–53, 377.

69. 35 cm. H., found in 1888: Calza (supra n. 63) 60 no. 90; Wegner, *Hadrian* 74, 118–19; and Manderscheid (supra n. 63) 78 no. 89. Calza dates this to AD 102.

70. V. Mannucci, "Restauro di un complesso archeologico," *Archeologia Laziale* 3 (1980) 129–32, revising the Trajanic date tentatively proposed by Meiggs (supra n. 62) 408–409.

71. Italian marble, 42 cm. H. and perhaps originally embellished with a diadem, found in 1831–1836: Calza (supra n. 63) 78 no. 125; Carandini (supra n. 3) 145–47; Manderscheid (supra n. 63) 79 no. 101; Bonanno Aravantinos (supra n. 3) 285. Carandini dates the portrait to AD 125/126, Calza, to 115–120.

72. Opaque white marble with some spotting; 58 cm. H., head alone 37 cm. H.: Calza (supra n. 63) 61 no. 92; Manderscheid (supra n. 63) 79 no. 100; cf. Wegner, *Hadrian* 122. The head was found in 1928.

73. Bonanno Aravantinos ([supra n. 3] 269–77) also compares to this the head of Marciana formerly at S. Maria Capua Vetere and Marciana's portrait now at the Metropolitan Museum of Art, New York (inv. no. 20.200).

74. Life-sized head of Trajan, opaque Greek marble, overall 25 cm. H., dated to AD 108: Calza (supra n. 63) 55 no. 82, and Manderscheid (supra n. 63) 79 no. 99; colossal head of Hadrian, Italian marble, now 25 cm. H.: Calza (supra n. 63) 74 no. 118; cf. Wegner, *Hadrian* 19, 104.

75. Although R.B. Ward ("Women in Roman Baths," *HTR* 85.2 [1992] 125–47) holds rightly that women used public baths during the empire, the literary passages he adduces (see

below) suggest that women went to them in lesser numbers and with less frequency than men. Ward refutes the common opinion that Hadrian prohibited mixed bathing (139–42).

76. Manderscheid (supra n. 63) 35–36: 7 such statues in Italy, found in 3 baths; 4 in Asia, in 3 baths; 7 in Africa Proconsularis, in 4 baths; 11 in 4 baths in Numidia, and 5 in 3 baths in other regions. The chronology begins with Nero, and Manderscheid counts 4 Trajanic pieces, 7 Hadrianic, and 7 Antonine. Pekáry (supra n. 57) 49–50, notes that many of the examples we have are not secure.

77. L. Jacobelli, *Le pitture erotiche delle Terme Suburbane di Pompei* (Rome 1995). The literary and epigraphic texts Ward adduces for women's presence in Roman baths (supra n. 75, esp. 134–39; e.g., Ovid *Ars Am.* 3.639–40; Quint. *Inst.* 5.9.14; Mart. *Epig.* 7.35) also attest the baths' "immoral" reputation.

78. Jacobelli (supra n. 77) 80–82.

79. This inscription seems to date to the first century AD. A later epigram, *Anth. Pal.* 10.112, is similar.

80. Marvin (supra n. 68) esp. 378–83, also noting bath sculptures that transgress boundaries.

81. See M. Myerowitz, "The Domestication of Desire: Ovid's *Parva Tabellae* and the Theater of Love," in A. Richlin ed., *Pornography and Representation in Greece and Rome* (New York 1992) 144.

82. Cf. Pekáry (supra n. 57) 50.

MORTALS, EMPRESSES, AND EARTH GODDESSES
Demeter and Persephone in Public and Private Apotheosis

SUSAN WOOD

Many recent studies of antiquity, including some in the present volume and its predecessor, have addressed the "construction of gender" in various historical periods; that is, society's creation of a set of expectations about the appropriate traits of character and forms of behavior for men and women.[1] Such stereotypes and socially established norms of conduct were often taken at the time to be natural and inevitable but were in fact dependent on and varied according to cultural and historical circumstances. Examination of these gender constructs is important and necessary, exposing as it does the fallacious and often contradictory logic behind the assumptions of many antifeminists that nature, or God, has placed some inevitable restrictions on the freedoms and opportunities available to women. On the other hand, our understanding of ancient societies (or of modern ones, for that matter) is not complete if we do not also examine the other side of that coin: the ways in which certain intractable biological facts about human existence affect all human cultures, producing some patterns of behavior, particularly of religious belief and ritual, that are remarkably universal and consistent. Some of these facts include sex, as opposed to gender (the biological facts of copulation and reproduction, rather than the elaborate structures of behavior and social roles that surround these activities), physical danger, illness, and mortality. Walter Burkert published a masterly examination of the biological origins of much religious behavior; I propose in this essay to examine in particular the fears, and religious responses to those fears, that have their origins in the sexual vulnerability of females.[2] Rape and sexual murder are, of course, dangers to all human beings, male or female, young or old, but the nature of female physiology causes women to be more aware of the danger than men, and causes the parents of young girls, in particular, to fear for the safety of their children.

Contemporary American culture has produced some mythologies of its own that express such anxieties, one of which has received extensive examination in the recent book *Abductions,* by John Mack, a psychologist who treats patients who claim to have been abducted by extraterrestrials. To the great dismay of many of his professional colleagues, Mack appears to believe that on some level of psychological reality, at least, the events that his patients describe have really occurred. I will leave it to others to debate phenomena such as self-hypnosis and false memory, but whatever the merits of Mack's conclusions, the narratives that he recounts do display a remarkably consistent pattern: the patients usually claim to have been visited by the extraterrestrials while in bed asleep (i.e., in a passive and vulnerable state), carried helplessly aboard alien spacecraft and subjected to barbaric experiments, often involving sexual violation. By way, perhaps, of compensation, the aliens then grant them enlightenment on some issue such as ecology or world peace and finally return the victims to their beds, apparently unharmed, until they "recover" the memory of the event at some later date. Some are also convinced that their children are being abducted on a regular basis, and one man claims to have seen his infant son aboard an alien spacecraft.[3] Many of these "experiencers,"

despite their conviction that they have been brutally victimized, also seem to regard these abductions as something like a religious experience: another popular book on the subject bears the title *Communion*.[4] It is easy for nonbelievers in U.F.O. mythology to laugh at these claims, yet they give voice to real and profound fears of death, of rape, and of losing a child. Reaction to such terrifying realities can take the form of destructively superstitious behavior, of which Americans have recently witnessed another horrifying example in the nationwide witch-hunts for child-abusers that began with the case of the McMartin School.[5] These fears, however, can also manifest themselves in a more benign spirituality and in a range of behaviors between those benign and destructive extremes.

Stories of alien abduction display remarkable consistency with mythological patterns throughout history. Carl Sagan has already documented their resemblance to medieval stories of incubi and succubi.[6] They also resemble the very familiar topos in Greek and Roman mythology of rape by a god, in which some powerful being attacks and abducts a human or a less-powerful deity, carrying the victim forever away from the life that he or she once knew but giving the abductee some form of immortality, in another shape or another sphere of existence. Images of such episodes, like the rape of the daughters of Leucippus by Castor and Pollux, or Selene descending from her chariot to embrace Endymion who would then sleep forever, proved understandably quite popular in funerary art.[7]

Among these numerous myths, however, the rape of Persephone held special pride of place in Greek and Roman religion. As recorded in the *Homeric Hymn to Demeter* and in Ovid's *Metamorphoses* and *Fasti,* Hades, the god of death, seized and carried away Persephone as she was picking flowers with her companions. Her mother Demeter, goddess of the earth and of fertility, then searched for her missing daughter, and during her quest received hospitality from Celeus, whom she rewarded by curing his sick child Triptolemos. She then attempted to go farther and give the boy immortality, a scheme that his mother inadvertently frustrated, but although Demeter failed to make the child immortal, she promised that she would one day grant to him the secrets of cultivation of grain. When Demeter finally learned from the nymphs that her daughter was in the underworld, she won Persephone's release and return to the world of the living, on condition that, because she had eaten pomegranate seeds in the underworld, she must return for part of every year to the realm of the dead.[8] This fable of death and seasonal regeneration appears to have been the central event that the mysteries of Eleusis reenacted for the enlightenment of the initiates. Unlike most mythological rapes, it involves a definite resurrection: not immortality in some other plane of being but a return to life in this world. Moreover, the myth is striking for its female character: a dominant theme of the *Homeric Hymn to Demeter,* and of the cult at Eleusis, is the loving bond between mother and daughter and the association of both with the seasons, fertility, and cultivation of grain, traditionally women's work.[9]

A feminist theologian has tried to compose a kinder, gentler, "prepatriarchal" version of Persephone's descent to the underworld, in which there is no rape and the goddess goes voluntarily to care for the souls of the dead.[10] But as John Mack's patients intuitively recognize when they recount their experiences of alien abduction, the story will not work without the rape. The fear of death, expressed as the horror of violation, is central to the meaning of the myth and to the cathartic experience of the initiate. Rape is a shattering reality for countless victims, a danger of which all women become aware at an early age and for that very reason the most powerful possible metaphor for helplessness in the face of some event or force of nature beyond human control. In Cohen's study of rape scenes in ancient art, she rightly advised modern analysts to recognize the literal as well as metaphorical meanings of these representations: what the

viewer sees first is a scene of violent abduction, and one responds to this image before intellectualizing the scene as a reference to life, death, and the seasons.[11]

The mysteries of Eleusis, with all of their emotional and psychological resonance, continued to be celebrated throughout the Roman imperial period. Many emperors, along with countless Roman citizens, became initiates, and at least three emperors lavished architectural patronage on the site.[12] Ovid devotes long passages in two of his poems to the myth of Persephone and Demeter and seems familiar with the rites of Eleusis.[13] Cicero describes Eleusinian initiation as raising mankind from a brutish to a civilized existence, providing a source of joy in life and a reason to die with hope.[14] Somewhat closer to home for Italians, the island of Sicily claimed possession of the very spot where Persephone vanished into the underworld, at the spring of Kyane, where one of the earliest cult images of the goddess was found, a sculptured head in the Daedalic style of the late seventh or early sixth century.[15] This image and numerous terracotta votive statuettes and plaques attest the enormous popularity of the cult of Demeter and Persephone in Sicily and in southern Italy.[16] Non-Greek peoples of Italy also enthusiastically embraced this myth, especially in funerary art.[17] The story of Persephone was, in short, not only thoroughly familiar to most Romans of the imperial period but deeply entrenched in the religious traditions of their homeland. For many men and women of all classes, the myth was also associated with the profound religious experience of initiation at Eleusis.

It is only to be expected, then, that Persephone (also known as Kore, "The Maiden") has a special association with the funerary monuments of men and women, both in Greek and in Roman art, and that in those of women there would be an implied identification of the goddess with the deceased, whose mourning relatives might hope that she, like the goddess, would enjoy victory over death in the form of a happy afterlife. Two Archaic Greek statues of the early sixth century BC, the well-known Berlin Kore and the more recently discovered statue of Phrasikleia, were undoubtedly tomb markers and probably represent the deceased rather than the goddess Persephone, yet the young women appropriate some of her attributes, like the polos headdress decorated with flowers.[18] The Berlin Kore carries another of the goddess's attributes, the pomegranate. Phrasikleia carries a flower, like the ones on her headdress; flowers, with their self-evident meaning of youth, vitality, and potential sexuality, are an important element of the story of Persephone. The spilled and abandoned flowers that she left behind form a powerful image of untimely death in literature and in the visual arts.[19] The inscription found with this statue identifies it as "the marker of Phrasikleia. I shall always be called "Maiden" (Kore), since the gods gave me this name instead of marriage."[20] The wording of the inscription, like the attributes and iconography of the figure, seem to blur the distinction between her identity and that of the queen of the underworld. Since the unmarried Phrasikleia must have died very young, her situation bore special comparison with that of Persephone, and the grief of her bereaved parents to that of Demeter. Six centuries later, when sculptured sarcophagi became popular in the Roman empire, the identification of the deceased with Persephone enjoyed popularity once again (fig. 5.1). Long before the manufacture of these tomb monuments, however, Demeter and Persephone had long been associated in Roman art with mortal women, not only to express hopes for their existence after death but often to honor and heroize them while they were still alive.

During the Roman imperial period, visual association of living or recently deceased women with goddesses became an acceptable, and eventually a common practice, both for private individuals and for women of the imperial family. Identification with Ceres was one of the earliest such forms of apotheosis, and one of the most enduringly popular, perhaps because the goddesses of the earth, with their intimate connection to the

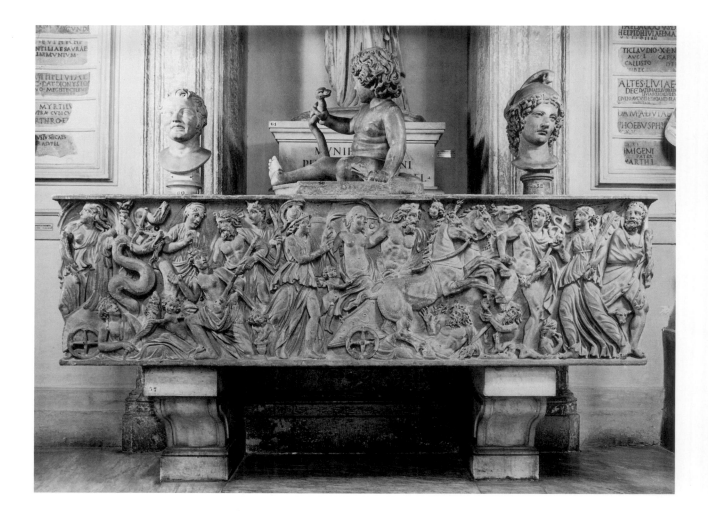

daily lives and survival of humans, seemed especially appropriate for assimilation with mortals.[21] In most cases, the meaning of the association is simple and direct: Ceres is a goddess of fertility and the mythological archetype of the loving mother and protector of the young. The primary social role of aristocratic and imperial Roman women was to perpetuate their families by bearing children. One of the earliest such identifications with Ceres to be clearly attested in coins and inscriptions is that of Livia, the wife of Augustus and mother of Tiberius.[22] Two centuries later, a handsome statue of the empress Julia Domna, the mother of the emperors Caracalla and Geta, presented her with the attributes of the goddess, and this statue had obviously been an object of love and veneration for the people of Ostia, since the circumstances of its find suggest that it was carefully buried to protect it from destruction.[23] The volume of extant material attesting identification of actual women with the chthonian goddesses is far too great for a comprehensive survey here. Let us examine, however, some early examples that demonstrate how such associations became acceptable.

Augustus had become an initiate at Eleusis at a pivotal time in his career, shortly after his victory at Actium in 31 BC but before he secured his final victory over Egypt.[24] His devotion to the cult and its personal meaning to him were probably sincere, but for Augustus, sincerity was never inconsistent with political opportunism, and he undoubtedly recognized the prestige of the cult and the propagandistic value of the beloved goddesses. The earliest known portrait statue of his wife Livia in the Greek-speaking eastern part of the empire stood along with a statue of himself at Eleusis that must have been set up soon after his initiation in 31, even though Livia would certainly not have

been with her husband at that time. It is clear, however, that both members of the imperial couple had a special relationship to the sacred site from the very beginning of Augustus's regime. Livia definitely did accompany Augustus on a later trip to the Greek world in 19 BC, when he attended the mysteries again, requesting a special repetition of the ceremonies for his benefit, even though it was not the usual time of year for their celebration. No literary accounts record whether or not Livia became an initiate on this occasion, but it would have been rather surprising if she had not. A more unexpected and shocking event, however—the suicide of one of the initiates—may have over- shadowed other more routine occurrences at that celebration in 19 BC and caused our sources to omit mention of them.[25] Whether or not Livia was an initiate, the identifica- tion of her with Ceres that pervades her portrait imagery may have its origins in her husband's special devotion to the cult of Eleusis.

The beautiful maternal goddess of the Ara Pacis Augustae is a very eclectic being who will probably never receive an identification that satisfies everyone.[26] She displays, however, many aspects and attributes of Ceres.[27] These allusions were undoubtedly intentional, whether or not "Ceres" is the name by which we should call this goddess. This eclectic being, in turn, bears a subtle but undoubtedly intentional resemblance to a living woman on the same monument: the emperor's wife Livia, in the south pro- cessional frieze, wears a veil, a vegetal crown under the veil, a coiffure with a simple middle part (not the prevailing fashion at the time) and long, cascading locks that hang down behind her ears to her shoulders, an element that did not become common in actual fashions until years later.[28] During the principate of her son Tiberius, while Livia was still alive, coins and inscriptions refer to her as "Ceres Augusta," and at least some cameo gems that represent her with the corn-ear crown may also date to her lifetime.[29] The emperor's daughter-in-law Livilla, the mother of his twin grandsons, probably also appears on a group of cameos with the poppy and corn-ear crown and in two cases with her all-important babies as well.[30] The identification of Livilla's likenesses is prob- lematic, but if these gems do represent her, they must certainly date to her lifetime, since she died in disgrace in AD 32, executed for alleged involvement in the murder of her husband, and would certainly never have been honored after her death.[31]

Cameos are a relatively private and intimate medium in which more explicit deifica- tion may be possible than in public coinage or sculpture. More public apotheoses of living women appear in the following principate, that of Caligula, who made his dynas- tic and monarchical intentions clear from his earliest days in power. The living women of his family, who represented the hope of perpetuation for the Julian family, thus received extravagant public honors. His favorite sister Drusilla, whom he named as the heir to the empire in his will, appears on a coin of Smyrna with the corn ears and pop- pies either of Demeter or of Kore, and her only fully preserved statue follows a Classical Greek type known as the Kore Albani.[32] It is in this guise, with slight variations necessi- tated by representation in relief, that Persephone appears on the fifth-century Greek sculpture known as the "Eleusinian relief," as she and Demeter bestow the gift of agri- culture on Triptolemos and send him on his mission.[33] Drusilla was the first Roman woman to be deified after her death, but both of these representations almost certainly date to her lifetime: the coin from Smyrna bears the names of magistrates of the year 37, and the statue, like at least two other portraits of Drusilla, was recut at some point after its manufacture to add an attribute, the beaded *infula* that crosses her forehead and hangs to her shoulders. The only possible motivation for the recutting was Drusilla's death and deification, at which time her images required some additional mark of sanc- tity. The statue in its original form must then have presented Drusilla not as a *diva* but as the emperor's living heir and associated her with Persephone as a fertility goddess and restorer of life to the earth in spring. When Caligula named Drusilla as his heir, he had recently suffered a life-threatening illness. The political urgency of naming a young,

apparently healthy and fertile successor to renew the Julian family in the event of his death must have been compelling to him and to the viewers of this statue.

Although Claudius presented a more restrained public image of himself and his family, public identification of living women with goddesses had clearly become acceptable by his time, since his last wife Agrippina the Younger appears as Demeter on coins of the Roman mint, the medium through which imperial likenesses received perhaps their widest public distribution. When the profiles of Agrippina appear on the reverses of the aurei and denarii of Claudius from the Roman mint, and on the obverses of coins that represent her son Nero on the reverse, she invariably wears the corn-ear crown.[34] In the Greek-speaking East, where notions of divine kingship had deeper traditional roots, such an identification also appears in monumental public sculpture, on a relief panel of the Sebasteion of Aphrodisias, where Agrippina as Ceres-Demeter clasps the hand of a figure of Claudius in the guise of Zeus.[35]

Cameos, as usual, can express the identification even more extravagantly: one such work in the Cabinet des Médailles represents the imperial couple as Triptolemos and Ceres, bestowing the gifts of prosperity on their grateful subjects.[36] Agrippina here has an oddly small and misshapen head, suggesting that she has been recut from an image of the previous wife Messalina. If so, then the idea of associating the emperor's wife with Ceres predated his marriage to Agrippina the Younger. During the short period at the beginning of Nero's principate when Agrippina still enjoyed considerable power, she continued to appear in the guise of Demeter in both public and private works of art. On a cameo vase, the young emperor and his mother appear in the dragon-drawn chariot of Triptolemos and Demeter, just as Claudius and Agrippina had done on the earlier gem, and the message is the same: that the blessings of prosperity flow to the people from the generous and fertile imperial family.[37] In the Neronian gem, there may be an added implication: the emperor's mother stands in the same relationship to him as the mighty goddess to her younger, mortal protégé.

During the principate of Claudius, deceased women of the imperial family also began to appear in public art with explicitly goddesslike attributes, and for them, too, Ceres and Proserpina were some of the most popular objects of identification. Drusilla had been the first Roman woman deified, but her cult was short-lived, ceasing to serve any useful political purpose after the coup that ended Caligula's principate. Livia would have been the most obvious first choice for deification, and indeed she was worshiped as the goddess Ceres Augusta in some provincial cities after her death, even before her official consecration, but Drusilla's untimely death caused her unexpectedly to "jump the queue."[38] It remained therefore to Claudius to deify his grandmother Livia, a wise political move for him, since his kinship to her was far closer than to Augustus. Sculptures that associate Livia not only with Ceres but with syncretic beings like Ceres-Fortuna undoubtedly helped to promote this politically useful new cult.[39] Claudius also did not neglect his own mother, Antonia the Younger, who never received official consecration but who nonetheless appears on coins wearing the corn-ear crown[40] and in at least one statue of the Kore Albani type.[41] This, too, is a syncretic image with attributes of Aphrodite, a goddess with whom Persephone had deep and ancient associations, especially in Italian cult.[42] Since the statue of Antonia as Persephone-Aphrodite appeared in a group with statues of her two grandchildren Octavia and Britannicus, her association with goddesses of fertility was especially appropriate.[43]

Such allusions to the chthonian goddesses often appear as well in portrait statues of non-imperial women, both living and dead. At least one surviving statue attests the use of the Kore Albani type for portraits besides those of Drusilla and Antonia Minor.[44] The Large and Small Herculaneum Women, which probably represented Demeter and Kore respectively, became very popular prototypes for portrait statues.[45] One of the earliest such adaptations appears in the statue of Nonia Balba, the daughter of a local philan-

thropist who rebuilt the basilica of Herculaneum and was consequently entitled to decorate it with statues of himself and his family.[46] The group probably belongs to the principate of Tiberius, thus predating even the earliest extant imperial statues in the guise of Persephone or Demeter. It is possible that Nonia Balba had already died by the time the group was dedicated and so was singled out for special honor, but her statue appeared in a definitely non-funerary context.

When portrait statues follow these Hellenistic prototypes but do not actually hold the attributes of Demeter and Kore, it is not certain whether the original meanings of the statues were uppermost in the minds of their patrons and sculptors.[47] The dignity and quiet stance of the figures may simply have lent themselves well to images of elite women. The Large Herculaneum Woman was, however, undoubtedly understood by Roman patrons to represent Demeter, since statues of this type, including portrait statues, frequently hold her attributes of the corn ears and poppies.[48] This type was, moreover, extremely popular not only in public statues of aristocratic women but in funerary statues and reliefs, sometimes appearing on grave stelai and sarcophagi along with other portraits that followed the type of the "Small Herculaneum Woman." In these settings, the two types clearly seem to identify actual mothers and daughters with the Eleusinian goddesses.[49]

In funerary art, the story of the rape of Persephone retained all its emotional power and indeed was one of the most popular subjects for mythological sarcophagi. A large number of sarcophagi represent the rape in a pattern so consistent that although the artists and patrons introduce some variations into the formula according to individual needs and wishes, all must be at least loosely based on a common model (figs. 5.1, 5.2).[50] In every case, the central scene is that of Hades in his chariot, carrying his struggling victim away, while Persephone's companions react with gestures of alarm. Hot on his heels, the goddess Athena grips the arm of Hades and attempts to hold him back, sometimes assisted by Artemis. These warlike virgin goddesses had become part of the myth at least by the fifth century BC, when Euripides, in a choral strophion of the *Helen,* mentioned their efforts to aid Demeter's search for her daughter, and the decision of Zeus to thwart them.[51] On a number of sarcophagi, another deity intervenes: Venus, who has set the chain of events in motion by inspiring the lust of Hades, grips Athena's shield and pulls her back, so that the rape scene becomes a three-way tug-of-war between virginity, sex, and death.[52] Behind the central group, Demeter mounts her dragon-drawn chariot and begins her long pursuit, brandishing the torches that will light her way, but ahead of the central group, Hermes Psychopompus is already directing the chariot of Hades into the underworld.

Sculptors and workshops could of course introduce variations into the formula: for example, some show Hades holding Persephone at a diagonal, with her head forward toward the horses, so that her legs kick out behind the group (fig. 5.2), while others

FIGURE 5.2

Sarcophagus with the Rape of Persephone. Florence, Galleria Uffizi inv. 86. [photograph: Deutsches Archäologisches Institut, Rome, Inst. Neg. 72.120]

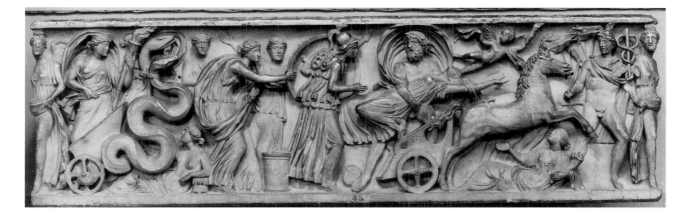

show her standing more upright but leaning backward with her torso and brandishing her arms.[53] Place personifications like Tellus, Oceanus, Caelus, mountain gods, and nymphs may appear to help set the scene, and some sarcophagi also include the scene of Hades pouncing on Persephone as she picks flowers (fig. 5.1), but all follow this basic format with a fair degree of consistency. Given its ideal adaptation to a long, continuous rectangular field, the sequence of figures as we see them on sarcophagi was probably created specifically for this type of monument, but some of the figure groups, in particular the chariots of Hades with Persephone pursued by Athena, and of Demeter with her torches, have older origins.[54] The work that inspired the adaptations in stonecutters' pattern books was most probably a celebrated painting by Nicomachus that had been brought to Rome and displayed in the Capitolium until it was accidentally destroyed by fire, probably in 64 or 69.[55] Until then, the work would have been available to Roman patrons and artists for observation and emulation. After its loss, however, as artists worked from copies of copies and adapted them to a variety of media, spaces, and surfaces, the composition almost inevitably evolved into diverse versions. Venus, for example, as she intervenes to stop Athena's rescue effort, is probably a Roman invention, reflecting a version of the story best known from the *Metamorphoses* of Ovid.

One of the earliest replicas of this composition is not a sarcophagus but a small ivory plaque from Pompeii, apparently a decorative attachment of a small cupboard, possibly an inlay into a door or more probably a vertical handle.[56] Whatever its precise function, it must have been visible from both sides since both are decorated (fig. 5.3). Because of the small scale of the plaque, the scene must be divided into two: the chariot of Hades as he carries away his victim on the convex side, and the pursuing figures of Demeter, Artemis, and Athena on the reverse. This plaque has a companion piece of identical shape that represents more problematic mythological scenes, but scenes that may, if my interpretation is correct, present striking parallels and contrasts to the story of Persephone that would explain why they have been paired (figs. 5.4–5.5). The outer, convex side portrays a woman wearing a diadem and long chiton and holding a scepter, sitting on a birthing chair while a midwife kneels in front of her to deliver her child (fig. 5.4).[57] Given the small scale and somewhat mediocre carving of the ivories, the scene is difficult to interpret, and some have seen it as a doctor tending the wound of a male warrior, but all the figures in the scene do appear to have breasts and to wear long female garments.[58]

Other sculptural works that unambiguously represent birthing scenes display very similar compositions: a simple terracotta plaque from the tomb of a midwife at the Isola Sacra of Ostia, for example, shows the mother sitting more or less upright on a birthing chair, an assistant standing behind her to support her upper body, and a midwife reaching between her legs.[59] Several biographical sarcophagi represent the moment immediately after the birth in a very similar format: the mother on a birthing chair, the attendant behind her, and the midwife in front of her, this time holding the infant in her hands and preparing to bathe him.[60] This version of the birthing scene has the advantage of depicting the individual of greatest interest to the artist and patron (the child, the rest of whose life is depicted in the other scenes on these monuments) and also allows a more dignified presentation of the mother than in the plaques that recorded the profession of midwives. In these sarcophagi, the mother is modestly covered, her skirt drawn down over her legs. The ivory plaque likewise depicts the mythological mother modestly, with all but her lower legs concealed, and probably shows the moment before the birth, as the midwife reaches toward the patient's groin or possibly washes her in preparation for the delivery, since she is holding some round object in her hand that might be a sponge. (This object appears too small to be an infant's head, but that possibility cannot be altogether ruled out.) The ivory plaque shares as well another feature with birthing scenes on some sarcophagi: the presence of a figure at the

FIGURE 5.3
Ivory Plaque with the Rape of Persephone. From Pompeii. Naples, Museo Nazionale Archeologico 109905B. [photograph: Deutsches Archäologisches Institut, Rome, Inst. Neg. 66.1837]

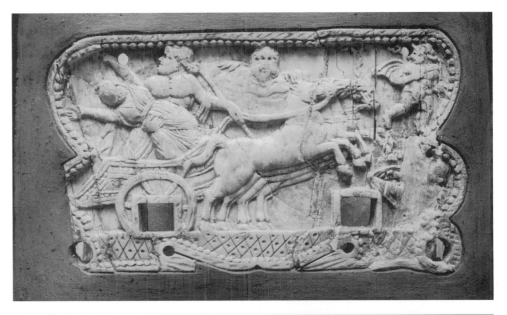

FIGURE 5.4
Ivory Plaque with the Birth of Meleager (?). From Pompeii. Naples, Museo Nazionale Archeologico inv. 109905A. [photograph: Deutsches Archäologisches Institut, Rome, Inst. Neg. 66.1838]

FIGURE 5.5
Reverse of plaque shown in figure 5.4: the dying Meleager carried by his companions. [photograph: Deutsches Archäologisches Institut, Rome, Inst. Neg. 74.1337]

far left who has no evident task to perform in the delivery. On sarcophagi, there are often three such figures, one of whom writes on a globe, as though to record the astrological destiny of the newborn. In different contexts, they can bear the attributes either of the Muses or of the Fates.[61] The figure on the Pompeiian plaque may, then, play a similar role, foretelling the fate of the child.

On the other side, two helmeted men lift the nude body of a dead or dying comrade, as an old man laments in the background, lifting the limp arm of the fallen man (fig. 5.5). This is a very stereotypical scene that could represent the death of any number of heroes and has numerous precedents in Greek vase painting.[62] One of the closest extant parallels in Roman sculpture is the tiny relief of the ransom of Hector's body on the *Tabula Iliaca* in the Museo Capitolino, a small marble plaque that illustrates every book of Homer's *Iliad* in abbreviated form with extensive inscriptions.[63] Virtually the identical group—the limp body with its head toward the viewer's right, the two men facing inward toward him and bending to lift him, and the mourning figure behind him—occurs in the uppermost register at the far right, where an inscription identifies the dead man as Hector. In the fifth register from the bottom, however, a very similar composition appears, this time identified as the death of Patroclus, whom his companions are hoisting into a chariot. Because of the battlefield setting, the mourning old man is absent, but he can appear in the death scenes of Achilles, Hector, Meleager, Paris, or virtually any young hero to represent the hero's father or his pedagogue as the narrative demands. The dead hero in this case must, however, be someone whose fate is intimately connected with the birth scene on the other side, since on the analogy of the Persephone plaque, these must be two episodes of the same story. The artist, moreover, has gone to great pains to give them parallel compositions: both sides have a total of four figures, of whom three direct their attention to a seated or semireclining figure in the middle, and the midwife bends toward her patient in much the same manner as the warrior on the other side bends to lift the feet of his fallen comrade. The oak tree behind the woman on the birthing chair adds a vertical element to the composition at the same position as the old man on the other side.

Of the possible candidates, therefore, Achilles and Meleager seem the likeliest, since both of these men had portentous births. In both cases, the Fates appeared to their mothers and warned them of their son's deaths: Thetis learned before his conception that Achilles would die young in battle, while Althaia heard on the day she gave birth that Meleager would live only as long as a brand that was at that moment burning in the fire. Both mothers attempted to defeat fate: Thetis by dipping the infant Achilles in the Styx, Althaia by seizing the brand from the fire, quenching the flames, and putting it safely away. But in both cases, the effort ultimately failed. Thetis neglected to dip Achilles' heel in the Styx, while Althaia, when she learned years later that Meleager had killed her brothers in battle, threw the brand back into the fire and caused his death.[64] Both of these stories would make appropriate pendants for the Persephone plaque, since all three myths deal with mothers whose children are fated to an early death but who can exercise some control over that fate. Demeter, in this pairing, is the archetypal good mother, whose loyalty to her daughter never flags and who wins in the end at least a partial victory over death. If Thetis is the mother on the second plaque, then she too is an exemplum of maternal love, although her effort to save Achilles is less successful. If she is Althaia, on the other hand, she embodies the opposite qualities from Demeter: she is the treacherous mother who brings about both her son's destruction and her own.

Which mother and son, then, do the plaques depict? In favor of Achilles are the extant examples of the scene of his birth, although none exactly match the birth scene on this plaque, whereas representations of Meleager's birth are otherwise unknown.[65] A fragmentary relief from the first century AD, half of which survives in Grottaferratta, the

other half in the Palazzo Colonna at Rome, shows the death of a hero in a manner almost identical to the Pompeii plaque, although with additional figures that the small scale of the ivory plaque did not allow; Luisa Musso has advanced arguments for the identification of this marble relief as the death of Achilles.[66]

On the other hand, by far the most common use of this visual topos in Roman imperial sculpture is for the death of Meleager, whose life and death were an enormously popular theme for sarcophagi (fig. 5.6).[67] All of them represent the group moving from left to right rather than from right to left, and the men carrying the hero's feet face away from rather than toward the body, since they are already walking toward their destination rather than lifting him. The earliest of these monuments must be at least sixty or seventy years later than this plaque and probably follow a version of the scene created specifically for narrative friezes with their traditions of continuous physical movement from one scene to the next. The left–right reversal of the scene, likewise, is a common adjustment in adaptations for sarcophagi, dictated by the convention that the action of the story should flow from left to right, the direction in which the Latin language was written and the direction of great narrative friezes like the Columns of Trajan and Marcus Aurelius. In a similar manner, most painted and mosaic versions of the rape of Persephone show the chariot of Hades in motion from right to left, but all but five extant sarcophagi reverse the direction of movement.[68]

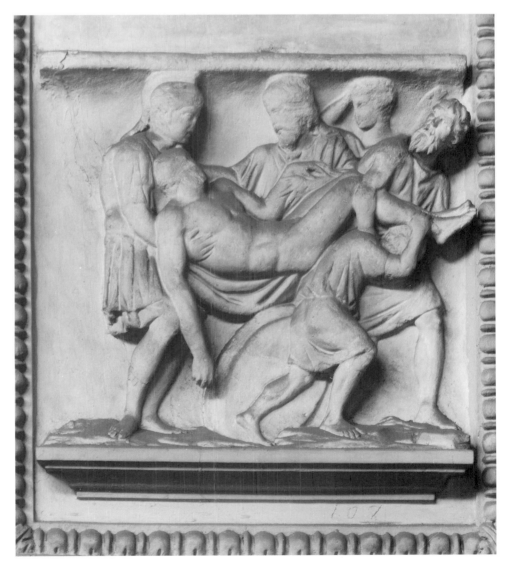

FIGURE 5.6
Sarcophagus Fragment, Showing the Dying Meleager Carried by His Companions. **Rome, Museo Capitolino inv. 619, mid to later second century.** [photograph: Deutsches Archäologisches Institut, Rome, Inst. Neg. 68.3477]

The bulk of the evidence, in my opinion, favors an identification of the Pompeiian plaque as the birth and death of Meleager. The pendant plaques, then, would present didactic examples of the good mother, Demeter, and the evil mother, Althaia. The literal power of life and death that any mother exercises over a helpless infant is both awe-inspiring and terrifying, and these two plaques would represent those two extremes of motherhood. The context of the find suggests that the luxurious object to which these plaques belonged was some item of female use, such as a jewelry box.

Unlike the plaques, most later objects that represent the myth (mosaics, paintings, cinerary urns, altars, and sarcophagi) do have recognizably funerary functions. In many cases, there is no way to know whether the bodies that once lay in these tombs were male or female, but funerary altars of the late first and early second centuries sometimes include the chariot group of Hades carrying off Persephone as a little vignette above or below an inscribed tablet, and in these cases at least, it is clear that the myth was considered equally appropriate for men, women, or married couples.[69] Centuries earlier, Etruscan patrons had represented the myth on the cinerary urns of both men and women, since six of the eight examples that Lindner catalogues have lids that represent reclining male figures.[70] When the deceased was a woman, however, the identification of her with the young goddess could become explicit, through the use of her portrait face on the figure of Persephone, as in a sarcophagus of the mid third century AD in the Museo Capitolino (fig. 5.1). Here, the myth has been changed almost beyond recognition, from a scene of violence and violation to a joyous wedding procession in which Persephone appears to be a fully voluntary participant. Instead of kicking and brandishing her arms, the dignified figure stands up in the chariot, holding her veil like a traditional bride.[71] The designer of this monument suppresses the cruelty of the abduction in favor of a more optimistic vision of death as a beginning of a happy afterlife. Heracles, the veteran of many journeys to the underworld, is prominent among the wedding guests leading the chariot, and the dog Cerberus at his feet reminds us of one of his better-known triumphs over death. It is he, rather than Hermes Psychopompus, who closes off the scene, as the final figure at the far right of the frieze: a physical embodiment of the "happy end." Even in this sanitized version of the myth, however, it is impossible to ignore the grief and rage of the survivors: Demeter still pursues, and Artemis and Athena still attempt to intervene.[72]

Portraits appear as well in a mosaic from a family mausoleum of some years earlier, probably the later second century.[73] Here, Persephone's face is missing, but her shocked companion who kneels on the ground beside the chariot group wears the contemporary hairstyle fashionable at the time of Faustina the Elder. Possibly, both of these figures represent girls of the family who died young. As they appear here, however, the scene seems to express one sister's loss of the other. Alternatively, the figure of Persephone could have been purely ideal, in which case the only "real" figure in the picture, the portrait-companion, would be a mortal witness to the scene, emblematic of the universality and inevitability of death. In either case, since Demeter's chariot does not appear in this composition, the portrait-companion allows for the presence of a surviving mourner who can emphasize the impact of the scene. The four seasons in the medallions at the corners of the decorative border of the floor could remind the viewer of Persephone's eventual return in spring, but this mosaic differs from the Capitoline sarcophagus in refusing to gloss over the violence of the scene. Indeed, this mosaic bears a striking resemblance to the Hellenistic fresco at Vergina that represents the rape of Persephone with particular poignancy. There is good reason to believe that this mosaic, like that fresco, is one of the most faithful extant copies of the famous lost painting by Nicomachus.[74]

The rape of Persephone is not the only context in which the goddess appears on sarcophagi and funerary monuments. She can be presented iconically, as the queen of

the underworld, as for example on a relief from Ostia, now in the Vatican. The small scale and concave shape of this work strongly suggest that it originally stood in a niche of a small family tomb or similar sort of shrine.[75] The divine couple sits facing the viewer on an ornate double throne, Persephone holding the torch of the Eleusinian rites and Hades holding a scepter, but the two are characterized as rather different beings. Hades is almost rigidly frontal, although he inclines his face slightly toward his bride, and he holds his scepter vertically. Persephone, although equally majestic, seems a little more gracefully relaxed and reacts more affectionately to her husband, placing her left arm around his shoulders and holding the torch diagonally in the crook of the right. Both her gestures parallel those of the little nude winged boy beside her, who stands in an even more relaxed, off-balance pose, with a torch in the crook of his right arm, his legs crossed, and one hand resting on the back of the throne behind Persephone's shoulder. A corresponding figure of a girl on the opposite side, falsely restored as Isis, stands by a water jar. Since an Eros with a torch is a standard image for Hymenaeus and the water jar is part of the apparatus of a wedding ceremony, this relief could represent the sacred marriage of Hades and Persephone, although the solemn frontality of the figures argues against a narrative content.

The characterization of Persephone as the more gentle and emotional of the two gods, however, is something that occurs again when the enthroned underworld gods appear in narratives. They can appear in this way amid mythological scenes, as on the Velletri sarcophagus, in which the iconic group takes its place in the middle of the upper register, directly above the scene of the rape of Persephone, and demonstrates the triumphant transformation of Persephone into the mighty goddess of the underworld (fig. 5.7).[76] The enthroned couple can also appear among biographical or quasi-biographical scenes concerning the deceased.[77] On a Trajanic sarcophagus lid in the Museo Capitolino, which appears today set on a box to which it does not belong, Hades and Persephone sit facing frontally in the central panel, as on the Velletri sarcophagus, but to the viewer's right we meet two figures in contemporary dress and hairstyle, seated side by side on their marriage bed, apparently saying their farewells (fig. 5.8). On the other side panel we meet the same couple on their knees, entreating the three Fates, presumably without success. The wife appears once more in single, upright figure to the viewer's left of the central group, while Hermes Psychopompus appears on the corresponding panel on the other side, apparently to lead her from the bedroom scene to the underworld. The woman does not directly interact with the underworld gods themselves or entreat them for mercy, but they appear to interact both with her and with the viewer, extending their right hands with the palms exposed. This is a universally understood human gesture of friendly welcome and, from a more powerful being, of clemency. Hades and Persephone thus become characters in someone else's story: the rulers of the underworld who will judge the souls of the dead and display mercy to those who deserve it.[78]

They also play this role in several mythological sarcophagi. The sarcophagus of Gaius Junius Euhodos and Metilia Acte (fig. 5.9) states unambiguously that the underworld gods will show clemency toward deserving mortals like the mythological heroine Alcestis, a mortal who shares with Persephone the important trait of a return from death.[79] Unlike Persephone, she voluntarily chose to offer her life in place of her husband's and was rewarded for her valor by rescue from the underworld. In Euripides' tragedy, Heracles liberates her by wrestling Death into submission, but the designers of some Roman sarcophagi clearly have another idea. In these versions, the underworld gods voluntarily agree to release Alcestis, as they will presumably also grant an afterlife to Euhodos and Metilia, whose portrait faces appear on the figures of the mythological couple.[80] Here, the underworld gods actively participate in the scene of the heroine's return. At the viewer's right, Persephone stands, leaning over the throne of Hades, placing an arm

around his shoulder and obviously entreating, while Hades gestures acquiescently. The goddess who returns from the dead every spring, it appears, has both the will to take mercy on mortals and the power to intercede for them with her more severe husband; the torch that she holds in her right hand in this sarcophagus recalls both wedding torches and the ceremonial torches of the Eleusinian mysteries and remind us of her role as a goddess of rebirth. Behind the group of Alcestis and Heracles returning from the underworld, the three Fates, recognizable by the open scroll that one of them holds in her hand, look on with apparent approval, turning their heads toward Admetus-Euhodos as he clasps hands with Heracles. The Fates often appear in Roman funerary

FIGURE 5.7
Velletri Sarcophagus. Mid to later second century. From Velletri. Velletri, Museo Capitolare. [photograph: Deutsches Archäologisches Institut, Rome, Inst. Neg. 59.53]

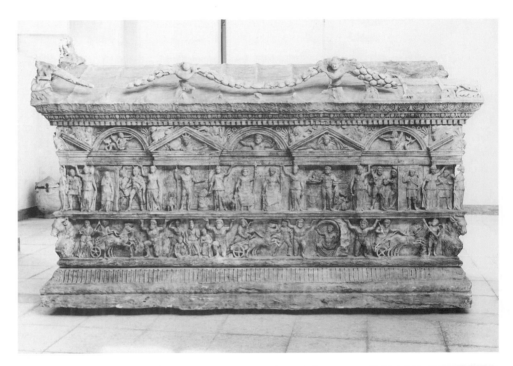

FIGURE 5.8
Sarcophagus. The lid depicts the underworld gods, center, the deceased couple, to the right, and the couple entreating the Fates, to the left. Early second century, probably Trajanic. Rome, Museo Capitolino inv. 723. [photograph: Deutsches Archäologisches Institut, Rome, Inst. Neg. 62.796]

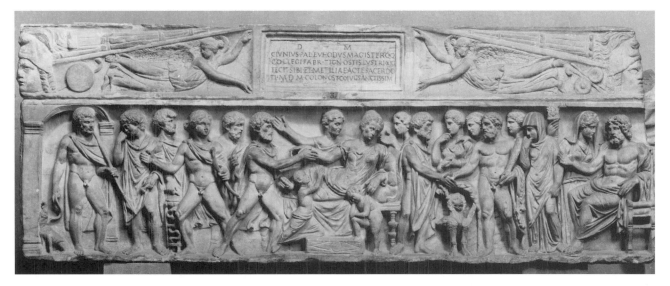

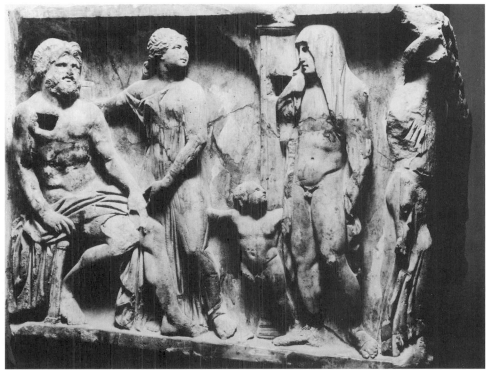

FIGURE 5.9

Sarcophagus of Caius Junius Euhodos and Metilia Acte. Ca. 160–170, from Ostia. Vatican, Museo Chiaramonti inv. 1195. [photograph: Deutsches Archäologisches Institut, Rome, Inst. Neg. 72.590]

FIGURE 5.10

Sarcophagus Depicting the Myth of Protesilaos and Laodamia. Short end: Protesilaos before the underworld gods. Naples, Church of S. Chiara. [photograph: Deutsches Archäologisches Institut, Rome, Inst. Neg. 62.876]

art as the "accusatores," or prosecuting attorneys, in the judgment of the souls of the dead, on the lid of the sarcophagus in the Museo Capitolino, for example (fig. 5.8), and in frescoes of the hypogeum of Vibia and Vicentius, to be discussed below.[81] In the case of Alcestis-Metilia, it is evident that the "accusatores" have been thoroughly won over by the forces of clemency.

Persephone plays the part of intercessor for the dead in at least one more mythological sarcophagus, another story of a mortal who won a temporary release from the underworld.[82] The mortal this time is male, the hero Protesilaos who died on the beaches of Troy, the very first victim to fall. His wife Laodamia so impressed the gods with her grief and devotion that they permitted Protesilaos to return from the dead for a one-day reunion with his bride. A handsome sarcophagus in the church of S. Chiara in Naples (fig. 5.10) devotes the main facade to the scene of the return of the hero, but the short sides represent his first arrival in the underworld, and his return to the realm

of death after the reunion with Laodamia. In the arrival scene, Protesilaos approaches a group of Hades and Persephone much like the group on the Euhodos sarcophagus. Hades sits majestically on his throne, while a rather provocatively dressed Persephone stands beside him, an arm around his shoulder, and gestures toward him. This time, she turns her face toward her protégé (or client, to use the term that would have occurred most readily to a Roman viewer) rather than toward Hades, but in this relief, as in the Euhodos and Metilia sarcophagus, one requires no imagination to understand her actions. She is exercising the sacred and traditional right of a wife to influence her husband. To hammer the point home, a little figure of Amor stretches out his arms to draw Protesilaos toward his divine patron.[83]

Persephone can thus inspire hope in two ways: first as an example of a being who overcomes death and second as a goddess who perhaps because of her own dual nature, not only as the awesome and terrifying queen of the underworld but as the bringer of renewed life, can grant such a victory to others. The sarcophagus in the Galleria Uffizi in Florence that depicts the rape of Persephone on its main frieze (fig. 5.2) implies such a message by associating the goddess with at least one and more probably two mortal women who either returned from the underworld or secured a return for a loved one. Graceful figures of the seasons decorate the corners of this box, reminding the viewer of the cycles of life and death that Persephone represents and drawing the viewer's attention around to the short ends, which as usual are a little more summarily carved than the main frieze but still display considerable attention to iconographic detail. On one side is Hermes leading a veiled woman, and on the other, Heracles, leading a similar figure in the opposite direction. The latter can only represent Alcestis returning from the dead. The group on the other end of this sarcophagus is more problematic: most scholars have interpreted it to represent Alcestis on her way to the underworld, before her release, but Andreae believes that this figure could be Laodamia, who committed suicide after her brief reunion with Protesilaos in order to be with him forever. Despite its somber ending, her story thus has certain parallels with that of both Alcestis and Persephone: the notion that death can be overcome and that the love of a married couple can extend beyond death. The iconographic message of the Florence sarcophagus is more oblique than that of the monument of Euhodos and Metilia, but nonetheless it suggests to the viewer through the juxtaposition of scenes that Persephone's death and resurrection is the archetypal victory that allows mortal heroines like Alcestis and Laodamia to hope for clemency from the rulers of the underworld.

Persephone's role as a potentially merciful intercessor for the dead lasted well into the fourth century and after the establishment of Christianity. In the small underground tomb of a woman named Vibia, we see Vibia escorted into a clearly Christian paradise by a Good Angel.[84] On the center of the barrel vault above this lunette, however, Vibia approaches the enthroned figures labeled by inscriptions as Dis Pater (that is, Hades) and Aeracura (another name for Persephone). This time it is Alcestis who seems to act as an advocate for the deceased, whom she escorts. The clear implication is that the gods can take mercy on other virtuous mortals, just as they did for Alcestis. And here too, the deceased can be identified not only with heroines but with the goddess herself. On another panel of the vault, Hades carries away his victim, in the traditional iconography for the rape of Persephone, but the inscription tells us that this is the ABREPTIO VIBIES, the abduction of Vibia. The inscription above her entry into paradise, INDUCTIO VIBIES, obviously a parallel construction, emphasizes the "happy end" of Vibia's passage to the next world. Here, then, the painter invokes the myths both of Alcestis and of Persephone herself to express the hope that the deities of the underworld will display clemency to Vibia and grant her a happy afterlife.

Let us now briefly review some of the salient characteristics of Demeter and Persephone and compare them to the female saint who eventually replaced them in the

hearts of Christians. Demeter is a mother whose child dies an untimely death but then miraculously rises from the dead in spring. Through her exemplary virtue as a loving and loyal mother, Demeter gains the power to defeat death. She is often represented as a beautiful but melancholy figure, veiled and seated in a quietly meditative pose.[85] The similarity of her images to those of the Virgin Mary are obvious. Bieber has documented how Christian artists adapted the type of the "Large Herculaneum Woman" for images of the Madonna.[86] Another statuary type of Demeter, the veiled figure that was popular for portraits of aristocratic and imperial women including Sabina and Julia Domna in the statues found at Ostia, was also transformed into a Madonna in at least one medieval work of sculpture.[87] Persephone is a virgin who dies but then ascends from the world of the dead, in her physical body. Like the Virgin Mary, whose sacred month is May and whose altars and images are traditionally decorated at that time with fresh flowers, Persephone has a special association with spring and renewal and is often represented with garlands of flowers. She, also like the Virgin Mary, has the power to intercede for mercy toward the dead and can be depicted majestically, as an enthroned queen. The Virgin Mary thus appears in significant ways to incorporate the characteristics of both goddesses, through her unique status as virgin and mother.

The human psychological need for something like the myth of Persephone, and for divine figures with the characteristics of the two Eleusinian goddesses, appears not to have ended with the suppression of the cult at Eleusis in Christian times, nor was it by any means unique to Greek and Roman culture. The Mesopotamian goddess Inanna-Ishtar, who likewise is a goddess of fertility, journeys to the underworld, but her vengeful sister Ereshkigal, the goddess of the Land of No Return, entraps her, strips her of her jewelry, clothes, and divine powers, and torments her with all forms of misery.[88] To secure her rescue, Ea, the goddess of wisdom, creates a clever and handsome eunuch (or, in the Sumerian version of the story, a pair of sexless beings) who ingratiates himself with the queen of the underworld and tricks her into agreeing to Inanna's release. This myth does not use the image of sexual aggression for the death of the goddess, but it does share with the story of Persephone the theme of sterility and drought that devastate the earth while the goddess Inanna is dead and the return of the earth to fertility with her return to life. Here too, as in the story of Persephone, the goddess's freedom from the underworld is not complete, and she, like Persephone, also becomes in part a goddess of death. The powers of the underworld demand a sacrifice in exchange for her; she gives them her husband Dumuzi but then barters for an agreement that will let him spend half of every year in the underworld, while his sister spends the other half there in his place. The structural similarities to the myth of Persephone are obvious, and they are not, I think, the result of direct borrowing of the mythology from one culture by another. Rather, they probably owe their similarities to the fears that all human beings share and to the hope that drought, famine, and death can be overcome.

Those fundamental human concerns, and their mythological expressions, remain as strong in our secular modern society as in ancient ones. The realities of life that the myth attempts to express (the inevitability and terror of death, and the inexplicable cruelty of a violent or untimely end) have not changed. The story of Demeter and Persephone deals specifically with one of the harshest types of bereavement: the loss of a beloved child who has not yet fulfilled her potential in life. Phrasikleia's grieving relatives understood the special relevance of the myth to their emotional state when they commissioned the statue and inscription that implied the assimilation of that young, unmarried girl to the goddess, and so did Noelle Oxenhandler, in her 1993 essay "Polly's Face" in *The New Yorker*.

I began this essay with references to imaginary abductions, but I end with a very real one: 12-year-old Polly Klaas, who was playing with friends in her home when an intruder kidnapped her at knifepoint and later raped and murdered her. In the months following her disappearance and before the discovery of her body, the citizens of Peta-

luma, California, made every effort to find her, but virtually the only effort possible was to post pictures of the missing girl in the hope that someone would see and recognize her. Oxenhandler describes how after a certain point, these photographs took on almost the property of cult images. I can offer no more eloquent testimony to the eternal power of the myth of Persephone than to quote her words about Polly Klaas:

And here we touch upon the cosmic horror of this crime: kidnapping has to do with the invasion of the "bright" world in which children chatter and play . . . by another world, the dark world of unspeakable sorrows, the underworld. Part of the horror of Polly's story is how swiftly these two worlds connected, how easily the dark world made its claim—as when, in the ancient myth, a crack opened up in the earth, and golden-haired Persephone, who had been happily playing with her companions, vanished with the dark figure of Hades into the ground. "This child is the light of our lives," Polly's mother was quoted in the newspaper as saying—speaking the language of Demeter, goddess of earth and growing things, who when her daughter vanished cast the shadow of drought upon the whole world. The photographs of Polly show a child as beautiful as Persephone: flowing hair, soft, dark eyes; a radiant, dimpled smile. . . . And as those of us who remain here grow accustomed to her face, which everywhere denotes her absence, we cannot help participating in her transfiguration. Even as we refuse to give up hope for her return, we find ourselves going in and out of the bank, the post office, the bookstore, turning a girl into a goddess.[89]

NOTE

Thanks to the American Academy in Rome, where I completed most of the work on this article, for permitting me to stay as a visiting scholar and to a number of friends and colleagues both at Oakland University and at the American Academy whose suggestions and information facilitated my research: in particular, Bettina Bergmann, Ada Cohen, Robert Cro, Eve D'Ambra, Katrina Dickson, Christine Kondoleon, and Louisa Ngote. Christina Huemer, Antonella Bucci, and the library staff of the American Academy in Rome also offered me invaluable assistance. Magda Cima of the Direzione dei Musei Capitolini generously facilitated my study of a mosaic in the closed section of the Palazzo dei Conservatori; I am especially grateful to her for her kind cooperation on short notice. I owe thanks also to the Deutsches Archäologisches Institut in Rome for the use of their photographic archives.

Abbreviations of frequently cited works:

ANDREAE, *Studien*
B. Andreae, *Studien zur römischen Grabkunst* (Heidelberg 1963)

COHEN
A. Cohen, "Portrayals of Abduction in Greek Art: Rape or Metaphor?," in Kampen, *Sexuality in Ancient Art* 117–35

KOCH, *Meleager*
G. Koch, *Die Mythologische Sarkophage 6: Meleager* (Berlin 1975)

KOCH-SICHTERMANN, *Sarkophage*
G. Koch and H. Sichtermann, *Römische Sarkophage* (Munich 1982)

KOORTBOJIAN
M. Koortbojian, *Myth, Meaning and Memory on Roman Sarcophagi* (Los Angeles and London 1995)

LINDNER
R. Lindner, *Der Raub der Persephone in der antike Kunst* (Beiträge zur Archäologie 16, Würzburg 1984)

MIKOCKI
T. Mikocki, *Sub Specie Deae: Les impératrices et princesses romaines assimilées à des déesses: Étude iconologique* (Rome 1995)

SICHTERMANN-KOCH, *Mythen*
H. Sichtermann and G. Koch, *Griechische Mythen auf Römische Sarkophagen* (Tübingen 1975)

ZUNTZ
G. Zuntz, *Persephone: Three Essays on Religion and Thought in Magna Graecia* (Oxford 1971)

NOTES

1. E.g., N.B. Kampen, "Gender Theory in Roman Art," in Kleiner and Matheson, *I, Claudia* 14–24.

2. W. Burkert, *Creation of the Sacred: Tracks of Biology in Early Religions* (Cambridge, Mass. and London 1996).

3. J. Mack, *Abduction: Human Encounters with Aliens* (New York 1994) 178−79.

4. W. Streiber, *Communion: A True Story* (New York 1987). On the conviction of experiencers that they have a spiritual mission, see Mack (supra n. 3) 181−87, 230. 247−56, and passim. A fairly representative statement is on p. 253: "It seems to me that Eva is a pioneer with a global mission of healing and peace."

5. D. Nathan and M. Snedeker, *Satan's Silence: Ritual Abuse and the Making of a Modern American Witch Hunt* (New York 1995) passim. See esp. pp. 29−50 on the origins of panic, and 147−54 for an instructive comparison to the interrogation of children and use of their testimony in the Salem witch trials.

6. C. Sagan, *The Demon-Haunted World: Science as a Candle in the Dark* (New York 1995) 115−33.

7. J. Bayet ("Hercule Funéraire," *MEFR* 39 [1921−1922] 228−29) gives a useful categorization of the types of myths that appear most commonly on Roman sarcophagi. The largest category is "enlèvements" (abductions). Another large category is "amours divines et immortalité," some of which are essentially rapes, although the god does not carry away his or her victim. Koortbojian 63−113.

8. *Homeric Hymn to Demeter,* Ovid *Met.* 5.341−678, *Fast.* 4.417−620. The detail that Demeter cured Triptolemos of a near-fatal illness before attempting to give him immortality may be a late addition; the hymn does not mention it, but Ovid *Fast.* 4.529−44 narrates it in some detail.

9. See E.H. Spitz, "Mothers and Daughters: Ancient and Modern Myths," *Journal of Aesthetics and Art Criticism* 48 (1990) 411−20.

10. Charlene Spretnak, quoted by M.L. Keller, "The Eleusinian Mysteries of Demeter and Persephone: Fertility, Sexuality and Rebirth," *Journal of Feminist Studies in Religion* 4 (1988) 39−40. It is possible that some of the terracotta plaques from Locri record a version of the myth in which Persephone voluntarily weds Hades, but this interpretation is far from certain: a figure who rides in a dove-drawn chariot is probably Aphrodite rather than Persephone, and the great majority of the Locrian *pinakes* that represent the chariot group of Hades and Persephone follow the standard iconography. Some that represent a beardless young man and a woman who is not struggling may portray a mortal couple at their marriage rather than the mythological scene. In any case, the sexual union with the male ruler of the underworld remains a central element of the Persephone story. See Zuntz 164−68, and Cohen 125−126, figs. 51.a and b and 52.

11. Cohen 118. See also W. Burkert, *Ancient Mystery Cults* (Cambridge, Mass. and London 1987) 12−29, on the function of mystery cults in answering personal needs, in particular alleviating the fears of death or future disaster; see esp. 21−22 on the cult at Eleusis.

12. Suet. *Aug.* 93; Dio Cass. 51.4.1; Augustus was an initiate. For a history of the site in Roman times, see K. Clinton, "The Eleusinian Mysteries: Roman Initiates and Benefactors, Second Century BC to AD 267," *ANRW* II.18.2 (1989) 1499−1539, and G. Mylonas, *Eleusis and the Eleusinian Mysteries* (Princeton 1961) 155−86. See in particular p. 156 on the sack of the sanctuary in AD 170 by the Kostovoks and the subsequent restoration by Marcus Aurelius; 162−66 on the Greater Propylaea, probably completed during the principate of Marcus Aurelius, and 183−186 on projects sponsored by Hadrian.

13. Ovid *Met.* 5.332−678, *Fast.* 4.417−620. In *Fast.* 4.535−36, Ovid mentions that the initiates at Eleusis break their fast at nightfall, as did Demeter on her arrival at the house of Celeus. If Ovid knew what the initiates do, he had presumably been initiated.

14. Cic. *Leg.* 2.14.36; see Keller (supra n. 10) 27.

15. Ovid *Met.* 346−61, 409−24, *Fast.* 4.419−21. On the Laganello head from the sanctuary near the spring of Kyane: G.P. Carratelli ed., *The Western Greeks,* exhibition catalogue, Palazzo Grassi, Venice, March−December 1996 (Venice 1996) 675 no. 72; *LIMC* IV1 862 no. 189 (as Demeter); Zuntz 71; E. Langlotz and M. Hirmer, *Ancient Greek Sculpture of South Italy and Sicily* (New York 1965, originally published as *Die Kunst der Westgriechen in Sizilien und Unteritalien* [Munich 1963]) 48, 251, with earlier literature, pl. 3.

16. Zuntz 70−89 on the importance of cult in Magna Graecia, 89−173 on Sicilian terracotta votives. Terracotta statuette from Medma: Zuntz frontispiece, xi. Terracotta reliefs from Locri: Zuntz 164−168; Langlotz and Hirmer (supra n. 15) 271, pls. 71−75; Carratelli (supra n. 15) 701−702 nos. 166.I−166.VI.

17. Lindner 49−54 nos. 34−41; L. Sperti, *Rilievi greci e romani del Museo Archeologico di Venezia* (Rome 1988) 130 under no. 40.

18. See B.S. Ridgway, *The Archaic Style in Greek Sculpture* (Princeton 1977) 109, n. 32, on the implied identification of the deceased with the goddess and the significance of the *polos* as a mark of divinity. Persephone wears a *stephane*

decorated with flowers in several of the terracotta plaques from Locri, including the one that represents her enthroned as queen of the underworld beside Hades and another in which she looks on as a girl picks pomegranates. See supra n. 16, for references.

19. See Ovid *Met.* 5.398–401.

20. J. Boardman, *Greek Sculpture, The Archaic Period* (New York and Toronto 1978) 73; Ridgway (supra n. 18) 109, n. 32. See also Cohen 134–35 for the special significance of a reference to Kore in the monument of a young girl who died unmarried.

21. See Mikocki, passim, esp. 90–94.

22. Identifications as Ceres Augusta: *CIL* X, 7501; *CIL* XI, 3196 (the latter is definitely datable to AD 18, during Livia's lifetime); W.H. Gross, *Julia Augusta: Untersuchungen zur Grundlegung einer Livia-Ikonographie* (Göttingen 1962) 43–47, 106–31; B.S. Spaeth, "The Goddess Ceres in the Ara Pacis Augustae and the Carthage Relief," *AJA* 98 (1994) 88, n. 206; Mikocki 18–21, 151–54 nos. 1–26 for epigraphic and numismatic evidence.

23. Statue of Julia Domna as Ceres, Ostia: Kleiner, *Roman Sculpture* 326, 327, fig. 291, 354, with literature; Bieber, *Copies* 166, figs. 740–41; R. Calza, *Scavi di Ostia 9: I ritratti romani dal 160 circa alla metà del III secolo D.C.* (Rome 1977) 50–51 no. 63, pls. 49–50. Epigraphic evidence for identification of the deified Julia Domna as NEA ΔHMHTHP: *CIG* II, 2815 and 3642. On the "priestess of Ceres" type that this statue follows, and its many replicas in both imperial and private portraits, see Bieber, *Copies* 163–67, figs. 728–33, 738–40. This statue follows Julia Domna's latest portrait type and may postdate her death and deification. Mikocki (141) notes that during the Julio-Claudian dynasty, identification of living women with Ceres was popular but that during the second and third centuries, it became more common for women, both imperial and private, who had died.

24. Dio Cass. 51.4.1.

25. Rose, *Dynastic Commemoration* 140–41 no. 71; Clinton (supra n. 12) 1507–1509; Dio Cass. 54.9.10 on the celebration of the rites in 19 BC and the public suicide of an Indian man named Zarmaros, who had just been initiated.

26. See K. Galinsky, "Venus, Polysemy, and the Ara Pacis Augustae," *AJA* 96 (1992) 457–75. See in particular pp. 471–72 on the syncretic associations of Venus with Ceres and of Ceres with Tellus.

27. Spaeth (supra n. 22) 65–100.

28. Spaeth (supra n. 22) 88–89, fig. 14.

I arrived independently at the same conclusion. See also R. Winkes, *Livia, Octavia, Iulia* (*Archaeologica Transatlantica* 13, Louvain 1995) 49 and 156 no. 79.

29. Identifications as Ceres Augusta: see supra n. 22.

Cameos possibly datable to Livia's lifetime:

A. Florence, Museo Archeologico no. 26, inv. 14549, *LIMC* IV 905 no. 172, with earlier literature, s.v. Demeter/Ceres (S. De Angeli); W.-R. Megow, *Kameen von Augustus bis Alexander Severus* (Berlin 1987) 255 no. B17, pl. 13.9; Mikocki 157 no. 41, pl. 2.

B. Florence, Museo Archeologico no. 177, inv. 1453, onyx cameo, H. 0.048. Jugate portrait of Tiberius, laureate, and Livia, wearing a crown of poppies and corn ears behind a crescent diadem. The presence of Tiberius and Livia together on the gem suggests that both were still alive when it was made. Mikocki 157 no. 40, pl. 2, with earlier literature; Megow (supra) 179–80 no. A49, pl. 10.10.

The dating and interpretation of the Gemma Tiberiana remain highly controversial. It is certain that Livia appears here with the attributes of Ceres, but it is less certain whether the gem belongs to her lifetime or later. See Mikocki 157–58 no. 45, pl. 7. with earlier literature.

30. Mikocki 34–35, 174–75 nos. 161–64, pl. 4, figs. 161–63; Megow (supra n. 29) 29–31, 295–97 nos. D22–D26.

31. Tac. *Ann.* 4.3–8, 11; Suet. *Tib.* 62.1; Dio Cass. 58.11.6–7.

32. Coin from Smyrna: D. Klose, *Die Münzprägung von Smyrna in der römischen Kaiserzeit* (*AMUGS* 10, Berlin 1987) 15, 217–19 nos. 1–36; W. Trillmich, *Familienpropaganda der Kaiser Caligula und Claudius* (*AMUGS* 8, Berlin 1978) 123. Statue in Museo Gregoriano Profano: for a full discussion of the identification of this statue, with earlier literature, see S. Wood, "Diva Drusilla Panthea and the Sisters of Caligula," *AJA* 99 (1995) 471–82, figs. 15–17. On the coins and the statue, Mikocki 42–43, 184 nos. 223, 224, pl. 27. Mikocki discusses the various identifications of the statue but favors the identification as Drusilla.

33. Eleusinian relief: Athens National Museum. *LIMC* IV 875 no. 375, with earlier literature, s.v. Demeter (L. Beschi).

34. *RIC* I² 125 no. 75, 126 nos. 80–81, pl. 16; A. Banti and L. Simonetti, *Corpus Nummorum Romanorum* XVI (Florence 1978) 65–75 nos. 1–17 (aurei) and 86–94, nos. 33–46 (denarii). Agrippina also appears with the corn-ear crown in a jugate portrait with Claudius on

tetradrachmas from Ephesus, pp. 77–81 nos. 18–23. See also Trillmich (supra n. 32) 55–59, pl. 11, figs. 11 and 15, and Mikocki 39, 179–80 nos. 192–201, pl. 5, nos. 192, 195.

35. Mikocki 39, 180 no. 202; R.R.R. Smith, "The Imperial Reliefs from the Sebasteion at Aphrodisias," *JRS* 77 (1987) 106–10 no. 3, pls. 8–9.

36. Paris, Bibliothèque Nationale, Cabinet des Médailles 276: Megow (supra n. 29) 207 no. A86, pl. 27.3; Mikocki 39, 180 no. 203, pl. 9.

37. Lindner 111, pl. 24.2; *LIMC* IV¹ 902 no. 138, s.v. Demeter/Ceres (S. De Angeli); Mikocki 180–81 no. 205.

38. An example of "unofficial" worship of Livia includes a small but prominently located shrine dedicated to Ceres Augusta in the theater of Leptis Magna. The colossal cult image, although highly idealized, appears to be a portrait of Livia wearing the turret-crown and corn-ear and poppy garland: a syncretic combination of the attributes of Ceres, Cybele, and Tyche. See G. Caputo and G. Traversari, *Le sculture del teatro di Leptis Magna* (Rome 1976) 76–79 no. 58, with full earlier references, pls. 54–55; D. Kreikenbom, *Griechische und Römische Kolossalporträts bis zum späten ersten Jahrhundert n. Chr.*, JdI–EH 27 (1992) 180–81 no. III39, pl. 11.c; J.A. Hanson, *Roman Theater Temples* (Princeton 1959) 59–60, figs. 21–22, on the shrine.

39. Statue of Livia as Ceres-Fortuna:

A. Ny Carlsberg Glyptotek inv. 1643. Winkes (supra n. 28) 119–20 no. 43; Poulsen I 73–74 no. 38, pls. 60–63; Gross (supra n. 22) 118–19; Mikocki 22, 159 no. 53, pl. 11.

B. Louvre, MA 1242. Winkes (supra n. 28) 148–50 no. 74; Mikocki 22, 159 no. 51, pl. 11, with earlier literature.

Capitoline bust of Livia-Ceres: Fittschen-Zanker III 3–5 no. 3, pl. 2.3; W. Eck, K. Fittschen, and F. Naumann, *Kaisersaal: Porträts aus den Kapitolinischen Museen in Rom* (Köln, Römische-Germanisches Museum, 23 April–22 June, 1986) 56–57, photo p. 29. For a discussion of Livia's "Ceres Type" and catalogue of extant replicas: Fittschen-Zanker III 4, 5, n. 10, under no. 3.

40. *RIC* I² 124–25 nos. 65–68, pl. 15; *BMCRE* I 180 nos. 109–14; Trillmich (supra n. 32) 69–77 nos. 1–32, pl. 6.

41. B. Andreae, "Le Sculture," in G. Tocco Sciarelli ed., *Baia: Il ninfeo imperiale sommerso di Punta Epitaffio* (Naples 1983) 54–56 no. 6, pls. 122–23, 126–30; B. Andreae, *Odysseus* (Frankfurt 1982) 202–207.

42. Zuntz 164–68.

43. Andreae (supra n. 41, 1983) 56–60 nos. 8–9, figs. 156–57, 163; Andreae (supra n. 41, 1982) 207–208.

44. Munich Glyptothek 208. B. Vierneisel-Schlörb, *Klassische Skulpturen des 5. und 4. Jahrhunderts v. Chr.* (Munich 1979) 163–73 no. 15, figs. 74–79.

45. M. Bieber, "The Copies of the Herculaneum Women," *ProcPhilSoc* 106 (1962) 111–34; *LIMC* IV 853 no. 62, s.v. Demeter (L. Beschi). Doubts have been raised about whether the Hellenistic originals did in fact represent Demeter and Persephone; they were recently discussed by Catherine de Grazia Vanderpool in "Clothes and the Woman," presented at the annual meeting of the Archaeological Institute of America/American Philological Association (AIA/APA), 28 December 1997, abstract *AJA* 102 (1998) 362.

46. On the Balbus group: J.J. Deiss, *Herculaneum: Italy's Buried Treasure;²* (New York 1985) 158–66; E.R. Barker, *Buried Herculaneum* (London 1908) 155–57, figs. 12, 14. On the female statues and the dating of their hairstyles: K. Polaschek, "Studien zu einem Frauenkopf im Landesmuseum Trier und zur weibliche Haartracht der iulisch-claudischen Zeit," *TrZ* 35 (1972) 162–64; Bieber, *Copies* 150, pl. 116, figs. 683–87.

47. J. Trimble, "Greek Style, Roman Statues: The Small Herculaneum Women," presented at the annual meeting of the AIA/APA, 30 December 1995, abstract *AJA* 100 (1996) 389–90; Mikocki 92.

48. Bieber, *Copies* 153; Bieber (supra n. 45) 124; *LIMC* IV¹ 853 no. 62, s.v. Demeter (L. Beschi).

49. Bieber, *Copies* 153 (on a funerary statue from the Isola Sacra of Ostia) and 154–56 on stelai and sarcophagi; Bieber (supra n. 45) 128–33. An example of a stele that shows portraits of an older and younger woman in the Large and Small Herculaneum Woman types is an Antonine stele in Athens, now built into the wall of the Small Metropolis: Bieber, *Copies*. fig. 718. A similar pairing appears in a sarcophagus now in the Palazzo Colonna: Bieber, *Copies* 155 figs. 721–23.

50. *LIMC* IV 901 nos. 126–34, s.v. Demeter/Ceres (S. De Angeli); Koch-Sichtermann, *Sarkophage* 175–79 no. 38; B. Andreae, *Studien zur römischen Grabkunst* (Heidelberg 1963) 47–48, for a catalogue of representations of the rape of Persephone in Roman funerary art.

51. Euripides *Helen* 1313–18.

52. Lindner 113–14. The presence of Venus is constant in the sarcophagi that she classifies as

Group C, pp. 76–80 nos. 93–104 and pp. 113–14. Venus also appears on some sarcophagi of Lindner's Group D, pp. 81–82 nos. 106, 109, 110. On the role of Venus as instigator of the rape of Persephone: Ovid *Met.* 5.363–84.

53. For a complete discussion of the typology and categories of these sarcophagi, see Lindner 64–86, 108–14. Figure 2: Galleria Uffizi, Florence, inv. 86. *LIMC* IV[1] 901 no. 128, s.v. Demeter/Ceres (S. De Angeli); Sichtermann-Koch, *Mythen* 57 no. 60 with earlier references, pl. 147, figs. 2, 3, pl. 148, fig. 2, pls. 149, 150, 151, fig. 1; Lindner 77, no. 94. An example of the sarcophagi in which Persephone reaches backward with her arms is Walters Art Gallery, Baltimore, inv. 23.219. *LIMC* IV[1] 901 no. 132; Koch-Sichtermann, *Sarkophage* 177, 263, fig. 204; G. Koch, "The Walters Persephone Sarcophagus," *JWalt* 37 (1978) 74–83; Lindner 64–65 no. 68.

54. Koch (supra n. 53) 79.

55. Pliny *HN* 35.108; Lindner 11. On the relationships of this famous lost painting to extant works, including the Hellenistic frescoes in Tomb B at Vergina and later Roman versions in sculpture, mosaic, and painting, see Lindner 30–34 no. 21, and 108; J. Oakley, "Reflections of Nicomachos," *BABesch* 61 (1986) 71–75; Sperti (supra n. 17) 130 under no. 40.

56. Naples, Museo Nazionale Archeologico inv. 109905 B. *LIMC* IV 901 no. 135, s.v. Demeter-Ceres (S. De Angeli); Lindner 88–89 no. 155, 105, pl. 18.1; V. Spinazzola, *Le Arti decorative in Pompeii e nel Museo Nazionale di Napoli* (Milan, Rome, Venice, Florence 1928) 224, pl. 33; P. Williams Lehmann, *Roman Wall Paintings from Boscoreale in the Metropolitan Museum of Art* (Cambridge, Mass. 1953) 58, fig. 39; A. Sogliano, "Rilievi di Avorio," *Giornale degli Scavi di Pompeii* n.s. 3 (1874) 12–16; Hans Graeven, *Antike Schnitzereien aus Elfenbein und Knochen in photographischer Nachbildung* (Hannover 1903) 39–46 nos. 25–28.

This plaque and its companion piece were discovered in Insula 2, Regio I of Pompeii on 27 June 1873, with other ornaments that evidently belonged to an object described in the excavation report as "un piccolo armadio." Sogliano suggests that the plaques decorated the fronts of drawers and that the inner sides are more badly damaged due to the contact with the objects inside the drawers. Graeven suggested the interpretation as vertical handles, attached by the holes in their lower borders, although they could have been reused at some later date.

57. Naples, Museo Nazionale Archeologico inv. 109905A. Koortbojian 53–56, fig. 17. Luisa

Musso, "Il Trasporto funebre di Achille sul rilievo Colonna-Grottaferrata," *BullComm* 93 (1989–1990) 14–16, fig. 11, with full earlier literature; Koch, *Meleager* 118, n. 5; *LIMC* I[1] 227 no. 43 and I[2], pl. 168, s.v. Adonis (B. Servais-Soyez); Spinazzola (supra n. 56) 224 and pl. 33; Lehmann (supra n. 56) 57–58, fig. 38. On the significance of the midwife scene: N.B. Kampen, "Social Status and Gender in Roman Art: The Case of the Saleswoman," in D'Ambra, *Roman Art in Context* 124, originally published in M.D. Garrard and N. Broude eds., *Feminism and Art History* (New York 1982) 60–77. Reference to Pompeiian plaque is on p. 70.

58. Spinazzola ([supra n. 56] 224) describes this as the wounding and death of Adonis, an interpretation followed by Lehmann (supra n. 56) 57–58, Servais-Soyez in *LIMC* I[1] 227 no. 43, and partially by Koortbojian 53–56. Graeven (supra n. 56) proposes that it represents the scene of Homer's *Iliad* E 336, in which Aphrodite, while attempting to intervene in battle, is wounded by the spear of Diomedes.

59. Kampen, *Image and Status* 69–72, fig. 58, and Kampen (supra n. 57, 1993) 124, 126, fig. 49.

60. Kampen, *Image and Status* 33–44. Some especially good and clear examples include the sarcophagus of a child in Paris, Musée du Louvre MA 319: Kampen, *Image and Status* 34, 37, 76, 147 no. 23 (with earlier literature), fig. 8.

61. Kampen, *Image and Status* 37, 38–39, text fig. 1.

62. Koch, *Meleager* 34. See also *LIMC* VII[1] 697–698 nos. 3–15 and *LIMC* VII[2] nos. 3–15, pls. 520–523, s.v. Sarpedon (D. von Bothmer).

63. *Tabula Iliaca:* miniature relief in very fine grained white marble, 0.25 m. H., 0.28 W., left part of composition lost. Museo Capitolino inv. 316. Musso (supra n. 57) 14, fig. 7, with full earlier references; *LIMC* I[1] 105 no. 433; 129–30 nos. 543, 547; 135 no. 572; 179–80 no. 845a, s.v. Achilleus (A. Kossatz-Deissmann) and *LIMC* IV[1] 493 no. 93; 494 no. 105, s.v. Hektor (O. Touchefeu); Helbig[4] II 1266; Stuart-Jones 165–72 no. 83.

64. On the accounts of the birth of Achilles and prophesies of his fate, see *RE* I 225, s.v. Achilleus (J. Escher-Bürkli). Catullus 64.323–81: the Fates predict the entire life of Achilles at the wedding of Peleus and Thetis, implying his early death in battle in lines 362–64. The earliest version of the story that Thetis bathed him in the Styx to make him invulnerable is Statius *Ach.* 1.133–39, 269–70. At least one representation of the birth of Achilles in the visual arts shows the Fates present: a mosaic of the fourth–fifth cen-

tury AD at Nea Paphos, Cyprus. *LIMC* I[1] 42–43 no. 3; I[2] pl. 56, no. 3, s.v. Achilleus (A. Kossatz-Deissman).

On the birth and death of Meleager: Ovid *Met.* 8.451–547. The birth of Meleager: 451–59. Althaia's vengeance: 460–514. Death of Meleager: 515–25. Lament, funeral, suicide of Althaia: 526–47.

65. *LIMC* I 42 nos. 1–4 for birth of Achilles; 43–45 nos. 5–18 for his bath in the Styx, s.v. Achilleus (A. Kossatz-Deissman).

66. Musso (supra n. 57) 9–19, figs. 1–5; Koch, *Meleager* 118.

67. Koch, *Meleager* 106–18 nos. 73–111 catalogues 37 examples of the scene of Meleager carried home by his companions; the Museo Capitolino sarcophagus inv. 619 is 113 no. 88, pl. 81.c.

68. Lindner 74–76 nos. 88–92, pl. 23, catalogues the five examples of Persephone sarcophagi in which the action moves from right to left.

69. Lindner 60–63 nos. 56–66. Of the altars with inscriptions, two (nos. 57 and 58) are of women, four (nos. 59, 60, 62, and 63) of men, and two (nos. 61 and 65) of couples. The altar of Marcus Antonius Asclepiades and Julia Philumen, Lindner's no. 61, has been published with a good illustration by G. Daltrop, "Bildnisbüsten von Ehepaaren an römischen Grabaltaren," *Eikones: Festschrift Hans Jucker* (Bern 1980) 87, pl. 27.2. I am indebted to Eve D'Ambra for calling this altar and the publication to my attention.

70. Lindner 49–52 nos. 34–41 for a catalogue of Etruscan sarcophagi with the rape of Persephone. Nos. 34 and 38 have lids with reclining female figures; the remainder are male.

71. P. Blome, "Zur Umgestaltung Griechischer Mythen in der Römischen Sepulkralkunst. Alkestis-, Protesilaos- und Proserpinasarkophage," *RM* 85 (1978) 449–57, esp. 451 on the significance of Heracles.

72. See Cohen 123–24 for an analysis of a similarly romanticized version of the rape of the Leucippidae on a red-figured hydria by the Meidias Painter. Here too, one of the "victims" behaves like a fully willing participant in an elopement, but there are still tensions and contradictions in the iconography that indicate that the Meidias Painter was conscious of the more familiar and brutal version of the story that he was trying to soften.

73. Helbig[4] II no. 1674; H.P. L'Orange and P.J. Nordhagen, *Mosaik von der Antike bis zum Mittelalter* (Munich 1960) 47, pl. 24.B; Lindner 58 no. 50, pl. 14.1.

74. Lindner 32–33, 58 no. 50, 108; Oakley (supra n. 55) 73, fig. 4. On the Vergina fresco, see also Cohen passim, esp. 122–23.

75. Vatican, Vestibolo Rotondo inv. 1137, marble, heavily restored, 0.95 m. H., 1.06 W. Helbig[4] I, 195–96 no. 253.

76. Velletri sarcophagus: Kleiner, *Roman Sculpture* 259, 265, with earlier literature, figs. 229–30. On the group of the enthroned underworld gods: Andreae, *Studien* 26–32; on the scene of the rape of Persephone, pp. 45–47.

77. Sarcophagus lid: Museo Capitolino inv. 723. Helbig[4] II 213–14 no. 1406 (B. Andreae); Andreae, *Studien* 27 no. 16, 31–32.

78. Andreae, *Studien* 30–32.

79. Andreae, *Studien* 44. Vatican, Museo Chiaramonti inv. 1195.

80. *LIMC* I[1] 535 no. 8, 536 no. 16, with full earlier literature, and *LIMC* I[2] pls. 401.8, 401.16, s.v. Alkestis (M. Schmidt) ; Blome (supra n. 71) 441–45; S. Wood, "Alcestis on Roman Sarcophagi," *AJA* 82 (1978) 499–510, and "Alcestis on Roman Sarcophagi: Postscript," in D'Ambra, *Roman Art in Context* 96–99; Sichtermann-Koch, *Mythen* 20 no. 8, pls. 16, 17.2, 18, 19; Calza, *Ostia* 9 (supra n. 23) 27–29 no. 31.

81. Andreae, *Studien* 31–32.

82. Sichtermann-Koch, *Mythen* 65–66 no. 70, pls. 168.1, 171; Blome (supra n. 71) 445–49.

83. Andreae, *Studien* 37.

84. Andreae, *Studien* 49–50; M. Borda, *La Pittura Romana* (Milan 1958) 347, photo p. 348; J. Wilpert, *Die Malereien der Katakomben Roms* (Freiburg im Breisgau 1903) 144, 392, pl. 132. See in particular p. 392 for discussion of the inscriptions.

85. Representations of Demeter seated, veiled, with a melancholy expression: *LIMC* IV[1] 858 no. 122 (the fresco in the tomb at Vergina); 859 nos. 138, 140, 143 and p. 862 nos. 190–91 for examples in sculpture. S.v Demeter (L. Beschi).

86. Bieber, *Copies* 155, figs. 648–49.

87. Bieber, *Copies* 167.

88. "Descent of Ishtar to the Nether World," *The Ancient Near East,* James B. Pritchard, ed. (Princeton 1958) 80–85; D. Wolkstein and S.N. Kramer, *Inanna: Queen of Heaven and Earth: Her Stories and Hymns from Sumer* (New York 1983), translation of text 52–89, commentary 155–69. For an analysis of the narrative patterns of the myth, see Burkert (supra n. 2) 61–62.

89. N. Oxenhandler, "Polly's Face," *The New Yorker* (29 November 1993) 95–96.

NUDITY AND ADORNMENT IN FEMALE PORTRAIT SCULPTURE OF THE SECOND CENTURY AD

EVE D'AMBRA

My subject is a peculiar type of portrait of private Roman citizens, the mythological portrait, which represents subjects in the form of gods or heroes. In the late first and second centuries, women were honored by the mythological portrait in greater numbers than before. Of all the goddesses whose identities could have been assumed for the divine dress-up of the portraits, Venus provides the most provocative and startling examples because of the complete or partial nudity. The female nude was a contradictory and complex category for Roman citizens who expected chastity and rigid standards of conduct from the stern women who were praised as their wives or daughters. Yet, of course, there were different standards of modesty for matrons than there were for statues.

The portrait statues of women as Venus raise important questions of interpretation of the female nude and the role of female portraiture in Roman society. In these examples from the late first and early second centuries, the statues consist of portrait heads with individualized features and bodies borrowing statuary types of Venus,[1] particularly the Capitoline Venus.[2] The bodies conform to the conventional poses of the Capitoline and other Venus types, and they bear the traditonal attributes of dolphens, water pitchers, and pieces of fringed cloth. What strikes us as especially incongruous or awkward is the juxtaposition of the aging, grim faces of matrons with the nubile, sexy figures of the nude goddess. Would urbane and cosmopolitan Romans have been troubled by this dichotomy of body and head or disturbed by the full frontal nudity?

The few ancient sources on these works testify to their use as commemorative statues set up in tombs to honor deceased women. In the late first century, the poet Statius consoles Abascantus, an imperial freedman and secretary of Domitian, on the death of his wife, Priscilla, by praising the appointments of the tomb and its sculptures that portray Priscilla as Venus and Maia, Diana, and Ceres in marble and bronze (*Silvae* 5.231–33). The archaeological evidence from the tomb of Claudia Semne, the wife of an imperial freedman of Trajan, that indicates her depictions *in formam deorum* has been assembled by Henning Wrede.[3] The elaborate tomb, dating to 130, had small shrines with pediments sculptured in reliefs that depict Claudia Semne as Venus; in the niches below stood small statues of the deceased in the form of Venus, as well as in the form of Spes and Fortuna in other aediculae.

Given the funerary context of the sculpture, it would be difficult to attribute motives other than those of the highest seriousness to those who commissioned these sculptures for their wives. In his opening remarks to the grieving Abascantus, Statius may overcompensate with his observation, "For to love a wife is a joy, while she is alive, and a religion, when she is departed" (*Silvae* 5.4–5), yet neither the deceased Priscilla nor Claudia Semne was believed to have become immortal; rather, their portrait galleries suggest that they were honored as exemplary matrons, worthy of comparison to the goddesses.

The ancient sources and archaeological evidence indicate a social context: the two women were wives of imperial freedmen, that is, their husbands had been slaves of the emperor who were manumitted, usually, to assume more prominent posts in the imperial administration.[4] For men with servile backgrounds, they had access to the highest circles of power through their positions in the court and their ties to the emperor. I assume that their taste would have been conservative, that they would have emulated the artistic styles of the court on which their status and wealth depended. The court provided a model with the mythological portrait: imperial women from Livia onward have been depicted as goddesses. Yet the extant statues represent women of the Julio-Claudian dynasty as draped Venuses rather than as resplendent nudes.[5] Furthermore, the stray reference to these statues in the ancient sources is not explicit about their appearance (Dio Cass. 59.11.2−3, 63.26.3). The evidence does not permit us to conclude whether the nudity of the Venus portraits of the late first and second centuries AD was a traditional aspect of the mythological portrait that has not survived or, rather, an innovation of the freedmen and -women who commissioned them.

In another essay I have proposed that the nude body of Venus represented in these portrait statues did not shock because it was recognized as a convention of art, and, more importantly, it stood for the productive sexuality of matrons, the bearing of children that was the reason for marriage (Soranus *Gynecology* 1.34).[6] That Aphrodite-Venus could come to represent a productive and pristine sexuality was determined by the Trojan legend of Aeneas's birth from Venus, who was promoted as the mother of the Julian line not only in epic poetry but also through the temples dedicated to her and the numerous coins that represented her on their reverses.[7] Besides the political propaganda and the acclamation of Augustan poets, Venus also served the state through her cults: the cult of Venus Verticordia, for example, directed women of all classes toward marriage and motherhood with uplifting activities, such as the ritual bathing and dressing of the cult statue along with ablutions and anointment of the worshipers, and the cult of Venus Obsequens demanded atonement from adulterous wives.[8] As imperial propaganda and cult ritual transformed the seductress Aphrodite of the Greeks into the matronly Venus of the Romans, so the erotic power of the statues is domesticated into the sexuality of the marriage bed.

In particular, it is the combination of portrait head with the nude body that confers meaning on these statues. The portrait heads, although depictions of individuals, tend to conform to a type of woman in her middle years whose grave and modest expressions convey the self-restraint necessary to control the sexually explicit bodies. The ancient gynecological and physiognomic texts define the female body as weak, loose, and rather formless matter in need of firm discipline.[9]

I would like to turn to several other examples of Venus portraits from the second century that have caused me to refine my earlier hypothesis about the opposition of the heads and bodies: the nudity is a costume, as Larissa Bonfante has pointed out.[10] It provides a semblance of divinity and its heightened physical powers. Aphrodite governed sexual matters: in this capacity, she supervised the transformative ritual of the bath, with its ointments and unguents, perfumes and incenses. Note that the Capitoline and Knidian types used for the portraits are represented bathing.[11] The body of Venus summons the feminine arts of adornment, or *cultus* (cultivation), the beauty regimens, cosmetics, and finery used by women not only to entrap men, as the satirists would have it, but also to create an elegant image worthy of the public renown or achievement of the spouses of the women depicted in these portraits.[12] In other words, the nudity of the portraits is not only acceptable but desirable; the nude may evoke the fertility of the female form and also the ideals of cultivation and refinement represented by the perfect physique of the goddess. Within the context of the divine disguise of the mythological portrait, the nude figure may serve as adornment by itself; for the fictional context of

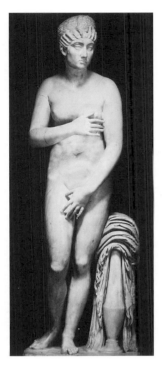

FIGURE 6.1

Statue of a Woman Represented as Venus. 130–140. Naples, Museo Nazionale Archeologico. [photograph: museum]

the bath, the nude is part of the process of beautification, preliminary to the decking out of the figure. That these images counter the dire warnings of moralists against vanity and luxury gives us evidence that a sophisticated appearance could merit approval in certain circumstances and serve as a woman's "badge of honor" (Livy 34.1–8), a display of feminine glory as a counterpart to the male honors of political office or military triumph.[13]

I propose that we dispose of scholars' separate treatment of the head and the body: they compose, after all, one statue.[14] Rather than focusing only on the dichotomy of the fictional body and the realistic portrait, we should also examine the elaborate hairstyles that crown the statues. From afar, the hairstyles are the first sign that these statues do not represent Venus herself (whose hair is arranged in waves, centrally parted, or with large curls on top). Do the towering coiffures reflect contemporary fashions? Can they be understood as another example of the refinement and cultivation of the subject? The labor-intensive hairstyles may also indicate status, particularly if they are fashioned from wigs.[15] Yet showy wigs in the form of wreaths of ringlets or plaited diadems attract attention at the same time as they hide the real hair of the subject; like the full-figured bodies borrowed from the goddess, the styled hair may enhance the disguise by evoking both modesty and allure.[16] The Venus statue type may be more than a prop for the portrait head, because its representation of the well-maintained female body complements the meticulous constructions of hair.

We may look at three portrait statues, one nude and the others partially clothed, that depict the female body under cultivation. The first statue, from the Farnese Collection and now in the Museo Nazionale Archeologico in Naples, represents the Capitoline type (fig. 6.1).[17] We can date it to about 130–140 because of the style of the coiffure and the carving. The identity of this portrait has been contested, mostly because of the high quality of the work that, according to some scholars, points to an imperial commission. The features find no definitive match in any portrait type of the imperial women, although Marciana (the sister of Trajan), both Matidia the Elder and Matidia the Younger (niece and grandniece of Trajan), Faustina the Elder (wife of Antoninus Pius), and Avidia Plautia (the mother of Lucius Verus) have all been identified as the subject of this portrait.[18] I believe that the portrait represents an anonymous woman, although it is not known whether the statue served as a funerary commemoration or as another kind of honorific statue, because it lacks a documented archaeological context. The quality of the work does not disqualify it as a private commission.

The work conforms to the type of the Capitoline Venus in its pose: the weight-bearing leg is on the left with the right slightly flexed, the upper torso stooped slightly with the head turned to the left, and the right arm is raised to the breasts, while the left is dropped to the groin.[19] As in most of the other versions of this type, the mature figure appears fleshy, with fully rounded forms. The Naples statue closely resembles the Capitoline statue in the rather high placement of the breasts, the solid haunches, and the deep dimpled navel (it differs from the well-known copy in the angle in which the head is turned and in the degree to which the shoulders are rounded and body hunched forward).

The figure of the Naples statue, interrupted while bathing, is frankly erotic. Yet, as discussed above, the eroticism of Venus was tempered by Roman institutions, dynastic propaganda, marriage, medicine, and cult worship into socially acceptable desires.[20] The expression of the portrait head maintains the composure common in these works: this may indicate to the viewer that the subject of the portrait, because of the divine disguise, is, after all, worthy of dignity and respect. The complicated coiffure, also a characteristic of these works, makes the figure appear "dressed" in a way that also points out the fiction of the nudity.

The genre aspect of the interrupted bath is established through the props: the vase

with its tall, narrow neck supports a thick clump of drapery piled on it. The arms, here restored along with a section of the left shoulder, are posed to shield the body from the spectator who has happened on the goddess in her bath. The hands at the breast and genitals have been discussed in the literature as a device that ostensibly serves the goddess's modesty but also draws attention to precisely those parts of the anatomy that require covering.[21] Clearly the portraits in the Capitoline type articulate this tension between the respectable response to the unwanted viewer and the erotic display of the female physique. That the latter could be accompanied by a show of mock modesty is evident in an episode from Apuleius's *Metamorphoses*, a novel written in the mid second century AD.[22] The protagonist, Lucius, sees his mistress, a serving girl, disrobe for the first time:

There she stood, transformed into a living statue: the love goddess rising from the sea. The flushed hand with which she pretended to screen her mound of Venus showed that she was well aware of the resemblance; certainly it was not held there from modesty (trans. W. Adlington, 2.17).

Not only does Apuleius evoke Venus to express the loveliness of this vision, but he expressly compares the mistress to a statue of Venus born from the foam, albeit a different type than that of the Naples portrait, but one that also represents the goddess with a gesture, here unequivocally interpreted as a sexual invitation. The *tableau vivant* suggests that the hand at the groin ostensibly indicated modesty, if only as a pretense, because the gesture could, and did, provoke sexual responses (and, in the case of Lucius's serving girl, was intended to do so). The moral compasses of the eager mistress in Apuleius's novel and the honorable matrons commemorated with statuary are miles apart, yet the gesture is appropriate for both in its allusions to grace and modesty as well as its deployment for erotic provocation.

The portrait head depicts a woman who appears mature but not old.[23] Creases under the eyes outline small pockets of loose flesh, but the square jaw is firm, without a sagging underchin in the profile view. The large eyes, with incised irises and pupils as well as heavy lids in the form of thick folds of flesh, are set slightly close together under sharply arched brows, delineated with curving contours and the carving of individual hairs. With the coiffure pressing low on the forehead, the face is dominated by a strong nose (although the tip and part of the lower line are restored, perhaps making it look wider), broad jaw, and large chin. The mouth is particularly small, with bowed lips set as if slightly pursed. Without the stern expression and severity of the other Venus portraits, the subject appears less forbidding but plain.[24]

The coiffure is exceptionally ornate, with crimped hair fanning out over the forehead, interrupted in the center by a plumelike extension of curls, which overlaps a large, braided turban on top of the head. The hairstyle seems to be held together by a cord threaded through the waves in front.[25] This is a more elaborate version of the turban coiffure, popular in the Trajanic and Hadrianic periods, but the turban is complemented with the crimped locks and the ornamental ringlets for an opulent effect.[26] It is likely that the spray of curls represents a homely version of a more exotic plumage. Clearly this elegant coiffure, like the others, implies that the subject is dressed up, just as the body is cosmetically improved through the borrowing of the form of the resplendent nude goddess.

Klaus Fittschen has suggested that the turban coiffure imitates the hairstyle of priestesses; this hypothesis endows the hairstyles with the insignia of rank and status rather than merely describing them as the accessories of wealth or fashion.[27] What has been missing in discussions of the coiffures is an appreciation of the manipulation of the hair into such complex, architectonic forms, typically marked by the plaiting, wrapping, and crimping of the hair. Hair is transformed through a laborious process that served to

I CLAVDIA II

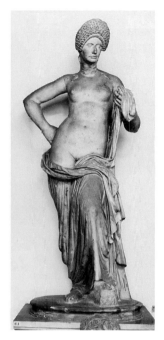

Portrait of a Woman as Venus.
Second century. Rome,
Museo Capitolino. [photo-
graph: Franc Palaia]

check and mold luxuriant tresses. The coiffures of the early second century may repre-
sent the regulation of wayward, undisciplined locks, that is, of rampant nature into con-
coctions that speak the language of culture: order, status, hierarchy.[28] It is likely that the
subject is wearing a wig or, rather, hairpieces. I will return to this subject because, if the
turban coiffure is created by a wig, then was the hairpiece meant to cover the head in
the manner of a hat or to adorn it with a sumptuous style (or both)? It would seem that
the ideals of beauty and adornment have a double edge: the statues show an opulent
surface that, however, is matched by a self-consciousness and a typically Roman preoc-
cupation with physical appearance as a uniform that establishes rank.

The complementary effects of the figures and hairstyles are found in many of the
Venus portraits, whether nude or semidraped. A partially nude portrait in the Museo
Capitolino (fig. 6.2) from 100–120 is of particular interest in this regard.[29] It was found
in Rome near S. Sebastiano, suggesting a funerary context in the tombs along the Via
Appia. The statue in the Capitoline borrows the pose of the type of the Venus of Capua,
with one leg raised and the weight displaced to one side with the hip thrust out and the
arm held akimbo above that (reconstructed correctly).[30] More of the naked body is
shown without the arms obstructing the view (as they do in the Capitoline Venus) and,
although technically the statue is draped, the garment seems to be arranged over the
thighs expressly for the purpose of gliding off. Although the left hand holds up the
edge of the garment, this action seems to offer little resistance to the drapery's down-
ward pull.

The Venus of Capua, a Hadrianic copy found in the amphitheater at Capua, is
thought to reflect a late-fourth or third-century BC Greek prototype that represents the
goddess with her weight on her right leg, while her left leg is propped on the helmet of
Mars.[31] The goddess, crowned with a diadem and draped in a mantle from the hips
down, turns left toward a shield she once held in her hands. Her gazing at her reflection
in Mars's shield, turning his weaponry into an instrument of feminine vanity, reflects a
theme popular in the Hellenistic period: the disarming of Mars by Venus (Apollonius
Rhodius *Argonautica* 1.752–46).[32]

The pose of the Venus of Capua is adapted in the Capitoline portrait, as it was in the
Roman representation of a Victory inscribing a shield and in second-century reliefs and
statuary groups of couples as Venus and Mars, many of which depict partially draped or
clothed figures rather than nudes.[33] That the Venus of Capua type was represented as a
partner of Mars implies that it also evoked victory, an association noted by Tonio Höl-
scher on the evidence of the dedications of Sulla, Pompey, and Julius Caesar to Venus
Victrix, also prominently represented on the reverses of coins.[34]

There is no explicit association between the Capitoline statue and victory, yet the
borrowing of the type for a funerary portrait of a matron points to the appeal of the
state imagery. The type was altered, and the attributes of the helmet and shield were
omitted (the orientation of the figure was also shifted). Clearly, the frontal position of
the torso and of the arms bent at each side differs from the Capua type, and some schol-
ars have seen the influence of the second-century BC Aphrodite of Melos or late Hel-
lenistic statuettes in these features.[35] The composition of this statue, then, draws on
diverse traditions of cult, genre, and state imagery.

Yet, it is important to notice how these adaptations from established types affect the
composition of the figure. The figure of the statue in the Capitoline stands with the
weight thrust back, shoulders opened, and head held high. The head is slightly turned
to the left and stares out, rather than down. With one hand striking a pose at the hip
and the other raised to the height of the breasts, the viewer's attention is directed
towards the torso, particularly to the broad expanse of the hips and lower abdomen.
This part of the anatomy is fairly flat, without much interior modeling, and the hipshot
pose with the weight slung backward makes it loom larger. The figure is dominated by

the ample midriff that provides ballast for the elongated and angular upper body and head. With the mantle slipping just below the genitals (revealing more of the anatomy than in the Venus of Capua types), the lower torso and exposed upper thigh are given emphasis.

The pose lacks the modesty of the type of the Capitoline Venus and the concentration of the Capua type and, instead, asserts a sense of self-possession and, perhaps, self-consciousness. The high carriage of the head and the more erect posture are similar to the poses of the draped Venus types. The pose, then, displays the nude torso with a certain degree of boldness.

The long (although abraded) locks on either side of the head, falling onto the shoulders and chest, indicate that the head has been reattached to the statue by means of plaster fill in the neck, to which it belongs.[36] The long and narrow head is marked by a strong nose with a high bridge (the tip is restored). The other features also are imposing: the almond-shaped eyes with narrow lids are set fairly close together, and the mouth, although wide with thick lips, reveals no expression, possibly as another indication of the subject's self-possession and reserve. Signs of age are not readily apparent on the smooth cheeks, but a sagging underchin and some loose flesh at the jawline can be seen in the profile view. These imperfections, along with the commanding features, point to the subject's maturity. As in some of the other portraits discussed above, the head projects the dignity, probity, and authority of the *materfamilias*.

The hair is worn in the style consisting of a high wreath of tight ringlets framing the upper face and with the rest of the hair drawn back in braids and wound in a wide bun at the back of the head. Attested as a Flavian court style, this coiffure is laboriously constructed from a wig and resembles nothing more than a large bonnet in profile. This version of the hairstyle is thought to be later in date, from the Trajanic period in the early second century, because of its height, the regular order of the uniformly shaped ringlets, and the band marked with parallel striations over the forehead and temples.[37]

The long locks on the shoulders and chest allude to the ideal hairstyle of Venus.[38] It is curious that the most familiar features of Venus's hairstyle, the wavy, centrally parted coiffure or the large loopy curl on top in other versions, are not represented but, rather, the long locks over the shoulder allude to divinity. A contemporary hairstyle, then, can be modified to include the attributes of divinity and bear symbolic meaning.

Perhaps the long locks were appropriate because they would not interfere with the coiffure built on top of the head. Juvenal and Statius comment on the lofty beauty of high-piled hairstyles that give their wearers added height and prestige. Juvenal in *Satire* 6 claims, "So important is the business of beautification; so numerous are the tiers and storeys piled upon one another on her head! In front you would take her for an Andromache—she is not so tall behind" (501–504). Not only does hair make the woman, according to Juvenal, but hair fortifies the woman, making her formidable and fierce!

Venus provides the model for Statius's Violentilla, the bride of the poet's friend and, in fact, in *Silvae* 1.2.111–13, Venus asserts that the lovely Violentilla has grown up in the goddess's image, that Venus herself has smoothed her tresses with rich balm. The hairstyle with the bonnet of ringlets is not the only kind of tall coiffure, but the satirist's and the poet's comments hint that towering coiffures not only distinguish their wearers but also ennoble them. The brim of curls on top elevates the status of the matron among her peers, and the long tresses below allude to divinity.

The suggestion of boldness may be attributed to the pose and composition, which were drawn from sources in Late Classical and Hellenistic statuary.[39] That the Venus of Capua type was paired with Mars in portrait groups reflects the tradition of the state imagery with its depictions of the goddess of female sexuality and the god of war as divine ancestors of the Romans.[40] Other adaptations of the Capua type, such as the

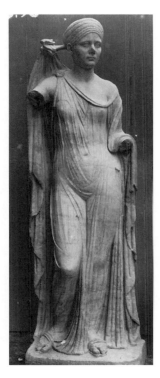

Venus Victrix and the Victory writing on a shield, provide another shade of meaning: military conquest and triumph are in Venus's domain.[41] Venus's association with Mars and her role in bringing victory attest the capacity and resilience of a mature female sexuality; she is a partner worthy of and equal to Mars. The Capitoline portrait statue may express some residue of this in its attitude of authority and its commanding presence, which is in no way diminished, and is in fact enhanced, by the coiffure.

There are several Venus types in which the opposition between the nude and the clothed does not seem to be valid. Statues of women represented as Venus Genetrix illustrate this (fig. 6.3).[42] This Trajanic–early Hadrianic statue in the museum in Ostia, although missing most of the right arm, conforms to the type of the Venus Genetrix, with the sheer garment at least slipping from the left shoulder, if not uncovering the breast as in other examples, and the mantle being raised by the right hand (a strut indicates the point at which the hand would have held the corner of the mantle).[43] The Genetrix type is thought to resemble the type of the Aphrodite of Fréjus, a late-fifth-century BC Greek work often attributed to Kallimachos, which was the inspiration for Arkesilaos's cult statue in the Temple of Venus Genetrix in the Forum of Julius Caesar in Rome.[44] No doubt because of its esteemed Hellenic lineage, the type regained popularity under Hadrian and the Antonines.[45]

The Ostian statue has been identified as Sabina, Hadrian's wife, in part because it was found in the *collegium* of the Augustales, the headquarters of the priesthood of the imperial cult, in Ostia.[46] Yet several scholars have doubted this identification, because the facial features do not resemble those represented on other, securely identified portraits of Sabina, such as the portrait statue in Vaison.[47] A matron from a prominent family could have been honored with this statue in the *collegium* of the Augustales: other examples of female honorific statuary in civic contexts include Eumachia's statue in Pompeii and Plancia Magna's in Perge, Asia Minor.[48] The anonymous woman, whom I think was depicted in this statue in Ostia, may have been a benefactress recognized for her services to the port city or even a priestess of another cult who was known in her official capacity.[49] The adoption of the identity of Venus Genetrix, a deity depicted on the reverses of several coin types of Sabina,[50] does not necessarily indicate that she was a member of the imperial court.

Neither does the findspot in the headquarters of the Augustales mandate that this statue represent the empress. The Augustales were mostly affluent freedmen, in trade and the professions, who served as priests of the imperial cult; their wealth was used to benefit the community and to advance their own standing in the eyes of their peers.[51] In their clubhouse the Augustales met, dined, and made offerings. Would a draped female portrait in the form of the Genetrix type be more appropriate for this setting than a nude statue?

On close inspection, it appears that the drapery of the Ostian statue actually conceals little of the figure. Although it is true that the tunic does not reveal the left breast (as in other copies[52]), it comes very close to doing so and appears about to slip from the shoulder at any moment. Not only does the pose threaten exposure, but the drapery, a fine fabric pulled taut about the torso and legs, emphasizes the contours of the figure. On the right shoulder the fine tunic hangs from a decorated *fibula* or round clasp in a series of folds that forms flattened bands on the torso and tapers into a pattern of V-shaped folds pressed flat against the body, making a linear pattern and revealing the nipples and navel; broad catenaries frame the lower torso, and the drapery is closely tucked around the genitals. As with many of these draped statues, the clothing does not seem to be worn by the figure so much as it is exists to sheath it with patterns that define the body and give it structure. In one sense, the tunic barely succeeds in containing the body, yet the body seems to exist only in relation to the sheath of drapery, so closely are the gossamer tucks and folds inscribed in the surface that adheres to the flesh.

In comparison, the Venus Genetrix in the Galleria Borghese[53] wears a tunic that is made visible only by the bold arabesques of its folds that appear to run down the figure like a rinse: here the transparent drapery asserts itself as pure fiction; it can only be carved in the places where it encounters resistance from the form of the body beneath it. In both of these works, the tunic fits like a second skin, but in the Galleria Borghese statue the drapery is given the appearance of a film or coating on the surface, whereas the tunic of the statue in Ostia asserts itself with its ribbonlike network of folds over a compact physique.

At the same time that its contours are being revealed by the tight tunic, the body seems to recede beneath the drapery that veils it. The mantle, however, is being lifted in order, we assume, to afford the viewer a better glimpse of the figure. The appeal of the statue lies in the viewer's contemplation of the figure's physical charms, also enhanced by the relaxed, hipshot posture implied by the contrapposto stance. The extended left hand held, perhaps, an attribute (an apple?), which further engages the viewer.

The portrait head depicts a mature but still youthful woman. The face is full in the cheeks with a square jaw, the heavy-lidded eyes are set far apart under a low brow, the short nose (broken at the tip on the right side) appears to have been hooked in profile, and the mouth is thin lipped and small. The fleshy cheeks are more visible in the profile view, along with an underchin. Marks of age are present but do not dominate: there are lightly scored lines under the eyes, along with those from the nostrils to the corners of the mouth. Both the underchin and the full cheeks may be signs of physical well-being, comfort, and affluence, rather than simply of age.[54]

Like many of these portraits, the face is fixed in an expression that is impassive and reticent. It is composed to reveal little of what we may consider its personality or inner life. Although the head is turned slightly in the direction of the opened left hand, the mouth is set firmly, the brow is lowered in its normal position, and the eyes gaze steadily straight ahead.

A comparable portrait is found in a relief decorating the Villa Medici in Rome (fig. 6.4), which dates to about 110–120.[55] The relief, probably originally from a tomb, depicts a couple, the woman in the guise of Venus Genetrix, the man in military uniform. His head was reworked in the sixteenth century, but the portrait of the woman forms a telling comparison to that of the statue in Ostia. The thin face has a sharply defined brow, prominent cheekbones, drawn cheeks, wide mouth, and large, tapering cleft chin. The sculptor has carved the face to show the bone beneath the skin, perhaps to indicate the subject's maturity, but this treatment also projects an image of the woman as hard, tough, and uncompromising. The expression of the wide-open eyes aligned under the sharply cut brows and the mouth fixed in place by what seems to be a locked jaw conforms to a type that is common to the period. This expression reflects the proper comportment of matrons whose modesty was their acceptance of stern responsibilities, hardship, and suffering without complaint. The Stoic Seneca questioned Marcia, in an essay consoling her for the loss of her son, in the first century, "Do you therefore, Marcia, always act as if you knew that the eyes of your father and your son were set upon you?," a reminder that the subject of the relief portrait never forgot, even despite her divine masquerade (*Ad Marciam de Consolatione* 25.3). The individual appearance of this anonymous matron, the gaunt and tense quality of her features, was configured according to a matronly ideal that shunned any aspect of feminine weakness.

Although the Ostian portrait has fleshier features and a softer expression, it shares the revealing attire and elaborate hairstyle with the Villa Medici portrait. Why would such otherwise plainly wrought women be crowned with elaborate hairstyles or hairpieces? We need to consider the coiffures carefully. The Ostian portrait has a coiffure in the form of a turban.[56] The turban, consisting of three narrow braids stacked over the fore-

head and then three wider ones on top, is wrapped around the head in a compact, curving profile. In front of each ear a small curl extends forward, and the narrow braids are swept behind the ear. The hair in the back is tucked up under the circle of braids. As mentioned above, the turban hairstyle may recall the authority and discipline of a venerable priestess; if we speculate that the subject of the portrait was a woman honored for her public service in Ostia, then the hairstyle might distinguish her role, if not as a priestess then perhaps as a local benefactress.

The woman depicted in the Villa Medici relief wears a more elaborate hairstyle. Three superimposed tiers, one band of hair and two braids, frame the forehead, interrupted on the sides by the ears and at the peak with an ornament (a jewel?) hooked outward. At the crown of the head a narrow fan-shaped extension rises upward. It may be decorated with a starburst ornament that mirrors the shape of the ornament on the forehead. A wide, loose coil of hair is wound at the back of the head and held in place with a net of narrow horizontal bands. The hair is fixed in forms that recall materials

FIGURE 6.4
Funerary Relief of a Married Couple, with the Woman in the Guise of Venus. 110–120.
Rome, Villa Medici. [photograph: Franc Palaia]

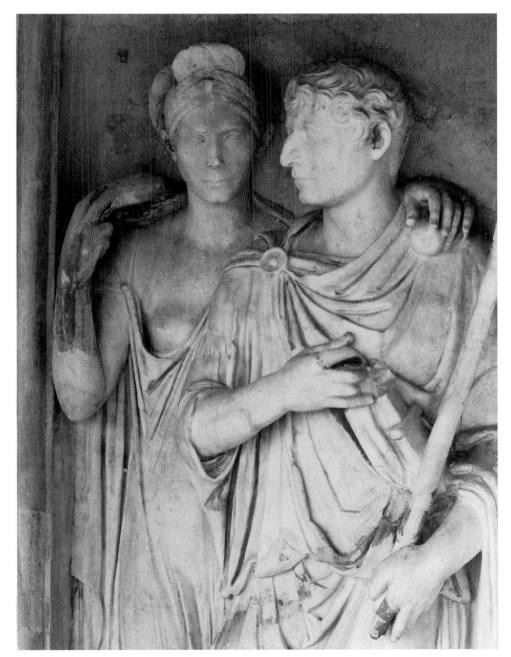

other than hair: the braids look like basket weaving, the plumelike extension resembles a fan or a small tiara, and the large coil of hair could pass for a wreath. As an elegant display of feminine finery, its purpose may have been to create an illusion of adornment out of the natural fabric of hair. The plumage or braided tiara of the anonymous matron may even have been a homely version of the golden crown of Aphrodite or the jeweled diadems of empresses.

These hairstyles provide an elegance through modest and homespun means, even if they were created with wigs or augmented with partial hairpieces. We do not know what relationship the coiffures or wigs had to the hairstyles that the subjects may have worn on other occasions or whether the subjects wore wigs at all in their daily lives (some fashionable women wore wigs apparently woven from real hair in the late first and early second centuries BC–AD [57]). If we accept that wigs were responsible for many of these hairstyles, then the hairpiece itself is an artificial adornment, like jewelry or cosmetics, to be put on or taken off when the occasion demands. The wigs may be said to flatter the vanity of their subjects by drawing attention to their elaborate and intricate hairstyles. The wigs may also have concealed the subjects' real hair in the manner of a veil and, thus, preserved their modesty.[58]

For all the rhetoric of display and finery that accompanies the discussions of these portraits, we must remember that the hair depicted in the portrait may not be that of the subject herself and should be seen as an accessory that does not compromise the woman who is shown wearing it. In fact, the opposite may be true: the coiffures may elevate the status of the subject through their allusions to rank or refinement. The hairstyles, then, are worn by the subject but are not part of them; they may represent wigs woven from real hair but are inert objects; they summon the expense and effort required to maintain the appearance of rigorously coiffed hair, even if only a wig. Yet if the purpose of these hairstyles was to demonstrate the discipline that matrons imposed on their hair, then this was only an illusion, because the precious commodity was hidden beneath it. The hairstyles that resemble the headgear of privilege or the tiaras of a regal headdress are not made of rare or costly materials: the striations and plaited lines carved on the marble coiffures indicate that they are only, after all, hair.

These statues also suggest that mythological portraiture had little to do with the invective of the moralists and satirists. For example, the women portrayed as Venus Genetrix do not meet the criteria set out by the younger Seneca, who decries the wearing of transparent garments that revealed as much as if the wearer had gone naked.[59] The costly wigs and time-consuming coiffures would also merit censure for extravagance and vanity, the advance signs of moral depravity. Yet the images of nude or scantily clad and elaborately coiffed women posing as Venus afforded their husbands and families honor.

The process of beautification carried out under the supervision of a cult or the medical establishment merited approval: as noted above, grooming and self-cultivation had their role in the Venus cults with their ritual baths, as well as the bathing and dressing of the cult statue. In the later second century, Galen notes that there are cosmetics, when applied by doctors, that can prolong beauty (he separates these from unnatural procedures, such as bleaching skin or dyeing hair).[60] The appearance of a sophisticated, well-turned-out woman in public was cause for praise not only for herself but for her husband. In the close quarters of a Roman city, with its well-defined pecking order, being seen at public events was not always as crucial as making a smart appearance in the company of one's spouse. Cornelius Nepos wrote at the end of first century BC: "Who among the Romans is ashamed to take his wife to a party? In whose household does the mother not hold the place of honor and circulate in full public view?"[61] The Venus portraits endow their subjects with an image of feminine cultivation, which may have had nothing to do with the subject's habits of dress or grooming but nonetheless

implies that there were instances in which the adorned woman was appropriate and desirable.[62] Matrons, respectable married women in their middle years, could display their own or their husbands' wealth, particularly in the contexts of the pageantry of state ceremonies or religious processions.[63]

For the goddess, the feminine arts give her power over men, mortals and immortals alike; for the Roman woman, the ritual ablutions of the Venus cults and the regimen of makeup and hairdressing led to marriage and family. If the Roman matron was expected to complement her husband's career or profession with her elegance and sophistication, then the Venus portraits accomplish this in a manner that reconciles the diverse aspects of the works and creates no scandals: after all, the nude or semidraped body is not really her own, and even the intricate locks on her head may conceal her own hair. The nude or semiclad body in these works has little to do with raw nature; instead it summons the care, labor, and control maintained over the body in order for it to appear well groomed and elegant.

Previously the portraits of matrons as Venus have generated interest only when they were identified with imperial women.[64] Yet these works are significant because they link the funerary reliefs of humble, anonymous women with imperial portraits, and they may even indicate how freedmen and -women not affiliated with the court initiated their own portrait types with greater degrees of nudity and distinct hairstyles; they indicate how canonical types of mythological statuary were adapted for portrait statues of subjects of diverse social backgrounds; they also demonstrate how the patriotic imagery of Venus Victrix or Genetrix could serve for a funerary dedication or an honorific statue of an exemplary woman. Yet, another question remains to be asked: how did Roman women view these statues?

The ancient sources are less than forthcoming, but several epitaphs of girls and young women may permit us to see why mothers and fathers thought Venus a worthy dedication for their daughters who died before them. An inscription from Ostia tells us that the unhappy parents of Arria Maximina, who died at the age of 15, erected a statue of Venus in her honor (*CIL* XIV, 610). In 168 a wealthy merchant from Gabii, near Rome, dedicated a temple to Venus, complete with bronze statuary, to the memory of his deceased daughter, Plutia Vera (*CIL* XIV, 2793). The epitaphs do not indicate whether the statues were nude or draped or if they incorporated portraits of the young women. Clearly the bittersweet identification with Venus in these circumstances evokes the pleasures and duties denied to girls whose lives ended when they were about to become women. Venus conveys not only standards of beauty but also the feminine arts, the regimen of carefully constructed appearances that signal social position and worth; in other words, *cultus* (cultivation). Particularly in a funerary context, Venus may summon not only the powers of the fertile body but also the ability to transcend appearances: as the goddess bridges the domains of love and war with her consort Mars and her epithet, Victrix, so the deceased girl identified with Venus is supplied with grace and resilience. The epitaphs and sculpture attest a moral code of a certain complexity, appropriate for an urbane and sophisticated culture.

We should turn to an alternate rhetoric of adornment: orators and poets had long evoked the *cultus* of the female as a metaphor for the creative act. As Maria Wyke observes, Cicero characterizes his own style as being enhanced by the "scent box" and "rouge" of his Greek models, and Molly Myerowitz Levine points out that Ovid in his *Ars Amatoria* treats the various female physical types as if they were raw material requiring the craft of the poet to be made into subjects worthy of his poetry.[65] We may even see the statue types represented in the portraits, the Venuses interrupted while bathing and those alluringly lifting their mantles or revealing a breast, as conceits for the cultivation of the female body as a work of art. Not only do the earnest and somber matrons display a beauty that is neither natural nor pristine in its dependence on the rouge pot,

wigs, and countless other recipes for maintenance and self-improvement, but the effect is doubled by their disguise as the goddess whose celebrated statues provide visions of loveliness. The arts of Aphrodite become synonymous with the beauty of art and the stratagems, the wonders of artifice.

Abbreviations of frequently cited works are as follows:

D'AMBRA, *"Venus"*
E. D'Ambra, "The Calculus of Venus: Nude Portraits of Roman Matrons," in Kampen *Sexuality* 219–32

WREDE, *"Claudia Semne"*
H. Wrede, "Das Mausoleum der Claudia Semne und die bürgerliche Plastik der Kaiserzeit" *RM* 78 (1971) 125–66

WREDE, *Consecratio*
H. Wrede, *Consecratio in Formam Deorum: Vergöttlichte Privatpersonen in der römischen Kaiserzeit* (Mainz 1981)

NOTES

1. Wrede, *Consecratio* 306–23, for catalogue of statues. See also S.B. Matheson, "The Divine Claudia," in Kleiner and Matheson, *I, Claudia* 182–93.

2. For example, Bieber, *Copies,* fig. 240.

3. Wrede, "Claudia Semne" 125–66.

4. Wrede, "Claudia Semne" 126–27, 154–55. Priscilla may have come from an equestrian or senatorial background; see Wrede, *Consecratio* 95 n. 266.

5. T. Mikocki, *Sub Specie Deae: Les impératrices et princesses romaines assimilées à des déesses. Étude iconologique* (Rome 1995) 18–30.

6. D'Ambra, "Venus" 219–32.

7. D'Ambra, "Venus" 221; see also R. Schilling, *La religione romaine de Vénus;*[2] (Paris 1982) 301–45, 358–65.

8. Ovid *Fast.* 4.145–56.

9. D'Ambra, "Venus" 225–27; see also Soranus *Gynecology* 1.35, R. Förster ed., *Scriptores Physignomonici Graeci et Latini* (Leipzig 1893) 2, 1.192F.

10. L. Bonfante, "Nudity as a Costume in Classical Art," *AJA* 93 (1989) 543–70.

11. *Homeric Hymn to Aphrodite* 60–66, for Aphrodite's bath, the anointing with oil and perfuming with ambrosia, and then the decking out with gold by the Graces; P. Friedrich, *The Meaning of Aphrodite* (Chicago 1978); L. Kahil, "Bains de statues et de divinités," in R. Ginouvès, A.M.

Guimier-Sorbets, J. Jouanna, and L. Villard eds., *L'Eau, la santé et la maladie dans le monde grec* (*BCH Supplement* 28, Paris 1994) 217–23.

12. M. Wyke, "Woman in the Mirror: The Rhetoric of Adornment in the Roman World," in L. Archer, S. Fischler, and M. Wyke eds. *Women in Ancient Societies: An Illusion of the Night* (New York 1994) 134–51, esp. 135–37.

13. Wyke (supra n. 12) 139–41.

14. Wrede, *Consecratio* 306–23, for the separate discussion of heads and bodies, although this follows an established tradition.

15. Infra n. 57.

16. M. Myerowitz Levine, "The Gendered Grammar of Ancient Mediterranean Hair," in H. Eilberg-Schwartz and W. Doniger eds., *Off with Her Head! The Denial of Women's Identity in Myth, Religion, and Culture* (Berkeley and Los Angeles 1995) 76–130, esp. 102–10.

17. E. Gerhard and T. Panofka, *Naples antike Bildwerke* (Stuttgart and Tübingen 1828) 45, n. 138. J.J. Bernoulli, *Aphrodite: Ein Baustein zur griechischen Kunstmythologie* (Leipzig 1873) 227, 243 no. 5; R. West, *Römische Porträt-Plastik,* vol. 2 (Munich 1941) 81 no. 8, ill. 79; F. Muthmann, *Statuenstützen und dekoratives Beiwerk an griechischen und römischen Bildwerken* (Heidelberg 1951) 106; G. Richter, "Who Made the Roman Portrait Statues—Greeks or Romans?," *ProcPhilSoc* 95 (1951) 189, ill. 47; Wegner, *Hadrian* 121, 123; Wrede, *Consecratio* 310–311 no. 297; M. Bonanno Aravantinos, "Un ritratto femminile inedito già nell'Antiquarium di S. Maria Capua vetere. I ritratti di Marciana: una revisione," *Rendiconti* 61 (1988–1989) 261–308.

18. Gerhard and Panofka (supra n. 17): Marciana; Bernoulli (supra n. 17): Marciana or a private woman; West (supra n. 17): Matidia; Wegner, *Hadrian:* private woman; Wrede, *Consecratio:* perhaps Avidia Plautia.

19. B.M. Felletti Maj, "Afrodite pudica: saggio d'arte ellenistica," *ArchCl* 3 (1951) 33–65; D.M. Brinkerhoff, *Hellenistic Statues of Aphrodite* (New York and London 1978); *LIMC* II[1], 52–53 nos. 409–18.

20. D'Ambra, "Venus" 219–32.

21. W. Neumer-Pfau, *Studien zur Ikonographie und Gesellschaftlichen Funktion hellenistischer Aphrodite-statuen* (Bonn 1982). Brinkerhoff (supra n. 19) 100.

22. J.H. Tatum, *Apuleius and the Golden Ass* (Ithaca 1979); J.J. Winkler, *Auctor and Actor: A Narratological Reading of Apuleius's The Golden Ass* (Berkeley and Los Angeles 1985).

23. For the problems of determining the ages of subjects depicted in portraits on the basis of formal evidence alone, see D'Ambra, "Venus" 224–25.

24. Compare the facial features to the Copenhagen and Vatican Magazzini portraits discussed in D'Ambra, "Venus" 223–25, 227 and figs. 94–95.

25. B.M. Felletti Maj, *Museo Nazionale Romano: I ritratti* (Rome 1953) 98 no. 186, for a portrait with a nearly identical hairstyle, although other features cast doubts on the authenticity of this work.

26. On the turban coiffure, see Fittschen-Zanker III 62–63 no. 84 (K. Fittschen).

27. Fittschen in Fittschen-Zanker III 63 no. 84.

28. My discussion of the coiffures is inspired by and dependent on the ideas of Molly Myerowitz Levine (supra n. 16).

29. J.J. Bernoulli, *Römische Ikonographie* 2 (1886) 2, 51; Stuart-Jones 127 no. 54, fig. 25; G. Lippold, *Griechische Plastik, Handbuch der Archäologie* 3.1 (1950) 299 no. 1; U. Hausmann, "Bildnisse zweier junger Römerinnen in Fiesole," *JdI* 74 (1959) 175, n. 46; G. Becatti, *L'età classica* (Florence 1965) 317; idem, *StudiMisc* 17 (1970–1971) 31, figs. 34, 62; G. Traversari, *Aspetti formali della scultura neoclassica* (Rome 1968) 35; Wrede, *Consecratio,* 309 no. 294; Fittschen-Zanker III 52–53 no. 68, pl. 85 (P. Zanker).

30. H. Knell, "Die Aphrodite von Capua und ihre Repliken," *AntP* 22 (1993) 117–40.

31. Knell (supra n. 30); T. Hölscher, "Die Victoria von Brescia," *AntP* 10 (1970) 67–80, reference to Capitoline portrait statue on 76; Helbig⁴ IV 313 no. 3338 (P. Zanker on the copy in the Villa Albani); O. Broneer, "The 'Armed Aphrodite' on Acrocorinth and the Aphrodite of Capua," *University of California Publications in Classical Archaeology* 1 (1929) 65–84.

32. Although there is some discussion that the arming of the goddess reflects an old cult: see Helbig⁴ 313 (P. Zanker); for another opinion, see Knell (supra n. 30) 131–32.

33. Hölscher (supra n. 31) 67–80; D.E.E. Kleiner, "Second-Century Mythological Portraiture: Mars and Venus," *Latomus* 90 (1981) 512–44, with bibliography.

34. Hölscher (supra n. 31) 73, idem, *Victoria Romana* (Mainz am Rhein 1967) 142–47.

35. Fittschen-Zanker III 52–53 no. 68.

36. Fittschen-Zanker III 52; *contra* Hausmann (supra n. 29) 175, n. 46. and Wrede, *Consecratio* 309 no. 294.

37. Fittschen-Zanker III 53.

38. The Venus portrait statue from the tomb of the Manilii (now in the Vatican Magazzini) also has the ideal long hair over the shoulder: see D'Ambra, "Venus" 220, fig. 93, and 228, fig. 95, 232, n. 41.

39. Supra ns. 31 and 32.

40. Kleiner (supra n. 33).

41. J. Flemberg, *Venus Armata: Studien zur bewaffneten Aphrodite in griechisch-römischen Kunst* (Stockholm 1991) 27–28.

42. Bieber, *Copies,* figs. 124–149, for types of Venus Genetrix.

43. R. Calza, *Scavi di Ostia,* vol. 5.1: *I ritratti* (Rome 1964) 77–78 no. 124, pl. 72 (Sabina); Wegner, *Hadrian* 127 (private portrait); A. Carandini, *Vibia Sabina* (Florence 1969) 134–35, figs. 10–12, pl. 22 (Sabina); Helbig (4) IV 73 no. 3082 (Sabina, H. von Heintze); H.-J. Kruse, *Römische weibliche Gewandstatuen des zweiten Jahrhunderts n. Chr.* (Diss. Göttingen 1968), D30, D342 (possibly a young Sabina?); Fittschen-Zanker III 63 no. 84c (private portrait, perhaps a priestess, K. Fittschen); Mikocki (supra n. 5) 199 no. 336, pl. 31 (young Sabina).

44. Pliny *NH* 35.155, on Arkesilaos; on Kallimachos: Pliny *NH* 34.92; Pausanias 1.26.7; A. Stewart, *Greek Sculpture* I (New Haven and London 1990) 39, 271–272, with bibliography; on the Roman setting, R. Ulrich, "Julius Caesar and the Creation of the Forum Iulium," *AJA* 97 (1993) 49–80.

45. J. Aymard, "Vénus et les impératrices sous les derniers Antonins," *MEFRA* 51 (1934) 178–96.

46. G. Calza, "Ostia: edificio degli Augustali," *NSc* (1941) 196–215; R. de Chirico, "Ostia: sculture provenienti dall'edificio degli Augustali," *NSc* (1941) 216–46, esp. 230–34, on the finding of the statue in the forecourt of the Schola of the Augustales in June 1941; C. Pavolini, *Ostia* (Rome 1983) 213–14, on the Schola (5.7.2), which consisted of a vestibule and an apsidal aula with a forecourt adorned with statuary (besides that of the matron depicted as Venus Genetrix, there was a portrait statue of a Constantinian matron, perhaps Fausta, and another of an emperor, possibly Maxentius, as Pontifex Maximus); although the Pontifex Maximus statue is, of course, an imperial portrait, the other female statue may also represent a private matron; the statuary was also complemented by the waterworks of fountains in the center of the hall.

47. Wegner, *Hadrian* 130–31, pls. 41.b and 42. See also M.T. Boatwright, "Just Window Dressing?," in this volume.

48. M.T. Boatwright, "Plancia Magna of Perge: Women's Roles and Status in Roman Asia Minor," in S.B. Pomeroy ed., *Women's History and Ancient History* (Chapel Hill 1991) 249–72; F. Bernstein, "Pompeian Women and the *Programmata*," in R.I. Curtis ed., *Studia Pompeiana et Classica in Honor of Wilhelmina F. Jashemski* (New Rochelle, N.Y. 1988) 1–18; K. Wallat, "Der Marmorfries am Eingangsportal des Gebäudes der Eumachia (VII 9,1) in Pompeji und sein ursprünglicher Anbringungsort," *AA* (1995) 345–73; W. Moeller, "The Building of Eumachia: A Reconsideration," *AJA* 76 (1972) 323–27; R. MacMullen, "Women in Public in the Roman Empire," *Historia* 29 (1980) 208–18.

49. K. Fittschen (in Fittschen-Zanker III 63 no. 84c) remarks that the turban coiffure imitates the hairstyles of Roman priestesses, perhaps that of the Vestals; E. Forbis, "Women's Public Image in Italian Honorary Inscriptions," *AJP* 111 (1990) 493–512.

50. Bieber, *Copies,* figs. 144–45 (denarii of Hadrian with Venus Genetrix on the reverse, American Numismatic Society); *BMCRE* III 356, n. 920, pl. 65.5: reverse depicting Venus Victrix.

51. A. Woods, *The Funerary Monuments of the Augustales in Italy* (Diss. University of California at Los Angeles 1991); S.E. Ostrow, "*Augustales* along the Bay of Naples: A Case for Their Early Growth," *Historia* 34 (1985) 64–101; J. D'Arms, *Commerce and Social Standing in Ancient Rome* (Cambridge, Mass. 1981); *contra* D'Arms on the subject of freedmen's independence from their patrons: R. Duthoy, "La fonction sociale del l'Augustalité," *Epigraphica* 36 (1974) 134–54.

52. Bieber, *Copies,* figs. 124–46, for the copies in the Louvre, Naples, Galleria Borghese, the Uffizi, and the Vatican.

53. Bieber, *Copies,* fig. 129.

54. The so-called Venus rings, lines around the neck on female portraits, may indicate the full physique of a woman in her reproductive years; see N. Thompson, *Female Portrait Sculpture in the First Century BC in Italy and the Hellenistic East* (Diss. Institute of Fine Arts, New York University 1995).

55. G.-C. Picard, "Bas-relief inédit de la Villa Médicis," *MEFRA* 66 (1939) 136–50; A. Piganiol, "Note sur un bas-relief de la Villa Médicis," in *Hommages à Joseph Bidez et à Franz Cumont* (*Coll. Latomus* 2 [Brussels 1949]) 265–70; M. Cagiano de Azevedo, *Le antichità di Villa Medici* (Rome 1951) 25–31, fig. 14 (G.-C. Picard); Wegner, *Hadrian,* 120; Wrede, "Claudia Semne" 159.

56. Fittschen-Zanker III 63 no. 84, for a list of Trajanic-Hadrianic portraits with turban coiffures (K. Fittschen).

57. Ovid *Ars Am.* 3.165–68; Mart. *Epig.* 9.37; for separately carved marble wigs, made to adorn portraits statues, see Calza (supra n. 43) figs. 191–92, pl. 106, and Kleiner and Matheson, *I, Claudia* no. 120.

58. A woman's change of status was marked by the veiling of the wedding ceremony; the bride's hairstyle, the *sex crines* also worn by the Vestal Virgins, probably alluded to the bride's chastity, and the *tutulus,* the early Roman headdress, was explained as protective gear by Varro *Ling.* 7.44; Festus, s.v. *tutulum,* Lindsay, *Sexti Pompei Festi de verborum significatu quae supersunt cum Pauli epitome* (Leipzig 1913) 484–85; see Myerowitz Levine (supra n. 16) 102–10; Bonanno Aravantinos (supra n. 17) 301, on the coiffures' allusion to moral character; see also the essays in J.L. Sebesta and L. Bonfante eds., *The World of Roman Costume* (Madison 1994).

59. Seneca *ad Helviam* 16.3.

60. Galen 12.308, 434 (ed. Kühn); P. Virgili, *Acconciature e maquillage. Vita e costume dei romani antichi* VII (Rome 1989) 11, 30–31; A. Richlin, "Making Up a Woman: The Face of Roman Gender," in Eilberg-Schwartz and Doniger (supra n. 16) 185–213.

61. Cornelius Nepos *Vitae* praef. 6–7; N. Horsfall, *Cornelius Nepos: A Selection* (Oxford 1989).

62. Wyke (supra n. 12) 142, on female adornment "as a marker of women's incorporation into the civic community. . . ." Wyke considers girls' preparation for rites of passage, such as marriage, as providing exceptions to the usual attitudes toward a cultivated appearance.

63. Apuleius *Met.* 11.8–10; E. Fantham, in E. Fantham, H.P. Foley, N.B. Kampen, S.B. Pomeroy, and H.A. Shapiro, *Women in the Classical World* (Oxford 1994) 262–63.

64. Supra ns. 18 and 43 on the confusion concerning the identity of the Naples and the Ostia portrait statues; also, M.T. Boatwright, "The Imperial Women of the Early Second Century A.C.," *AJP* 112 (1991) 513–40, on the "domestic and submissive" roles of the women of the Trajanic and Hadrianic courts.

65. Cicero *ad Att.* 2.1.1–2; Wyke (supra n. 12) 145; M. Myerowitz Levine, *Ovid's Games of Love* (Detroit 1985).

JEWELRY FOR THE UNMARRIED

ANDREW OLIVER

In the summer of 1993, an archaeological team sponsored by the Soprintendenza Archeologica di Roma excavated an ancient cemetery south of Rome situated near the via Laurentina beyond the E.U.R. in a district known as Vallerano. It was an ordinary cemetery of the middle imperial period in which about a hundred graves were investigated. What characterized this project was the care with which the work was done, in particular the preservation and analysis of the skeletal remains. Material finds were not the primary objectives. In the preliminary report published in the *Quaderni di archeologia etrusco-italica,* the team of Alessandro Bedini, Carla Testa, and Paola Catalano provided three types of information: a statistical assessment of the sex of skeletal remains, a typological survey of the burials, such as urn or cist, and a brief description of selected diagnostic objects recovered from the tombs, specifically lamps and stamped roof tiles (used to construct some of the graves), which could provide dates.[1] And while Bedini, one of the authors of the report, observed that the furnishings of one tomb, Tomb 2, were rich, he gave no hint of their character, merely mentioning that they would be covered in a soon-to-be-published separate monograph.

This monograph has now appeared in the form of a well-illustrated catalogue accompanying an exhibition of the contents of Tomb 2, held at the Accademia Valentino in Rome from December 1995 to February 1996.[2] There we can see what made this grave so special and warranted an exhibition devoted to it, namely, the high quality of the grave furnishings, in particular the jewelry.

From essays by Bedini and his colleagues we learn that the excavators made careful notes and drawings of the grave plot and the locations of the grave furnishings. The plot itself is thought to have been once marked by a sizeable stone. The deceased, a young woman between 16 and 17 years old, as analysis of the bones confirmed, had been buried in a lidded marble sarcophagus of plain design. Outside the sarcophagus but within the pit excavated for it in antiquity were found two simple ceramic vases, a lamp from the firm of Lucius Fabricius Masculus datable to ca. 150–180 and the remains of a wood box with bronze hinges and a silver clasp. Within the sarcophagus, around and on the remains of the body, were found a silver mirror (fig. 7.8), a silver compact in the form of a scallop shell, two amber pins, and a set of gold jewelry, clearly worn by the deceased at the time of burial: two necklaces (figs. 7.1–7.2), a pair of armbands (not bracelets) (figs. 7.3–7.4), three brooches, at least two of them used to fasten her dress at the shoulders (fig. 7.5), and six rings, apparently three for each hand (figs. 7.6–7.7). In addition, gold thread and beads recovered must have decorated her dress. No earrings were reported.

Large-scale color illustrations of the jewelry in the monograph edited by Bedini give us a vivid impression of the jewelry buried with this young woman. The craftsman or craftsmen involved made good use of precious and semiprecious stones: in one necklace, blue stone beads, perhaps sapphires, threaded on gold links (fig. 7.1); on the other

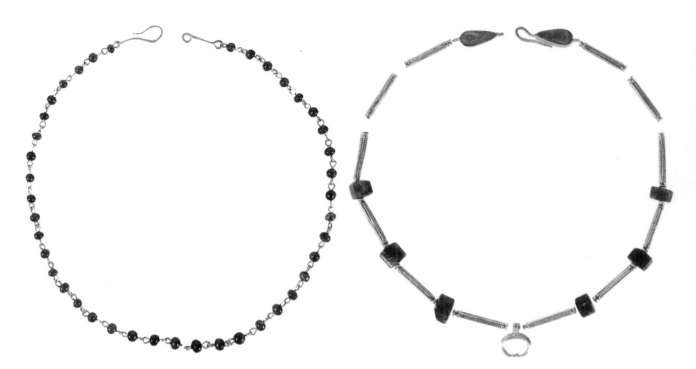

FIGURE 7.1

Necklace. Gold and blue stones (possibly sapphires). 36.5 cm. L. From Vallerano, Tomb 2. Rome, Museo Nazionale Romano 414059. [photograph: after A. Bedini ed., *Mistero di una fanciulla. Ori e gioielli della Roma di Marco Aurelio da una nuova scoperta archeologica* (Rome 1995) 42, fig. 9]

FIGURE 7.2
Necklace with crescent pendant. Gold and green beryl. 36.5 cm. L. From Vallerano, Tomb 2. Rome, Museo Nazionale Romano 414060 (necklace) and 414065 (pendant). [photograph: after A. Bedini ed., *Mistero di una fanciulla. Ori e gioielli della Roma di Marco Aurelio da una nuova scoperta archeologica* (Rome 1995) 43, fig. 11]

necklace, hexagonal green beryl beads once strung together with gold rod spacers on a string of some perishable, organic material, now lost (fig. 7.2); the armbands have sapphires (figs. 7.3–7.4), while the rings have sapphires (fig. 7.6), emeralds, garnets, and even a diamond (fig. 7.7). Diamond rings of the Roman period are known in public and private collections, but this one may well be the first to come from a recorded excavation.[3] The three brooches are set with colored stones: one has an amethyst carved in the round, the two others have banded onyx and garnet stones, both with intaglio reliefs.

The editors of the exhibition catalogue compared the furnishings of Tomb 2 to previously discovered burials of girls and young women, and they included in the catalogue photographic surveys of the objects found in these other burials. Four sets of tomb furnishings, all with gold jewelry, seem to be of particular relevance: the burial of a woman about 20 years old, found in 1887 near Vetralla whose grave contained two necklaces, both with beryl beads, a ring set with garnets, a box, and a wealth of amber and rock crystal;[4] the burial of a girl between 17 and 19 years old, found in 1889 during the construction of the Palazzo di Giustizia in Rome, containing a wreath, earrings, a necklace, a brooch, three rings, a silver mirror, a box, and an ivory doll;[5] the burial of a very young girl ("giovanissima donna"), found in 1954 at Mentana (Nomentum), whose body, when found, was dressed in a white tunic embroidered with gold and who wore a necklace of mounted teardrop garnets and two rings;[6] and lastly, the burial of a girl about 8 years old, found in 1964 on the Via Cassia outside Rome, with earrings, a necklace, a ring, a little amber, and an ivory doll.[7]

To these Italian burials one should add the grave of an 8- to 10-year-old girl excavated in 1954 in Bonn.[8] The girl had been interred in a plain sandstone sarcophagus with a silver mirror, glass and ceramic tableware, toys, and a wood box within the remains of which were found two gold rings, a gold necklace, a pair of earrings, a gold chain, and a set of seven bronze coins, the latest, one of Volusianus (251/252). Associated with her left hand were three gold rings and a single agate bracelet, all of which she must have been wearing at the time of burial.

In general the burials are alike typologically. All of them contained jewelry and toilet

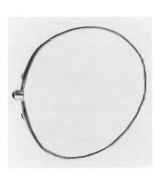

FIGURES 7.3 & 7.4
Armband. **Gold and sapphire.**
7.7 cm. Max. D. From Val-
lerano, Tomb 2. Rome,
Museo Nazionale Romano
414070. [photograph: after
A. Bedini ed., *Mistero di una*
fanciulla. Ori e gioielli della
Roma di Marco Aurelio da una
nuova scoperta archeologica
(Rome 1995) 45, fig. 14]

articles, and some of them contained toys. There were boxes in the burial of Crepereia Tryphaena and the Vallerano, Vetralla, and Bonn graves, of bone and ivory in the first, of wood in the other three. But dolls in several burials and the amber and rock crystal that are more lavishly present in the Vetralla grave are lacking in the Vallerano burial.

Stylistically some of the jewelry from Vallerano bears comparison with selected items of jewelry found in the Bonn and other Italian burials. One of the rings from Vetralla would not be out of place in the Vallerano find, and the brooch from the burial of Crepereia Tryphaena finds a good parallel in one of the Vellerano brooches (fig. 7.5). The arrangement of the stones in the earrings from Bonn matches that in one of the rings from Vallerano (fig. 7.6).[9] In general, however, the jewelry exhibits considerable variety, even among more or less contemporaneous sets. The differences are more pronounced than the similarities.

Curiously the one aspect of these burials of girls from well-to-do families that one would consider normal, namely, the presence of gold jewelry, is in fact unusual because gold jewelry is scarce in the graves of women. Most Roman jewelry recovered in modern times in western Europe, including Italy, has come not from tombs but through the recovery of objects lost through natural disaster or unretrieved after having been intentionally buried in times of political upheaval. In the West, most Roman jewelry has been found through discoveries made, on the one hand, in Pompeii, Herculaneum, and villas around Vesuvius buried in 79 and, on the other, in France and Germany from a host of caches deposited by the well-to-do in the years of political uncertainty in the mid third century. Roman jewelry from graves is relatively uncommon, and that is what makes the jewelry from this burial at Vallerano so significant.[10] Gold earrings are perhaps the most that one would ordinarily expect to find in the grave of an older woman. Such is the case, for example, in the burial of Ulpia Athenais at Voghenza in the region of Ferrara, where the sole item of gold jewelry was a pair of cut-out sheet earrings in the form of Amazon shields, attractive but of no particular merit.[11] Only families at the limits of the empire or barbarians living beyond those limits buried sets of jewelry (and other valuables such as Roman silver) with their dead. This must be the case of a second-century woman in her early 50s splendidly interred with her jewelry, toilet articles, and clothing, whose sarcophagus was excavated in 1970 at Mangalia (ancient Callatis) in Romania.[12] Though the contents, among them a wooden box packed with bottles and a bronze lamp on a lampstand, not to mention the jewelry, are quite Roman in style, we should remember that Callatis would not have been a desirable destination for a proper Roman, and long-time inhabitants might well have followed non-Roman traditions. Callatis was situated not far south of Tomis (modern Costanta), where Ovid suffered in exile (and where the tomb's furnishings are now displayed in the local museum). Roman jewelry has also been found in tombs in Georgia, Asia Minor, Syria, and elsewhere in the East.

In Italy and the fully Romanized regions of the empire is it chance that has given us so much jewelry from the graves of girls and young women, or could it be the case that custom stipulated that valuable sets of gold jewelry be deposited only in their graves, while older women, dying after rearing a family, received at best a pair of earrings and a ring? The deceased in the burials found in Bonn and Italy cited above were girls and young women under the age of 20. Are any of them likely to have been married? Legally a girl could be married at the age of 12, and it used to be thought that many, if not the majority, were married in their teens. Now, however, it is recognized that while some girls from the upper classes might be betrothed and married early, in practice marriage at or after the age of 19 was normal for most Roman women.[13] The presence of dolls in the Via Cassia burial and in that of Crepereia Tryphaena provide confirmation that the girls in these two burials at least were not married, for we know that upon

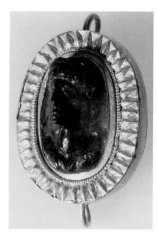

FIGURE 7.5
Brooch. Gold and amethyst.
Dimensions unknown. From
Vallerano, Tomb 2. Rome,
Museo Nazionale Romano
414061. [photograph: after
A. Bedini ed., *Mistero di una
fanciulla. Ori e gioielli della
Roma di Marco Aurelio da una
nuova scoperta archeologica*
(Rome 1995) 46, fig. 15]

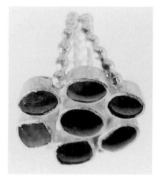

FIGURE 7.6
Finger ring. Gold and sap-
phires. Dimensions: 1.7 x
1.6 cm. From Vallerano,
Tomb 2. Rome, Museo
Nazionale Romano 414057.
[photograph: after A. Bedini
ed., *Mistero di una fanciulla. Ori
e gioielli della Roma di Marco
Aurelio da una nuova scoperta
archeologica* (Rome 1995) 52,
fig. 18]

marriage, young women gave up their dolls, dedicating them to Venus (Perseus *Satire* 2.70) or to the Lares (Varro in Nonius *De compendiosa doctrina* 863.15 L).[14] So while possible, it is unlikely that any of these girls, even the teenagers, were married.

The scarcity of gold jewelry from Roman graves in general seems to square nicely with the prominence given to jewelry as a component of legacies in Roman law. The notion of handing down jewelry and other valuables from one generation to the next clearly runs counter to the practice of burying such things with the dead. The *Digest* of Justinian contains explicit passages drawn from earlier Roman law that deal with legacies of women's jewelry, toilet articles, and clothing. The classic definition of women's jewelry comes from Ulpian, a Roman jurist who flourished in the first quarter of the third century and was one of the principal sources for the *Digest*.

Ornamenta muliebria sunt, quibus mulier ornatur, veluti inaures armillae viriolae anuli prae-ter signatorios et omnia, quae ad aliam rem nullam parantur, nisi corporis ornandi causa: quo ex numero etiam haec sunt: aurum gemmae lapilli, quia aliam nullam in se utilitatem habent (Ulpian Ad Sabinum, book 44; Dig. 34.2.25.10).

Feminine ornaments are those with which a woman is adorned, for example, earrings, bracelets, arm bands, rings (apart from signet rings), and everything is procured for no other purpose than to adorn the body. This category also includes gold, gems, and stones, which have in themselves no other use (Treggiari's translation).[15]

Through some oversight, necklaces are omitted, but this need not concern us. What is important is to recognize that this passage presumably helped to answer the question of what constituted women's jewelry in the context of legacies. Ulpian provided a suc-cinct summary that included the observation that stones count also but with one quali-fication, as he states a few sentences on:

Margarita si non soluta sunt vel qui alii lapides (si quidem exemptiles sint), dicendum est ornamentorum loco haberi: sed et si in hoc siut resoluti ut componantur, ornamentorum loco sunt. Quod si adhuc sint rudes lapilli vel margaritae vel gemmae, ornamentorum loco non erunt, nisi alia mens fuit testantis, qui haec quoque, quae ad ornamenta paraverat, orna-mentarum loco et appellatione comprehendi voluit (Ulpian Ad Sabinum, book 44; Dig. 34.2.25.11).

Pearls, if they are not loose, or other stones (if in fact they are removable) are to be held classed as jewelry; but even if they have been removed for resetting they constitute jewelry. But if the stone or pearls or gems are in an unpolished state, they will not count as jewelry unless the testator's intention was otherwise, meaning those, too, which he had acquired for [use as] jewelry to be included in the category and term jewelry (Shelagh Jameson's translation).

Intent had a place here. Stones designed to be set in jewelry, whether or not they were actually in place as part of the jewelry, counted as jewelry. Only if they had been acquired for some other purpose, as an investment to be traded, for example, were they not to be considered jewelry. These passages define jewelry in documents drawn up by men. But women could also write wills. A mother, for instance, could leave a *fideicom-missum*, namely, a testamentary request, that her personal possessions not be disposed of but given to her daughter.

Quisquis mihi heres erit, fidei eius committo, uti ornamenta mea omnia aurum argentum ves-timenta, quibus ego usa sum, ne veneant et filiae meae reserventur (Scaevola Dig., book 18; Dig. 34.2.16).

Whoever shall be my heir, I impose upon him a fideicommissum to prevent the sale of all my

FIGURE 7.7
Finger ring. Gold and diamond. Dimensions: 1.6 x 1.5 cm. From Vallerano, Tomb 2. Rome, Museo Nazionale Romano 394563. [photograph: after A. Bedini ed., *Misiero di una fanciulla. Ori e gioielli della Roma di Marco Aurelio da una nuova scoperta archeologica* (Rome 1995) 52, fig. 20]

jewelry, gold, silver, clothes, which I have used, and to preserve them for my daughter (Jameson's translation).

Two more sections also speak of women's legacies involving jewelry:

Hoc amplius filia mea dulcissima e medio sumito tibique habeto ornamentum omne meum muliebre cum auro et si qua alia muliebria apparverint (Paul Ad Vitellium, book 2; Dig. 34.2.32.4).

Further, let my dearest daughter take from the residue and have for herself all my women's jewelry, together with the gold and other female accoutrements (Jameson's translation).

Mulier ita legavit: quisquis mihi heres erit, Titiae vestem meam mundum ornamentaque muliebria damnas esto dare (Paul Ad Plautium, book 9; Dig. 34.2.8).

A woman left a legacy in the following terms: "Whoever shall be my heir, let him be obliged to give my clothing, toilet equipment, and female jewelry to Titia" (Jameson's translation).

In reading these passages, both those defining women's jewelry and those having to do with a woman leaving things to her daughter, one clearly gains the impression that there was a Roman tradition of passing on jewelry from one generation to the next and that every little piece mattered. Just as it was not generally customary for Athenians, for example, to deposit gold jewelry in the fifth and fourth centuries BC, so it was not the custom for Roman citizens to do so during the principate. But was this practice universal among Romans in Italy? Were there not differences of opinion about disposition of jewelry at death? Another passage from the *Digest* reveals how different members of a family might feel about the situation:

Mulier decedens ornamenta legaverat ita: "Seiae amicae mea ornamenta universa dari volo." Eodem testamento ita scripserat: "funerari me arbitrio viri mei volo et inferri mihi quae-cumque sepulturae mea causa feram ex ornamentis lineas duas ex margaritis et viriolas ex smaragdis." Sed neque heredes neque maritus, cum humi corpus daret, ea ornamenta, quae corpori iussus erat adici, dederunt. Quaesitum est, utrum ad eam, cui ornamenta universa reliquerat, pertineant an ad heredes. Respondit non ad heredes, sed ad legatariam pertinere (Scaevola Dig., book 17; Dig. 34.2 40.2).

A dying woman had left her jewelry in the following terms: "I desire that my entire collection of jewelry be given to my friend Seia." In the same will, she had written: "I wish to be buried as my husband deems fit, and whatever I wear for the purpose of burial, I wish there to be put on me from my jewelry, two strings of pearls and my emerald bracelets." But neither the heirs nor the husband, when he buried the body, buried the jewelry which he had been ordered to put on the body; it has been asked whether it belongs to the legatee to whom all the jewelry had been left or to the heirs. The answer was given that it does not belong to the heirs, but to the legatee (Jameson's translation with changes).

Here, even with specific language, the heirs and widower refrained from placing the jewelry in the burial. What could one expect without testimentary or precatory language? With this case before us, it is unlikely that many families voluntarily placed valuable jewelry in tombs. In fact, in a section of the *Digest* dealing with funerals, Ulpian is quoted as saying:

Non autem oportet ornamenta cum corporibus condi, nec quid aliud huiusmodi, quod homines simpliciores faciunt (Ulpian Ad Edictum, book 25; Dig. 11.7.14.5).

Moreover it is not right to bury ornamenta with the dead, nor anything else similar, as more simpleminded people do (Harry Hine's translation).

This somewhat pejorative statement, implying class distinctions among different social practices, suggests that a proper family in Italy did not ordinarily dress the deceased with *ornamenta* (which I would translate here as jewelry), though who could say what the lower classes, not to mention foreigners and the *nouveaux riches,* might do. This makes it seemingly even more exceptional to find jewelry in the tombs of the young women we have been discussing. What is the reason for it? A further passage in the *Digest* combined with a papyrus text may help us with the solution.

Iure succursum est patri, ut filia amissa solacii loco cederet, si redderetur ei dos ab ipso profecta, ne et filiae amissae et pecuniae damnum sentiret (Pomponius Ad Sabinum, book 14; Dig. 23.3.6).
 The law assists a father who has lost his daughter by returning the dowry which he provided so as to comfort him and not let him suffer the loss of his daughter and his money (Grant McLeod's translation).

Normally land and slaves constituted dowry. But we know from the Greek and Latin papyrus texts of marriage contracts of the Roman period from Egypt that, in addition, jewelry, toilet articles, and clothing could also constitute part of a dowry. An often cited Latin text on a papyrus preserved in Ann Arbor, Michigan, datable not earlier than ca. 100, lists a house, land, jewelry, clothing, toilet articles (including a mirror) and other household effects, and a slave girl.[16] The father and the bride have Roman names, and even though it has been pointed out that what was true for Egypt need not have been the case for Italy, the language of the contract and the nationality implied by the names suggest that the terms conformed to Italian practice. In the event of his daughter's death, a father would recover the dowry that he had provided, though certain qualifications applied: for each child who survived, for example, a husband was entitled to keep one-fifth of the dowry. If she died young and unmarried, the father would retain the dowry he had been assembling, and if she died married but without children, he regained possession of it from his son-in-law. When the dowry included jewelry and clothes, I would argue that custom required that some of the items be conveyed, as it were, with the deceased daughter to the hereafter instead of being left to the family. Legal opinions, such as the following quoted in the *Digest,* clearly indicate a link between possession of a dowry and obligations for funeral expenses:

Aequissimum enim visum est veteribus mulieres quasi de patrimoniis suis ita de dotibus funerari et eum, qui morte mulieris dotem lucratur, in funus conferre debere, sive pater mulieris est sive maritus (Ulpian Ad Edictum, book 25; Dig. 11.7.16).
 For the early lawyers thought it only fair that the funerals of women should be paid for from their dowries, as though from their estates, and that anyone who gained the dowry on the woman's death, whether her father or her husband, should contribute to her funeral expenses (Harry Hine's translation).

The grieving father of the young girl, in possession of her dowry and in charge of her funeral, was probably expected to make a statement to family and friends by dressing his dear daughter with the finery she would have brought to her household.

There seems to be a corollary among boys with regard to the committing of *ornamenta* to the grave. Grown men would be buried with their signet rings, and we know of countless graves yielding signets, gold, silver, or bronze, often the sole objects of significance from the burials. But boys, dying before reaching manhood, might be buried with another article of jewelry, a *bulla.* The *bulla* was a round locket containing an amulet worn at the breast until the boy reached manhood and then dedicated to the

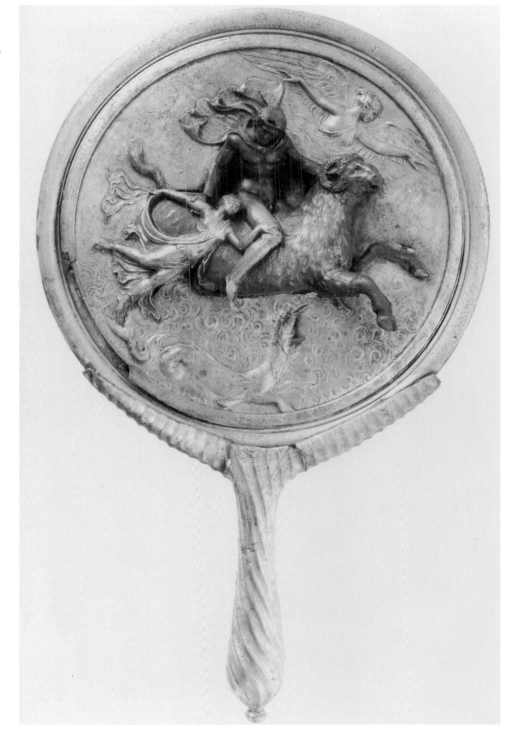

Lares as the young man assumed the *toga virilis,* the all-white toga.[17] At least two such burials have been found: one at Ostia in the first half of the nineteenth century,[18] another at Ariccia in 1933.[19] At Ariccia, a small, undecorated marble sarcophagus (no longer preserved) contained a denarius of Vespasian, a group of thirteen amber appliqués that look like toys, and a gold *bulla.* The stated size of the sarcophagus suggests that it was a child's burial, though no skeletal remains were analyzed or are today preserved. Had the boy outgrown the use of the *bulla,* it would have been dedicated in a

lararium and then put away with the rest of the family valuables, as must have been the case with the gold *bulla* found packed away in a wood chest with the family jewels and silver in the House of the Menander in Pompeii.[20]

The presence of a silver mirror in the Tomb 2 at Vallerano helps to confirm the validity of the argument that unmarried girls were buried with their jewelry. Mirrors were considered toilet articles, and toilet articles were linked with jewelry in matters of legacies, as we know from the passages of Ulpian in the *Digest*. Here is what follows his classic description of women's jewelry:

Mundus mulieris est, quo mulier mundior fit: continentur eo specula matulae unguenta vasa unguentaria et si qua similia dici possunt, veluti lavatio riscus (Ulpian *Ad Sabinum*, book 44; *Dig. 34.2.25.10*).

Women's toilet equipment is what is used to make a woman more attractive; it includes mirrors, jars, perfumed oils, bottles for perfume, and anything similar such as washing vessels and storage chests (Treggiari's translation, with changes).

The mirror in Tomb 2 at Vallerano was no ordinary mirror; it is one of the finest Roman mirrors known (fig. 7.8).[21] The back of the disk features the legend of Phrixus and Helle boldly done in repoussé relief. The handle is spirally fluted, the disk attachments corrugated. A dotted inscription gives the mirror's weight as two pounds, five ounces. There is nothing like it outside the Vesuvian finds. With only a few exceptions, fine pieces of silver were not placed in tombs under ordinary circumstances by civilized Romans. Our principal collections of Roman silver in western Europe come, like those of jewelry, not from tombs but from discoveries made in localities buried by the eruption of Vesuvius in 79 and from the recovery of caches buried in times of political turmoil in France and Germany in the mid third century; in addition, the recovery of temple treasures, lost in antiquity, has augmented our corpus of Roman silver.[22] As in the case of jewelry, only families not fully Romanized seem to have buried silver with their dead. Witness to this is the splendid Roman silver from tombs at the edge of or beyond the borders of the empire: silver cups from Hoby in Denmark, silver plates from Georgia, a complete silver service from Kayseri in Cappadocia, to name just a few examples.[23] A Roman family did not consign silver to tombs unless there was a special circumstance. And that special circumstance must have been the death of an unmarried girl or bride without children from a family of substance. The father of the girl buried at Vallerano still possessed the silver mirror from his daughter's dowry, and it was only proper that it should be placed with her in the grave.

NOTES

1. A. Bedini, C. Testa, and P. Catalano, "Roma—Un sepolcreto di epoca imperiale a Vallerano," *Quaderni di archeologia etrusco-italica* 23 (*Archeologia Laziale* XII, i, Rome 1993) 319–31. The objects are in the Museo Nazionale Romano.

2. A. Bedini ed., *Mistero di una fanciulla. Ori e gioielli della Roma di Marco Aurelio da una nuova scoperta archeologica* (Rome 1995).

3. F.H. Marshall, *Catalogue of the Finger Rings, Greek, Etruscan, and Roman in the Departments of Antiquities, British Museum* (London

1907, reprinted 1968) 127–29 nos. 778–79, 785, 787–90; J. Ogden, *Jewellery of the Ancient World* (New York and London 1982) 95 and ns. 16–17, color pl. 29, upper right.

4. Bedini (supra n. 2) 89–97; G. Bordenache Battaglia, *Corredi funerari di età imperiale e barbarica nel Museo Nazionale Romano* (Rome 1983) 49–78: L. Pirzio Biroli Stefanelli, *L'Oro dei Romani. Gioielli di età Imperiale* (Rome 1992) 244–45 nos. 101–103, figs. 147–51 (jewelry only).

5. Bedini (supra n. 2) 65–75; *Crepereia Tryphaena. Le scoperte archeologiche nell'area del Palazzo di Giustizia* (Rome 1983); Pirzio Biroli Ste-

fanelli (supra n. 4) 251–52 nos. 135–40, figs. 186–94.

6. Bordenache Battaglia (supra n. 4) 40–48.

7. Bedini (supra n. 2) 77–83; Bordenache Battaglia (supra n. 4) 100–23; Pirzio Biroli Stefanelli (supra n. 4) 233 nos. 22–23, figs. 23–25, 27–28.

8. W. Haberey, "Ein Mädchengrab römischer Zeit aus der Josefstrasse in Bonn," *BJb* 161 (1961) 319–32, pls. 57–63.

9. Style of brooches: Bedini (supra n. 2) 46 no. 15 (Vallerano); *Crepereia Tryphaena* (supra n. 5) 42–45 no. 6 (Palazzo di Giustizia). Arrangement of stones: Bedini (supra n. 2) 50 no. 18 (ring from Vallerano); Haberey (supra n. 8), fig. 2, pl. 60 (earrings from Bonn).

10. I have provided a catalogue of jewelry of the Roman imperial period in datable contexts in A. Calinescu ed., *Ancient Jewelry & Archaeology* (Bloomington and Indianapolis 1996) 141–51. Italian burials with jewelry not already mentioned here include the following: the grave of a young girl at Orbitello with a gold necklace: G. Maetzke, "Orbitello—Trovamenti archeologi vari," *NSc* (1958) 42, fig. 10; one or more tombs or deposits excavated in Lovere in 1907 with silver, glass, and jewelry: G. Patroni, "Lovere. Tombe romane con oggetti preziosi e suppellettile sepolcrale di età preromana e romana," *NSc* (1908) 4–16; Comune di Milano, *Milano capitale dell'impero romano 286–402 d.c.,* exhibition catalogue Milan, Palazzo Reale (Milan 1990) 274, 277–78, ill. p. 309. Details of skeletons are not known, and it has even been suggested that some of the finds came not from a burial but were part of a secreted treasure.

11. *Voghenza. Una necropoli di età romana nel territorio ferrarese* (Ferrara 1984) 166–67, 196, fig. 133.

12. *Bellezza e Seduzione nella Roma imperiale,* exhibition catalogue, Rome, Palazzo del Conservatori (Rome 1990) 65–74, 111–16, description of the skeleton in n. 7 on p. 74; see also *Goldhelm, Schwert und Silberschätze. Reichtümer aus 6000 Jahren rumänischer Vergangenheit,* exhibition catalogue, Frankfurt, Schirn Kunsthalle (Frankfurt am Main 1994) 202–209 no. 80.

13. B.D. Shaw, "The Age of Roman Girls at Marriage: Some Reconsiderations," *JRS* 77 (1987) 30–46.

14. On dolls, see the discussions of Anna Mura Sommella in *Crepereia Tryphaena* (supra n. 5) 49–56 and B. Rawson, "Adult-Child Relationships in Roman Society," in B. Rawson ed.,

Marriage, Divorce, and Children in Ancient Rome (Oxford 1991) 19–20.

15. For the English versions here and elsewhere I borrow translations from Treggiari, *Roman Marriage* 389 and from Harry Hine, Shelagh Jameson, and Grant McLeod in Alan Watson's edited translations of the *Digest* in the University of Pennsylvania edition: T. Mommsen and P. Krueger eds., A. Watson trans. and ed., *The Digest of Justinian,* 4 vols. (Philadelphia 1985).

16. H.A. Sanders ed., *Michigan Papyri VII: Latin Papyri in the University of Michigan Collection* (Ann Arbor 1947) 21–27 no. 434 = S. Riccobono et al. eds., *Fontes iuris romani anteiustiniani;*[2] III (Florence 1968–1969) 17; cited by Gardner, *Women in Roman Law* 50 and n. 72; Treggiari, *Roman Marriage* 350, n. 145, and R.P. Saller, *Patriarchy, Property and Death in the Roman Family* (Cambridge 1994) 212, n. 26.

17. Propertius *Elegy* 4.13.1; Macrobius *Saturnalia* 1.6.9–14.

18. In the Vatican Museum. *Musei Etrusci quod Gregorius xvi Pontifex Maximus in aedibus Vaticanis constituit monimenta* (Vatican City 1842), pl. 123.4; Helbig[4] I 571 no. 767; M. Cristofani and M. Martelli eds., *L'Oro degli Etruschi* (Novara 1983) 316 no. 267, ill. on p. 267.

19. In the Museo Nazionale Romano. Bordenache Battaglia (supra n. 4) 34–39; Pirzio Biroli Stefanelli (supra n. 4) 232 no. 21, figs. 21–22.

20. A. Maiuri, *La Casa del Menandro e il suo tesoro di argenteria* (Rome 1936), pl. lxv; J. Ward-Perkins and A. Claridge, *Pompeii AD 79,* exhibition catalogue, Boston, Museum of Fine Arts (Boston 1978) I 31, color plate, no. 40; II 132, no. 40.

21. Bedini (supra n. 2) 12, fig. 1, and 40–41 no. 8.

22. The silver recovered at Berthouville, France, and now in the Cabinet des Médailles was such a temple treasure: E. Babelon, *Le trésor d'argenterie de Berthouville près Bernay (Eure)* (Paris 1916). Inscriptions also record valuables in temples. See, for example, the inscription from near Nemi (where there was a temple of Diana), which lists things transferred to a shrine, apparently of Isis, also located there; among the items are silver and bronze objects, jewelry such as earrings and necklaces set with stones, and clothing: *CIL* XIV, 2215 = H. Dessau, *Inscriptiones Latinae Selectae* II, i (Berlin 1955) no. 4423 (now in the Castello Ruspoli in the villiage of Nemi). On the sanctuary at Nemi, see G. Ghini, "La ripresa delle indagni al Sanctuario di Diana a Nemi,"

Quaderni di archeologia etrusco-italica 21 (*Archeologia Laziale* XI, Rome 1993) 277–89.

23. Hoby: one illustrated in D.E. Strong, *Greek and Roman Gold and Silver Plate* (London and Ithaca 1966), pl. 35.b; large-scale illustrations of both in *Roman Reflections in Scandinavia,* exhibition catalogue, Malmö Museer, Sweden (Rome 1996) 94–95 nos. 72–73; Georgia: K. Matchabely, *La toreutique de la Georgie dans l'Antiquité tardive* [in Russian with a French summary] (Tbilisi 1976); Kayseri: M. Eskioglu, "Garipler tümülüsü ve Kayseri'deki tümülüs tipi mezarlar," *Türk Arkeoloji Dergisi* 28 (1989) 189–221.

THE ELDER CLAVDIA
Older Women in Roman Art

SUSAN B.
MATHESON

One of the most striking aspects of Roman sculpture is the so-called veristic style that characterizes the portraits of the Late Republic. The naturalistic appearance of these portraits and the apparent verisimilitude with which they represent their subjects give us the feeling that we are truly looking at the faces of ancient Rome. Some scholars have argued that such portraits do not reproduce reality with perfect accuracy, seeing instead a set of stylistic conventions that create the illusion of naturalism.[1] This debate is beyond the scope of this paper, but a second proposal, namely, that the veristic style, whatever its level of accuracy, embodies or personifies or symbolizes Republican values, contributes in a significant way to our understanding of portraits of the Elder Claudia.

The veristic style appears most vividly in portraits of old men and women.[2] Here the signs of age are visible to all, in a matter-of-fact, unromanticized way. Our own culture makes it relatively easy for us to see the old man as dignified, wise, rich in life's experiences. But can we, products of a society that virtually worships youth, especially in women, see such lined female faces as embodying similar virtues rather than as being just old? Would it have been any easier for the Romans than for us? What was the Roman attitude toward older women, and how was the Elder Claudia portrayed in Roman art?

As we consider the portraits of old Roman women, we should remember that in ancient Rome, the average life expectancy for a person who survived the first year of life was between 20 and 30 years.[3] The average age of the Roman population was around 25. More than half the population was between 15 and 50, while more than a third was under 15. This meant that only around 15% of the population was over 50 and that only a very small proportion of the population survived into what we would consider old age. Women tended to die at a younger age than men, especially during the childbearing years, and fewer women than men survived into old age. There is no epigraphical evidence in Rome for women over the age of 85, although funerary inscriptions from Roman North Africa record women who lived to be 100, 115, and even 135.[4]

Much of our evidence for these statistics comes from funerary inscriptions. Historians will be familiar with the problematic nature of such evidence for establishing age at death. There is much information of value, but one must constantly bear in mind that although the sample is large (more than 25,000 inscriptions have been studied and tallied in the numerous articles on Roman demography), it is skewed and biased. A large portion of the population was not commemorated at death with such inscriptions. Children under the age of 1 were generally not honored, and older people were commemorated less often than wives and husbands in the childbearing years. As a woman aged, it became increasingly unlikely that a husband (on average nine years older than she) would survive to memorialize her. Parents were commemorated by their sons, but the age of the parents was often not included in the commemorative inscription. The majority of funerary inscriptions, in fact, do not record the age at death. This is especially true for older people. Funerary monuments tended to provide such facts about a

person's life only if there was something out of the ordinary or particularly touching to record: a girl who died before marriage, a mother and daughter who died together in a shipwreck, a long or an early marriage. Only in a few cases is a long life commemorated. The evidence of the funerary inscriptions is thus of most use for individual cases, and it will be used in this way from time to time in what follows.

Inscriptions provide evidence, for example, that women over the age of 50 continued to marry in Rome and its environs. Funerary epitaphs record such marriages at the age of 50 (a woman who lived to be 80 and was married to this husband for thirty years), 51, 57, and 64.[5] These women were presumably widows.[6] Augustan social legislation required remarriage of widows of the upper classes after a ten-month period of mourning, but this requirement ceased once a woman reached the age of 50. Many of these older Roman widows were wealthy, and they had the right to distribute their property at their death. This made them particularly vulnerable as targets for marital fortune-seekers, particularly if the widows were childless, and some of these late marriages may be the result of opportunistic suitors. The majority of older widows apparently chose to adhere to the ideal of the *univira* (the woman who married only once) or did so by default. Aside from the absolution from remarriage after the age of 50, Roman law has little specific to say about the rights of women over a certain age, and the implication is that their rights were the same as those of younger women.[7] The case is somewhat different in Roman Egypt, however, where a second-century papyrus from Alexandria records restrictions on women over 50. In Egypt, for reasons unknown to us, a woman over 50 could not inherit property, and a gift or dowry given by a woman over 50 to a man under 60 would be confiscated by the state.[8]

The problem in relating the statistics to Roman art is that although we have a good number of portraits of old/older women, few of them preserve inscriptions giving the age of the woman represented. A few of the sculptured funerary altars that Diana Kleiner has published state the age of the deceased, but most of the women were young; few were older than 30.[9] None of the freedman reliefs in Kleiner's study of this second type of monument gives any epigraphical indication of age.[10] Thus we must determine the age of the women from the portraits themselves.

Many of the large number of freedmen reliefs that show older women give their names as well as those of their family members or fellow freedmen who are represented with them. The inscriptions sometimes state the family relationships, although these must often be elicited from the relative age of the individuals as they are represented in their portraits. A typical example is a relief from the North Carolina Museum of Art, showing Vesinia Iucunda and her family (fig. 3.8 [vol. I, no. 150]).[11] All three figures are named. The *dextrarum iunctio* gesture indicates that the man to the left of Vesinia is her husband. Vesinia's face bears signs of aging, and she is shown as mother of a grown son, who is depicted as younger than Vesinia's husband. We are not sure who commissioned the monument and whether Vesinia was alive, recently dead, or long remembered. Although we do not know precisely how old Vesinia Iucunda actually was, yet we have no doubt that she was old. The visible signs of age in portraits of Roman women are the same as those we recognize in faces or portraits today.

The most typical indications of age are familiar enough. Sagging flesh is the most fundamental characteristic. It is evident, for example, in a first-century portrait (fig. 8.1)[12] and another from the third century,[13] both now in the Vatican, and in a third-century portrait in the Museo Capitolino in Rome (fig. 8.2).[14] The nasal labial lines are accentuated. We see sagging cheeks. There are bags under the eyes, and sagging eyebrows with creases at the corners. The neck muscles are attenuated, as on a late Flavian or early Trajanic portrait in the Capitoline (fig. 8.3).[15] We see crow's feet on the same portrait. We see sunken cheeks on this portrait and on many others. Sometimes an old woman appears to have lost her teeth, as in a Trajanic portrait in the Palazzo dei

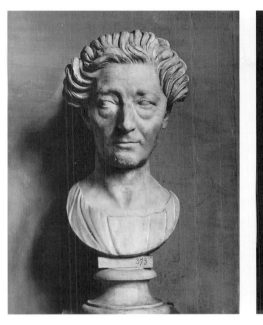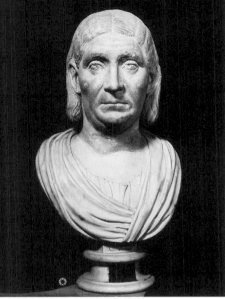

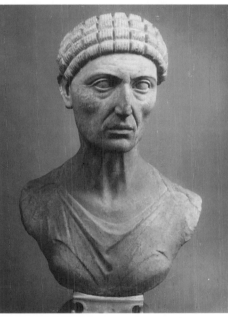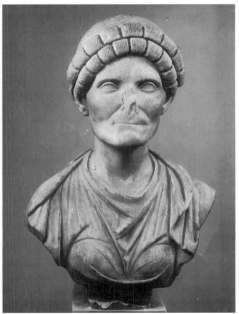

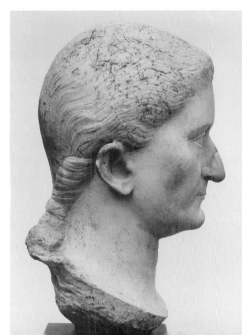

Conservatori (fig. 8.4).[16] Thinness accentuates some of these characteristics, as fatness does others. Age is often more evident in profile than in frontal view. Sometimes a tight-lipped severity of expression characterizes an old woman, as in a first-century portrait in Copenhagen (fig. 8.5).[17] What we do *not* generally see is the furrowed brow so characteristic of portraits of old men. Otherwise, the physical traits used to indicate age in portraits of women can generally be said to be the equivalent of those used in portraits of men.

Two aspects of a woman's appearance that do not seem to indicate old age are hairstyle and dress. While certain hairstyles, such as the so-called melon coiffure, were generally reserved for young girls, there is no corresponding "old age" hairstyle. Indeed, older women were as eager as their younger counterparts to be shown in their portraits in the most fashionable hairstyle possible. A typical example is the portrait of Petronia Hedone and her son from the Museum of Fine Arts, Boston (fig. 3.9 [vol. I, no. 151]).[18] Petronia's face shows signs of age, despite her elegant coiffure and dress. Petronia was still alive at the time the portrait was made, since the inscription indicates that she dedicated it herself. This may mean that the portrait reflects how she wanted to appear to posterity, in contrast to portraits executed after the death of the woman, when the woman's appearance may in some way have been controlled by others, in particular her husband.

An even more vivid demonstration can be seen in a portrait of Severan date in Copenhagen that shows an old woman wearing a wig.[19] One of several surviving portraits with added or updated coiffures, it is one of the few to show a woman advanced in years. Whatever the circumstances of the commissioning of this portrait and its new hair, the portrait provides clear evidence that continuing attention to fashion did not diminish with age. In this regard, it should be noted, the Roman woman did not differ from her male counterpart.

Within the context of fashionable coiffures, a hint of aging may be indicated by what appears to be thinning hair. In several portraits, a fundamentally stylish coiffure appears less full, less buoyant, and in some cases less detailed than its counterpart as worn by younger women (fig. 8.5).[20] The fundamental style is there, but it looks, in modern terms, as if it were done at home, rather than at a salon, or in eighteenth-century terms, as if it were the woman's own hair rather than a wig. If, as some scholars believe,[21] women quite frequently wore wigs as fashion accessories, then these portraits of older women may indeed be drawing a visible distinction between younger women who typically wore wigs and older women who did not.

What are these portraits of older women telling the Roman viewer? Freedman reliefs (e.g., fig. 3.8) emphasize the role of the older woman in the family, as wife and mother. This is a standard role, and it results in what appear to be standardized portraits, consistent within a narrow range in pose, hairstyle, and the devices used to indicate age. The importance of the inscription in these reliefs, with its emphasis on the name and freed status of the subjects, is equal to that of the portrait.

Greater individuality is evident in the freestanding portraits of the imperial period. In part, this can be attributed to skill in carving and the ability to pay for it. But the context for which the portrait was made and the status of the subject and commissioner may also have had an impact on its appearance. Like the freedman reliefs, many of these freestanding portraits were probably funerary, heads surviving from bust monuments that were installed in the family tomb or columbarium. Unlike freedmen reliefs, which could commemorate no more than two generations of a family,[22] individual portraits of many generations of the same citizen family could adorn the family tomb. Some of these portraits, especially those of men, may have stood in the house. These portraits, in contrast to the reliefs in facades of tombs that lined the streets, would be designed less for public consumption than for the successive generations of family, friends, and clients

who visited the house. Such viewers would be likely to be familiar with the appearance of the subject, and details of appearance would be correspondingly important. As in the reliefs, the freestanding bust portraits were probably accompanied by funerary inscriptions naming the deceased, but because the inscriptions were separate from the portrait, their significance relative to the visual image is diminished, increasing the importance of the descriptive representation of the individual.

In both funerary portraits and inscriptions commemorating women, epitaphs state that the women embody the virtues valued by Roman society.[23] In the case of older women, these are matronly virtues such as piety, fidelity, chastity, and care of family. Several terms describing general virtue are used, for example, *innocens, rarissima, praestans*. Service to others is celebrated: *mater omnium hominum* ("mother of all men"), *parens o[m]nibus subvenies* ("mother [or parent] who came to the aid of all"). The frequent role older women played in raising the family's children (grandchildren, nieces, and nephews) is acknowledged, with praise and affection: *conservatrix dulcissima* ("sweetest caretaker"). A cheery disposition is the virtue acknowledged at the close of an epitaph: *tristem fecit neminem* ("she made no one sad"). All these tributes are taken from a single epitaph, that of a woman who lived to the age of 81.[24] In another epitaph, a grandmother is acknowledged by her grandson with similar devotion: *avia carissima educatrix dulcissima* ("most beloved grandmother, sweetest bringer-up").[25]

Many readers will be familiar with a completely different and far less dignified image of older women in the Roman world, that of Roman comedy and satire, best represented in the work of Plautus, Terence, Horace, Juvenal, and Martial. Since the poets have created images of old Roman women every bit as vivid and visual as the marble portraits, it seems worth looking at these verbal images briefly and comparing them to the ideal projected by the marble portraits and epitaphs. Juvenal, in his sixth satire, "Against Women," can find nothing good to say about any married woman, young or old. Married women are oversexed, libertine drunks who wear too much makeup and squander the family fortunes on finery. Wealthy wives of noble birth think of nothing but their distinguished ancestors, and they are so boring that even their money cannot redeem them. Even if a man marries for money, once three wrinkles appear in the face of his wife, he will send her packing. If wives are a trial, old wives are unendurable.

Inappropriate behavior of all types in women of all ages is derided in satire and comedy, but older women, including such stock types as the mother-in-law, are particularly frequent targets. Much of the emphasis in this writing is on sex and the inappropriateness of interest in it among old women. Old women in satire are truly old, as old as the women of Troy (Martial).[26] They are like old crows, proverbially long-lived birds (Martial again, and Pliny on the birds).[27] They are repulsive: "rotted away with the passing of time, . . . [they have] blackened teeth and old age is ploughing [their] forehead[s] with wrinkles, . . . [they have] breasts sagging like mare's teats, . . . [a] pendulous belly, and . . . skinny thighs"; "their makeup, colored with crocodile dung, streaks in the heat" (Horace).[28] Gordon Williams, whose translations of Horace I quote here, quite rightly characterizes such writing as misogyny, while Amy Richlin has called it invective.[29] Both scholars emphasize that such writing, always by men, tells us more about the writers than about their victims. Richlin concludes that such "repulsive stereotypes give women a set of boundaries" for their behavior by defining what is *un*acceptable,[30] as opposed to the boundaries defining virtuous aspiration that characterize moralistic literature and the funerary epitaphs.

The more traditional view is also found in literature, for example, in Catullus 61, where the hope is expressed for a long and happy marriage lasting into old age.[31] Other traditional values prized in older women are mentioned by several writers. Seneca, the Stoic philosopher, encourages his mother not to mourn unduly, because she has always shown too fine a character to succumb to such excesses; the assumption is that noble

character continues into old age; Seneca's mother must have been at least in her 60s when this essay, "To Helvia on Consolation," was written. Ironically, he urges her not to be too much like a woman.

Cornelia, mother of the Gracchi, was perhaps the woman most consistently cited in literature as the epitome of the virtuous Roman matron, the ideal of Roman womanhood. Her story is well known. Daughter of a hero, wife of a noble Roman who chose to die so that she could live, Cornelia was left a widow with twelve children. Of these, only a daughter and two sons, who became heroes of the Roman people, survived, but Cornelia bore her sufferings so nobly and raised her surviving children so well that she became the ultimate role model. In her old age, she was commended for her learning, for remaining a widow, and for not showing her grief for her sons. Because of this last, according to Plutarch, "some thought she had lost her mind because she was old and had suffered so greatly" and that she did not show her grief because her misfortunes had made her insensible.[32] But Plutarch counters that it is Cornelia's critics "who are insensible of how much nobility and good birth and education can help one in times of sorrow"[33]—a man's view, but one that both Romans and modern students of Rome acknowledge as embodying the Roman ideal.

Sometimes the role a woman played outside the family dictated that she be shown at a mature age in a portrait. A Hadrianic portrait of a priestess, now in Boston, shows her in the act of sacrifice, that is, carrying out her public office.[34] This office was a position of dignity attainable only by a woman of proper matronly status and character; this status is indicated in the portrait by showing the mature age of the woman. Likewise, a mid-first-century portrait of a woman in the guise of the goddess Cybele, now in the J. Paul Getty Museum, depicts her at the mature age suitable for a priestess of this major cult.[35] The priestess of the Magna Mater, the Great Mother, should be a matron, not a young Venus. One might imagine that the portrayal of a woman in the guise of a goddess, such as we see in the Getty portrait, might be an occasion for idealization, and indeed this often occurs in portraits of deified empresses. The emphasis on individualization is dominant, however, in portraits of non-imperial women in the guise of goddesses. This is particularly striking in portraits of middle-aged matrons as Venus, but these are a special case, which Eve D'Ambra discusses elsewhere in this volume.

Occasionally a specific statue type was used to symbolize maturity. The so-called Large Herculaneum Woman, a fourth-century BC Greek type associated with Praxiteles, was used for portraits such as an Antonine statue in the Palazzo dei Conservatori.[36] Close in appearance and thus in date to portraits of Faustina the Elder, this portrait apparently represents a woman contemporary with the empress, not the empress herself. Portraits featuring this body type were used in both public and funerary contexts, and the type was favored by older women. The corresponding Small Herculaneum Woman, with a different pose and generally shown with her head bare, was favored for younger women. A portrait of a woman now in the Museum of Fine Arts, Dallas, uses the Small Herculaneum type, although with the head veiled like the Large type.[37] The face of the Dallas woman is young, like the body type, but the veiling of the head suggests a maturity equivalent to that of the Large type. This is one of the few instances where an element of dress is used to signify age.

The portraits that we have been looking at so far in this paper are non-imperial; they are the portraits of middle-class women and freedwomen rather than of empresses and other women of the emperor's family. Imperial portraits tell a more complex story.

A few empresses lived very long lives indeed, but one generally looks in vain for any indication of this in their portraits. Livia, for example, was born in 58 BC and died in AD 29, at the age of 86. In light of the statistics cited near the start of this paper, this was exceptionally old for a Roman woman. Historians do not describe Livia's appearance

(in contrast to Suetonius's detailed descriptions of Augustus and Caligula), except to say that Augustus was fascinated by Livia's beauty.[38] This statement, from the *Annals* of Tacitus, comes at the point where Tacitus records Livia's death. She is described as aged *(aetate extrema),* but there is no information about her appearance as the old woman she was when she died.

Her portraits are similarly silent, offering a generally idealized impression of her appearance. The traditional chronology divides Livia's portraits into four types.[39] In this view, Type I was probably made around 35 BC, at the time of Livia's marriage to Augustus; Livia was in her early 20s at this time. The portrait is classicizing, comparable to contemporary portraits of Augustus. Exemplary of Type I are the portraits in the Villa Albani and in Bonn.[40] Type II, which is dated to ca. 30 BC, is also classicizing; a portrait in Copenhagen is the primary example.[41] Type III, probably based on a type created in the 20s BC, is represented by another portrait in Copenhagen, which was used for a group dedicated in the Fayum probably after death of Augustus in AD 14.[42] Livia was thus over 60 when the Copenhagen portrait was dedicated, but she is still shown as youthful.

Type IV, the Marbury Hall type, is generally considered the latest.[43] According to Diana Kleiner, for example, the portrait shows "some signs of age," the "face [is] still unlined, although the flesh on her cheeks, jaw, and neck has begun to sag and there are slight lines next to her nose and mouth." The original of this type is thought to date between 20 and 10 BC, that is, when Livia was between 38 and 48. Based on surviving evidence, no new portrait types seem to have been created after this one, from the middle of Livia's life.

There is one exception to this general tendency toward youthful appearance, a portrait of Livia in Barcelona from the city of Ampurias (figs. 8.6–8.7).[44] The portrait shows evident signs of age, such as hollow cheeks, heavy nasal-labial lines, and thin lips and mouth. Rolf Winkes characterizes it as "rendered in the tradition of Roman Republican portraiture, reflecting so-called veristic traits," but he does not suggest that it replicates a Republican-style original. The portrait is an example of the Marbury Hall type, the only replica of the type to show aging to this degree. Winkes attributes the portrait's distinctive quality to the choice of the local artist, who may have emphasized aging in order to characterize Livia as a *matrona,* the proper image of the wife of the *princeps*.[45] In spite of the Barcelona portrait, Winkes has proposed repositioning the Marbury Hall type, traditionally considered the latest, as the earliest.[46] I leave it to scholars better versed in these matters than I to decide the merits of this case, but the very fact that such a suggestion can be made underscores the point that I wish to make here, namely, that there is little indication of aging in Livia's portraits. The Barcelona portrait remains an exception; Livia's portraits were generally idealized, like those of Augustus, throughout her lifetime. Since Livia's posthumous portraits were based on types created during her lifetime, this idealization naturally continued after her death and eventual deification.

A similar timelessness adheres to the portraits of many empresses, as we see, for example, in the portraits of Sabina.[47] There are a few exceptions, among them the portraits of Plotina, wife of the emperor Trajan. Plotina was born between 62 and 72 and died in 121/122; she was thus at most around 60 when she died. Her single portrait type can be dated on the basis of coins to 112; it thus shows her at an age somewhere between 42 and 52. She is associated with Vesta on coins, emphasizing the purity of her family life.[48] Surviving marble versions of this portrait type show a woman who is mature and aging but not truly old. A replica in the Capitoline Museum in Rome is the oldest-looking of these, showing creases between the brows and sagging flesh under the chin.[49] There is clearly less idealization here than in portraits of Livia or Sabina. Plo-

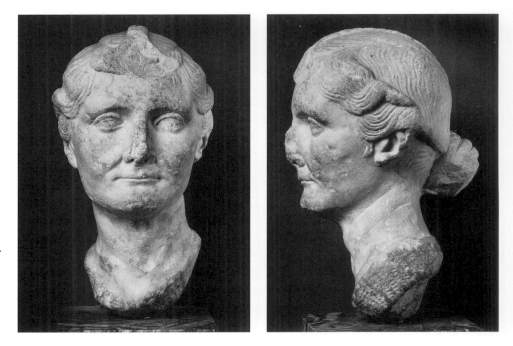

FIGURES 8.6 & 8.7
Portrait of Livia. **From Ampu-
rias. Barcelona, Museo
Arqueologico.** [Photograph:
Deutsches Archäologisches
Institut, Madrid (P. Witte)]

tina's portrait type was created when she was already in middle age, and with her asso-
ciation with Vesta, it was more appropriate to represent her as a *matrona* than as a young
bride.

A rare case in which the portraits of an empress show her aging over time is that of
Domitia Longina, the wife of Domitian. Eric Varner, in his recent study of Domitia's
portraits,[50] states that the Type III portraits, created after Domitian's death, include
"noticeable signs of aging." Among these are marked nasal-labial lines and heavy
pouches beneath the eyes, best seen in the portrait in Paestum.[51] Other versions of the
Type III portrait, such as the example in the San Antonio Museum of Art (fig. 8.8),[52]
although less extreme than the Paestum version, do show, in Varner's view, the sugges-
tion of flaccid cheeks, nasal-labial lines, and heavy underchins. Domitia lived into the
principate of Hadrian, and all the replicas of this third portrait type can be dated to the
principate of Trajan. Varner notes that Domitia's involvement in the murder of her hus-
band eventually led to Trajan's own succession to the principate, and it explains Trajan's
interest in including Domitia's portrait in his portrait galleries along with those of his
immediate female relatives.[53] I would also suggest that the visible signs of age in this last
portrait type emphasize that it represents Domitia after the assassination, underscoring
her continuity in favor beyond and in spite of the *damnatio memoriae* suffered by her
husband. This emphasis on the later life of Domitia could explain the divergence in
these portraits from the more frequent practice of showing the empress as eternally
young.

A slightly different scenario arises with a woman of the imperial family who did not
become empress. Antonia the Younger, daughter of Mark Antony and Octavia, niece
of Augustus, wife of Drusus the Elder, sister-in-law of Tiberius, mother of Claudius,
grandmother of Caligula, and great-grandmother of Nero, died by her own hand on
1 May 37. She was 72. Ancient writers record that Antonia was known for her beauty,
but they do not give a description of her.[54]

Three portrait types for Antonia have been defined by Patricia Erhart.[55] Type I,
described as youthful and idealized, is embodied in the portrait of Antonia on the south
frieze of the Ara Pacis and in a portrait in Catania.[56] Type II, defined as youthful and
individualized, is best seen in a portrait in Tripolis, from Leptis Magna.[57] The Leptis

Magna head is Tiberian and thus dates after his accession in 14, but Antonia is shown as youthful, even though she was already over 50 by the time Tiberius became emperor. Other portraits of this type were found with inscriptions naming Antonia as the mother of Claudius and the grandmother of Caligula—a youthful grandmother indeed. So far, Antonia's portraits follow the typical imperial pattern.

Definite signs of aging appear with Type III, however, which is called "mature and individualized" and is exemplified by a portrait in the collection of the Harvard University Art Museums (fig. 8.9 [vol. I, no. 11]).[58] This type first appears on coins struck by Antonia's son Claudius, but it was probably created under Tiberius. It shows Antonia at the age of around 45. The Harvard portrait is generally agreed to be the most mature portrait of Antonia to survive, and it is unparalleled among her confirmed portraits in the indications of age. Erhart describes it as having "drawn features, tight skin, pursed lips, thinness, a drooping chin, and a severe expression."[59]

A possible fourth type has been suggested in a portrait from Nomentum, now in the Museo Nazionale in Rome (fig. 8.10).[60] It was found together with a portrait of Drusus

FIGURE 8.8
Portrait of Domitia Longina.
San Antonio Museum of Art
86.134.99, Gift of Gilbert
Denman, Jr. [photograph:
museum]

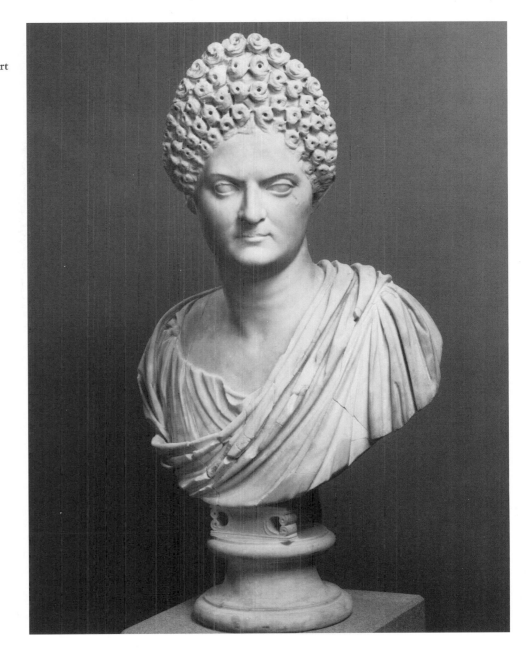

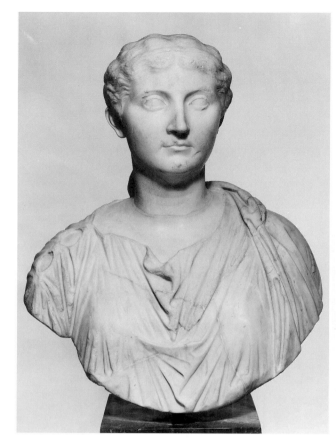

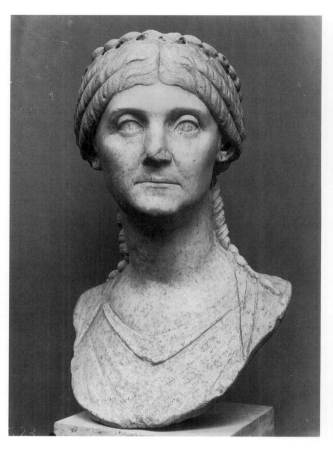

FIGURE 8.9
Portrait of Antonia the Younger.
Cambridge, Massachusetts,
Arthur M. Sackler Museum,
Harvard University Art
Museums 1972.306, Fund in
Memory of John Randolph
III, Harvard Class of 1964
and the David Robinson
Fund. [photograph: museum]

FIGURE 8.10
*Portrait of Antonia the
Younger(?).* From Nomen-
tum. Museo Nazionale
Romano 125713. [photo-
graph: Deutsches Archäo-
logisches Institut, Rome]

the Younger and one of Germanicus, both originally from statues. The three date from
the late Tiberian period to the time of Caligula and were apparently part of a Julio-
Claudian gallery of portraits officially exhibited in a building in the Forum at Nomen-
tum. The Nomentum portrait shows a more typically aged woman, along the lines of
the private portraits we have explored above, closer to what one would expect in a por-
trait of a woman in her late 60s or 70s. If it is Antonia, it is one of the least idealized
portraits of an imperial woman to survive, and it creates a vivid visual biography that
is a virtual renunciation of the normal imperial trend toward idealization.

The phenomenon of idealization is of course comparable to that widely recognized
in portraits of many imperial males, and its application to women is likely to stem from
the same sorts of reasons that inspired it in men. This is far too complex a topic to
discuss here, except to make two basic suggestions: first, that during the emperor's life-
time, idealization may be said to reflect the emperor's policies and values, and second,
that in posthumous portraits, idealization emphasizes the deification of the emperor.
Both of these explanations also appear to inspire portraits of women.

Imperial women were important as mothers, as producers of children who ensured
the continuity of the dynasty, and it would be appropriate to show them in their child-
bearing years to underscore this role. Idealization in this case thus emphasizes both
imperial policy and family values.

Deification or association with a goddess would also inspire idealization. A goddess
is eternally young. This is especially true of Venus, but even Juno, Vesta, Ceres, Cybele,
and Magna Mater, in other words the mature goddesses, are shown idealized. The por-
trait of the empress in the guise of any one of these goddesses idealizes her, shows her
young. Likewise, the portrait of the empress as the *diva,* the deified empress, idealizes
her and shows her young.

The different circumstances under which portraits of elderly imperial and non-

imperial women were commissioned may have determined the degree of objectivity seen in their likenesses. Imperial women often had portraits created at several points in their lives. The series of events that inspired such portraits (e.g., marriage, birth of children, awarding of the title *Augusta*) resulted in a succession of portrait types, most established in early to mid-life. Each new type recorded an event that was, in the larger picture, more important for the imperial dynasty and its policies than for the life of the empress herself. The empress's role rather than her biography was the message of these portraits, and the idealization of her physical appearance was appropriate in this context. The empress's assimilation to the ageless Venus, other deities, and personifications in her portraits only served to reinforce her ideal image. It was precisely through such assimilation and idealization that the portraits of the empress conveyed the values of the imperial family and served as vehicles for the dissemination of imperial ideals throughout the empire. When exceptions occurred, there were probably specific circumstances that warranted it, as noted above for Plotina and Domitia. With the desire to perpetuate the idealized image of the empress even after death, there was no need to create a new type showing the elderly empress, even if she lived long enough to merit it.

Most of the non-imperial female portraits, on the other hand, are funerary.[61] They must often have been the only portraits made of a given individual. For some women, this meant that the first time they were represented in a portrait was when they were old. Here the recognition factor becomes important. As Diana Kleiner has shown, funerary portraits of the non-elite were very public monuments, a source of pride for their owners.[62] This pride is evident in the inscriptions but equally evident in the individualization of the portraits. The Romans who commissioned the portraits wanted the Romans who saw them to recognize the face as well as the name. If that face showed signs of age, it only served to emphasize the long life of virtue lived by the deceased. It is the piety, chastity, nobility, and *gravitas* celebrated in heroic older Roman women such as Cornelia, mother of the Gracchi, that are evoked in the dignified, at times severe, portraits of elderly Roman women.[63] The Roman emphasis on the dignity of the matron and the moral authority of the mother, both of which increased with age, is what encourages the realistic representation of aging in portraits of Roman women. The Romans saw these virtues embodied in visual images of aging as much as in the more obvious epitaphs. Respect for maturity is inherent in the realistic images of older men and women alike. That these elderly women appeared severe in their nobility rather than lovable reflects the Republican origin of this concept of the ideal matron. A "veristic" representation of aging perfectly embodies a Republican ideal of virtue.

NOTES

In the course of preparing this paper, I have benefited from discussions with Gordon Williams, Eric Varner, and Colin Wells, and it is a pleasure to thank them here.

1. E.g., S. Nodelman, "How to Read a Roman Portrait," *Art in America* (January/February 1975) 27–33; J.P. Small, "Verism and the Vernacular: Late Roman Republican Portraiture and Catullus," *PP* 37 (1982) 41–71; see, however, Kleiner, *Roman Group Portraiture* 88–117 for the changing degrees of objectivity and idealization in the evolution of Republican and early Augustan group portraiture.

2. Man: the so-called *Capito Velato,* Musei

Vaticani: Museo Chiaramonti 135 (1751) ; old woman from Pompeii, Museo Nazionale Archelogico, Naples: B. Andreae, *The Art of Rome* (New York 1977), figs. 171 and 172 respectively. Kleiner, *Roman Group Portraiture* 96–107 demonstrates that portraits of women prior to 30 BC are idealized, while the veristic style is already in use for portraits of old men by this time. Objective, descriptive portraits of old women become common, although not universal, in the period between 30 and 13 BC, and they continue into the Republican period, despite the classicizing trends in Augustan court portraiture.

3. The literature on demographics in ancient Rome is extensive. I have relied on R.P. Saller and B.D. Shaw, "Tombstones and Roman

Family Relations in the Principate: Civilians, Soldiers and Slaves," *JRS* 74 (1984) 124–56; K. Hopkins, "On the Probable Age Structure of the Roman Population," *Population Studies* 20 (196) 245–64; A.G. Harkness, "Age at Marriage and Death in the Roman Empire," *TAPA* 27 (1896) 35–72; B. Frier, "Roman Life Expectancy: Ulpian's Evidence," *HSPh* 86 (1982) 213–51; I. Kajanto, "On the Problem of the Average Duration of Life in the Roman Empire," *Soumalainen Tiedeakatemia* 153 (1968) 1–30; see also J.D. Durand, "Mortality Estimates from Roman Tombstone Inscriptions," *American Journal of Sociology* 65 (1959–1960) 365–73; F.C. Bourne, "The Roman Republican Census and Census Statistics," *CW* 45 (1952) 129–35; W.R. Mac-Donnell, "On the Expectation of Life in Ancient Rome," *Biometrika* 9 (1913) 366–80; A.R. Burn, "*Hic breve vivitur:* A Study of the Expectation of Life in the Roman Empire," *Past and Present* 4 (1953) 1–31.

4. Pliny's report of the census under Vespasian (*HN* 7.162–64) lists several men aged 100 or over; some scholars believe that these ages (and the North African ones) are exaggerated, possibly as a function of the difficulty in calculating age using the consular calendar. Ulpian's life expectancy chart (Life Table) for the structure of annuities in the *Digest* is another written source often cited as evidence. Bruce Frier finds that it is more or less consistent with the results/statistics derived by scholars from the funerary inscriptions combined with modern (United Nations) population studies.

5. Harkness (supra n. 3) 49.

6. On widows in Roman law, see Gardner, *Women in Roman Law* 50–57. On widows in Roman Egypt, see Ann Ellis Hanson, "Widows Too Young in Their Widowhood," in this volume.

7. Most aspects of Roman law that would have applied to older women would have related to questions of inheritance, especially after remarriage; on these, see Gardner, *Women in Roman Law* 50–57, 179–90.

8. Berlin Papyrus 1210, Alexandria, second century, cited and translated in Lefkowitz and Fant 119–20.

9. D.E.E. Kleiner, *Roman Imperial Funerary Altars with Portraits* (Rome 1987).

10. Kleiner, *Roman Group Portraiture.*

11. Raleigh, North Carolina Museum of Art 79.1.2; V. Kockel, *Porträtreliefs Stadtrömischer Grabbauten* (Mainz 1993) no. K3, pls. 82.a–c, 83.e; D.E.E. Kleiner, "Social Status, Marriage and Male Heirs in the Age of Augustus: A

Roman Funerary Relief," *North Carolina Museum of Art Bulletin* 14 (1990) 20–28; Kleiner and Matheson, *I, Claudia* cat. no. 150.

12. Musei Vaticani, Museo Gregoriano Lateranense Profano; L. Goldscheider, *Roman Portraits* (Oxford 1940), pl. 39.

13. Musei Vaticani, Museo Gregoriano Lateranense Profano inv. no. 597; Goldscheider (supra n. 12), pl. 75.

14. Museo Capitolino 472; Fittschen-Zanker III 110 no. 164, pls. 192–93.

15. Rome, Museo Capitolino 400; Fittschen-Zanker III 58–59 no. 78, pls. 97–98.

16. Rome, Palazzo dei Conservatori 2430; Fittschen-Zanker III 58 no. 77, pls. 96–97.

17. Ny Carlsberg Glyptotek 605 (I.N. 741); Poulsen I 112 no. 76, pls. 132–133.

18. Boston, Museum of Fine Arts 1899.348; Kleiner and Matheson, *I, Claudia* cat. no. 151.

19. Ny Carlsberg Glyptotek 733a (I.N. 2741); Poulsen II 14–46 no. 143 (as Julia Maesa?), pls. 230–31. On portraits of women with separate wigs and hairpieces, see Kleiner and Matheson, *I, Claudia* cat. no. 130, with additional bibliography.

20. E.g., several portraits in Copenhagen: Poulsen I nos. 76 and 102, when compared with nos. 75 or 80, similar/contemporary hairstyles on younger women; also Poulsen I no. 118; and several in Rome: Fittschen-Zanker III no. 164, when compared with no. 161 or no. 162, or even the more modest no. 159.

21. See the discussion in Eve D'Ambra, "Nudity and Adornment," in this volume.

22. Kleiner, *Roman Group Portraiture* 18.

23. E.g., the relief portrait of Cominia Tyche in the Metropolitan Museum of Art, New York, where she is celebrated as *sanctissimae, castissimae, amantissimae;* Kleiner and Matheson, *I, Claudia* cat. no. 149. For other epitaphs enumerating virtues, see R. Lattimore, *Themes in Greek and Latin Epitaphs* (Urbana 1940) 266–300.

24. *CIL* VIII, 7384: *conservatrix dulcissima, mater omnium hominum, parens o[m]nium subvenies, innocens, castissima, praestans, rarrissima, v(ixit) a(nnos) LXXXI. tristem fecit neminem,* as cited by Lattimore (supra n. 23) 295 (my translations).

25. *CIL* VI, 1478, as cited by Dixon, *Roman Family* 155 (translation Dixon). On the grandmother and other mother substitutes, see S. Dixon, *The Roman Mother* (Norman 1988) 141–67, esp. 154; as Dixon (*Roman Mother* 154) notes, Quint. *Inst. Or.* 6 praef. 8, spoke of his son being raised by a grandmother *(avia educans).*

26. Mart. *Epig.* 10.67.1–4; other examples cited by A. Richlin, "Invective Against Women

in Roman Satire," *Arethusa* 17 (1984) 67–80, esp. 69–70.

27. Mart. *Epig.* 10.67.5; and Pliny *HN* 7.153. on the longevity of crows.

28. Horace *Epodes* 8 and 12, trans. G. Williams, "Representations of Roman Women in Literature," Kleiner and Matheson, *I, Claudia* 134.

29. Williams (supra n. 28) 134–37; Richlin (supra, n. 26).

30. Richlin (supra n. 26) 77.

31. G. Williams, "Some Aspects of Roman Marriage Ceremonies and Ideals," *JRS* 48 (1958) 16–29; T.E.V. Pearce, "The Role of Wife as *Custos* in Ancient Rome," *Eranos* 72 (1974) 19–33. Pearce also cites Tib. 2.2.19–20 as mentioning old age and being about the love of married couples.

32. Life of Gaius Gracchus, trans. Lefkowitz and Fant 21.

33. Life of Gaius Gracchus, trans. Lefkowitz and Fant 21.

34. Boston, Museum of Fine Arts 34.113; ca. 125–130; M.B. Comstock and C.C. Vermeule, *Sculpture in Stone: The Greek, Roman, and Etruscan Collections of the Museum of Fine Arts Boston* (Boston 1976) 224 no. 355.

35. Malibu, The J. Paul Getty Museum 57.AA.19; Kleiner and Matheson, *I, Claudia* cat. no. 64.

36. Palazzo dei Conservatori 904; Fittschen-Zanker III 69 no. 90, pl. 111.

37. 1973.11; Kleiner and Matheson, *I, Claudia* cat. no. 71. On the uses of the Herculaneum woman types, see M. Bieber, "The Copies of the Herculaneum Women," *ProcPhilSoc* 106 (1962) 111–34.

38. Tacitus *Ann.* 5.1.

39. For the traditional chronology, see W.H. Gross, *Iulia Augusta: Untersuchungen zur Grundlegung einer Livia-Ikonographie* (Göttingen 1962); Fittschen-Zanker III 1–3; Kleiner, *Roman Sculpture* 76–77, with additional bibliography on 118.

40. Villa Albani-Bonn type: Villa Albani 671 (Fittschen-Zanker III 2, n. 3a; Kleiner *Roman Sculpture*, fig. 53); Bonn, Akademisches Kunstmuseum B79 (Fittschen-Zanker III 2, n. 3b).

41. Copenhagen, Ny Carlsberg Glyptotek 616 [I. N. 748] Fittschen-Zanker III 2, n. 4a; Poulsen I 71 no. 35, pls. 55–56.

42. Copenhagen, Ny Carlsberg Glyptotek 615 [I. N. 1444] Fittschen-Zanker III 2, n. 6a; Poulsen I 65–71, pls. 52–54; Kleiner, *Roman Sculpture*, fig. 54.

43. Fittschen-Zanker III 7 (for a list of replicas, 3, n. 7); Gross (supra n. 39), pl. 18; Kleiner, *Roman Sculpture* 76–77; R. Winkes, *Livia, Octa-via, Iulia (Archaeologica Transatlantica,* Louvain 1995) 25–33.

44. Barcelona, Museo Arqueológico, from a Roman villa at Ampurias. R. Winkes, "A Spanish Image of Livia," *RBArch* (1990) 75-78; Winkes (supra n. 43) 26–28, 84 cat. no. 5; E. Bartman, *Portraits of Livia: Imagining the Imperial Woman in Augustan Rome* (Cambridge 1999) 166 no. 45, figs. 151–52. I am grateful to Professor Winkes for bringing this portrait to my attention.

45. In spite of the Barcelona replica, Winkes argues that the Marbury Hall type is the earliest Livia type because its hairstyle is closest to those of Octavia, as well as the most complex of Livia's coiffures. Since the general tendency in Augustan portraiture is toward increasingly simple hairstyles and features, such complexity indicates an early portrait. The Barcelona/Marbury Hall type would be succeeded, in Winkes's chronology, by the Albani-Bonn type, considered Type I by other scholars, as noted above. It is difficult, in my view, to see the Marbury Hall type as representing Livia in her 20s, even leaving the Barcelona replica aside.

46. See Winkes, "Livia," in this volume and his recent book on portraits of Livia (supra n. 43).

47. On portraits of Sabina, see Wegner, *Hadrian;* A. Carandini, *Vibia Sabina* (Florence 1969); Kleiner and Matheson, *I, Claudia* cat. no. 23.

48. E.g., an aureus of 113–117: *RIC* 730.

49. Museo Capitolino 439; Fittschen-Zanker III 8–9 no. 7 pl. 9; on the dating of Plotina's portraits, see Fittschen-Zanker III 8–9; also Wegner, *Hadrian* (on Plotina). A version from Ostia, now in the Museo Nazionale delle Terme 339 (Kleiner, *Roman Sculpture* 212, fig. 176), shows the empress with an idealized unlined face; Fittschen-Zanker consider both the Terme and Capitoline portraits as lifetime images.

50. E.R. Varner, "Domitia Longina and the Politics of Portraiture," *AJA* 99 (1995) 187–206.

51. Museo Archeologico; U. Hausmann, "Zu den Bildnisse der Domitia Longina und der Julia Titi," *RM* 82 (1975) 320, pl. 109.1.

52. 86.134.99; Kleiner and Matheson *I, Claudia* cat. no. 125. Varner confirmed to me at the symposium that the San Antonio portrait is the one formerly in the Landsdowne collection; see his note 93 (supra n. 50), with bibliography.

53. Varner (supra n. 50) 204–205.

54. Sources are cited by N. Kokkinos, *Antonia Augusta: Portrait of a Great Roman Lady* (London 1992) 194, n. 81.

55. K.P. Erhart, "A Portrait of Antonia Minor in the Fogg Art Museum and Its Iconographical Tradition," *AJA* 82 (1978) 193–212.

56. Ara Pacis: Erhart (supra n. 55), fig. 4; on the identification of this portrait as Antonia, see n. 15. Catania, Museo Communale 361: Erhart (supra n. 55), figs. 8–9.

57. Erhart (supra n. 55) 203, fig. 12.1.

58. 1972.306; Kleiner and Matheson, *I, Claudia* cat. no. 11.

59. Erhart (supra n. 55) 208–209.

60. Kokkinos (supra n. 54) 128–29, fig. 86, for bibliography, see 204, n. 48; for the group, see L. Nista in M.L. Anderson and L. Nista, *Roman Portraits in Context,* exhibition catalogue, Emory University Museum of Art and Archaeology, Atlanta, 14 July 1988–3 January 1989 (Rome 1988) 47–51 cat. nos. 5–7.

61. Private portraits commissioned for display in the home would generally have been of men, not women. Public portraits of non-imperial women who were celebrated as benefactors were generally identified by inscription, permitting them to be more idealized images, often adaptations of stock Greek statue types.

62. Kleiner, *Roman Group Portraiture* 18–20.

63. E.W. Leach ("The Politics of Self-Presentation: Pliny's *Letters* and Roman Portrait Sculpture," *ClAnt* 9 [1990] 14–39) argues that Pliny the Younger does not view physical appearance as a reliable indicator of character. This would certainly be a strong Roman voice against the position proposed here. However, as Leach acknowledges, Pliny concedes that it is natural to want a good likeness, that commissioners of portraits can and should make choices in the physical traits that they wish to have featured in their portraits and that they can and should seek the sculptor or painter best qualified to represent them. Again, as Leach admits, Pliny sees physical appearance as an indicator of the person's place in a structure of social values, and since the character traits that I see evoked in the portraits are those valued by Roman society, I see no fundamental conflict between Pliny and the view offered here.

MARRIAGE EGYPTIAN STYLE

DIANA DELIA

Thousands of Greeks immigrated to the brave new world of Egypt after the Macedonian conquest in 332 BC. Many were mercenaries, attracted by the prospects of good pay and conditions of service such as those celebrated by Theokritos in his 14th *Idyll*.[1] After serving on campaigns for which they had initially enlisted, some mercenaries availed themselves of the opportunity to become settlers in the recently reclaimed area south of Memphis constituting the Arsinoite nome, known today as the Fayum. Here, in return for military service upon summons, they procured land allotments to work themselves or lease to others. Some came to Alexandria, attracted by the city's urban sophistication and extraordinary commercial potential, already notable under the early Ptolemies.[2] Glowing reports sent home from Egypt encouraged a steady flow of immigrants, seeking their fortunes or family reunion.[3]

At Alexandria, Memphis, and other cities in Egypt, immigrants tended to settle in ethnic neighborhoods where they endeavored to perpetuate their cultural identities in an environment that was essentially alien.[4] At the same time, especially in towns and villages where compatriots were scarce, Greek settlers entered into lawful marriages with native Egyptians. This furthered the Hellenization of Egyptian partners but also enhanced Greek understanding of Egyptian practices.[5]

The marital activities of the second-century BC Cretan cavalry officer Dryton admirably illustrate both patterns. Dryton himself (or his family) appears to have emigrated to Egypt from Crete. When we meet him in the documents, he is described as a citizen of Ptolemais.[6] Earlier he had been married to an *aste,* or female citizen, presumably of the same city, who bore him a son; this earlier marriage was dissolved by death or divorce. Subsequently, Dryton settled at Pathyris in the Thebaid where he married Apollonia a/k/a Senmonthis, whose family members going back four generations had dual Greek and Egyptian names. Occasionally, Apollonia-Senmonthis employs her husband as a *kyrios* (legal representative) in business transactions; but the archive also contains several contracts in which she acts independently without recourse to one. Hence sometimes we see her operating as a proper Greek matron, at other times exercising the independence accorded Egyptian women under native law, namely, possessing their own legal identity and conducting their own affairs as the equals of men and responsible for their own actions.[7] As for Dryton, forty years of marriage to a shrewd businesswoman must have inculcated respect for the self-sufficiency of Egyptian women, and this may explain the alteration in his final will deleting the appointment of guardians, even for their minor daughters.[8]

Among ancient Mediterranean peoples, cohabitation or sharing a household constituted lawful marriage. Marriage was a private act requiring simple consent, devoid of religious or legal ceremonies and documentation.[9] One of the tales in the ancient Egyptian Setne Khamwas cycle describes a typical Egyptian marriage: the bride, Ahura, was taken to her husband's home and received presents from her family; a family celebration was held in the new home, then the couple slept together.[10] Athenian marriage

likewise involved the transfer of a bride to the house of her intended spouse.[11] Friends and relatives gathered at the bridal home for a wedding feast while another banquet was also held for members of the husband's *phratry,* or clan. Children born to the couple were formally presented by their father to his clansmen and declared on oath to be born from an Athenian citizen and his lawful wife. When sons reached 18 years of age and applied for citizenship, the oral testimony of these guests was solicited in corroboration of their claim.[12] Among Romans, too, marriage was defined as cohabitation, initiated by the merry procession of a bride and her parents to her new home, where she would be handed over to her husband.[13]

Until the *constitutio Antoniniana* bestowed Roman citizenship on most of the inhabitants of the Roman empire circa AD 212, Greek settlers in Egypt found their situations radically altered; unless admitted to citizenship in one of the four Greek cities there, they lived outside the traditional structure of the *polis,* forfeiting the political rights and collective body of social traditions formerly enjoyed in their native cities as well as the sanctions securing these. Moreover, no new written law code could possibly accommodate the vast range of customs of Greek settlers coming from so many different cities. For persons living in mixed marriages, a certain accommodation with Egyptian practices also had to be made.

Although marriage was an oral compact among Egyptians, Greeks, and Romans that did not require the drawing up of written contracts, Greek immigrants to Egypt needed a viable means of articulating matrimonial rights, responsibilities, and sanctions formerly protected by the laws of their native cities.[14] To this end, they adapted to their own needs an already existing Egyptian practice that was distinct from, but ancillary to, the marriage act itself: entering into matrimonial property agreements either at the time of marriage or at some subsequent date.[15]

Hundreds of Egyptian matrimonial property agreements, written in demotic, have been collated and studied by Pieter Pestman, Erich Lüddeckens, and Janet Johnson. These tend to fall into three distinct categories:[16]

In the first type of document, the husband promises to give his wife as a "marriage gift" a stipulated sum in coin or grain; the "women's possessions" brought by the wife are listed along with their valuation. During the marriage, the husband administers both his "marriage gift" and the "women's possessions." In the event of divorce, the husband agrees to restore the "women's possessions" to his wife in the form of similar goods or their value. If the husband divorces the wife by repudiation, he will also hand over the marriage gift as a penalty.[17]

A second type of matrimonial property settlement took the form of an I.O.U. declaration by the husband acknowledging that he has received from his wife the "payment to become a wife"—a stipulated sum in coin (or occasionally goods) that the husband will manage during the marriage; in return, the husband promises to repay his wife by means of an annual food and clothing allowance. In the event of divorce, the husband must repay in thirty days the entire unpaid balance of "the payment to become a wife."

A third type is a variation of the preceding, in which the husband pledges all of his property as security for repaying "the payment to become a wife."[18]

All three types of agreements were entered into either at the time of marriage or many years later by couples long since married and even possessing children. Hence these contracts did not document the marriage act, but are essentially economic agreements, itemizing the financial contributions of both partners and detailing the husband's obligations; from this point of view, they especially favor women. In all the contracts, a wife is assured the return of her "women's possessions" regardless of who initiates divorce. Moreover, in the first type of contract, a repudiated wife also receives the entire "marriage gift" contributed by her husband. In the third type, full reimbursement of the wife's "payment to become a wife" is secured by all of her husband's prop-

erty. Hence Egyptian women and their families probably urged potential or already existing husbands to enter into such agreements, and the contracts approved by long-married partners may have been due to new economic circumstances, such as inheritance, that now made such agreements desirable.

Another Setne Khamwas tale illustrates the lengths to which some women might go to secure a matrimonial property agreement.[19] One day Setne saw and lusted after Tabubu, the lovely daughter of the priest of the Bastet temple at Memphis. He sent servants with bribes to entreat her to sleep with him; but Tabubu led Setne on until he agreed to draw up a matrimonial property contract pledging all his property as security. Thoroughly infatuated, Setne complied at once. Then, when Tabubu appeared in a diaphanous garment that left nothing to his imagination, he hastened to grant her further demand that his children also subscribe to the contract. Before the interview was over, wily Tabubu apparently brought about the deaths of these children, lest some day they prevent her or her children from inheriting Setne's estate. Having achieved this goal, Tabubu at last agreed to lay down with Setne. He stretched out his hand to touch her, and she opened her mouth wide in a loud cry. Setne awoke in a state of great heat, his phallus in a (chamberpot?).[20] Finding clothes and escaping to Memphis, Setne ultimately discovers that his children were actually alive and the encounter with Tabubu was merely a dream or delusion induced by powerful magicians seeking the scroll of Thoth, which he had stolen. Apart from its lascivious appeal, this Setne Khamwas story imparts the didactic message that men ought to be wary of cunning women demanding matrimonial property settlements.

Egyptian women's ability to take initiative and represent themselves sharply contrasts with the limitations imposed on traditional Athenian and Roman women. An Athenian daughter remained under the power of her father, normally also her guardian, until given by him in marriage to a husband who became her new guardian and whose household she joined. The bride's father nevertheless retained the right to dissolve his daughter's marriage.[21] Throughout their lifetimes, Athenian women might not own land and were never legally capable of self-representation.[22] Roman women subject to *patria potestas* were likewise given by their fathers in marriage. Once emancipated *(sui iuris),* they might own property but could not administer it without the consent of their guardians until Augustan legislation released freeborn married women who had produced three children (and freedwomen, four) from this restriction. Women who married with *manus,* although rare by the early principate, merely exchanged subordination to paternal authority for that of husbands.[23]

Greek adaptation of the Egyptian matrimonial property contract first appears in the form known as the συγγραφὴ συνοικισίου or marriage contract, the earliest example of which dates to 311 BC.[24] Note how the description of the partners' respective financial contributions, so precisely detailed in the Egyptian contracts, has been truncated to mere valuation of the dowry and the declaration that the husband will provide all necessities; here, too, as in the Egyptian contracts, the wife's dowry is secured by the husband's property. In view of the traditional subordination of a Greek wife to her husband, the egalitarian nature of this contract is truly remarkable: the couple will jointly decide where to live and on the selection of arbitrators in the event of malfeasance, and each will be given a copy of the contract in the event it becomes necessary to produce it against the other. Moreover, husband and wife are subject to equally severe penalties for moral transgressions. One actually wonders whether Egyptian attitudes about female capability had already begun to influence Greeks residing in Egypt, since this would explain the unusual deference accorded to wives in such agreements.

By the mid second century BC, a new type of Greek matrimonial property contract appears, the συγγραφὴ ὁμολογίας, of which there are nearly a hundred examples published to date.[25] This type differs from συγγραφὴ συνοικισίου contracts, insofar as

the bride is no longer being offered or bestowed (ἔκδοσις) by her father or guardian. Here again, the impact of Egyptian attitudes concerning women can perhaps be discerned, since this innovation abandons the treatment of women as marital objects. P. Tebt. I 104 is a typical example, notable for its detailing of the partners' marital obligations to one another. Many similar contracts were endorsed by couples who had hitherto been living together in ἄγραφος γάμος. Although the onomastic criterion is risky to employ, so many Egyptian names occur as the names of marital partners in these Greek contracts that it appears to be the case that Hellenized Egyptians began to employ the Greek form of matrimonial property agreement in lieu of their own.[26] Roman citizens living in Egypt also adopted the form to document *donationes ante nuptias,* which also was the only time that potential marital partners might legally exchange gifts.[27]

In the fascinating study, *Ancient Egypt: Anatomy of a Civilization,* Barry Kemp characterizes the Egyptian mindset as "tidy" and "bureaucratic," precise in inspection, description, measurement, and quantification, exact in the recording and preservation of such details. Scribes were ubiquitous in all Egyptian cities and towns, accompanying officials on their rounds and abundantly staffing religious and administrative centers. Village clerks like Menkhes, residing in the town of Kerkeosiris during the last quarter of the second century BC, were constantly dictating or writing reports, inspecting and listing properties, and routinely corresponding with local residents as well as their superiors.[28] Regardless of medium—monumental stone, ostraca or papyrus—this penchant to record in order to convey and preserve essential information was very ancient; from pharaonic through Roman times, row after row of texts were inscribed on the walls of royal monuments, private tombs, and just about everywhere Egyptians frequented.[29]

Documentation pervaded every aspect of Egyptian life and was especially evident in judicial matters. Writing shortly after the Roman annexation of Egypt, Diodorus Siculus's description of standard procedure in Egyptian courts demonstrates the extent to which Egyptian practices contrasted with Greek forensic rhetoric:[30]

It is the custom for a plaintiff to list the bases for his accusations, how they happened, and the cost of the injury or damages incurred. Next the defendant, on receiving the plaintiff's written complaint, prepares a written response to each charge. . . . The law then requires the accuser to write a rebuttal and the defendant once again to respond. After both parties have twice rendered their written arguments to the judges, the thirty judges must take counsel with one another, and finally the chief justice places the small figure of Truth on one of the two written briefs. Egyptians conduct all court cases in this way, convinced that the eloquence of advocates often obscures the truth and that clever orators, the spell cast by a harangue, or the tears of the accused would cause many men to disregard the rigor of both laws and the truth.

Although Diodorus has sometimes been dismissed as an unreliable witness, abundant evidence corroborates his testimony about the pervasiveness of writing in Egyptian investigations and judicial proceedings, most notably the official documents concerning the great Theban tomb robbery of 1107 BC.[31] Numerous treasures from the tomb of Queen Isis, wife of Ramses III, had been found in the homes of eight tomb makers, apparently uncovered in the course of a non-routine house-to-house search. A list of the loot was carefully drawn up, each man's portion weighed and listed, before the men were taken across the river and incarcerated in a storeroom of the temple of Ma'at, pending trial. Scribes were present at the interrogation of the men and their relations, who were compelled by beatings and torture to name names so that all the thieves and their associates, having received a share of the stolen grave goods, might be rounded up. Confessions by the robbers, detailing what they had taken, kept, or disposed of and to whom, were extracted and carefully written up to aid in recovery of the items, which, eventually, was completely successful. Meanwhile, a commission was sent across the

river to inspect security arrangements for the necropolis, and a list of village houses was drawn up. The entire village was punished by withholding of grain rations for more than forty days pending successful conclusion of the investigation. Naturally, villagers were in an uproar. Each day, scribes of the village record entries in their papyrus journals as follows: "The tomb makers do not work, they are hungry and weak; eight prisoners remain in the temple of Ma'at." [32] By the time the workers were brought to trial, every name entered in the confessions had been tracked down, and a final list of the recovered items was prepared. At the trial, this entire body of written evidence was presented to the tribunal. While it is true that this incident occurred more than a millennium before the Roman annexation of Egypt, it is equally true that ancestral customs of ancient Egyptians were adamantine and often impervious to the passage of time.

Commenting on the transmission of family records by one generation to the next among classical Athenians, Rosalind Thomas noted the very short span of family memory supported by oral transmission alone. [33] Eighteen years after the birth of a son to Athenian citizens, it was still possible to summon the oral testimony of clansmen who had witnessed the father's acknowledgment of paternity. But how many clansmen would conceivably be living two generations or more after the event? And how could these same oral practices serve citizens who abandoned their native communities in order to assume permanent residence overseas?

It is for such reasons that I suggest that Greek immigrants to Egypt adopted a "papyrological habit" (to modify a phrase coined by Ramsay MacMullen with reference to the abundance of Roman imperial inscriptions [34]), a habit that had already extensively permeated Egyptian society. That is not to claim a high degree of literacy for Hellenistic and Roman Egypt, which would be untrue, but rather to observe that people at every social and economic level enjoyed the affordability of papyrus and inexpensive, ready access to professional scribes. In mobile societies, the benefits of certified or certifiable written documentation are soon appreciated whenever it becomes necessary to substantiate vital information. Moreover, among Greeks, whose litigiousness was proverbial, the ability to enter into evidence documents that substantiated claims must have proved irresistible. Already in the private orations of fourth-century Athenian orators, written depositions of witnesses regularly appear as part and parcel of the trial record.

An interesting document demonstrates just how useful written documentation could be. [35] This is the petition of an abandoned wife, Syra, to the chief justice of a Greek court, complaining that her husband had squandered the dowry entrusted to his care, insulted, beaten, and then finally deserted her. She refers to the sum of her dowry noted in the matrimonial property contract they had drawn up and demands that her husband be compelled to repay both this and the additional 50% penalty stipulated in the contract for contravention of his obligations. [36] While we do not know the outcome of Syra's petition, it is clear that she was in a much stronger position to regain what was rightfully hers by being able to produce written documentation as evidence in support of her claims. In this respect, too, marriage Egyptian style enhanced the social recognition and economic advantages of women residing in Egypt sooner and to a far greater extent than anywhere else in the Hellenistic and Roman world.

APPENDIX OF DOCUMENTS

1. Matrimonial Property Agreement (BM 10394: [Thebes, 226 BC])

Year 21, . . . Epeiph, of King Ptolemy (III), son of Ptolemy (II) and Arsinoe (II), the Brother-Sister Gods, Melas, a Greek, son of Apollonios, his mother being Raru, says to the woman Senobastis, daughter of Ptolemy, her mother being Senminis:

I have made you my wife. I have given you 1 deben of silver (or 5 staters) . . . as your marriage gift. If I dismiss you as wife, whether to slight you or because I love another woman, I will give you 2 debens of silver (or 10 staters) in addition to the aforesaid sum I have given you as your marriage gift, making 3 debens of silver (or 15 staters) in all.

Your oldest son is my oldest son, master of all the property I now possess and also whatever I shall acquire. I will give you one-third of all the property I now possess and whatever I shall acquire.

Description of the women's possessions that you have brought with you to my house: a veil (valued) at 1 deben of silver, 6 kites, a cloak at 2 -1/2 kites, a garment at 1 deben of silver, a bronze [. . .] at 1-1/2 kites, a bronze cup at 1 kite, a [. . .] at 1 deben of silver, a silver collar at 4 kites, a bed at 2 kites, another bed at 1 kite, a pair of [. . .] at 1 kite, a woman's . . . at 1 kite . . . totaling 5 debens of silver (or 25 staters) as the value of the women's possessions that you have brought with you to my house. I have received them from your hand; meanwhile, they are complete, with nothing lacking. My heart is satisfied with this state of affairs. If you remain within, they remain with you; if you depart, you take them with you. You have their use, I have their custody.

If I dismiss you as wife or if on your own initiative you wish to depart, I will give you the aforesaid women's possessions or their value in silver in accordance with what is written above. I cannot declare to you with the goal of despoiling you concerning the aforesaid women's possessions, saying "you did not bring them with you into my house." You are the person exercising authority over them by consultation with me. . . .

Written by Herieus, son of Harsieus.

2. Matrimonial Property Agreement (BM 10593 [Siût, 170 BC])

Year 9, 17 Choiak, of Pharaoh Ptolemy (VI), son of Ptolemy (V) and Cleopatra (I), Gods Manifest (and) Gracious. . . . The lector-priest of the necropolis of the great town of . . . , Paigesh, son of Paybes, whose mother is Tatiisis, has declared to the woman Tatiimhotep, daughter of Patiatum, her mother being Awa:

I have made you my wife. Here is the list of the possessions that you brought to my house: 1 veil (valued) at 50 silver pieces, a cloak at 10 silver pieces, a . . . at 5 silver pieces, a . . . at 25 silver pieces, making 90 silver pieces.

I will give you 20 pieces of silver as your marriage gift besides the 90 pieces of silver which you brought to my house, making 110 pieces of silver. . . . If I abandon you as wife or if you abandon me, I will give them to you within thirty days of the day you ask them from me. . . . If I do not do so within thirty days, here is the description of the food and clothing allowance which I will give to you each month until I have paid in full your aforesaid silver pieces: I will give you 1 artaba of wheat, 1 hin of oil, and 5 pieces of refined silver monthly until I have paid in full your aforesaid silver pieces, making 12 artabas of wheat, 12 hin of oil, and 60 silver pieces for your food and clothing for one year at the house you prefer. You are entitled to secure your food and clothing in my custody. I will give them to you without being able to say, "I have given you food and clothing and everything else" without a legal receipt and without being able to dispute it with you with respect thereto while the above contract remains in your possession. Everything that I possess and will acquire is security, as aforesaid, for your money, your food, and clothing until I pay you them in full. The property that you remove from my house I will reckon as part of the aforesaid money.

Paybes the younger, son of Patiisis, whose mother is Nakhtisis, declared:

Write an acceptance of the aforesaid contract by Paigesh, son of Paybes the younger, my aforesaid eldest son. My heart is satisfied with everything aforesaid. Let him act accordingly to you at all times.

Written by Horianub, son of Amennakht, who writes in the great town and its suburbs.

3. Matrimonial Property Agreement (P. Eleph. 1 [311 BC])

Year 7 of King Alexander, son of Alexander, year 14 of Ptolemy's governorship, in the month of Dius. Marriage contract of Herakleides and Demetria.

Herakleides takes as his lawful wife Demetria, a Coan, from her father, Leptines, a Coan, and her mother, Philotis, both possessing free status, she bringing clothing and adornments worth 1,000 drachmas. Herakleides will furnish Demetria with all that befits a freeborn wife, and we will live together wherever it seems best to Leptines and Herakleides consulting together.

If Demetria is discovered committing some wrong that shames her husband Herakleides, she will be deprived of all that she brought if Herakleides proves his allegations against Demetria before three men approved by both.

Herakleides is not permitted to introduce another woman for the sake of insulting Demetria or to have children by another woman or to injure Demetria for any reason. And if Herakleides is discovered doing any of these things and Demetria proves it before three men approved by both, Herakleides will return to Demetria the dowry of 1,000 drachmas that she brought, and he will forfeit an additional 1,000 drachmas of silver on Alexander's standard. The right to exact payment from Herakleides and from all of Herakleides' possessions both on land and sea will belong to Demetria and her representatives as if by legal action.

This contract will be valid in every respect as though the agreement had been made in that place wherever Herakleides produces it against Demetria or Demetria and her representatives produce it against Herakleides. Herakleides and Demetria may each guard their own copies of the contracts and produce them against each other. (Signatures of six witnesses follow.)

4. Matrimonial Property Agreement (P. Tebt. I 104 [92 BC])

Year 22 of the reign of Ptolemy (X) . . . 11th day of Mecheir, at Kerkeosiris in the Polemon division of the Arsinoite nome.

Philiskos, son of Apollonios, acknowledges to Apollonia also known as Kellauthis, daughter of Herakleides, having with her as guardian her brother, Apollonios, that he has received from her in copper coin 2 talents, 4,000 drachmas as the agreed upon dowry for Apollonia.

Apollonia will live with Philiskos, obeying her husband as a wife should, maintaining their possessions in common. Philiskos will provide Apollonia with all necessities and clothing and all other things proper for a married woman, regardless of whether he is at home or away from home, in accordance with their means. Philiskos is not permitted to introduce another woman besides Apollonia or to keep a concubine or a boy or to have children by another woman as long as Apollonia lives or to live in another house over which Apollonia is not mistress or to expel or insult or injure her or to alienate any of their property to the detriment of Apollonia. And if it is proven that he has done any of these things or if he does not supply the necessities or clothing or other things as written, Philiskos will immediately pay Apollonia the dowry of 2 talents, 4,000 drachmas of copper. Likewise, Apollonia will not be permitted to spend the night or day away from Philiskos's house without his consent or to be with another man or to dishonor their household or to shame Philiskos by any act that brings shame to a husband.

If Apollonia voluntarily chooses to separate from Philiskos, Philiskos will pay her the basic dowry within ten days from her request. And if he does not repay as written, he will immediately forfeit one and one-half times the dowry which he received. (Signatures of six witnesses follow.)

5. Complaint against a Husband (P. Oxy. II 281 [AD 20–50])

To Herakleides, priest, chief justice, superintendent of the **chrematistae** and the other courts, from Syra, daughter of Theon. I married Sarapion, bringing him by contract a dowry amounting to

200 drachmas of silver. As he lacked all means, I received him into my parents' house, and, for my part, I behaved blamelessly in all respects. But Sarapion, having squandered my dowry as he pleased, continually ill-treated and insulted me, using violence towards me and depriving me of the necessities of life. Finally he deserted me, leaving me in a state of destitution. Therefore I beg you to order him to be brought before you so that he may be forcibly compelled to repay my dowry increased by half. This petition is without prejudice to any other claims that I have or may have against him.

NOTES

1. Lines 58–68. See also D. Delia, "'All Army Boots and Uniforms?': Ethnicity in Ptolemaic Egypt," in *Alexandria and Alexandrianism* (Malibu 1996) 41–53.

2. Strabo 17.1.7–10.

3. Herodas 1.23–33; see also Josephus *AJ* 12.9.

4. Delia (supra n. 1) 46.

5. D. Delia, "Egyptians and Greeks," in F.B. Titchener and R. Moorton eds., *The Eye Expanded* (Berkeley 1999) 147–54.

6. The Dryton archive is scattered among many collections. For a list of the principal published documents, consult W. Peremans, E. Van't Dack, et al. eds., *Prosopographia Ptolemaica* II 2206 (Dryton) and IV 10642 (Apollonia) (*Studia Hellenistica* 8 [Leuven 1952] and 12 [Leuven 1959]).

7. S.B. Pomeroy, *Women in Hellenistic Egypt from Alexander to Cleopatra* (New York 1984) 123–31. See also N. Lewis, *Greeks in Ptolemaic Egypt* (Oxford 1986) 88–103.

8. P. Grenf. I 21 (Pathyris, 126 BC). For the standard papyrological abbreviations employed, see J.F. Oates, R.S. Bagnall, W.H. Willis, and K.A. Worp, *Checklist of Editions of Greek and Latin Papyri, Ostraca and Tablets*[4] (Atlanta 1992) or as subsequently updated on the Duke Databank of Documentary Papyri CD ROM, now also available online.

9. W.F. Edgerton, *Notes on Egyptian Marriage Chiefly in the Ptolemaic Period, SAOC* 1.1 (Chicago 1931) 25; H.J. Wolff, *Written and Unwritten Marriages in Hellenistic and Postclassical Roman Law* (APA Philological Monographs 9, Haverford 1939) 65; R. Taubenschlag, *The Law of Greco-Roman Egypt in the Light of the Papyri, 332 BC–640 AD*[2] (Warsaw 1955) 112; P.W. Pestman, *Marriage and Matrimonial Property in Ancient Egypt* (Papyrologica Lugduno-Batavia 9, Leiden 1969) 60; S. Allam, *Everyday Life in Ancient Egypt* (Guizeh 1985) 29, and "Quelques aspects du mariage dans l'Égypte ancienne," *JEA* 67 (1981) 116.

The Roman religious ritual of *confarreatio* and imaginary sale by *coemptio* were ways that Republican Roman women entered into *manus*, or "control" by their husbands, but *manus* was distinct from *matrimonium:* Treggiari, *Roman Marriage* 16–29.

10. M. Lichtheim trans. and ed., *Ancient Egyptian Literature* III (Berkeley 1980) 127–28. On this cycle of stories, see E. Bresciani, "Chaemwese-Erzählungen," in W. Helck ed., *Lexikon der Ägyptologie* 1 (Wiesbaden 1972) cols. 899–901.

11. Lysias *Murder of Eratosthenes* 6: "When I had decided to marry and brought a wife home." See also A.R.W. Harrison, *The Law of Athens,* I, *The Family and Property* (Oxford 1968) 17–18.

12. Isaeus 8.18–20; cf. Arist. *Ath. Pol.* 42; Demosth. *Against Neaera* 122: " This is marriage: when a husband begets children and presents his sons to his phratry and deme and gives his daughters, as being his own, in marriage to their husbands. We keep *hetairai* (mistresses) for pleasure, *pallakai* (concubines) for the daily care of our bodies, but wives for the procreation of legitimate issue and to be the faithful guardians of our household." See also W.K. Lacey, *The Family in Classical Greece* (Ithaca 1968) 110.

13. *Dig.* 23.2.1 and 24 (Modestinus). Treggiari, *Roman Marriage* 159–70.

14. J. Mélèze-Modrzejewski, "Le mariage et la condition de la femme mariée dans l'Égypte grecque et romaine," *Annuaire, L'École Pratique des Hautes Études,* sect. 4: *Science Historique et Philologique* 111 (1978–1979) 304; and "La structure juridique du mariage grec," in E. Bresciani et al. ed., *Scritti in onore di Orsolina Montevecchi* (Bologna 1981) 250.

15. Taubenschlag (supra n. 9) 113–14.

16. E. Lüddeckens, *Ägyptische Eheverträge* (*Ägyptologische Abhandlungen* 1, Wiesbaden 1960) passim; idem, "Ehe," in Helck (supra n. 10) cols. 1162–83; Pestman (supra n. 9) 21–43; J. Johnson, "Legal Status of Women in Ancient Egypt," text of a lecture delivered at Brown University in June 1995.

17. BM 10394 (Thebes, 226 BC); E. Revillout, *Précis du droit Égyptien comparé aux autres droits de l'antiquité* II (Paris 1903) 1050–52; W.

Pestman, J. Quaegebeur, and R.L. Vos, *Receuil de textes démotiques et bilingues* (Leiden 1977) no. 7. See no. 1 in the appendix of documents that appears at the end of this essay.

18. BM 10593 (170 BC); H. Thompson, *A Family Archive from Siut in the British Museum, Including an Ancient Account of a Trial before the Laocritae in the Year BC 170* (Oxford 1934). See no. 2 in the appendix of documents that appears at the end of this essay.

19. Lichtheim (supra n. 10) 133–36.

20. The meaning of *shy3,* here tentatively rendered as "chamberpot," is uncertain.

21. Demosth. 41.4; Harrison (supra n.11) 30–32; Modrzejewski (supra n. 14, 1978–1979) 312–14. See also P. Oxy. II 237 (AD 186), in which a father claims the right to compel the divorce of his daughter against her will.

22. Harrison (supra n. 11) 112–15; D.M. Schaps, *Economic Rights of Women in Ancient Greece* (Edinburgh 1979) 5–6.

23. Taubenschlag (supra n. 9) 142; Treggiari, *Roman Marriage* 32 and 69. On the *ius liberorum,* see P. Oxy. XII 1467 (AD 263).

24. P. Eleph. 1 (311 BC). See no. 3 in the appendix of documents that appears at the end of this essay. See also Taubenschlag (supra n. 9) 120; Wolff (supra n. 9) 11-18; Modrzejewski (supra n. 14, 1978–1979) 305.

Greek matrimonial property contracts published to date were catalogued by O. Montevecchi, "Ricerche di sociologia nei documenti dell'Egitto greco-romano, II: i contratti di matrimonio e gli atti di divorzio," *Aegyptus* 16 (1936) 3–83, updated in idem, *La Papiroiogia*², rev. and corr. S. Daris (Milan 1988) 203–207 and 568.

25. P. Tebt. I 104 (92 BC). See no. 4 in the appendix of documents that appears at the end of this essay. See also Taubenschlag (supra n. 9) 113–15; Wolff (supra n. 9) 19–20.

26. P. Oxy. II 267 = *M. Chr.* 281 (AD 36); P. Ryl. II 154 (Bacchias, AD 66); *BGU* I 183 = *M. Chr.* 313 (Soknopaiu Nesos, AD 85); *CPR* I 24 = *M. Chr.* 288 (Fayum, AD 136); *BGU* IV 1045 = *M. Chr.* 282 (Fayum, AD 154). See also Taubenschlag (supra n. 9) 114.

27. Treggiari, *Roman Marriage* 165–66 and 366–74. The *Gnomon of the Idios Logos* also preserves several stipulations restricting testamentary gifts from wives to their husbands: *BGU* V.1 (Theadelphia, AD 150–151) clauses 24–25 and 31.

28. P. Tebt. I 38, 39, 43–51 and 63 (113–118 BC); Lewis (supra n. 7) 106–23.

29. T.G.H. James, *Pharaoh's People: Scenes from Life in Imperial Egypt* (London 1984) 25–50. See also R. Parkman and S. Quirke, *Papyrus* (Austin 1995) 49–50.

30. 1.75–76. Consider also Hdt. 2.77.1.

31. J. Romer, *Ancient Lives: Daily Life in Egypt under the Pharaohs* (New York 1984) 156–62.

32. G. Botti and T.E. Peet eds., *Il giornale deila necropoli di Tebe* (Turin 1928) anno 17, I B, recto 17: Romer (supra n. 31) 158.

33. *Oral Tradition and Written Record in Classical Athens* (Cambridge 1989) 126.

34. R. MacMullen, "The Epigraphic Habit in the Roman Empire," *AJP* 103 (1982) 233–46.

35. P. Oxy. II 281 (AD 20–50). See no. 5 in the appendix of documents that appears at the end of this essay.

36. The standard percentage imposed as a penalty for breach of contract.

WIDOWS TOO YOUNG IN THEIR WIDOWHOOD

ANN ELLIS
HANSON

Greeks of the Archaic and Classical periods associated premature widowhood with the sack of the city and defeat in war, as an enemy routed the defenders in battle. Hector of the Iliad chided his young wife Andromache for her imaginings about the day when he would be felled and sacred Ilium would perish, yet Hector knew all too well that his death meant captivity and a slave's life for her in the house of a victorious Greek. When Hector died at Achilles' hand and Andromache lamented him from Troy's battlements, her thoughts, however, centered on their small son, still a baby, and the diminished circumstances that constricted the life of an orphan boy. The words Thucydides assigned Pericles in the Funeral Oration for the soldiers dead in the first year of the Peloponnesian War concluded with condolences for the bereft families: the parents still able to bear children were encouraged to seek comfort for sons lost by replacing them with new ones; the orphans of the dead were to be provided for by the polis at state expense until they came of age; the widows were exhorted to lead quiet and honorable lives so that they be least talked about by the men of the community. The Greeks of the Roman period came increasingly to enjoy the benefits of the Pax Romana, as foreign wars became of concern largely to those on the periphery of empire. Internecine strife was officially discouraged; rivalries among elite families were channeled into euergistic competitions; those who entered Roman military service were long prevented from conducting a legal marriage prior to discharge. Although widows of war and spearbrides remained pathetic figures in the high literature of epic and tragedy, the young women who nonetheless continued to lose husbands to death and divorce are now visible to scrutiny, as never before.

I. MEDICAL WRITERS ON WIDOWHOOD

If the uterus turns toward the liver, the woman loses her voice suddenly, she grates her teeth, her color becomes livid, and she suffers these things, although she was healthy. This happens especially to old virgins and to widows too young in their widowhood. . . . When she is better, cleanse her uterus with an enema—if she is bilious, with something that cleans out bile; if she is phlegmatic, with something for phlegm. Then have her drink boiled ass milk; fumigate her uterus with sweet smells and insert a pessary of beetles; in the evening, oil of almond; stop for two days and then douche her with sweet smells. Widows need to do these things and it is best if they become pregnant. . . . (Hippoc. Mor. Mul. 2. 127, 8.272–74 ed. Littré).[1]

The gynecologies of the Hippocratic Corpus, composed during the course of the fifth century BC, considered widows too young in their widowhood particularly susceptible to uterine displacements that suffocated, or choked, the woman, rendering her suddenly helpless. Interventionist Hippocratic doctors recommended fumigations and other therapies, but they ultimately thought it best if young widows remarried, becom-

ing proper wives and mothers once again. A quite different, but perhaps more lethal, malady afflicted two women, Phaethusa of Abdera and Nanno of Thasos, according to their case histories in Epidemics 6, when both were deprived of their husbands through exile. The women ceased to menstruate, their voices deepened, shaggy beards grew, and their progressive masculinization ended in death, since menstruation was never restored for them.[2]

Special concern for the physical health of the young and previously married woman who had lost her husband disappeared from later medical literature. While Galen, doctoring at Rome in the High Roman Empire, did worry about old widows whose husbands were long dead, for they likewise experienced uterine suffocation, he relied upon an updated etiology for this disease. The cause for Galen lay in the retention and putrefaction of the woman's generating seed and of her menses, not in a uterus that traveled willfully about her body.[3] If medical writers retreated from the assertion that the once married young woman required remarriage in order to maintain her health, the physical consequences of abstinence among the previously sexually active continued to thread their way through other literary genres, from Roman satirists, who focused upon the widow's sexual cravings, to the Christian hagiographers.[4] At the end of antiquity, stories were circulating about St. Pelagia of Antioch, who, after a successful career as a prostitute, lived out her life as a bearded and penitent monk on the Mount of Olives, and about St. Galla, whose doctors countered her desires to enter a convent after the death of her husband, for fear she grow a beard.

There can be little question but that the pagan societies of Greece and Rome preferred to position the sexually active young woman as wife and mother, mistress of her husband's household. Modern social historians long accepted this preference as representing antiquity's reality, and they assumed that the woman too young in her widowhood was universally recycled into the marriage market, whether her widowhood occurred because of her husband's death or because of divorce.[5] The year 1994 was a turning point for "young widow studies," for in that year both Richard Saller and Jens-Uwe Krause, relying on more sophisticated manipulations of demographic data, argued vigorously against the assumption that after loss of a spouse, fertile females up to age 50 inevitably remarried in the populations of the Roman empire.[6] Rather, both claimed that the number of unattached, postmenarchic and premenopausal females, nearly all of them formerly married, represented a significant portion of the population. Krause considered the Christian apologists who warned a young woman contemplating marriage that she was giving up her virginity for nothing, since she would discover widowhood soon thereafter, were not necessarily wide of the mark.[7] When Krause turned to probe the data he collected for the percentage of widows in the female population of the Roman empire, he estimated that among sexually mature women aged 30 or younger, some 13 to 15% were already widowed through the death of their husbands and that the percentage rose rapidly to about 40% for women between 30 and 50 years of age.[8] Saller's data told him that while chances for remarriage were relatively positive for previously married young women in their 20s, these declined precipitously thereafter.[9] Remarriage no longer seems a certainty for those still fertile women of the Roman empire who married and lost their husbands not long thereafter.

II. WIDOWS IN THE CENSUS DECLARATIONS OF ROMAN EGYPT

To Eirenaeus and Maron and Heracleides and Ammonius and Petesouchus, scribes for the census, and to Heracleides, village scribe of Philadelphia, from Tatybynchis, daughter of Mares, from the same village, with my guardian (kyrios), my kinsman Patouamtis, son of Ptollis. I register for the current 20th year of Tiberius Caesar Augustus (= 33/34 AD): my son Panetbeuis, son of

Cephalon, dwelling in my house, . . . about 5 years, and myself, Tatybynchis, daughter of Mares, about 35 years, with a scar on my right thumb. . . .[10]

Information from the census declarations of Roman Egypt figured large in the considerations of both Saller and Krause, although only Saller relied on the investigation of the census documents by Roger Bagnall and Bruce Frier that also appeared in 1994. The census returns spanned the years AD 11 to 257 and, from the principate of the emperor Tiberius onward, were submitted every fourteen years by heads of households who identified for Roman authorities those living in their household: wife, children, other kin, and, if also living in the household, lodgers and slaves. A woman sometimes submitted the declaration for her household, such as did Tatybynchis, daughter of Mares, in the village of Philadelphia.

The population represented by the declarations was predominantly an urban one, inhabiting the towns and villages of Middle Egypt; the majority possessed some property, but few were either prodigiously wealthy or totally penniless. The data from the census records are not without problems for demographers: the declarations are often only partially preserved; they survive through chance circumstances; they represent a limited group within the Roman province of Egypt. Nonetheless, many demographers have concurred that this is the best evidence we have against which to monitor computer-generated configurations of the Roman population at large and that idiosyncratic features of the society in the Romano-Egyptian province, such as the frequency of marriage between full and half brothers and sisters, do not prevent the data from being otherwise representative.[11]

Bagnall and Frier noted a striking difference in the marriage patterns of the adult men and the adult women in the census declarations: although virtually all free women married, those who were still married reached its high point for women in their late 20s and then began to decline. In the model they configured for the entire population of Roman Egypt, just over 80% of adult females were currently married when they reached their thirtieth birthday; by their fortieth birthday the figure fell to 66%; and by their fiftieth birthday only about 48% were still currently married. By contrast, the percentage of men who had married and were still married continued to climb for those in their 20s and 30s, reaching a high of about 70% for men in their 40s.[12] Put another way, the men of the census declarations pursued marriage and, if necessary, remarriage, with aggressive determination and obvious success, despite increasing age, while only some younger widows and divorcées were successfully recycled into the marriage market. Many younger women were not.

Among traditional Mediterranean populations, women normally married young but men only later. The mean gap in age between the husbands and wives of the census declarations at the time of their first marriage was about seven and one-half years, and this no doubt increased the likelihood that a husband might die before his spouse, even though female life expectancy at birth seems to have been several years lower than it was for males.[13] Those younger brides who were marrying men some seventeen to eighteen years their senior, perhaps as many as one-quarter of the female population, were particularly likely to lose their husbands and be left with fatherless minor children.

Bagnall and Frier's catalogue of the declarations also permits something to be said about the living arrangements and the exact, or approximate, ages of more than 290 women who are 13 years old or older—13 being the age of the youngest brides. I rely on their data for the following remarks (see also infra, Appendix), well aware that the nature of the evidence and the small size of my sample do no more than permit me to outline the residential patterns of the seemingly unattached women that were current in this population between AD 11 and 257. No husband is mentioned for some 145 adult females, and of that group, the 37 girls between 13 and 20 years who live with

parents, or a parent, or a brother, may be as yet unmarried.[14] The 4 women living with children who are labeled apatores, "without a father," are probably the common-law wives of soldiers, unable until the principate of Septimius Severus to enter a legal marriage as long as their soldier-husbands are still in service.[15] The remaining 104 are, for the most part, only putative widows and putative divorcées, because the formerly married are identified only for certain when the fact is stated in the census declaration itself, and the few declarations which do specify that a marriage ended in death or divorce do so because the woman's children are also mentioned.[16] Hence, my search for the widows too young in their widowhood must also lump together putative widows and putative divorcées, the women for whom no husband is mentioned in the census declarations.

Certain domestic patterns followed by the no-longer-married females of the declarations could perhaps have been predicted: unattached older women live with adult children and other relatives. Clear is the older widow's preference for joining the household of a grown son, a pattern still common in Mediterranean countries, although no longer so common in northern Europe or the U.S., where the current preference is to live with or near a daughter.[17] Thirteen of the 31 older widows live with a married son, as opposed to only 1 with a married daughter. Six other older widows live with a currently unattached adult son, while the others live with assorted male relatives. Survival of children to adulthood of course plays a role as to what choices are available to the older widow, yet those who join the household of a daughter do so principally when the daughter herself is also not currently married. Older widows' preference for living in a household headed by their own male kinsman, rather than in a household whose head was related to them only by marriage, highlights the women's fears of disrespect, or even mistreatment, at the hands of in-laws.

The younger unattached women display living patterns almost as various as the living patterns of unattached men. There is, however, a principal exception: the unattached female lodger is a rare phenomenon, and I have noted only 2 in the total of some 290 women; one of them is 80 years old and is accompanied by her freedwoman in the rented quarters.[18] Two patterns predominate among the younger women: 30 dwell with parents or other male relative: a father alone, a brother, a brother-in-law, a cousin. Three divorced women continue to live in the same household with their former husbands; at least 2 are full sisters of their former husbands, as well as, for a time, their wives. The alternate pattern, however, is the more interesting, perhaps because, although the phenomenon was known, its prevalence was not anticipated: that is, 39 of the 103 live in predominantly female households. The majority of these women are relatively young, and their households often include minor children, the woman's mother or sister, if she too is unattached, additional kin, which, if male, tends to be young, a family of lodgers (but seldom an unattached male lodger), and a complement of slaves.[19]

The census declarations present only the bare lists of persons inhabiting the household space and their ages, and the returns convey no sense of the dynamics that prevailed inside the dwelling. A first or second-century petition from Thermouthion of Oxyrhynchus, capital city of the district, may give some notion of the affective feelings in this predominantly female household, consisting of a woman living alone with her slaves. Thermouthion describes her household in the course of explaining an accident to which she wishes to draw the attention of Roman officials in the hope of receiving redress for another's carelessness: "I loved and took care of my serving girl Peina, a homebred slave, as though my own little daughter, in the hope that, when she came of age, I would have her to nourish me in my old age, since I am a woman who is helpless and alone" (P. Oxy. L 3555). Thermouthion's hopes of gerotrophia from Peina, however, have been dashed by the accident that seriously injured the young girl while she

was being escorted to her singing lessons.[20] The consternation of the mistress over the sad event and its aftermath is evident in the contorted language of Thermouthion's petition. Although she neglects to tell us how she came to be a woman alone, her intention that a slave fill the role of a daughter adds some flesh and personality to the two households of the census declarations in which an older woman declares only herself and a complement of slaves, one type of predominantly female establishment in the census records.[21]

Loss of a spouse, whether through death or divorce, tested a woman and her family. In order to hear what was on the minds of the widows too young in their widowhood, I turn to papyrus documents of other genres, for, as in the case of Thermouthion, it is the narrative documents that are the more suggestive.

III. ECONOMIC ASPECTS OF WIDOWHOOD: RECOVERY OF DOWRY

*Copy of agreement. Year 2 of Antoninus Caesar our lord, in the month Sebastos 2 (= 30 August 138 AD), in Tebtynis of the Polemon division of the Arsinoite nome. They acknowledge to each other—Cronion, son of Cronion, about 54 years of age, with a scar on his left forearm, and she who was his wife, being also his sister from the same father and the same mother, Taorsenouphis, about 50 years of age, lacking distinguishing mark, with her guardian, the father of them both, Cronion, son of Cheos, about 76 years old, with a scar on his right hand—that they have canceled their living together, which they had established with each other without a written contract and that it is possible for both of them to manage their own affairs as each chooses, and for Taorsenouphis to live with another man without recrimination of any sort. The jewelry that all the aforementioned affirm Cronion received from his sister Taorsenouphis—gold, weighing one mina and ten quarters, and uncoined silver, weighing twenty-eight staters—and which he converted into cash for his own use, the declarant Cronion must repay to his sister Taorsenouphis in equivalent jewelry within sixty days from the present day, with the right of execution belonging to Taorsenouphis herself against her brother Cronion and against all the property belonging to him. . . .
(P. Kron. 52.1–23).*

The strain of divorce is noticeable in the family archive of Cronion, son of Cheos, a farmer resident in the village of Tebtynis in the agricultural district of the Fayum. His family practiced brother-sister marriage in the extreme, for Cronion's two older sons married his two daughters, while his third and youngest son left home early, perhaps because there was no sister for him to marry.[22] After a marriage of about twenty-seven years and three children, two of whom are still minors, his eldest son, Cronion the younger, and his daughter divorced according to the terms spelled out above.

Two months prior to the agreement of divorce, the elder Cronion, now a widower, made his will, dividing the bulk of his property between his two younger sons, Harphaesis and Harmiysis, and his minor granddaughter, the younger Tephorsais; his two adult daughters, Taorsenouphis and Tephorsais, receive token awards, no doubt because they have already received their share of the family property in the form of the dowry they gave their brother-husbands at marriage.[23] Touching is the bequest Cronion made to his minor granddaughter, perhaps earmarked for her dowry in years to come. An adequate dowry is apparently of importance to Cronion, for, although a man of modest resources, he has already dowered his two daughters well. Father Cronion's bitter words in the will underscore his feelings toward his elder son: "Cronion (the elder) has designated for Cronion (the younger) only forty drachmas of silver because of the fact that he has been wronged by his son in many matters over the course of his lifetime. . . ."[24] As the couple's agreement of divorce forcefully enunciates, the younger Cronion was in

the wrong when he converted the dowry he received from his sister into cash for his own use, since it was intended for the wife's support. Now he must repay to her jewelry and silver of equivalent value within sixty days or face legal action.

For a time the younger Cronion apparently moved out of the family home, but a receipt for grain taxes, dated almost two years after the divorce, suggests that the upheaval was temporary and that after the hiatus the younger Cronion was once again farming together with his brother Harphaesis and his own elder son Sasopis. As a divorcée of some 50 years of age, however, the chances that Cronion's daughter Taorsenouphis would remarry are virtually nil, and she continues to live in the family home to which her brother and former husband eventually returns. At the very least, regaining possession of her dowry would enhance her status within the family, and its return is a dominant feature in their agreement of divorce.[25]

For younger widows and divorcées, not only did the return of a dowry make them more attractive contributors to the households of kin, should they return there, but personal wealth probably enhanced their chances for remarriage and certainly afforded them greater choice in future living arrangements. In the mid third century, a prominent and wealthy woman, Aurelia Dioscuriaena, from the city of Oxyrhynchus acknowledges the return of her young widowed daughter's dowry in accordance with the original contract of marriage (P.Coll. Youtie II 67). As she explains in her acknowledgment, her husband, Aurelius Spartiates alias Chaeremon, a former gymnasiarch and councilor of Oxyrhynchus, is currently out of town, serving as strategus in another district, the highest office in the Roman bureaucracy available to Greco-Egyptians during the Roman principate. As a Roman citizen, Aurelia Dioscuriaena is able to conduct legal business without a guardian, thanks to the right of children (ius trium liberorum).[26] Thus, she issues in her own name the receipt for the returned dowry to Aurelius Menon (?), son of Theon, who has been appointed guardian of the minor male child from her daughter's marriage. The dead husband's family is as distinguished as Aurelia Dioscuriaena's, and his brother, whose agreement with the receipt she also notes, is likewise a gymnasiarch and councilor of Oxyrhynchus. The return of the dowry seems to have been negotiated amicably enough, and the written receipt is probably employed for no other reason than the fact that the dowry itself is so large, including 16¾ minas of gold, a necklace and earrings worth 1,500 drachmas, clothing valued at 5,000 drachmas, and 1 talent earmarked for the purchase of slaves. At the same time, Aurelia Dioscuriaena stipulates at the close that upon his return, her husband has the right to either approve the present receipt or issue another one, once she has received back her receipt. What Aurelia Dioscuriaena also stresses is her intention to bestow the returned items once again upon her daughter, Aurelia Apollonarion, whenever she is to be married to another husband. Whether Aurelia Apollonarion does, in fact, remarry remains unknown, although she surely can attract suitors through her ample dowry. Yet even without a husband, this young woman's interests are protected by living parents, vigorous, wealthy, and influential.

Most surviving marriage contracts from Roman Egypt not only enumerate what the bride brings to the marriage in terms of money, slaves and household furnishings, garments, and jewelry, with the current value of each item recorded, but they also provide for the dowry's restitution in the event the marriage terminates. When father Sarapion gave his daughter Thais in marriage at Oxyrhynchus in AD 127, he dowered her handsomely with jewelry, clothing, and coined silver whose total worth was 4,100 drachmas.[27] Her grandmother added a slave woman for Thais as a special wedding gift. In the event of a separation, the marriage contract stipulates that Thais's dowry and the slave woman are to be returned, and if Thais is pregnant at the time of separation, she is to receive an additional 60 drachmas for birthing expenses. Further, although Thais's husband may dispose of his own property as he wishes, the contract provides that, if he dies intestate

and leaves Thais a widow with children, his property is to pass to their children. Thais, or her nearest male kinsman, is to share guardianship of the orphaned children with whomsoever her husband has appointed, and the children are to live with Thais until they come of age. If childless when widowed, Thais is again to regain her dowry and her slave woman. In each of the eventualities imagined, Thais has the right to choose between the items she brought to the marriage, or their equivalent in cash, suggesting that Thais and her husband, also named Sarapion, probably intend to use at least some of the dowry for current living expenses, until such time as each acquires more of their respective family's assets through inheritance.

Despite careful forethought and planning, restoration of a wife's dowry does not always precede without incident, as Tryphaene's complaint, lodged in Alexandria during the principate of Augustus, makes abundantly clear.[28] Tryphaene claims that her parents persuaded her into the marriage with Asclepiades, although she herself was unwilling. Her dowry was a small one, consisting of clothing worth 40 drachmas and 20 drachmas of coined silver. In her reasons for divorcing Asclepiades, she names him as villain: he kept going off throughout the marriage with no cause; he squandered her dowry; he abused her and treated her as if she were his bought slave. Thus provoked, Tryphaene is moving ahead with preparations for a divorce, intending that Asclepiades either contest the matter in a court of law or, at the very least, repay her 60 drachmas. Negotiating the return of her dowry weighs upon her mind.

Children of a marriage belonged by law to the father, or the father's family, in the event of his death. The widow's child sometimes appears to the deceased father's family and his heirs as an unwanted claimant on his estate, and the child's resigning of future claims is occasionally intertwined with the return of the widow's dowry. Dionysarion, daughter of Protarchus, married Hermias, son of Hermias, in the fall of 10 BC. Eighteen months later Dionysarion's husband Hermias was dead, leaving her pregnant with what is probably their first child. In order to retrieve her dowry, Dionysarion agrees to harsh terms in a contract with her former mother-in-law Hermione, filed at Alexandria before the same tribunal as Tryphaene's complaint against Asclepiades and in the same year.[29] In the contract Dionysarion acknowledges that she recovered from Hermione her dowry, consisting of clothing worth 240 drachmas, earrings and a finger ring, and 100 silver drachmas. She further assures her former mother-in-law that neither she nor her unborn child has any claim to her dead husband's holdings, renouncing litigation even with regard to the upcoming expenses for the delivery of her baby. Her deceased husband's family has no interest in the child, and Hermione grants Dionysarion not only the right to remarry whomsoever she wishes but also the freedom to expose her baby posthumously born without interference from her former in-laws. It is unknown whether or not Dionysarion carried out either course.

Nearly seventy years later in Oxyrhynchus the widow Ammonarion acknowledges that, as stipulated in the contract of marriage she made with Heraclas, her now deceased husband, she has received back her dowry as a cash settlement of 800 drachmas from her husband's heir, his nephew Antiphanes.[30] Ophelous, the daughter of Ammonarion's marriage, is also party to the agreement with Antiphanes, for, in common with her mother, she must also resign to this same nephew her claims to any additional share of her deceased father's property.

Recovery of their dowries was negotiated by both Dionysarion and Ammonarion at the cost of a written renunciation of any further legal action they, their children, or others acting in their behalf might mount against the deceased husband's family. Both young widows apparently considered the recovery of their dowry worth the price. While the documents need not signal animosity or a breakdown of trust among the adult individuals whose former bond was dissolved through death of the husband, there is disregard for the child of the union, especially on the part of the father's family.

IV. SOCIAL ASPECTS:
LIVING ARRANGEMENTS AND RESPECTABILITY

To Claudius Culcianus, **vir perfectissimus**, *prefect of Egypt from Aurelia Gle . . . , most noble inhabitant of the city of the Arsinoites. You are a helper to all, my lord prefect, and you allot to all their due, but most especially to women on account of the weakness of their nature. Therefore I too petition your lordship in the good hope of receiving your assistance. Now because I have large estates in the Arsinoite nome and pay not a few taxes (I am speaking of public imposts and supplies for soldiers) and because I happen to be a weak woman and a widow whose sons are in the army and absent on foreign service, I hired as my helper and manager of my affairs a certain Secundus and, after him, Tyrannus, supposing they would preserve my good reputation. But they behaved dishonestly and cheated me, and removing whatever property of mine was placed in their hands, they never presented me with the customary accounts. They obstinately opposed me in whatever they did, robbing me of two bulls . . . and despising my helplessness . . . (P. Oxy. I 71 ii 1–16 + BL I 314).*

Widows in the papyri were most likely to claim they are alone and helpless in the petitions they direct to government officials, and others acting in a widow's behalf make similar claims for her.[31] At the beginning of the fourth century, Aurelia Gle . . . employs the rhetoric of widowhood in her petition to the prefect that protests fraud and the sullying of her reputation, her bona fides, by dishonest overseers. The iteration in petitions to government officials over the centuries of the motif of a widow's helplessness suggests an acceptance in pagan society of the notion that a woman without a husband or concerned male kinsmen sometimes requires the special attention of the authorities.[32] Because Aurelia Gle . . . has sons in military service, she is no longer conspicuously young, and her concerns for her reputation seem rooted in preserving her ability to function as a responsible owner of estates once hired employees play her false.

The unattached female in the conservative societies of the Mediterranean had always to worry about reputation and respectability. Hellenistic and Roman literature is replete with tales of the widow's lust and of her lonely bed that cries out for a man and sexual gratification. Both Ovid and Petronius naughtily imagine the young widow as uniquely attractive, with her tears and loosened hair, actually discovering a new husband in the very act of mourning a previous husband.[33] The Pauline I Timothy exhorts the congregations of Asia to refuse charity to young widows, on the grounds that it makes them idle and turns them to gossip and meddling, "rather, let them marry again, bearing children and managing the house."[34]

The living patterns of the no-longer-married women noted above in the census declarations demonstrate concern for reputation and respectability through the young widow's marked preference for living in a household headed by either a father or other male kinsman, as opposed, for example, to the household of a sister's husband. If a biological clock begins to tick for the young women of the Roman empire on the day their marriages end, counting away the years in which remarriage remains at all likely, it tolls for both the widow and the divorcée alike. Although the young widow's success in the marriage market depends upon many factors, the majority of which lie beyond her control, presenting an appearance of respectability within her community is within her control. The fact that the census documents show only two unattached female lodgers, as opposed to the many unattached males who rented space in others' households, is one facet of this desire for outward respectability. Another lies in the fact that only two or three younger widows run the risk of having an unattached male lodger in their household, despite the convenience of having a man around the house to help with

chores and to serve as the woman's legal representative, whenever a male kinsman was unavailable.

When papyrus letters do recount gossip, it is often so allusive as to be incomprehensible to us modern voyeurs. Nonetheless a letter Artemis sends to Sarapion, a fellow soldier of her husband, displays this matron's displeasure over the behavior of Sarapion's unattached daughters, whom she has apparently brought into her own home. Charges and counter charges have already flown back and forth, and Artemis's annoyance with the tales in circulation is obvious, even if the precise scenario of events remains uncertain. "If you want to be content with the prostitution of your daughters," she writes, "do not interrogate me, but the elders of the Church, as to how those girls leapt out of the house shouting 'We want men!' and how Loucra was discovered with her adulterer, turning herself into a woman from Cadiz. As a result, they hate us because we have added them [into our household?] for your sake. But if you can name the fellow with regard to his family. . . ."[35] Artemis's cryptic message to Sarapion leaves much about the affair of Sarapion's daughters unclear and unresolved. Her remarks, however, look to the reputation of the young women and underscore the desirability of their not becoming objects of gossip among the men.

V. ARRANGEMENTS FOR THE CHILDREN

To Agathus Daemon, strategus of the Arsinoite nome, Heracleides division, and to Canopus alias Asclepiades, royal scribe of the same division, and to the village scribe of Caranis, and to scribes for the census of the same village from Herois, daughter of Castor, son of Onnophris and Taorsenouphis, from the village of Caranis, through the husband of my daughter, Longinus alias Zosimus, son of Leonides, from the same village. I register myself and those with me for the house-by-house census of the past 10th year (201/202 AD) in the property inherited from my father in the village, the half part of a house and courtyard in Thoereum Quarter: I am Herois, aforementioned, aged 50 years; and my daughter Soeris, daughter of Heron, son of Ptolemaeus, aged 21 years; and her daughter, Gaia, child of Longinus alias Zosimus, aged 1 year. . . .[36]

Although Longinus alias Zosimus serves as legal representative (kyrios) for his mother-in-law Herois in the submission of her declaration for the census of 201, he is not currently resident in her household in Caranis with his wife and 1-year-old daughter. Rather, he is registered in another declaration for the same census as living in his paternal household in the same village with his 6-year-old daughter, another Gaia, from his first marriage that ended with the wife's death. His 74-year-old grandmother submits the declaration for the household, counting off, in addition to Longinus alias Zosimus and Gaia, his father Leonides, aged 56, who served as his mother's representative in the transaction, and two other unattached siblings of Leonides, a 46-year-old brother and a 57-year-old sister. The two census declarations offer no reason for Longinus alias Zosimus's choice of domicile nor why he does not live with his current wife and younger daughter yet is nonetheless on sufficiently amicable terms to serve as legal representative for his mother-in-law. Women of both families own additional residential properties in the village, and the households appear to be equally prosperous. More than one scenario can no doubt be proposed for Longinus's decision to live with his own kin, but perhaps more important are the living arrangements that have been made for Longinus alias Zosimus's two little daughters named Gaia. Each girl lives in the household of a grandmother, or great-grandmother, and while Longinus alias Zosimus's natal family supports his 6-year-old from his first marriage, terminated by the wife's death, the family of his second wife supports his 1-year-old daughter.

The census declarations underscore that families deal in various ways with children from marriages terminated prematurely by death or divorce. Although the cases of Dionysarion and of Ammonarion and her daughter Ophelous testify that a deceased husband's family does not necessarily welcome a former daughter-in-law's offspring, for the child competes with other heirs for the father's estate, some young widows are more aggressive in vindicating their child's claims. Petronilla, a Roman citizen living somewhere in the Fayum in the middle of the second century, was also widowed while pregnant, and a lengthy dossier documents her efforts in behalf of her boy's rights as heir to the estate of her dead husband, Herennius Valens.[37] In the course of her pregnancy Petronilla claims to have observed the procedure known from the Roman praetorian edict as *de inspiciendo ventre custodiendoque partu* ("concerning a belly that has to be inspected and a birth that must be watched over"). The Roman praetor ruled:

In cases where a widow says she is pregnant, she must take care that the fact (of her pregnancy) be announced to those to whom these matters will be of concern, or to their agent, twice in a month, so that they may send, if they wish, women who will inspect her belly. The women to be sent, moreover, are to be free, up to five in number, and these are to do their inspecting all at the same time—lest one of them, while she is inspecting, touch the belly when the woman herself is unwilling. The woman must give birth in the house of a totally respectable woman (iustissima femina) whom I shall appoint. Thirty days before she expects to deliver, the pregnant woman must notify the interested parties, or their representatives, inviting them, if they wish, to dispatch persons to bear witness to the pregnancy. . . . (Dig. 25.4.10).

The praetor's procedure was designed to protect not only the interests of a legitimate child posthumously born but also the interests of the deceased father's family against an unscrupulous widow. Its detailed provisions covered the entire period of the pregnancy, once recognized, and included the birthing itself.[38] Thirty days before she expects delivery, the pregnant widow must again notify the interested parties, so that three men and three women of free status can be set at her door to keep watch and even search those who request entry. The birthing room is to have a single doorway, and additional entries are to be boarded up inside and out. The interested parties may also send women to witness the delivery, in addition to the two midwives and six slave assistants, a double complement of birthing personnel to represent the interests of both families.[39] The number in the birthing room, however, was limited to no more than ten free women and six slaves. All are to be examined prior to entering the chamber, to make certain none is pregnant, and at least three lamps are to be lit in the room, thus ensuring that no suppositious child can be slipped in unnoticed.

Much is at stake for both families, that of the widow and that of her deceased husband, and the very invocation of the procedure suggests a breakdown of trust among the interested parties. The first column in Petronilla's dossier, a petition she sent to Calvisius Patrophilus, the juridicus, has been lost, and the lost column contained the opening portions of the description of the inspection procedure she followed. Narration now begins only in the middle of things at the top of the second column:

. . . [the woman (iustissima femina)] to whom you ordered me to go. She reported to you that she had examined me in the company of my midwife; she acknowledged that I was pregnant, but that it was not possible for me to give birth at her house; instead she promised that she would watch over me, if I continued until all my time was fulfilled and nothing happened that was my fault. May I be benefited.
 (2nd hand) Farewell. (1st hand) Year 11, Thoth 27.
 (3rd hand) Summon her (the iustissima femina).[40]

Subsequent portions of Petronilla's dossier show other thrusts in Petronilla's strategy. She requests the juridicus Calvisius Patrophilus to appoint a guardian for her baby son, and she offers the names of two possible candidates. The juridicus forwards the names Petronilla suggested to the district governor of the Arsinoite nome where Petronilla lives, but because neither candidate is from that nome, the district governor then writes to his counterpart in the Aphroditopolite nome where the two candidates reside, in order, as he says, that a responsible choice be made. Back comes the response, also included in the dossier, that one candidate is better suited than the other to serve as the child's guardian. Another fragment from Petronilla's dossier reveals that kinsmen of the deceased father, probably representatives from her former mother-in-law, since they are said to be "in the female line of descent," continue to dispute the child's legitimacy.[41]

Elaborate though Petronilla's dossier is, it tells only her side of the story and thus fails to make clear whether Petronilla is the young innocent, whose posthumously born male child is being deprived of his paternal inheritance by Petronilla's greedy in-laws, or whether Petronilla herself is a scheming daughter-in-law, trying to pass off on her deceased husband's family a bastard, fathered not by their dead son but by another, or a suppositious child, smuggled into the birthing room in a basket. There are elements in Petronilla's own account that evidently aroused the suspicions of her mother-in-law. By her own admission, Petronilla did not follow the juridicus's instructions to give birth at the house of the woman he appointed, although the woman did promise to oversee Petronilla's pregnancy. Further, Petronilla does not nominate candidates for the infant's guardian from the area in which she currently resides and presumably the area in which her in-laws also live, but men whose principal residence lay at some distance across the Nile on the opposite bank. At the same time, there also seem to have been no parents or male kinsmen on hand to defend the young widow, and we may be witnessing only Petronilla's desperation at finding herself alone and under attack. Nothing more is known of her case, and we do not know the outcome of Petronilla's attempts to negotiate a favorable settlement with her former mother-in-law through appeal to government officials and the provisions of Roman law.

Widowhood, whether a marriage ended through the death of the husband or through divorce, impacted upon a young woman and upon her family, if she were fortunate enough to have living kin. Although society urged remarriage, once young widows and young divorcées reach 30 years of age, success in the marriage market becomes increasingly unlikely for them. Concerns to negotiate return of dowry and to assure future support for the children from the union vie with worries about reputation and respectability. Some of the formerly married young women of the papyri may have remarried. Those who did not may eventually have had the leisure to worry about the health of their female nature and to test the efficacy of the various means available for warding off uterine suffocation and other indispositions associated with premature widowhood. The documents do not tell us, although uterine amulets, intended, among other things, to restrain a uterus in its rightful place, have been found throughout the length and breadth of the Roman empire, as well as in Roman Egypt.[42] The documents from and about young widows and divorcées do, however, impress us with the seriousness of the practical concerns that occupy these women, even as the census declarations impress us by the sheer numbers of unattached young women in the population.

Studies of young widows, which began in earnest only in 1994, are still in their infancy, and my intention here has been merely to draw attention to matters that preoccupied those Claudias of the Roman empire who find themselves widows too young in their widowhood.

APPENDIX:

EMPIRICAL DATA FROM THE ROMAN CENSUS DECLARATIONS [43]

Women 13 years and older for whom something is known about their living arrangements and their age.

Adult females who are said to live with a husband (or father of their children): [44]
1 & 2. 33-Ar-1 (non-kin 7, age lost), (non-kin 8, age lost); [45] 3. 33-Ox-1 (3, age lost); 4. 33-Ox-2 (7, age lost); 5. 61-Ar-1 (5, 30 yrs.); 6. 75-Ar-2 (5, age lost); 7. 89-Ar-1 (2, 25 yrs.); 8–10. 103-Ar-1 (2, 26 yrs.), (non-kin 2, age lost), (non-kin 6, 35 yrs.); 11. 103-Ar-3 (5, 43 yrs.); 12. 103-Ar-5 (2, 18 yrs.); 13. 103-Ar-7 (1, age lost); 14. 103-Ar-8 (4, 25 yrs.); 15. 103-Ar-11 (2, 25 yrs.); 16. 117-Ap-3 (2, 29 yrs.); 17 & 18. 117-Ap-5 (5, age lost), (8, 20 yrs.); 19 & 20. 117-Ap-6 (4, 53 yrs.), (7, 18 yrs.); 21. 117-Ap-7 (3, 39 yrs.); 22. 117-Ar-1 (4, 28 yrs.); 23. 117-Ar-2 (3, 28 yrs.); 24 & 25. 117-Ar-3 (2, 32 yrs.), (non-kin 3, 26 yrs.); 26 & 27. 117-Ar-4 (2, 45 yrs.), (6, 39 yrs.); 28. 117-Ar-6 (2, 53 yrs.); 29–31. 117-Ar-7 (2, age lost), (6, age lost), (9, age lost); 32. 117-Ar-8 (non-kin 2, 35 yrs.); 33–35. 117-Ar-11 (2, 60 yrs.), (4, 30 yrs.), (9, 18 yrs.); 36. 117-Ar-12 Add (4, 36 yrs.); 37. 117-Ox-2 (5, age lost); 38. 131-Ar-3 (2, 42 yrs.); 39. 131-Ar-8 (2, age lost); 40. 131-Ar-12 Add (4, 60 yrs.); 41 & 42. 131-Be-1 (2, 60 yrs.), (5, 65 yrs.); 43. 131-He-2 (2, 20 yrs.); 44. 131-He-4 (3, 29 yrs.); 45. 131-Me-1 (1, 55 yrs.); 46 & 47. 131-Ox-1 (8, 60 yrs.), (13, 25 yrs.); 48–51. 131-Pr-1 (2, age not given), (6, age not given), (10, 29 yrs.), (15, 21 yrs.); 52. 145-Ar-3 (5, 18 yrs.); 53. 145-Ar-6 (4, age lost); 54 & 55. 145-Ar-9 (2, 41 yrs.), (4, 13 yrs.); 56. 145-Ar-12 (2, 70 yrs.); 57. 145-Ar-17 (2, 36 yrs.); 58 & 59. 145-Ar-19 (5, 20 yrs.), (6, 14 yrs.); 60. 145-Ar-20 (4, 20+ yrs.); 61. 145-Ar-23 (2, 28 yrs.); 62. 145-He-1 (2, 34 yrs.); 63–68. 145-He-2 (2, 54 yrs.), (4, 16 yrs.), (5, age not given), (9, 18 yrs.), (10, age not given), (11, age not given); 69. 145-Ox-1 (2, age lost); 70. 159-Ar-1 (3, 22 yrs.); 71 & 72. 159-Ar-4 (7, 35 yrs.), (10, 26 yrs.); 73–76. 159-Ar-5 (5, age lost), (9, age lost), (13, age lost), (20, age lost); 77. 159-Ar-7 (2, 29 yrs.); 78. 159-Ar-9 (3, 39 yrs.); 79. 159-Ar-10 (2, 20+ yrs.); 80 & 81. 159-Ar-11 (4, age lost), (5, age lost); 82. 159-Ar-13 (2, 13 yrs.); 83. 159-Ar-20 (2, 35 yrs.); 84 & 85. 159-Ar-21 (4, 32 yrs.), (6, age lost); 86. 159-Ar-22 (2, age lost); 87. 159-Ar-26 (2, age lost); 88. 159-Hm-2 (non-kin 2, age lost); 89. 159-Hm-3 (3, 57 yrs.); 90. 173-Ar-3 (2, 38 yrs.); 91. 173-Ar-9 (3, 38 yrs.); 92. 173-Ar-15 (2, 19 yrs.); 93. 173-Ar-16 (2, 24 yrs.); 94 & 95. 173-Me-3 (3, 40+ yrs.), (6, 31 yrs.); 96–98. 173-Pr-5 (2, 52 yrs.), (5, 16 yrs.), (7, 13 yrs.); 99. 173-Pr-7 (1, 47 yrs.); 100–103. 173-Pr-10 (2, 21 yrs.), (8, 40 yrs.), (12, 30 yrs.), (15, 19 yrs.); 104. 173-Pr-15 (?3, 16 yrs.); 105. 187-An-1 (? 2, age lost); 106. 187-An-2 (2, 21 yrs.); 107. 187-Ar-2 (2, 43 yrs.); 108–112. 187-Ar-4 (2, 54 yrs.), (9, age lost), (13, 29 yrs.), (19, 17 yrs.), (non-kin 2, 52 yrs.); 113 & 114. 187-Ar-8 (2, age lost), (6, age lost); 115. 187-Ar-11 (2, 34 yrs.); 116. 187-Ar-12 (2, age lost); 117. 187-Ar-16 (2, age lost); 118 & 119. 187-Ar-22 (3, 40 yrs.), (7, 18 yrs.); 120. 187-Ar-23 (2, age lost); 121. 187-Ar-32 (2, 43 yrs.); 122. 187-Hm-1 (5, 51 yrs.); 123. 201-Ar-1 (4, 35 years); 124. 201-Ar-2 (2, age lost); 125. 201-Ar-5 (2, 26 yrs.); 126. 201-Ar-6 (2, 44 yrs.); 127. 201-Ar-10 (4, 35 yrs.); 128. 201-Ar-12 (2, 16 yrs.); 129. 201-Ox-1 (2, 20 yrs.); 130. 215-Ar-3 (2, age lost); 131–133. 215-Ar-4 (2, 30 yrs.), (8, 29 years), (11, age lost); 134. 215-Ar-5 (2, 34 yrs.); 135 & 136. 215-Ar-6 (2, 49 yrs.), (5, 32 yrs.) 137. 215-Ar-7 (2, age lost); 138. 215-He-1 (2, age lost); 139. 215-He-2 (2, 25 yrs.); 140. 215-He-3 (3, 31 yrs.); 141. 215-Hm-2 (1, 30 yrs.); [46] 142. 229-Ar-2 (2, age lost); 143. 243-Ar-2 (2, age lost); 144 & 145. ???-Ar-3 (3, 38 yrs.), (7, 31 yrs.); 146 & 147. ???-Ar-5 (2, age lost), (7, age lost); 148. ???-Ox-2 (5, age lost).

Seemingly unattached females aged 13 and older:

Thirty-seven (between 13 and 20 years and living with parents or male kin) who are likely to be as yet unmarried.[47]

Living with parents, or a father: 1 & 2. 89-Hm-1 (5, 17 yrs.), (6, 14 yrs.); 3 & 4. 103-Ar-3 (6, 20 yrs.), (7, 14 yrs.); 5 & 6. 117-Ap-5 (6, 20 ? yrs.), (7, 16 yrs.); 7. 117-Ap-6 (6, 18 yrs.); 8. 117-Ap-7 (4, 15 yrs.); 9 & 10. 117-Ar-2 (5 & 6. 13 yrs., twins?); 11 & 12. 117-Ar-12 Add (5, 20 yrs.), (6, 17 yrs.); 13–15. 131-Ox-1 (9, 20 yrs.), (10, 15 yrs.), (11, 20 ? yrs.); 16. 131-Ox-4 (?3, 14 yrs. ?); 17 & 18. 159-Ar-4 (8, 17 yrs.), (9, 15 yrs.); 19. 159-Ar-9 (1, 16 yrs.); 20. 173-Ar-9 (4, age lost); 21. 173-Me-1 (3, 17 yrs.); 22. 173-Me-3 (?9, 19 yrs.); 23. 187-Ar-4 (10, 17 yrs.); 24 & 25. 187-Ar-8 (8, 14 yrs.), (9, 20 yrs.); 26. 187-Ar-26 (2, 13 yrs.); 27. 201-Ox-1 (3, 15 yrs.); 28. 215-Ar-3 (5, 16 yrs.); 29. 215-He-3 (6, 19 yrs.); 30. ???-Ar-3 (8, age lost, but 12+).

Living in the household of a brother or other male kin: 1. 103-Ar-12 (2, 14 yrs.); 2. 145-Ar-3 (? 4, 15 yrs.); 3. 145-Ar-19 (?7, 16 yrs.); 4. 159-Ar-10 (5, 14 yrs.); 5. 173-Pr-13 (? 3, 13 yrs.); 6. 187-Ar-7 (2, 14 yrs.); 7. 187-Ar-26 (?4, 15 yrs.).

Adult females who are likely to be common-law wives of soldiers, prohibited from contracting a legal marriage while in service; the young children are called *apatores*, "without a father."

1. 145-Ar-1 (1, 38 yrs., and 2, daughter, 13 yrs.); 2 & 3. 173-Ar-9 (7, 38 yrs., and 8, daughter, 12 yrs.), (? non-kin 1, 30 yrs., and 5, daughter, 4 yrs., 6, son, 2 mos.); 4. 187-Me-1 (1, 45 yrs., and 2 & 3, daughters, 20 yrs. & 12 yrs.).

Adult females who are putative widows and putative divorcées.[48]

Seemingly unattached older women who live with adult children:

With son + daughter-in-law: 1. 117-Ar-1 (1, 53 yrs.); 2. 117-Ar-6 (5, 75 yrs.); 3. 117-Ar-7 (10, age lost); 4. 117-Ar-12 Add (3, 64 yrs.);[49] 5 & 6. 145-Ar-3 (1, 40 yrs., certain divorcée), (5, 70 yrs., mother of 1); 7. 145-Ar-20 (5, 55 yrs.); 8. 159-Ar-10 (7, 54 yrs.); 9. 173-Ar-9 (5, 72 yrs.); 10. 173-Pr-15 (1, 42 yrs.); 11. 201-Ar-1 (1, 59 yrs.); 12. 201-Ar-10 (1, 54 yrs.); 13. 215-Ar-5 (3, 54 yrs.).

With daughter + son-in-law: 1. 131-He-2 (4, 50+ yrs.).

With currently unmarried son: 1. 11-Ar-1 (3, 70 yrs.); 2. 131-Ar-13 Add (2, 57 yrs.); 3. 145-Ar-22 (1, 51 yrs., 2 or 3 sons, 1 as *kyrios*); 4. 173-Pr-17 (2, 69 yrs.); 5. 201-Ar-9 (1, 74 yrs., 2 sons, 1 as *kyrios*, 56 yrs., 46 yrs.); 6. 215-Ar-1 (2, 60 yrs.).

With other male relatives: 1. 117-Ar-1 (5, 70 yrs., nephew + wife); 2. 131-Ox-1 (? 12, 50 yrs.); 3 & 4. 173-Pr-3 (2, 44 yrs.), (3, 48 yrs.); 5. 173-Pr-9 (? age lost, grand nephew); 6. 201-Ar-1 (? 3, 54 yrs.); 7. 201-Ar-6 (4, 57 yrs., divorced wife of joint, non-resident owner of house); 8. 201-Ar-9 (6, 56 yrs.); 9. 201-Ar-10 (3, 54 yrs., nephew); 10. 215-Ar-2 (? 6, 50 yrs.); 11. ???-Ar-3 (10, 60 yrs., and 1 son, 17 yrs., 2 daughters, ages lost, ? also widows).

Seemingly unattached younger women who live with relatives:

With parents: 1. 117-Ap-6 (5, 24 yrs.); 2. 117-Ar-6 (4, age lost); 3. 117-Ar-11 (12, 22 yrs.); 4. 131-Ar-12 Add (5, 31 yrs.); 5. 145-Ar-12 (3, 33 yrs., divorced?, 3 daughters live with husband); 6. 159-Hm-3 (4, 40 yrs.); 7. 173-Pr-5 (8, 24 yrs.); 8. 187-Ar-4 (8, 23 yrs.); 9. 187-Ar-22 (6, 22 yrs.); 10. 215-Ar-3 (4, 26 yrs.)

In a household headed by a male relative (father alone, brother, brother-in-law, cousin): 1. 117-Ar-1 (3, 33 yrs., br. + wife); 2. 131-Ar-11 (6, age lost, half-br. is

32 yrs.); 3. 145-Pr-1 (3, 24 yrs., father); 4. 159-Ar-4 (5, 47 yrs., brother); 5. 173-Ar-7 (2, age lost, father is 48 yrs.); 6. 173-Ar-9 (6, twin of 7, 38 yrs.); 7. 187-Ar-4 (non-kin? 7, 23 yrs.); 8. 187-Ar-8 (11, 29 yrs.); 9. 201-Ar-6 (5, daughter of 4, age not given, but 14+, lives with father); 10 & 11. 215-He-2 (4, 33 yrs.), (5, sister of 4, age lost); 12–16. ???-Ar-3 (14, 38 yrs., certain widow), (15, age lost, 1 daughter, 12 yrs.), (19, 35 yrs.), (20, age lost), (21, age lost, daughter, age lost).
In a household with ex-husband: 1. 159-Ar-4 (6, 29 yrs.; sis. and ex-wife of 1); 2. 159-Ar-5 (2, age lost; sis. and ex-wife of 1); 3. 159-Ar-8 (6, age lost, certain divorcée).

Seemingly unattached females, many of them younger, who live in a predominantly female household (with minor children; with a mother or sister, if also unattached; with other kin, which, if male, are, for the most part, young).
1. 33-Ar-2 (2, 35 yrs. + non-resident *kyrios,* and son, 5 yrs.); 2. 47-Ox-1 (? 2, 65 yrs.); 3. 103-Ar-9 (4, 35 yrs., and 3 sons, 5, 4, 1 yrs.); 4. 117-Ap-8 (broken at top, males lost ?, some females lost; females preserved: 1, 39 yrs.; 2, 18 yrs., and daughter, 2 yrs.); 5. 117-Ar-5 (1, 30 yrs., and 1 son, 10 yrs., 2 daughters, 8 yrs., age lost); 6. 145-Ar-2 (1, 29 yrs., certain divorcée, + non-resident *kyrios,* and son, age lost); 7. 145-Ar-4 (1, age lost, certain divorcée); 8 & 9. 145-Ly-1 (1, 40 yrs.), (2, daughter of 1, 21 yrs., and female orphan, 8 yrs.); 10. 159-Ar-19 (1, 44 yrs., + non-resident *kyrios*); 11. 159-Ar-25 (1, 48 yrs., + non-resident *kyrios,* a kinsman); 12. 159-Ar-27 Add (1, age lost, and 2, daughter, age lost); 13 & 14. 173-Ar-8 (1, 60+), (2, age lost); 15 & 16. 173-Ar-10 (1, age lost), (2, sis. of 1, age lost); 17 & 18. 173-Ar-11 (1, 32 yrs., and daughter, 3 yrs., son, 1 yr., and half-brother, 14 yrs.), (5, mother of 1, 48 yrs., and nephew, age lost); 19. 173-Pr-4 (1, 47 yrs., and daughter, 10 yrs.); 20. 173-Pr-11 (1, 48 yrs., and son, 15 yrs.); 21 & 22. 173-Pr-14 (1, 60 yrs.), (2, 20 yrs., daughter of 1); 23–25. 187-Ar-3 (1, 25 yrs.), (3, 33 yrs.), (4, age lost); 26. 187-Ar-29 (1, 36 yrs., and 2 daughters, 13 yrs., 4 yrs.); 27. 187-Ar-30 (1, 60 yrs., with slaves); 28. 187-Ar-34 (1, age lost, and daughter, age lost; male lodger?, 14 yrs.); 29 & 30. 187-Ox-3 (1, 25 yrs.), (2, sis. of 1, 22 yrs.); 31. 187-Ox-4 (1, 32 yrs., ? and 2 daughters, 3 yrs., 10 yrs.); 32 & 33. 201-Ar-8 (1, 50 yrs.), (2, daughter of 1, 21 yrs., and daughter, 1 yr.); 34. 215-An-1 (1, age not given, and 1 minor son, 1 minor daughter); 35. 215-Hm-3 (1, 72 yrs., with slaves); 36. 243-Ar-1 (1, 27 yrs., and 2 sons, age lost and 6 yrs.); 37. 243-Ar-4 (1, age lost, certain widow, and minor son); 38. 257-Ar-1 (1, 38 yrs., and 2 sons, 5 yrs., 1 yr.); 39. ???-Ar-2 (1, age lost, and daughter, age lost).

Seemingly unattached younger women in households in which the other adult is an unattached male lodger:
1. 187-Ar-9 (1, 39 yrs., and son, 16 yrs., and another child, age lost; male lodger is 54 yrs.);[50] 2. 187-Ar-10 (2, 49 yrs., certain divorcée, and daughter, 10 yrs.; lodger-*kyrios,* 36 yrs.). 3. 243-Ar-3 (1, 36 yrs., certain widow, and 3 sons, 16 yrs., 11 yrs., 7 yrs.; male lodger, 31 yrs., certain widower, and son).

Seemingly unattached female lodgers:
1. 145-Ar-20 (non-kin 1, ?8 yrs.); 2. 215-He-1 (non-kin 1, 80 yrs.).

Abbreviations for frequently cited works is are as follows:

BAGNALL-FRIER, *Demography*
Roger S. Bagnall and Bruce W. Frier, *The Demography of Roman Egypt* (Cambridge 1994)

KRAUSE, *Verwitwung*
Jens-Uwe Krause, *Verwitwung und Wiederverheiratung = Witwen und Waisen im römischen Reich I* (Stuttgart 1994)

SALLER, *Patriarchy*
Richard Saller, *Patriarchy, Property and Death in the Roman Family* (Cambridge 1994)

Papyri are cited according to the abbreviations in J.F. Oates, R.S. Bagnall, W.H. Willis, and K.A. Worp, *Checklist of Greek and Latin Papyri, Ostraca and Tablets*[4] (Atlanta 1992). For an updated version of the Checklist, see http://scriptorium.lib.duke.edu/papyrus/texts/clist.html.

NOTES

1. Repeated in Hippoc. *Nat. Fem.* 3, 71–72 ed. Trapp; cf. also *Morb. Mul.* 2.137, 8.310 ed. Littré. For Hippocratics's interventionism, see A.E. Hanson, "Conception, Gestation, and the Origin of Female Nature in the *Corpus Hippocraticum*," *Helios* 19 (1992) 31–71.

2. Hippoc. *Morb. Pop.* 6.8.32, 7.288–90 ed. Smith.

3. For the history of uterine suffocation from antiquity into the Renaissance, see H. King, "Once upon a Text: Hysteria from Hippocrates," in S.L. Gilman et al. eds., *Hysteria beyond Freud* (Berkeley 1993) 3–90.

4. Cf., e.g., Mart. *Epig.* 11.21, and additional references infra n. 33. For the saints, e.g., Iocabus Diaconus, *Legend of St. Pelagia of Antioch* 14.14 (ed. by H.K. Usener, *Legenden der Pelagia* [Bonn 1879]), and *Acta Sanctorum . . . Octobris* III (Brussels 1857) 149 (for 5 October).

5. See Krause, *Verwitwung* 2–3, for a list of social historians who either assumed that the number of unmarried women in the Roman population was very small or felt they had established that remarriage was common for particular populations in the late Republic or in the empire. Particularly important for the wide acceptance of the proposition was the study by Marcel Humbert, *Le remarriage à Rome. Étude d'histoire juridique et sociale* (Milan 1972).

6. Saller, *Patriarchy* 68; Krause, *Verwitwung* passim and esp. 7–107.

7. Krause, *Verwitwung* 46 and n. 128.

8. Krause, *Verwitwung* 73.

9. Saller, *Patriarchy* 68.

10. *SB* I 5661 + *BL* IX 243–44 = 33-AR-2, Bagnall-Frier, *Demography* 182. The declaration is complete, and no other inhabitants dwelt in the household.

11. E.g., Saller, *Patriarchy* 19–20; Bagnall-Frier, *Demography* 28–29, 42–47, 107–10.

12. Bagnall-Frier, *Demography* 121–26.

13. Bagnall-Frier, *Demography* 75–121.

14. But cf. infra n. 47.

15. Richard Alston, *Soldier and Society in Roman Egypt* (London and New York 1995) 54–60.

16. Bagnall-Frier, *Demography* 123–26.

17. A.B. Rugh, *Family in Contemporary Egypt* (Syracuse 1984) 22–23, 80–88, 188–204.

18. 145-Ar-20 (non-kin 1, ?8 yrs.), as the data appear in my *Appendix* (infra); the data are based on the presentation in Bagnall-Frier, *Demography*. This declaration was submitted for the Roman census of 145 from a household in the Ar(sinoite) nome; number 20 marks the declaration as the 20th for this year and area in the Bagnall-Frier catalogue; the woman is the first individual listed among non-kin inhabitants; the first digit of her age is lost. The 80-year-old female lodger is 215-He-1 (non-kin 1).

19. For an unattached male lodger in a widow's household, see infra, *Appendix,* for 187-Ar-10, 243-Ar-3, and possibly 187-Ar-9.

20. The nature of Peina's injuries remains a matter of discussion: perhaps extensive and causing shock (*BL* VIII 271), or localized in her arm (*BL* IX 154).

21. 187-Ar-30 (1, 60 yrs.) and 215-Hm-3 (1, 72 yrs.).

22. For the long-term effects of nuclear-family incest, see W. Scheidel, *Measuring Sex, Age and Death in the Roman Empire: Explorations in Ancient Demography* (*JRA* Supplement 21, Ann Arbor 1996) 9–81.

23. D.W. Hobson, "Women as Property Owners in Roman Egypt," *TAPA* 113 (1983) 311–21.

24. P. Kron. 50.6–8 + *BL* VII 74.

25. The receipt for grain taxes is P. Kron. 40 + *BL* IX 118–19. Cf. also the two instances in the census declarations of sister/ex-wives who continued to live in the same household with their brother/ex-husbands: 159-Ar-4 (6, 29 yrs.) and 159-Ar-5 (2, age lost) 159-Ar-8.

26. Treggiari, *Roman Marriage* 60–80, esp. 69.

27. *M. Chr.* 287 (= P. Oxy. III 496) + *BL* VI 97–98.

28. *BGU* IV 1105 + *BL* II 2 23.

29. *BGU* IV 1104.

30. P. Oxy. II 268 + *BL* VII 129.

31. Discussion and references in G. Tibiletti, "Le vedove nei papiri greci d'Egitto," in *Atti del XVII congresso internazionale di papirologia* III (Naples 1984) 985–94. For the distinction between consideration and charity, see Treggiari, *Roman Marriage* 498.

32. Egyptian officials were advertising their consideration for widows in tomb biographies as early as the Middle Kingdom (2040–1640 BC), but widows do not figure large in Egyptian documentary texts until the Christian centuries: cf. G. Robins, *Women in Ancient Egypt* (London 1993) 138 and 73. It is only in late antiquity that Judaeo-Christian influence brought to Graeco-Roman culture the notion that widows and their orphans were entitled to charitable donations (e.g. P. Bad. IV 97; SB XII 10926).

33. Ovid *Ars Am.* 3.431–32; Petronius 111.

34. I *Timothy* 5 : 11–15, for which see, e.g., R.S. Kraemer, *Her Share of the Blessings: Women's Religions among Pagans, Jews, and Christians in the Greco-Roman World* (Oxford 1992) 133–56.

35. P. Grenf. I 53 = *W. Chr.* 131. This letter, enclosed within a covering letter to Artemis's husband, is rudely written and often ungrammatical. Scholars differ as to the reading and precise intent of some of Artemis's phrases.

36. *W. Chr.* 204 + *BL* X 11 = 201-Ar-8, Bagnall-Frier, *Demography* 287. The document is complete, and no other individuals live in the household. For the declaration from Longinus Zosimus's grandmother, *BGU* II 577 (+ *BL* I 54 and X 15) = 201-Ar-9, Bagnall-Frier, *Demography* 287–88.

37. P. Gen. II 103 ii 1–30 + *BL* VIII 136 and IX 91–92. The first to emphasize the importance of Petronilla's dossier was Ulrich Wilcken, "Zu den Genfer Papyri," *Archiv* 3 (1906) 369–75. Petronilla is also discussed in Gardner, *Women in Roman Law* 53, and J.F. Gardner, "A Family and an Inheritance: The Problems of the Widow Petronilla," *Liverpool Classical Monthly* 9.9 (1984) 132–33.

38. See B. Rawson, "Adult-Child Relationships in Roman Society," in B. Rawson ed., *Marriage, Divorce, and Children in Ancient Rome* (Oxford 1991) 7–30, esp. 10–13.

39. For the praetor's provisions in the context of the medical literature on birthing, see A.E. Hanson, "A Division of Labor: Roles for Men in Greek and Roman Births," *Thamyris* 1 (1994) 157–202, esp. 170–76.

40. This revised reading for P. Gen. II 103 ii 10 will be presented in detail by me and Judith Evans Grubbs in a forthcoming volume of *ZPE*. Not only does the revision change the order from the office of the *juridicus* from "Summon [the] midwife!" to "Summon her (i.e., the *iustissima femina*)!," but the revised directive makes it all the more likely that Petronilla has herself already delivered at the time the dossier was assembled. Thus, her marriage to Herennius Valens produced but a single male child, the little Herennius Valens, whose interests are at the center of the dispute.

41. P. Gen. II 104, which, although little more than half lines are preserved, shows that in line 16 the charge of illegitimacy (*notheia*) has been raised.

42. For the amulets, see A.E. Hanson, "Uterine Amulets and Greek Uterine Medicine," *Medicina nei secoli* 7 (1995) 281–99.

43. All information is drawn from the catalogue of declarations in Bagnall-Frier, *Demography*. Only free women appear in these tables.

44. I gratefully acknowledge the advice of Professor Bruce W. Frier in assessing various aspects of the evidence from the census declarations as it affects the women no longer married, and I hope he can approve the use I have made of it. In general, the figures in this *Appendix* can do no more than suggest tendencies in women's living patterns. The number of women subsumed into this first section of the *Appendix*, the adult females living with a husband, is clearly too low, when compared to those for whom no husband is mentioned. This is due, at least in part, to the fact that sometimes a marriage relationship is not specified in the census return, and, in the case of the returns from the Oxyrhynchite nome, to the fact that women are listed only after the men, making the information on them more often prey to physical damage to the papyrus.

45. Notation of, for example, "1 & 2. 33-Ar-1 (non-kin 7, age lost), (non-kin 8, age lost)" is as follows: in the declaration submitted for the Roman census of 33 from a household in the Ar(sinoite) nome, number 1 for this year and area in Bagnall-Frier, *Demography,* there were two wives reported in the 7th and 8th positions in the list of non-kin inhabitants; their ages are now lost from the return. When a woman's age is reported

as lost, she has been subsumed into my data only when some indication of her age can nonetheless be derived from ages preserved for other family members. A question mark indicates that an aspect of the data is not certain.

46. The wife/sister apparently does not live in the same household with her husband/brother; cf. the same family in 229-Hm-1, where they do live in the same household but no longer say that they are husband and wife.

47. The six who are 20 years old (nos. 3, 5, 11, 13, 15, 25) are the most likely to be widows, especially nos. 5 and 15, whose age is per-haps in the twenties, rather than "20 ? yrs." If so, these two (or six) would join the "29 unattached younger women who live with relatives," bringing that total to 31 (or 35).

48. In the few instances in which the declarations note that a woman is either a widow or a divorcée, this is noted.

49. This widow still lives with her son and his wife at the next census, cf. 131-Ar-12 Add (3, 78 yrs.).

50. This return is not complete, however, and additional persons were declared.

SELECTED BIBLIOGRAPHY

ROMAN WOMEN AND
ROMAN SOCIETY

L.J. Archer, S. Fishler, and M. Wyke eds.,
*Women in Ancient Societies: An Illusion of the
Night* (London 1994).

M. Arthur, "'Liberated' Women: The Classical
Era," in R. Bridenthal and C. Koonz eds.,
Becoming Visible: Women in European History
(Boston 1977) 60–89.

C.L. Babcock, "The Early Career of Fulvia,"
AJP 86 (1965) 1–32.

J.P.V.D. Balsdon, *Roman Women, Their History
and Habits* (reprint, New York 1983).

A. Barratt, *Agrippina: Sex, Power, and Politics in
the Early Empire* (New Haven 1996).

R.A. Bauman, "The *leges iudiciorum publicorum*
and Their Interpretation in the Republic,
Principate and Later Empire," *ANRW* II.13
(1980) 103–233.

R.A. Bauman, *Women and Politics in Ancient Rome*
(New York 1992).

M. Beard, "The Sexual Status of Vestal Virgins,"
JRS 70 (1980) 149–65.

E.E. Best, Jr., "Cicero, Livy and Educated
Roman Women," *CJ* 65 (1970) 199–204.

J. Blayney, "Theories of Conception in the
Ancient Roman World," in B. Rawson ed.,
The Family in Ancient Rome (Ithaca 1986)
230–36.

M.T. Boatwright, "The Imperial Women of the
Early Second Century A.C.," *AJP* 112
(1991).

S.F. Bonner, *Education in Ancient Rome: From the
Elder Cato to the Younger Pliny* (London 1977).

F.C. Bourne, "The Roman Alimentary Program
and Italian Agriculture," *TAPA* 91 (1960)
47–75.

A.K. Bowman, *Life and Letters on the Roman Fron-
tier* (New York 1994).

K.R. Bradley, "Child Labour in the Roman
World," *Historical Reflections* 12 (1985)
311–30.

K.R. Bradley, "Ideals of Marriage in Suetonius'
Caesares," *Rivista Storica dell'Antichità* 15
(1985) 77–95.

K.R. Bradley, "Wet-Nursing at Rome: A Study
in Social Relations," in B. Rawson ed., *The
Family in Ancient Rome* (Ithaca 1986) 201–29.

K.R. Bradley, *Discovering the Roman Family*
(Oxford 1991).

A.C. Bush and J.J. McHugh, "Patterns of Roman
Marriage," *Ethnology* 14 (1975) 25–45.

A. Cameron and A. Kuhrt eds., *Images of Women
in Antiquity* (London 1993).

E. Cantarella, *Pandora's Daughters* (Baltimore
1987).

T. Carp, "Two Matrons of the Late Republic," in
H. Foley ed., *Reflections of Women in Antiquity*
(New York 1981) 343–54.

A. Castillo, "Sobre la controversia entre matri-
monio romano y pubertad femenina," *Rurius*
4 (1977) 195–201.

A. Chastagnol, "Les femmes dans l'ordre senato-
rial: titulature et rang social à Rome," *Revue
historique* 262 (1979) 3–28.

G. Clark, "Roman Women," *Greece and Rome*
ser. 2, 28 (1981) 193–212.

G. Clark, *Women in Late Antiquity* (Oxford
1994).

M. Corbier, "Divorce and Adoption as Roman
Familial Strategies," in B. Rawson ed., *Mar-
riage, Divorce and Children in Ancient Rome*
(Oxford 1991).

M. Corbier, "Family Behavior of the Roman
Aristocracy, Second Century BC–Third Cen-
tury AD," in S.B. Pomeroy ed., *Women's His-
tory and Ancient History* (Chapel Hill 1991)
173–96.

J.A. Crook, "Women in Roman Succession," in
B. Rawson ed., *The Family in Ancient Rome*
(Ithaca 1986) 58–82.

P. Csillag, *The Augustan Laws on Family Relations*
(Budapest 1976).

L.C. Curran, "Rape and Rape Victims in the
Metamorphoses," *Arethusa* 11 (1978) 213–41.

A. Dalby, "On Female Slaves in Roman Egypt,"
Arethusa 12 (1979) 255–63.

D. Daube, "The *Lex Julia* Concerning Adultery,"
Irish Jurist 7 (1972) 373–80.

D. Delia, "Fulvia Reconsidered," in S.B. Pome-
roy ed., *Women's History and Ancient History*
(Chapel Hill 1991) 197–217.

S. Dickison, "Abortion in Antiquity," *Arethusa* 6
(1973) 159–66.

S. Dixon, "A Family Business: Women's Role in
Patronage and Politics at Rome, 80–44 BC,"
Classica et Mediaevalia 34 (1983) 91–112.

S. Dixon, "*Infirmitas sexus:* Womanly Weakness
in Roman Law," *Tijdschrift voor Rechtsgeschied-
enis* 52 (1984) 343–71.

S. Dixon, "The Marriage Alliance in the Roman
Elite," *Journal of Family History* 10 (1985)
353–78.

S. Dixon, "Polybius on Roman Women and
Property," *AJP* 106 (1985) 147–70.

S. Dixon, *The Roman Mother* (Norman 1988).

S. Dixon, *The Roman Family* (Baltimore 1992).

D. Engels, "The Problem of Female Infanticide
in the Greco-Roman World," *CP* 75 (1980)
112–20.

E. Eyben, "Antiquity's View of Puberty," *Lato-
mus* 31 (1972) 677–97.

E. Eyben, "Family Planning in Antiquity,"
Ancient Society 11–12 (1980–1981) 5–82.

E. Fantham, *La femme dans le monde méditerranéen
I: L'antiquité* (Lyon 1985).

E. Fantham, H.P. Foley, N.B. Kampen, S.B.
Pomeroy, and H.A. Shapiro, *Women in the
Classical World* (Oxford 1994).

M.I. Finley, "The Silent Women of Rome," in
*Aspects of Antiquity: Discoveries and Controver-
sies* second ed. (New York 1977).

M.B. Flory, "Where Women Precede Men:
Factors Influencing the Order of Names in
Roman Epitaphs," *CJ* 79 (1984) 216–24.

H.B. Foley ed., *Reflections of Women in Antiquity*
(New York 1981).

E.P. Forbis, "Women's Public Image in Italian
Honorary Inscriptions," *AJP* 111 (1990)
493–512.

R.I. Frank, "Augustus' Legislation on Marriage
and Children," *CSCA* 8 (1975) 41–52.

V. French, "Midwives and Maternity Care in the
Roman World," in M. Skinner ed., *Rescuing
Creusa: New Methodological Approaches to
Women in Antiquity, Helios* 13.2 (1987)
69–84.

K. Galinsky, "Augustus' Legislation on Morals
and Marriage," *Philologus* 125 (1981) 126–44.

P.A. Gallivan, "Confusion Concerning the Age
of Octavia," *Latomus* 33 (1974) 116–17.

J.F. Gardner, *Women in Roman Law and Society*
(Bloomington 1986).

P. Garnsey, "The *Lex Julia* and Appeal under the
Empire," *JRS* 56 (1966) 167–89.

G. Giacosa, *Women of the Caesars: Their Lives and
Portraits on Coins* (Milan 1977).

A.S. Gratwick, "Free or Not Free? Wives and
Daughters in the Late Roman Republic," in
E.M. Craik ed., *Marriage and Property* (Aber-
deen 1984) 30–53.

M.J. Gray-Fow, "The Wicked Stepmother in
Roman Literature and History: An Evalua-
tion," *Latomus* 47 (1988) 741–57.

E.S. Gruen, "The Advent of the Magna Mater,"
Studies in Greek Culture and Roman Society
(Leiden 1990).

J.P. Hallet, *Fathers and Daughters in Roman Society:
Women and the Elite Family* (Princeton 1984).

R. Hawley and B. Levick eds., *Women in Antiq-
uity: New Assessments* (New York 1995).

H.E. Herzig, "Frauen in Ostia," *Historia* 32
(1983) 77–92.

S.K. Heyob, *The Cult of Isis among Women in the
Greco-Roman World* (Leiden 1975).

D. Hobson, "The Role of Women in the Eco-
nomic Life of Roman Egypt," *EchCl* 3 (1984)
373–90.

K. Hopkins, "Age of Roman Girls at Marriage,"
Population Studies 18 (1965) 309–27.

K. Hopkins, "Contraception in the Roman
Empire," *Comparative Studies in Society and
History* 8 (1965) 124–51.

K. Hopkins, "Brother-Sister Marriage in Roman
Egypt," *Comparative Studies in Society and His-
tory* 22 (1980) 303–54.

E. Huzar, "Mark Antony: Marriages vs.
Careers," *CJ* 81 (1986) 97–111.

S. Joshel, "Nurturing the Master's Child: Slavery
and the Roman Child-Nurse," *Signs* 12
(1986) 3–22.

I. Kajanto, "Women's *Praenomina* Reconsidered,"
Arctos 7 (1972) 13–30.

I. Kajanto, "On the First Appearance of
Women's *Cognomina*," in *Akten des VI. Inter-
nationalen Kongresses für Griechische und Latein-
ische Epigraphik, München 1972* (Munich 1973).

D.I. Kertzer and R.P. Saller eds., *The Family in
Italy from Antiquity to the Present* (New Haven
1991).

D.E.E. Kleiner, "'Democracy' for Women in the
Age of Augustus," *AJA* 98 (1994) 303.

N. Kokkinos, *Antonia Augusta: Portrait of a Great
Lady* (London 1992).

J. Kollendo, "Les femmes esclaves de l'empe-
reur," *Actes du colloque 1973 sur l'esclavage*
(Besançon 1976) 401–16.

R.S. Kraemer, "Ecstacy and Possession: The Attraction of Women to the Cult of Dionysos," *HTR* 72 (1979) 55–80.

R.S. Kraemer, "Women in the Religions of the Greco-Roman World," *Religious Studies Review* 9 (1983) 127–39.

W.K. Lacey, "2 BC and Julia's Adultery," *Antichthon* 14 (1980) 127–42.

M.R. Lefkowitz and M.B. Fant eds., *Women's Life in Greece and Rome: A Sourcebook in Translation*[2] (London 1982).

M.R. Lefkowitz, "Wives and Husbands," *Greece and Rome* 3 (1983) 31–47.

E. Levy ed., *La femme dans les sociétés antiques* (Strasbourg 1983).

M. Lightman and W. Feisel, "*Univira*: An Example of Continuity and Change in Roman Society," *Church History* 46 (1977) 19–32.

G. Luck, "The Woman's Role in Latin Love Poetry," in K. Galinsky ed., *Perspectives of Roman Poetry: A Classics Symposium* (Austin 1974) 15–31.

R.O.A.M. Lyne, *The Latin Love Poets: From Catullus to Horace* (Oxford 1980).

R. MacMullen, "Women in Public in the Roman Empire," *Historia* 29 (1980) 208–18.

G.H. Macurdy, *Vassal-Queens and Some Contemporary Women in the Roman Empire* (Baltimore 1937).

M. Manson, "The Emergence of the Small Child at Rome (Third Century BC–First Century AD)," *History of Education* 12 (1983) 149–59.

A.J. Marshall, "Roman Women and the Provinces," *Ancient Society* 6 (1975) 109–27.

A.J. Marshall, "Ladies at Law: The Role of Women in the Roman Civil Courts," in C. Deroux ed., *Studies in Latin Literature and Roman History* (Brussels 1989) 35–54.

M. McDonnell, "Divorce Initiated by Women in Rome," *AJAH* 8 (1983) 54–80.

T.A.J. McGinn, "The Taxation of Roman Prostitutes," *Helios* 16 (1989) 79–110.

T.A.J. McGinn, *Prostitution and the Law: The Formation of Social Policy in Ancient Rome* (New York 1998).

J.-P. Néraudau, *Être enfant à Rome* (Paris 1984).

D. Nörr, "The Matrimonial Legislation of Augustus," *Irish Jurist* 16 (1981) 350–64.

T.E.V. Pearce, "The Role of the Wife as *Custos* in Ancient Rome," *Eranos* 72 (1974) 19–33.

J Peradotto and J. P. Sullivan eds., *Women in the Ancient World: The Arethusa Papers* (Albany 1984).

J.E. Phillips, "Roman Mothers and the Lives of Their Adult Daughters," *Helios* 6 (1978) 69–80.

H.W. Pleket, "The Social Position of Women in the Greco-Roman World," *Epigraphica II: Texts on the Social History of the Greek World* (Leiden 1969) 10–41.

S.B. Pomeroy, "Selected Bibliography on Women in Antiquity," *Arethusa* 6 (1973) 125–57.

S.B. Pomeroy, *Goddesses, Whores, Wives and Slaves: Women in Classical Antiquity* (New York 1975).

S.B. Pomeroy, "The Relationship of the Married Woman to Her Blood Relatives in Rome," *Ancient Society* 7 (1976) 215–27.

S.B. Pomeroy, "Women in Roman Egypt," in H.P. Foley ed., *Reflections of Women in Antiquity* (New York 1981) 303–22.

S.B. Pomeroy, *Women in Hellenistic Egypt from Alexander to Cleopatra* (New York 1984).

S.B. Pomeroy ed., *Women's History and Ancient History* (Chapel Hill 1991).

N. Purcell, "Livia and the Womanhood of Rome," *PCPS* 212 (1986) 78–105.

N.S. Rabinowitz and A. Richlin eds., *Feminist Theory and the Classics* (New York 1993).

L.F. Raditsa, "Augustus' Legislation Concerning Marriage, Procreation, Love Affairs and Adultery," *ANRW* II.13 (1980) 278–339.

B. Rawson, "Family Life among the Lower Classes at Rome in the First Two Centuries of the Empire," *CP* 61 (1966) 71–83.

B. Rawson, "Roman Concubinage and Other *de facto* Marriages," *TAPA* 104 (1974) 279–305.

B. Rawson ed., *The Family in Ancient Rome* (Ithaca 1986).

B. Rawson, ed., *Marriage, Divorce, and Children in Ancient Rome* (Oxford 1991).

A. Richlin, "Approaches to the Sources on Adultery at Rome," in H.P. Foley ed., *Reflections of Women in Antiquity* (New York 1981) 379–404.

A. Richlin, *The Garden of Priapus: Sexuality and Aggression in Roman Humor* (New Haven 1983).

A. Richlin, "Invective against Women in Roman Satire," *Arethusa* 17 (1984) 67–80.

A. Richlin ed., *Pornography and Representation in Greece and Rome* (New York 1992).

J.E. Salisbury, *Perpetua's Passion: The Death and Memory of a Young Roman Woman* (New York 1997).

R.P. Saller, "*Familia, Domus* and the Roman Conception of the Family," *Phoenix* 38 (1984) 336–55.

R.P. Saller, "Roman Dowry and the Devolution of Property in the Principate," *CQ* 34 (1984).

R.P. Saller and B.D. Shaw, "Tombstones and

Roman Family Relations in the Principate: Civilians, Soldiers and Slaves," *JRS* 74 (1984) 124–56.

R.P. Saller, "*Patria Potestas* and the Stereotype of the Roman Family," *Continuity and Change* 1 (1986) 7–22.

R.P. Saller, "Men's Age at Marriage and Its Consequences in the Roman Family," *CP* 82 (1987) 21–34.

R.P. Saller, "*Pietas,* Obligation and Authority in the Roman Family," in *Festschrift für Karl Christ zum 65. Geburtstag* (Darmstadt 1988) 393–410.

D.F. Sawyer, *Women and Religion in the First Christian Centuries* (New York 1996).

J. Scheid, "Scribonia Caesaris et les Julio-Claudiens," *MEFRA* 87 (1975) 349–75.

J. Scheid, "Claudia, la vestale," in A. Fraschetti ed., *Roma al femminile* (Rome 1994) 3–19.

R. Schilling, "Les origines de la Venus romaine," *Latomus* 17 (1958) 3–26.

J.L. Sebesta and L. Bonfante eds., *The World of Roman Costume* (Madison 1994).

L. Sensi, "Ornatus e status sociale delle donne romane," *AnnPerugia* 18 (1980–1981) 55–102.

B.D. Shaw and R.P. Saller, "Close-kin Marriage in Roman Society," *Man* 19 (1984) 432–44.

B.D. Shaw, "The Age of Roman Girls at Marriage: Some Reconsiderations," *JRS* 77 (1987) 30–46.

J. Shelton, *As the Romans Did²* (New York 1998).

F.W. Singer, "Octavia's Mediation at Tarentum," *CJ* 43 (1947) 172–77.

B. Spaeth, *The Roman Goddess Ceres* (Austin 1996).

H. von Staden, "*Apud nos foediora verba:* Celsus' Reluctant Construction of the Female Body," in *Le latin médical: La constitution d'un langage scientifique, Actes du IIIᵉ Colloque international "Textes médicaux latins antiques,"* Université de Saint-Étienne, 11–13 September 1989 (Saint-Étienne 1991) 271–96.

H. von Staden, "Women and Dirt," *Helios* 19 (1992) 7–30.

A. Staples, *From Good Goddess to Vestal Virgins: Sexual Category in Roman Religion* (New York, 1998).

R. Syme, "Princesses and Others in Tacitus," *Greece and Rome* ser. 2, 28 (1981) 40–52.

R. Syme, *The Augustan Aristocracy* (Oxford 1986).

S. Treggiari, "Libertine Ladies," *CW* 64 (1971) 196–98.

S. Treggiari, "Domestic Staff at Rome in the Julio-Claudian Period, 27 BC to AD 68," *His-

toire Sociale: Revue Canadienne* 6 (1973) 41–55.

S. Treggiari, "Family Life among the Staff of the Volusii," *TAPA* 105 (1975) 393–401.

S. Treggiari, "Jobs in the Household of Livia," *BSR* 43 (1975) 48–77.

S. Treggiari, "Jobs for Women," *AJAH* 1 (1976) 76–104.

S. Treggiari, "Lower Class Women in the Roman Economy," *Florilegium* 1 (1979) 65–86.

S. Treggiari, "Questions on Women Domestics in the Roman West," in Maria Capozza ed., *Schiavitu, manomissione e classi dipendenti nel mondo antico* (Rome 1979) 185–201.

S. Treggiari, "*Concubinae,*" *BSR* 49 (1981) 59–81.

S. Treggiari, "*Contubernales* in CIL 6," *Phoenix* 35 (1981) 42–69.

S. Treggiari, "Consent to Roman Marriage: Some Aspects of Law and Reality," *Classical Views* 26 (1982) 34–44.

S. Treggiari, "*Digna condicio:* Betrothals in the Roman Upper Class," *EchCl* 28 (1984) 419–51.

S. Treggiari, *Roman Marriage* (Oxford 1991).

A. Van Sallet, "Fulvia oder Octavia?" *ZfN* 1 (1883) 167–74.

A. Wallace-Hadrill, "The Social Structure of the Roman House," *BSR* 56 (1988) 43–97.

A. Wallace-Hadrill, *Houses and Society in Pompeii and Herculaneum* (Princeton 1994).

R.B. Ward, "Women in Roman Baths," *HTR* 85.2 (1992) 125–47.

P.R.C. Weaver, "The Status of Children in Mixed Marriages," in B. Rawson ed., *The Family in Ancient Rome* (Ithaca 1986) 145–69.

T. Wiedemann, *Adults and Children in the Roman Empire* (New Haven 1989).

G. Williams, "Some Aspects of Roman Marriage Ceremonies and Ideals," *JRS* 48 (1958) 16–29.

R. Yaron, "Minutiae on Roman Divorce," *Tijdschrift voor Rechtsgeschiedenis* 28 (1960) 1–12.

V. Zinserling, *Women in Greece and Rome* (New York 1973).

ROMAN WOMEN AND ROMAN ART

J. Aymard, "Vénus et les impératrices sous les derniers Antonins," *MEFRA* 51 (1934) 178–96.

D. Baharal, "The Portraits of Julia Domna from the Years 193–211 AD and the Dynastic Propaganda of L. Septimius Severus," *Latomus* 51 (1992) 110–18.

H. Bartels, *Studien zur Frauenporträt der augusteischen Zeit* (Munich 1963).

M. Bergmann, *Studien zum römischen Porträt des 3. Jahrhunderts n. Chr.* (Bonn 1977).

M.T. Boatwright, "Plancia Magna of Perge: Women's Roles and Status in Roman Asia Minor," in S.B. Pomeroy ed., *Women's History and Ancient History* (Chapel Hill 1991) 249–72.

D. Boschung, "Die Bildnistypen der iulisch-claudischen Kaiserfamilie: ein kritischer Forschungsberichte," *JRA* 6 (1993) 39–79.

A. Carandini, *Vibia Sabina* (Florence 1969).

J. Crawford, "Capita Desecta and Marble Coiffures," *MAAR* I (1917).

G. Daltrop, U. Hausmann, and M. Wegner, *Die Flavier: Vespasian, Titus, Domittan, Nerva, Julia Titi, Domitilla, Domitia* (Berlin 1966).

E. D'Ambra, "The Cult of Virtues and the Funerary Relief of Ulpia Epigone," *Latomus* 48 (1989) 392–400.

E. D'Ambra, *Private Lives, Imperial Virtues: The Frieze of the Forum Transitorium in Rome* (Princeton 1993).

E. D'Ambra ed., *Roman Art in Context: An Anthology* (Englewood Cliffs 1993).

E. D'Ambra, "The Calculus of Venus: Nude Portraits of Roman Matrons," in N.B. Kampen ed., *Sexuality in Ancient Art* (Cambridge 1996) 219–32.

K. Patricia Erhart, "A Portrait of Antonia Minor in the Fogg Art Museum and Its Iconographical Tradition," *AJA* 82 (1978) 193–212.

J. Fejfer, "The Portraits of the Severan Empress Julia Domna: A New Approach," *AnalRom* 14 (1985) 131–34.

J. Fejfer and E. Southworth, *The Ince Blundell Collection of Classical Sculpture: The Portraits. Part 1: Introduction: The Female Portraits; Concordances* (London 1991).

K. Fittschen, *Die Bildnistypen der Faustina Minor und die Fecunditas Augustae* (AbhGött 126 [1982]).

K. Fittschen and P. Zanker, *Katalog der römischen Porträts in den Capitolinischen Museen und den anderen kommunalen Sammlungen der Stadt Rom III* (Mainz 1983).

M. Flory, "*Sic Exempla Parantur:* Livia's Shrine to Concordia and the Porticus Liviae," *Historia* 33 (1984) 309–30.

M. Flory, "Livia and the History of Public Honorific Statues for Women in Rome," *TAPA* 123 (1993) 287–92.

M. Flory, "Dynastic Ideology. The *Domus Augustus* and Imperial Women: A Lost Statuary Group in the Circus Flaminius," *TAPA* 126 (1996) 281–305.

H.G. Frenz, *Untersuchungen zu den frühen römischen Grabreliefs* (Mainz 1977).

M. Fuchs, "Frauen um Caligula und Claudius: Milonia Caesonia, Drusilla, und Messalina," *AA* (1990) 107–22.

L. Furnée-van Zwet, "Fashion in Women's Hairdress in the First Century of the Roman Empire," *BABesch* 31 (1956) 1–22.

G.E. Grether, "Livia and the Roman Imperial Cult." *AJP* 67 (1946) 222–52.

W.H. Gross, *Iulia Augusta. Untersuchungen zur Grundlegung einer Livia-Ikonographie* (AbhGött 52 [1962]).

U. Hausmann, "Zu den Bildnissen der Domitia Longina und der Julia Titi," *RM* 82 (1975) 315–28.

A. Helbig, "Osservazioni sopra i ritratti di Fulvia e di Ottavia," *MAAL* I (1889) 573–90.

J.J. Herrmann, "Rearranged Hair: A Portrait of a Roman Woman in Boston and Some Recarved Portraits of Earlier Imperial Times," *JMFA* 3 (1991) 35–50.

W. Jensen, *The Sculptures from the Tomb of the Haterii* I–II (Diss. University of Michigan 1978).

U. Kahrstedt, "Frauen auf antiken Münzen," *Klio* 10 (1910) 261–314.

N. Kampen, "Meaning and Social Analysis of a Late Antique Sarcophagus," *BABesch* 52–53 (1977–1978) 221–32.

N. Kampen, "Biographical Narration and Roman Funerary Art," *AJA* 85 (1981) 47–58.

N. Kampen, *Image and Status: Roman Working Women in Ostia* (Berlin 1981).

N. Kampen, "Social Status and Gender in Roman Art: The Case of the Saleswoman," in N. Broude and M.D. Garrard eds., *Feminism and Art History* (New York 1982) 63–77.

N. Kampen, "The Muted Other," *Art Journal* 47 (1988) 15–19.

N. Kampen, "Between Public and Private: Women as Historical Subjects in Roman Art," in S.B. Pomeroy ed., *Women's History and Ancient History* (Chapel Hill 1991) 218–48.

N.B. Kampen, "Looking at Gender: The Column of Trajan and Roman Historical Relief," in D. Stanton and A. Stewart eds., *Feminisms in the Academy: Thinking through the Disciplines* (Ann Arbor 1995) 46–73.

N.B. Kampen ed., *Sexuality in Ancient Art* (Cambridge 1996).

D.E.E. Kleiner, *Roman Group Portraiture: The Funerary Reliefs of the Late Republic and Early Empire* (New York 1977).

D.E.E. Kleiner, "The Great Friezes of the Ara Pacis Augustae: Greek Sources, Roman Derivatives, and Augustan Social Policy," *MEFRA* 90 (1978) 753–83.

D.E.E. Kleiner, "A Portrait Relief of D. Apuleius Carpus and Apuleia Rufina in the Villa Wolkonsky," *ArchCl* 30 (1978) 246–51.

D.E.E. Kleiner and F.S. Kleiner, "The Apotheosis of Antoninus and Faustina," *RendPontAcc* 51–52 (1978–1980) 389–400.

D.E.E. Kleiner, "Second-Century Mythological Portraiture: Mars and Venus," *Latomus* 40 (1981) 512–44.

D.E.E. Kleiner, "Private Portraiture in the Age of Augustus," in R. Winkes ed., *The Age of Augustus* (Providence 1986) 107–35.

D.E.E. Kleiner, *Roman Imperial Funerary Altars with Portraits* (Rome 1987).

D.E.E. Kleiner, "Women and Family Life on Roman Imperial Funerary Altars," *Latomus* 46 (1987) 545–54.

D.E.E. Kleiner, "Social Status, Marriage, and Male Heirs in the Age of Augustus: A Roman Funerary Relief," *North Carolina Museum of Art Bulletin* 14 (1990) 20–28.

D.E.E. Kleiner, *Roman Sculpture* (New Haven 1992).

D.E.E. Kleiner and Susan B. Matheson eds., *I, Claudia: Women in Ancient Rome* (New Haven 1996).

A.O. Koloski-Ostrow and C. Lyons eds., *Naked Truths: Women, Sexuality and Gender in Classical Art and Archaeology* (New York 1997).

M. Koortbojian, "*In commemorationem mortuorum:* Text and Image along the 'Street of Tombs'," in J. Elsner ed., *Art and Text in Roman Culture* (Cambridge 1996) 210–33.

S.B. Matheson, "A Woman of Consequence," *YaleBull* (1992) 86–93.

J. Meischner, *Das Frauenporträt der Severerzeit* (Diss. Berlin 1964).

T. Mikocki, *Sub Specie Deae: Les impératrices et princesses romaines assimilées à des déesses: Étude iconologique* (Rome 1995).

W.O. Moeller, "The Building of Eumachia: A Reconsideration," *AJA* 76 (1972) 323–27.

S. Nodelman, *Severan Imperial Portraiture, AD 193–217* (Diss. Yale University 1965) 110–36.

H.P. L'Orange, "Zum frührömischen Frauenporträt," *RM* 44 (1929) 167–79.

K. Polaschek, "Studien zu einem Frauenkopf im Landesmusum Trier und zur weibliche Haar-tracht der iulisch-claudisch Zeit," *TrZ* 35 (1972) 141–210.

K. Polaschek, *Porträttypen einer claudischen Kaiserin* (Rome 1973).

K. Polaschek, *Studien zur Ikonographie der Antonia Minor* (Rome 1973).

L. Richardson, jr, "The Evolution of the Porticus Octaviae," *AJA* 80 (1976) 57–64.

G. Rodenwaldt, "Porträtbusten vom Haterier-grab," *AA* 56 (1941), cols. 766–77.

C.B. Rose, *Dynastic Commemoration and Imperial Portraiture in the Julio-Claudian Period* (Cambridge 1996).

S. Sande, "Römische Frauenporträts mit Mauerkrone," *ActaAArHist* 5 (1985).

R. Schlüter, *Die Bildnisse der Kaiserin Iulia Domna* (Diss. Münster 1977).

E.E. Schmidt, "Die Mars-Venus-Gruppe im Museo Capitolino," *AntP* 8 (1968) 85–94.

A.M. Small, "A New Head of Antonia Minor and Its Significance," *RM* 27 (1990) 217–34.

N. Thompson, *Female Portrait Sculpture in the First Century BC in Italy and the Hellenistic East* (Diss. Institute of Fine Arts, New York University 1995).

W. Trillmich, *Das Torlonia-Mädchen. Zur Herkunft und Entstehung des kaiserzeitlichen Frauenporträts* (Göttingen 1976).

W. Trillmich, *Familienpropaganda der Kaiser Caligula und Claudius: Agrippina Major und Antonia Augusta auf Münzen* (Berlin 1978).

E.R. Varner, "Domitia Longina and the Politics of Portraiture," *AJA* 99 (1995) 187–206.

M. Wegner, *Die Herrscherbildnisse in antoninischer Zeit* (Berlin 1939).

M. Wegner, *Hadrian, Plotina, Marciana, Matidia, Sabina* (*Das römische Herrscherbild* 2.3, Berlin 1956).

K. Wessel, "Römische Frauenfrisuren von der severischen bis zur konstantinischen Zeit," *AA* 61 (1946–1947) 62–76.

E. Will, "Women in Pompeii," *Archaeology* 32 (1979) 37–41.

R. Winkes, *Livia, Octavia, Iulia* (*Archaeologica Transatlantica*, Louvain 1996).

S. Wood, "Alcestis on Roman Sarcophagi," *AJA* 82 (1978) 499–510.

S. Wood, *Roman Portrait Sculpture 217–260 AD* (Leiden 1986).

S. Wood, "*Memoriae Agrippinae:* Agrippina the Elder in Julio-Claudian Art and Propaganda," *AJA* 92 (1988) 409–26.

S. Wood, "Diva Drusilla Panthea and the Sisters of Caligula," *AJA* 99 (1995) 457–82.

H. Wrede, "Das Mausoleum der Claudia Semne

und die bürgerliche Plastik der Kaiserzeit," *RM* 78 (1971) 125–66.

H. Wrede, "Stadtrömische Monumente, Urnen und Sarkophage des Klinentypus in den beiden ersten Jahrhunderten n. Chr.," *AA* (1977) 395–431.

H. Wrede, *Consecratio in Formen Deorum: Vergöt-* *liche Privatpersonen in der römischen Kaiserzeit* (Mainz 1981).

H. Wrede, "Klinenprobleme," *AA* (1981) 86–131.

P. Zanker, "Grabreliefs römischer Freigelassener," *JdI* 90 (1975) 267–315.

INDEX

Christianity, 25, 26, 92, 150, 156
 and Eleusis, 93
Cicero, 2, 17, 79, 111
Claudia, 1, 2, 13
Claudia Antonia (daughter of Claudius), 18
Claudia Antonia Sabina, 17, 18
Claudia Antonia Tatiane, 18
Claudia Augusta, daughter of Nero, 21
Claudia Crateia Veviane, 18
Claudia Isadora (Appia), 3
Claudia Livilla, 2
Claudia Octavia, 2
Claudia Parata, 2
Claudia Pulchra, 2
Claudia (Pythia?), 18
Claudia Quinta, 2
Claudia Semne, Tomb of, 101
 as Venus, Spes, Fortuna, 101
Claudia Severa, 2
Claudia Sosipatra, 18
Claudia Trophime (1), 2, 3
Claudia Trophime (2), 3
Claudia Tyrannio, 19
Claudian family, 1, 2, 3, 19, 45, 46
Claudius, 2, 8, 17, 18, 20, 21, 38, 44, 46, 48, 49–50, 63, 81–82, 132, 133
 children of, 63
 son of Antonia the Younger, 133
 statue of, 66
Claudius Nero, husband of Livia, 32
Cleopatra, 12, 49
coinage, 3, 8, 9, 10, 11, 33, 45, 49, 50, 51, 53
 of Agrippina the Younger, 81–82
 of Claudius, 81
 of Drusilla, 81
 of Livia, 81
 with Nero, 81–82
Commodus, 22
concordia, 19
Constantia, 25
 portrait of (?), 25
Constantine, 25
Constantius Chlorus, 25, 26
contubernia, 54
Cornelia, Mother of the Gracchi, 17, 62, 130, 135
Cornelia, wife of Pompey, 17
Cornelia Salonina, 17
Cornelia Supera, wife of Aemilianus, 17, 24
Cornelius Nepos, 110
Crawford, Thomas, 20, **21**
Crepereia Tryphaena, burial of, 117
Crispina, wife of Commodus, 22
cultus, 102, 111
Cybele, 2, 3
 empress in guise of, 134
 woman in guise of, 130

damnatio memoriae, 132
daughters, 5, 8
deification, 134
Demeter, 3, 78–94
 deceased identified with, 79
 and Virgin Mary, 92–93
 women in guise of, 12
devotion, 11, 13
dextrarum iunctio, 7, 54, 126
Didia Clara, 22
Didius Julianus, 22

dinner parties, 3
Dio Cassius, 69, 102
Diodorus Siculus, 142
divorce, 7
 economic aspects of, 153–159
dolls, 117–118
domestic service, as profession, 4
Domitia Longina, 21, 132
 portrait(s) of, **133,** 135
Domitia Paulina, sister of Hadrian, 21
Domitian, 21, 132
 statue of, 66
domus, 5, 6
dowry, 5, 120, 126
 recovery of, 153–155
Drusilla, 81
 as Persephone, 81
 statue of, 81
Drusus, son of Agrippina the Elder, 20
Drusus the Elder, 10, 17, 32, 46–47, 49, 132
Drusus the Younger, 2, 21, 47, 48, 49
dynastic groups, 49, 62–63, 65, 82, 133–134
 on Ara Pacis, 9

education, 7, 43
Egypt, 139–165
 women in, 3, 139–165
Elagabalus, 23
elderly women, 7, 125–138, **127**
elected office, 3
Eleusis, 78–79, 80
 and Christianity, 93
 and mysteries, 80
Emesa, Syria, 22
Ephesus, 2, 18, 38
epitaphs, 7, 13, 129
 women as Venus in, 111
Eros, with Persephone in funerary art, 89
Eros/Amor, in Protesilaos myth, 92
estate, 3
Etruscilla, wife of Traianus Decius, 23
Euhodos and Metilia, 89–91, **91**
Eumachia of Pompeii, 3, 5, 53
 portrait of, 5, 107
Euripides
 Alcestis, 89
 Helen, 83

Fadilla, daughter of Marcus Aurelius, 22
family life, 5
Fates, 56, 86
 in funerary art, 90–91, **91**
Fausta, wife of Constantine, 25
Faustina the Elder, 22
 portrait of, **8,** 103
Faustina the Younger, 11, 22, 51
 coin(s) of, 51, **51**
Felicitas, 23
fertility, 7, 9, 11, 12, 13, 80
fidelity, 7, 9, 11, 13, 129
Fortuna, 3
 women in guise of, 12
Freedman reliefs, 128
Freedwoman, portrait of, **11**
Freedwomen, 3, 5, 9, 53–55
 statues of, as Venus, 102–112
funerary art, 7, 9, 53–55
 funerary portraits, **8, 25,** 135

funerary reliefs, woman as dedicant of, 3
 Rape of Persephone in, 83–84
 women as Venus in, 111
Furia Sabina Tranquillina, wife of Gordianus III, 24

Gaius and Lucius Caesar, 43, 46–47, 48, 51
Gaius Fulvius Plautianus, 23
Gaius, grandson of Augustus, 9, 10
Galba, 21
Galen, 110, 150
Gallia Narbonensis. *See* Vasio
Gallienus, 17, 25
Germanicus, 2, 17, 19, 20, **20**, 48, 49, 63
 daughters of, 63
 portrait of, 134
Geta, 22, 23, 52–53
 on coin, **53**
 portrait of (erased), **23**
girl, burials of, 115–124
girl(s), portrait of, **10**
gladiators, women as, 24
 —relief showing, **24**
goddesses, women in guise of, 12, 79
 in funerary art, 101–102
grave goods, 115–124
Graves, Robert, 1, 17
gravitas, 135

Hades, 78–94, **90, 91**
 in myth of Protesilaos, 92
Hadrian, 18, 21, 44, 50, 61, 66, 67, 132
 statue of, 64–65, 66–67
hairdressing, as profession, 4
hairstyles, 11, 12, 29–39
 and hairpieces/wigs, 104–105, 108–110
 and old age, 128
 and Venus bodies, 103–112
 Venus types on portraits, 106
Hector, Ransom of (*Tabula Iliaca*), 86
Helena, mother of Constantine, 25
 portraits of, 25–26
Hera, 2
Heracles, in myth of Alcestis, 89–90, **91**, 92
Herculaneum woman types, large and small, 62, 65, 82, 130
 large, as Virgin Mary, 93
Hermes, in Protesilaos myth, 92
Hestia, 2, 38
Hippocratic Corpus, 149–150
Homer, *Iliad*, 86, 149
Homeric Hymn to Demeter, 78
Horace, 129
household management, 12, 13
husband, associative power from, 3
Hygeia, 62

inheritance, 4, 43, 126
 jewelry and, 118–119
inscriptions, 126
Italiae Tellus, 46
ius trium liberorum, 10
Iustitia, 38, 49
 Livia as, **11**

jewelry, 5, 9, 115–122, **116–119**
 as dowry, 154
 in tombs of unmarried girls, 115–122

Julia, daughter of Augustus, 9, 19, 38, 47
 portraits of, 33
Julia, daughter of Titus, 21
Julia Domna, 5, 22, 23, 52–53
 as Ceres, 80
 on coin, **53**
 as patron of arts, 57
 portrait(s) of, 5, **6, 23**, 53
Julia Drusilla, 20
Julia Maesa, 23
Julia Mamaea, 23
Julia the Younger, granddaughter of Augustus, 19
Julian family, 19, 45, 46, 81
Julio-Claudian family, 1, 65
Julio-Claudians, dynastic groups of, 48–49
Julius Caesar, 1
Juno, 10, 29, 38
 empress in guise of, 134
 Juno/Hera, woman in guise of, 33–34
Juvenal, *Satire, 6*, 106, 129

Latin, 7
Laudatio Turiae, 13
law
 Egyptian, 139; written evidence and, 142–143
 Greek, written evidence and, 143
 Roman, 43, 54, 118
literacy, 143
Livia, 3, 5, 8, 9, 10, 12, 19, 22, 29–39, 43, 44, 45, 48, 49, 51, 57, 63, 130–131
 as *Augusta*, 49
 on cameo, with Tiberius, 47, **47**
 as Ceres, 80–81
 as Ceres-Fortuna, 82
 as *diva*, 46
 in guise of goddess, 102
 as *Iustitia*, **11**
 as *Pietas*, **11**
 Porticus of, 45
 portrait(s) of, **4**, 29–39, **30, 31, 33, 35, 36, 37**, 131, **132**; 45–46 (on Ara Pacis); 10–11, **11**, 45 (on coins)
 statue of at Eleusis, 80
Livia Drusilla, 1
Livilla, 21, 63, 81
Livy, 12
loom, 6
Lucius, grandson of Augustus, 9, 10
Lucius Verus, 22, 52
 portrait of, **52**
Lucretia, 12

Macrinus, 23
Magna Mater, empress in guise of, 134
 priestess of, 130
Manlia Scantilla, 22
manumission, 2, 5
Marcellus, 43, 45
Marciana, 18, 21, 62, 63
 portrait(s) of, 62, 64, **64, 69**, 103; 67–69 (Ostia); 69–70 (Forum of Trajan)
Marcus Agrippa, 47, 48
Marcus Aurelius, 22, 51
Marcus Numistrius Fronto, 4
Mariniana, wife of Valerian, 23
Mark Antony, 17, 18, 49, 132
marriage, 4, 6, 7, 8, 9, 43, 54
 age at for women, 6

contracts, 140–146 (Egyptian), 141–142 (Greek)
 between Greeks and Egyptians, 139–146
 legislation, Augustan, 6, 7, 9, 12, 126, 141
 Roman, 140
 soldiers and, 151–152
married couple, portrait of, **25, 26, 109**
 on sarcophagi, **8, 57, 90, 91**
Mars and Venus, couples as, 105–106
Martial, 129
Mater Castrorum, 23
Mater Patriae, 34, 45
Matidia the Elder, 18, 21, 61
 portrait of, 62, **63,** 64–65, 103
Matidia the Younger, 21, 22
 portrait of (?), 103
matrona, 9, 32, 132
Mausolea, 18
medical writings on women, 149–150
Meleager
 birth of (?), **85**
 death of, **85,** 86–88, **87**
Mentana, burial at, 116
Messalina, 2, 44, 49, 82
midwife, 3, 84–86
 midwifery as profession, 4
mirror, 115, 122, **121**
moral values, 7
mother(s), 7, 8
 and daughters, 9, 51
 Livia as, 34
 and sons, 9, 43–57, 86–88
Muses, 86
myth, 7

Nero, 1, 2, 8, 9, 11, 20, 21, 44, 49–50, 63, 82, 132
 coin portrait of, 8, **9,** 50, **50**
Nero, son of Agrippina the Elder, 20
Nerva, 21
 statue of, 64
Nichomachus, painting of Rape of Persephone by, 84, 88
nomen, 2, 3
Nonia Balba, statue of at Herculaneum, 82
nudity, 12, 101–112
 as costume, 102–112
 and portraiture, 101–112
 nude portraits as commemoratives, 101
nursing, as profession, 4

Octavia, 3, 9, 12, 17, 18, 29, 32, 45, 132
 Porticus of, 45
 portrait types, 33
Octavia, daughter of Claudius, 21, 48, 63
 statue of, 82
Octavian (Augustus), 32
Ostia, 61, 80
 Baths of Marciana, 67–70
 Baths of Neptune, 67–70
 collegium of Augustales, statue at, 107
 tomb of midwife at Isola Sacra, 84
Otacilia Severa, wife of Philip the Arab, 23
Otho, Marcus Salvius (emperor), 21
Ovid, 29, 32, 38, 79
 Ars Amatoria, 111
 Fasti, 78
 Metamorphoses, 78, 84
Oxyrhynchus, 3

Pamphylia, 64–66
papyri, 3, 120, 126, 140, 143–146
paterfamilias, 6
patria potestas, 141
patron of arts, freedwomen as, 54, 56–57
 Julia Domna as, 53, 57
 Livia as, 49
 women as, 5, 14, 43, 45, 57
Paul
 Ad Plautium, 119
 Ad Vitellium, 119
Paulina, wife of Maximinus Thrax, 23
Perge, 61, 64–66
Persephone, and Virgin Mary, 92–93
 as goddess of underworld, 89, **90, 91**
 as intercessor for dead on sarcophagi, 91–92, **91**
 deceased identified with, 79
 in funerary art, 79, 88–89
 on Christian sarcophagi, 92
 Rape of, 78–94, **80, 83, 85, 90**
personifications, 11, 84
Petronia Hedone, portrait of with son, 5, 54, **55,** 57
Phrixus and Helle, 121, **121**
Pietas, 19, 38, 49, 129
 Livia as, **11**
Plancia Magna of Perge, 5, 19, 64–66
 arch and gate of, 64–66
 freedmen of, 65
 statue(s) of, 65–67, **67,** 107
Plautilla, wife of Caracalla, 23
Plautus, 129
Pliny the Elder, 129
Pliny the Younger, 5
Plotina, 21, 44, 50–51, 61
 portrait(s) of, 50, 64–65, 67–68, **69,** 131, 135
Plutarch, 62, 130
Pompeii, 3, 5
 tomb of Eumachia, 53
Pomponius, *Ad Sabinum,* 120
Poppaea Sabina, 21
portrait types, related to events, 135
portraits, architectural setting of, 61–70
 commissioned by women, 5
 dynastic groups, 9, 48
 mythological, 101
portraiture, family resemblance in, 51–52
 public, of women in Rome, 62
 veristic, 125, 135
potestas, 7, 43
power, associative, 43
priestess, 3
professions, 4, 14
propaganda, 39
property ownership, 3, 139–146, 153–159
Protesilaos, and Laodamia, **91**
 Persephone in myth of on sarcophagus, 91–92
pudicitia statue type, 54, 66

Rape of Persephone, portrait of woman in, 88
 in Etruscan art, 88
 ivory plaque with, **85**
 on sarcophagus, **80, 83, 90**
real estate, 4
relief sculpture, 3
remarriage, for women, 6, 7
 of widows, 150–159
Res Gestae (Augustus), 5